Photoshop® Elements 8
ALL-IN-ONE
FOR
DUMMIES®

by Barbara Obermeier and Ted Padova

WILEY

Wiley Publishing, Inc.

Photoshop® Elements 8 All-in-One For Dummies®

Published by
Wiley Publishing, Inc.
111 River Street
Hoboken, NJ 07030-5774

www.wiley.com

Copyright © 2010 by Wiley Publishing, Inc., Indianapolis, Indiana

Published by Wiley Publishing, Inc., Indianapolis, Indiana

Published simultaneously in Canada

For general information on our other products and services, please contact our Customer Care Department within the U.S. at 877-762-2974, outside the U.S. at 317-572-3993, or fax 317-572-4002.

For technical support, please visit www.wiley.com/techsupport.

Wiley also publishes its books in a variety of electronic formats. Some content that appears in print may not be available in electronic books.

Library of Congress Control Number: 2009938252

ISBN: 978-0-470-54302-3

Manufactured in the United States of America

10 9 8 7 6 5 4 3 2

WILEY

About the Authors

Barbara Obermeier is the principal of Obermeier Design, a graphic design studio in Ventura, California. She is the author of *Photoshop CS4 All-in-One For Dummies* (Wiley) and has contributed as author or coauthor to over two dozen books on Photoshop, Photoshop Elements, Illustrator, PowerPoint, and digital photography. She is currently a senior faculty member in the Graphic Design Department at Brooks Institute.

Ted Padova is the former chief executive officer and managing partner of The Image Source Digital Imaging and Photo Finishing Centers of Ventura and Thousand Oaks, California. He has been involved in digital imaging since founding a service bureau in 1990. He retired from his company in 2005 and now spends his time writing and speaking on digital imaging, Acrobat, PDF forms, and LiveCycle Designer forms.

For more than 17 years, Ted taught university and higher education classes in graphic design applications and digital prepress at the University of California, Santa Barbara, and the University of California at Los Angeles. He has been, and continues to be, a conference speaker nationally and internationally at PDF conferences.

Currently he lives in the Philippines where he serves as President/CEO of his company ApoVisions, Inc. — a company working with third-world nations on developing electronic document workflows and forms routing.

Ted has written more than 30 computer books and is the world's leading author on Adobe Acrobat. He has written books on Adobe Acrobat, Adobe Photoshop, Adobe Photoshop Elements, Adobe Reader, Microsoft PowerPoint, and Adobe Illustrator. Recent books published by Wiley include *Adobe Acrobat PDF Bible* (versions 4, 5, 6, 7, 8, and 9), *Acrobat and LiveCycle Designer Forms Bible, Adobe Creative Suite Bible* (versions CS, CS2, CS3, and CS4)*, Color Correction for Digital Photographers Only, Color Correction for Digital Photographers For Dummies, Microsoft PowerPoint 2007 Just the Steps For Dummies, Creating Adobe Acrobat PDF Forms, Teach Yourself Visually Acrobat 5,* and *Adobe Acrobat 6.0 Complete Course*. He also coauthored *Adobe Illustrator Master Class — Illustrator Illuminated* and wrote *Adobe Reader Revealed* for Peachpit/Adobe Press.

Dedication

Barbara Obermeier: For Gary, Kylie, and Lucky, who constantly remind me of what's really important in life.

Ted Padova: For Arnie

Authors' Acknowledgments

The authors would like to thank our awesome project editor, Kim Darosett, who kept us and this book on track; Bob Woerner, our most excellent Executive Editor; Andy Cummings, Dummies Royalty; Dennis Cohen, our technical editing czar; Jennifer Riggs, our copy editor who made everything we wrote sound better; and all the dedicated production staff at Wiley.

Barbara Obermeier: A special thanks to Ted Padova, my coauthor and friend, who both celebrates and commiserates with me on the ups and downs of being an author.

Ted Padova: Many thanks to my dear friend and colleague Barbara Obermeier for asking me to join her on this project . . . and a little hand-holding along the way to help me get through it.

Publisher's Acknowledgments

We're proud of this book; please send us your comments at http://dummies.custhelp.com. For other comments, please contact our Customer Care Department within the U.S. at 877-762-2974, outside the U.S. at 317-572-3993, or fax 317-572-4002.

Some of the people who helped bring this book to market include the following:

Acquisitions and Editorial

Project Editor: Kim Darosett

Executive Editor: Bob Woerner

Copy Editor: Jennifer Riggs

Technical Editor: Dennis Cohen

Editorial Manager: Leah Cameron

Editorial Assistant: Amanda Graham

Sr. Editorial Assistant: Cherie Case

Cartoons: Rich Tennant
(www.the5thwave.com)

Composition Services

Project Coordinator: Katherine Crocker

Layout and Graphics: Joyce Haughey, Ronald Terry, Christine Williams

Proofreaders: Laura Albert, Melissa D. Buddendeck

Indexer: BIM Indexing & Proofreading Services

Publishing and Editorial for Technology Dummies

 Richard Swadley, Vice President and Executive Group Publisher

 Andy Cummings, Vice President and Publisher

 Mary Bednarek, Executive Acquisitions Director

 Mary C. Corder, Editorial Director

Publishing for Consumer Dummies

 Diane Graves Steele, Vice President and Publisher

Composition Services

 Debbie Stailey, Director of Composition Services

Contents at a Glance

Table of Contents

Introduction

*P*hotoshop Elements has evolved through several generations to become a sophisticated photo editor. What was once a low-end, consumer-grade product is now a tool for novice photo editors, amateur photographers, and professionals alike.

Elements shines on its own turf and is distinguished from Adobe Photoshop in many ways. Not only a program for improving image quality, Elements is a complex software application that offers you many different editing tools for designing a variety of photo creations and sharing your photos in a number of ways. Of course, it also gives you all the standard editing features you need for, say, controlling image brightness or working with color correction.

Why should you buy Elements (and, ultimately, this book)? The range of people who can benefit from using Elements is wide and includes a vast audience. Elements has something for everyone — from beginning image editors to intermediate users to more advanced amateurs and professionals. And in Photoshop Elements 8, the Macintosh version is once again supported.

We'll even stick out our necks a little and suggest that many Photoshop users can benefit greatly by adding Elements to their software tool chests. Why? Because Elements offers some wonderful creation and sharing tools that Photoshop hasn't yet dreamed of supporting. For example, in Photoshop Elements 8, you can create postcards, greeting cards, calendars, and photo albums with just a few mouse clicks. You can place orders with online service centers that professionally print your photo creations. All these opportunities are available in Elements, and we cover these and many more creation ideas in Book IX.

Don't think of Photoshop Elements as a scaled-down version of Adobe Photoshop. Those days are gone. If you're a digital photographer and you shoot your pictures in JPEG, TIFF, or Camera Raw format, Elements has the tools for you to open, edit, and massage your pictures into professional images. If you worry about color profile embedding, forget it. Elements can handle the task for you, as we explain in Book IX, Chapter 2, which covers color profiling and printing. For the professional, Photoshop Elements has just about everything you need to create final images for color desktop and commercial printing.

About This Book

This book is our best effort to provide a comprehensive view of a wildly feature-rich program for both Windows and Macintosh users. There's a lot to Elements, and we try to offer you as much as possible within our limited amount of space. We begged for more pages, but alas, our publisher wants to get this book in your hands in full color and with an attractive price tag. Therefore, even though we may skip over a few little things, all you need to know about using Photoshop Elements for designing images for print, sharing, Web hosting, versatile packaging, e-mailing, and more is covered in the pages ahead.

As we said, Photoshop Elements has something for just about everyone. We know that our audience is large and that not everyone will use every tool, command, or method described in this book. Therefore, we added a lot of cross-references in the text, in case you want to jump around. You can go to just about any chapter and start reading; if some concept needs more explanation, we point you in the right direction for getting some background when it's necessary.

If you're new to a *For Dummies All-in-One,* you should be aware that a book in this series is really several books in one. This work contains nine separate books covering distinct areas of Photoshop Elements. You can jump around in the book and investigate the areas that interest you most. Generally, there's no need to read through chapters in order before going to the chapter dealing with the tasks you're most interested in exploring.

Each of the nine books contains several chapters covering a particular category of image editing, sharing files, and making creations.

Book 1: Introducing Elements

We begin Book I by introducing you to Elements as it appears onscreen the first time you launch the program. The Elements Welcome screen permits you to enter several different workspaces.

We talk about changing workspaces, setting up your work environment, looking at tools and menus, discovering the various panels, using shortcuts, and getting help in Chapter 1. In Chapter 2, we explore in depth the tools used in Edit Full mode. We provide the basics for using the tools so you have a clear understanding of what they do before delving into chapters where we use the tools to create a variety of results.

In Chapter 3, we look at navigation and viewing. We explore using the Navigator panel, changing views between workspaces, zooming in and out of photos, and cover all you need to know about the Image window when working in Edit Full mode. In Chapter 4, we cover preference settings you use in the

Organizer and Edit Full mode for customizing your workspace. Every preference setting you can make in Photoshop Elements is covered in this chapter.

Book II: Elements Fundamentals

As the name implies, we talk about essential fundamentals in this book. Look here for opening, closing and saving files, using the Organizer workspace for Windows users and exploring Adobe Bridge for Macintosh users; acquiring images from your digital cameras and scanners; and a whole lot of coverage on sorting and finding your pictures. We also cover creating albums and keyword tags, creating new catalogs, and backing up your photos.

Book III: Image Essentials

In this book, we handle all you'd ever want to know about the characteristics of images. This book is *image-centric* — the place where we cover many essentials such as resolution, color modes, file formats, working with Camera Raw, and managing color.

Book IV: Selections

This important book gives you all the juicy details and techniques on creating and modifying selections. You find out about each of the selection tools and how to modify selections, feather selections, and refine edges, as well as save and load selections.

Book V: Painting, Drawing, and Typing

If you want to know about the drawing and painting tools, this book's for you. Here we cover the Brush and Pencil tools, along with the multifaceted Brushes panel. We also show you how to create vector shapes by using the shape tools and how to fill and stroke selections.

Head to this book to find out how to create both gradients and patterns and, last but not least, become familiar with the type tools and how to use them to create and edit standard type, type on and in a path, and type with special effects.

Book VI: Working with Layers and Masks

This book gives you everything you need to work with layers and masks. We show you how to save and edit selections as alpha channels so that you can reload them later. And we show you how to work with the various kinds of masks — quick masks, layer masks, and channel masks — and how you can use each to select difficult elements. We talk about managing layers, playing with opacity blends, and transforming and simplifying layers.

Book VII: Filters, Effects, Styles, and Distortions

We filled this book with tons of handy tips and techniques on using filters to correct your images to make them sharper, blurrier, cleaner, and smoother — whatever fits your fancy. We give you the scoop on the Smart Filters feature, which enables you to apply filters nondestructively. You also find out how to use filters to give your image a certain special effect, such as a deckled edge or water droplets. Finally, we introduce the Liquify command so that you can see the wonder of its distortion tools — and how they can turn your image into digital taffy.

Book VIII: Retouching and Enhancing

You find everything you need to know about color correction or color enhancement in Book VIII — getting rid of colorcasts, improving contrast and saturation, remapping, and replacing colors.

In addition, we include using the focus and toning tools to manually lighten, darken, smooth, soften, and sharpen areas of your image. You get to see how you can use the Clone Stamp tool, the Healing tools, and the Red Eye tool to fix flaws and imperfections in your images, making them good as new. We also show you the Color Replacement tool and how to replace your image's original color with the foreground color. Finally, you get some tidbits on how to composite images using some easy steps.

Book IX: Creating and Sharing with Elements

The wonderful world of creations and sharing is the topic for this book. Elements provides you with some extraordinary creation opportunities such as creating slide shows, photo books, calendars, greeting cards, flipbooks, and more. We go into detail for each of these creation options. Not all files are destined for online viewing, so we cover the complex world of printing color images and getting color right with color profiles in this book. Finally, we top off the last chapter with sharing projects using online services.

About the eCheat Sheet

We have a handy little guide for you that's hosted online. Download the Cheat Sheet file from www.dummies.com/cheatsheet/photoshopelements8aio.

Conventions Used in This Book

Throughout this book, we point you to menus where commands are accessed frequently. A couple of things to remember are the references for where to go when we detail steps in a procedure. For accessing a menu command, you may see a sentence like this one:

Choose File⇨Get Photos and Videos⇨From Files and Folders.

When you see commands like this one mentioned, we're asking you to click the File menu to open the drop-down menu, click the menu command labeled Get Photos and Videos, and then choose the command From Files and Folders from the submenu that appears.

Another convention we use refers to context menus. A *context menu* jumps up at your cursor position and shows you a menu similar to the menu you select at the top of the Elements workspace. To open a context menu, click the right mouse button. For Mac users with a one-button mouse, press the Control key and click to open a context menu.

A third item relates to using keystrokes on your keyboard. When we mention that some keys need to be pressed on your keyboard, the text is described like this:

Press Alt+Shift+Ctrl+S (Option+Shift+⌘+S on the Mac).

In this case, you hold down the Alt key, the Shift key, and the Control key and then press the S key (or hold down the Option key, the Shift key, and the Command key and then press the S key on the Mac). Then release all the keys at the same time.

Icons Used in This Book

In the margins throughout this book, you'll see icons indicating that something important is stated in the respective text.

A Tip icon tells you about an alternative method for a procedure by giving you a shortcut, a workaround, or some other type of helpful information related to working on tasks in the section being discussed.

Pay particular attention when you see the Warning icon. This information informs you when you may experience a problem performing your work in Elements.

This icon is a heads-up for something you may want to commit to memory. Usually, it tells you about a shortcut for a repetitive task, where remembering a procedure can save you time.

Elements is a computer program, after all. No matter how hard we try to simplify our explanation of features, we can't entirely avoid the technical information. If we think that a topic is complex, we use this icon to alert you that we're moving into a complex subject. You won't see many of these icons in the book because we try our best to bring the details to nontechnical terms.

This icon informs you that the item discussed is a new feature in Photoshop Elements 8.

Where to Go from Here

Feel free to jump around and pay special attention to the cross-referenced chapters, in case you get stuck on a concept. If you're new to image editing, you'll want to pick up some basics. Look over Books I and II to get a grip on images and the environment you work in with Elements.

When you need a little extra help, refer to Book I, Chapter 1, where we talk about using the online help documents available in Elements.

We wish you much success and enjoyment in using Adobe Photoshop Elements 8, and it's our sincere wish that the pages ahead provide you with an informative and helpful view of the program.

Book I
Introducing Elements

The 5th Wave By Rich Tennant

"I've got some new image editing software, so I took the liberty of erasing some of the smudges that kept showing up around the clouds. No need to thank me."

*B*ecause we try to present all books as stand-alone elements so you can move around and jump in at any chapter, a little foundation always helps make understanding the big concepts a bit easier.

We start this book with some essentials related to the Elements workspace, tell you how to launch the program, and offer you a description of many resources available to you.

If you're new to Elements, this book is your best starting place. Be sure to review Chapter 2 where we cover all the tools used in Edit Full mode and Chapter 4 where we talk about adjusting Preferences to customize your work environment.

Chapter 1: Examining the Elements Environment

In This Chapter

✔ **Starting up**

✔ **Setting up your workspaces**

✔ **Moving through the menu bar and context menus**

✔ **Picking your settings in the Options bar**

✔ **Playing around with panels and bins**

✔ **Shortening your steps**

✔ **Getting a helping hand**

*W*ow! There's a lot to Photoshop Elements 8! Just look at the many pages in this chapter — and we aren't even going to talk about fixing up your pictures. We *are,* however, going to talk about some pretty essential stuff to help you move quickly and efficiently around the program, as well as figure out how to access all those wonderful tools that Elements offers you for editing your pictures.

This chapter may not be the most fun part of this book, but it is a critical first step for anyone new to Elements. Stay with us while we break down all the areas in the Photoshop Elements workspace where you can turn that photo of Aunt Gina into something that Whistler's mom would envy.

Launching Elements

After running the installer from the Photoshop Elements DVD-ROM, double-click the program icon to launch Elements. Upon launch, you see the Adobe Photoshop Welcome screen, as shown in Figure 1-1 (Windows) or Figure 1-3 (Mac).

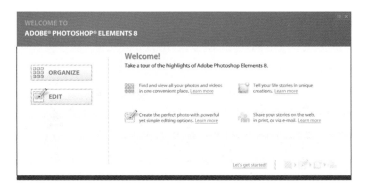

Figure 1-1: The Photoshop Elements Welcome screen for Windows.

At the left of the photo image in the Welcome screen (Windows), you find two buttons that take you to different windows where you can edit and manage your pictures. You also find some navigation buttons represented by left and right arrows, which are located in the lower-right corner. The buttons and arrows include

- **Organize:** Click the Organize button, and Elements opens the Organizer, the window where you take care of a plethora of file-management and organization tasks. Among other options, you can choose to load pictures in the Organizer window so they're ready to use for all your projects.

- **Edit:** Click the Edit button to open the Photoshop Elements Edit Full mode. Here you perform all the editing for your photos.

- **Right arrow:** Click the right arrow to advance to the next view in the Welcome screen.

- **Left arrow:** Click the left arrow to move to the previous view in the Welcome screen.

As you toggle screen views by clicking the left and right arrows, you find two additional buttons on the photo images, as shown in Figure 1-2. Click the Learn More button, and a Web page opens in your default Web browser where some help information is provided. Click the icon below See What You Can Do. An Adobe Flash video walks you through some steps related to the topic text at the top of the photo.

Each time you launch Photoshop Elements, the Welcome screen is the first item you see on your monitor. From the Welcome screen, you choose the kind of tasks you want to accomplish in a session. If you want to change

from one window to another, for example change from the Organizer to Edit Full mode, you can easily navigate workspaces after you open one editing environment, as we explain later in this chapter.

Figure 1-2: Click the right arrow, and the topic text and photo image in the Welcome screen changes.

The photo image you see in Figure 1-1, along with any of the help information displayed there, may be slightly different from what you see on your monitor when you launch Elements. The Welcome screen appears in an Adobe Flash interface, and the photo images scroll through a series of different images. You can manually scroll through the images and the help information by clicking the arrows at the bottom-right corner of the Welcome screen.

On the Mac, you find a different Welcome screen with different options. The Mac version of Elements doesn't have an Organizer. Instead, Adobe Bridge performs functions similar to the Organizer found on Windows. (For more information on Adobe Bridge, see Book II, Chapter 3.) Launch Elements on the Mac and you find a Welcome screen, as shown in Figure 1-3.

Options in the Mac Welcome screen include

✓ **Start from Scratch:** This button is the alternative to the Edit button found on the Windows Welcome screen. Click the button and the Photoshop Elements Edit Full mode opens.

✓ **Browse with Adobe Bridge:** Click this button to open Adobe Bridge, where you can organize and manage photos.

✔ **Import from Camera:** Click this button to import photos from a camera or card reader. On Windows, you have similar options via a menu command in the Organizer.

✔ **Import from Scanner:** Click this button to scan a photo.

✔ **Recent Images:** A list of recent images appears in the lower-left corner of the Welcome screen. Click an image in the list to open it in Edit Full mode.

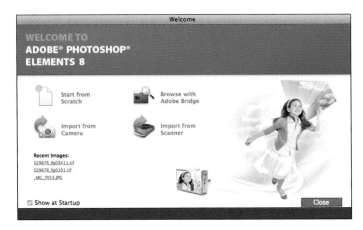

Figure 1-3: The Welcome screen as shown on the Mac.

Opening the Organizer (Windows)

The Organizer is one of several different workspaces available to you with Photoshop Elements. Unless you have an immediate task at hand for editing a photo in the Edit Full workspace, the Organizer is often going to be your first workspace to visit. In the Organizer, you can manage photos and navigate to every other editing workspace Elements provides you.

To open the Organizer, click the Organize button on the Welcome screen. When you first install Elements and first open the Organizer, you see an empty screen, as shown in Figure 1-4.

Photos are added to the Organizer window through a variety of options we cover in Book II, Chapter 1. For now, we focus on looking at the Organizer tools and understanding how they work. Some of the more important tools in the Organizer include

✔ **Elements Organizer:** Clicking this button opens a menu where you can choose to close, minimize, and maximize the Organizer workspace. The icon represents the Organizer, and in other workspaces, such as the Editors, clicking the icon returns you to the Organizer window.

✔ **Menu bar:** The menus contain all the commands you use in the Organizer workspace. Throughout all these books, we talk about using menu commands. You find much more detail about the Menu bar in Book II.

✔ **Options bar:** Some navigation tools appear active when you have photos added to the Organizer window. You can scroll images, change viewing zoom levels, and rotate images without opening them in one of the Editors.

✔ **Undo/Redo:** These tools permit you to undo and redo edits.

✔ **Display:** Open the drop-down list and you find an assortment of commands for importing files, changing views, and comparing files.

Figure 1-4: Upon first launch of the Organizer, you see an empty workspace.

🖝 **Welcome Screen:** Click this button to return to the Welcome screen.

🖝 **Features buttons:** The three buttons represented by tiny icons from left to right include: Minimize, Restore, and Close. These buttons function the same as you find with almost all Windows applications.

🖝 **Search:** Type text in the text box to search for photos in the Organizer window.

🖝 **Panel buttons:** Click a panel button to open the panel options: Fix to open a menu where you can choose an edit mode, Create to open the Create panel, and Share to open the Share panel.

🖝 **Panel Bin:** The four tabs at the top of the Panel Bin open panels. The names of these panels are shown at the top of the bin. The panels offer you a number of different options for organizing files, editing photos, creating projects, and sharing photos.

🖝 **Catalog Info:** In the lower-left corner of the Organizer window, you find some information related to a catalog. When you add photos to the Organizer, your photos are maintained in a catalog file. The information at the bottom of the Organizer window reports feedback on the catalog name, the number of items contained in the catalog, and the date range for when the photos were taken.

🖝 **Auto Analyzer:** Click the icon to enable or disable the Auto Analyzer. The Auto Analyzer Preferences dialog box opens where you can set options for auto-analyzing photos in the Organizer. (See Chapter 4 of this minibook for more information on setting Auto Analyzer preferences.)

🖝 **Catalog images:** When you add photos to your catalog, image thumbnails appear in this window.

Opening Adobe Bridge (Mac)

On the Mac, you don't have an Organizer. Elements ships with *Adobe Bridge* — a powerful organization tool used by Photoshop users. To open Adobe Bridge, launch Elements and click the Browse with Bridge button. The Adobe Bridge workspace opens, as shown in Figure 1-5.

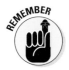

Adobe Bridge is a standalone application. You can create an alias and add it to the Dock or double-click the program icon in your Applications folder on your root drive. You don't need to launch Elements in order to organize and view files in Adobe Bridge.

You find some similar features in Adobe Bridge as in the Organizer. For a detailed view of Adobe Bridge, look over Book II, Chapter 3.

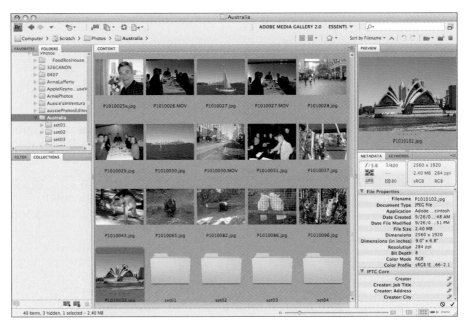

Figure 1-5: The Adobe Bridge workspace on the Mac.

Changing Workspaces

Think of the Organizer as your central workspace. From there, you travel to other workspaces where edits and creations are handled. The Organizer is like a huge file cabinet with a vast number of tools and commands that help you keep track of your images. It also offers you a gateway to other workspaces.

Visiting the Organizer (Windows)

You can't do much with the window shown in Figure 1-1 because you haven't added any photos. In order to manage photos and apply edits, you need to load some photos in the default catalog that appears (empty, obviously) when you first launch Elements.

To add some photos to the default catalog, do the following:

1. **Copy some photos to your hard drive.**

 Make a new folder on your hard drive and call it something like My Photos or use some other descriptive name.

2. **Launch Elements.**

 Double-click the program icon or use the Start menu to open Elements.

3. **Click Organize in the Welcome screen.**

4. **Choose File⇨Get Photos and Videos⇨From Files and Folders.**

 The Get Photos and Videos from Files and Folders dialog box opens, as shown in Figure 1-6. Open the Look In menu and navigate your hard drive to locate the folder where you copied your photos.

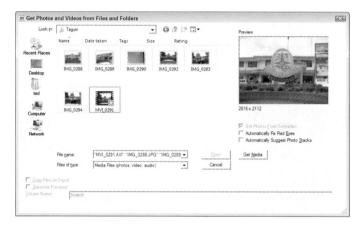

Figure 1-6: You select photos to import in a catalog from the Get Photos and Videos from Files and Folders dialog box.

5. **Select the photos to import.**

 If you want to import all photos from a given folder, press Ctrl+A (⌘+A on the Mac). If you want to select individual photos, click a photo and press the Ctrl (⌘) key while clicking additional photos.

6. **Click the Get Media button to import the photos into your catalog.**

 You have some other options available in the Get Photos and Videos from Files and Folders dialog box. But for now, just click Get Media and leave all the other items at the defaults.

7. **Click OK in the alert dialog box.**

 An alert dialog box opens, informing you that you need to click the Show All button if you want to see all photos in your catalog. This button appears at the top of the Organizer window, as shown in Figure 1-7.

Figure 1-7: Click Show All above the image thumbnails to show all photos in your catalog.

8. **View the photos in the Organizer.**

As shown in Figure 1-8, photos appear in the Organizer window. Drag the scroll bar at the right side of the Organizer and the left of the Panel Bin to scroll through the images.

Figure 1-8: Photos are added to the default catalog.

When you open the Get Photos and Videos from Files and Folders dialog box, you see thumbnail previews for images saved as JPEG or TIFF files. If you import Camera Raw images, you won't see image previews. For more information on working with Camera Raw images, see Book III, Chapter 3.

A number of file-management options are available in the Organizer for sorting images, tagging files with keywords, and creating albums of photos. We cover all you can do with file management in the section about the Organizer in Book II, Chapter 2.

Visiting Adobe Bridge (Mac)

On the Mac, you can easily copy photos to folders from the Desktop. Photos can be organized in subfolders, and all the folders are accessible to Adobe Bridge. When you launch Bridge, use the Folders tab (refer to Figure 1-5) to browse your hard drive to view thumbnail images of your photos. (We offer more detail on navigating the Bridge window in Book II, Chapter 3.)

Visiting Edit Full mode

Elements provides you with two editing modes — Edit Full and Edit Quick. The Edit Full mode is where you have access to all the tools and commands that provide you limitless opportunities for editing your pictures. Edit Quick mode can be used when you need to polish up an image in terms of brightness, contrast, color adjustments, and other similar editing tasks.

After you have files loaded in the Organizer (or Adobe Bridge on the Mac), you can easily open an image in an editing mode. Assuming you want to edit a picture, do the following to launch the Edit Full mode workspace:

1. **Click an image thumbnail in the Organizer.**

 Following this step presumes you have added photos to the Organizer, as we describe earlier in this chapter.

2. **Open the Fix drop-down list and choose Edit Photos.**

 At the top of the Organizer window, you see the Fix drop-down list, as shown in Figure 1-9. After making the menu choice, the selected image appears in the Edit Full workspace, as shown in Figure 1-10.

 On the Mac, double-click a photo in Abobe Bridge to open it in Elements Edit Full mode. If you have Adobe Photoshop installed and double-clicking a photo opens the image in Photoshop, you can click a photo, press the Control key, and click to open a context menu. From the menu options, choose Open With⇨Adobe Photoshop Elements 8.0.

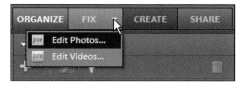

Figure 1-9: Choose Edit Photos from the Fix drop-down list.

3. **Click the Organizer button in the Edit Full mode workspace.**

 To return to the Organizer, click the Organizer button, as shown in Figure 1-10.

Figure 1-10: After choosing Edit Full from the Fix drop-down list, the file opens in the Edit Full workspace. To return to the Organizer, click the Organizer button.

When you open a file from the Organizer or you change to another workspace while the Organizer is open, you have two workspaces open in Elements. The second workspace (such as Edit Full mode) opens while the Organizer remains open. When you toggle back and forth between the modes, each mode remains open until you quit one mode or the other.

Visiting Edit Quick mode

If you've worked in earlier versions of Elements, you know that the Organizer provided you a direct link to either Edit Full mode or Edit Quick mode. Elements 8 has a slight change — you can only go directly to Edit Full mode from the Organizer.

The Edit Quick mode is easily opened after you enter Edit Full mode. While in Edit Full mode, choose Edit Quick from the Edit Full drop-down list, as shown in Figure 1-11.

Comparing the modes

When you examine Figures 1-8, 1-10, and 1-12, you see different tools and panel options. Each mode

Figure 1-11: While in Edit Full mode, you can easily open Edit Quick mode by choosing Edit Quick from the Edit Full drop-down list.

is designed to help you with different tasks. In Figure 1-8, you see the Organizer where you can manage files and easily work with projects and file sharing. In Edit Full mode, as shown in Figure 1-10, you have access to all of the Elements editing tools and menu commands to enhance your photos in limitless ways. In Edit Quick mode, as shown in Figure 1-12, you see the different options for giving images a quick makeover.

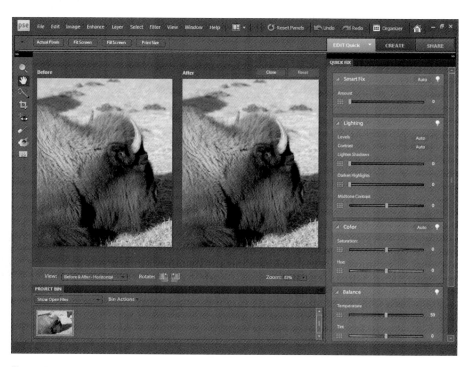

Figure 1-12: Edit Quick mode.

In the following chapters, we cover each of the modes, the tools accessible in each mode, and all the menu commands accessible to you for each mode. Be sure you understand how to toggle through the modes to gain access to the tools you want to use.

In addition to the buttons at the top of the Organizer and those in the Panel Bin, when in either editing mode you can easily navigate modes using the status bar (Windows) or the Dock (Mac). The status bar (Dock) serves to open applications. Click an application to open the workspace you want.

Getting help with Guided mode

Although not entirely a separate mode, the Guided panel changes the appearance of the Panel Bin to offer you help with many different editing tasks. When in either Edit Full or Edit Quick mode, choose Edit Guided from the Editor drop-down list. The Guided Edit panel opens, as shown in Figure 1-13.

The panel lists topics for you to review when performing edits relative to a particular category. Click one of the category items and the panel changes, displaying info tailored to that specific editing task as well as some options for performing a given edit. We clicked Crop Photo to open the Crop panel, as shown in Figure 1-14. From the Crop Box Size drop-down list, we chose 2.5 x 2 in.

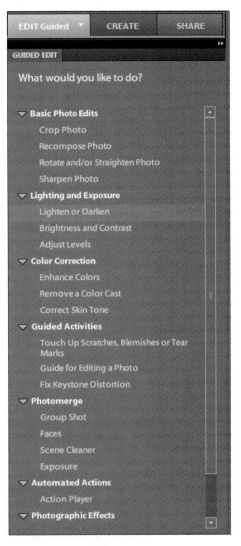

Figure 1-13: Choose Edit Guided from the Editor drop-down list to open the Guided Edit panel.

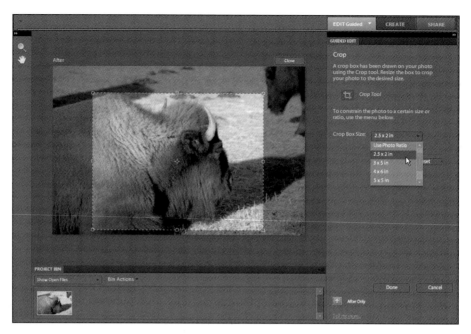

Figure 1-14: The Crop panel offers options for cropping images to standard photo sizes by making choices in a drop-down list.

Click other items in the Guided panel and you find helpful hints to guide you through a number of common image-editing tasks.

Moving through the Menu Bar

As with most programs on your computer, Elements offers you a number of drop-down lists with many different commands that invoke actions. It's not important to memorize all the menu commands. Instead, try to develop an understanding of the types of actions included in a given menu. A general understanding of uses of the different menus helps you find commands much faster.

The menus in the Organizer are different from those in the two editing modes. Edit Full and Edit Quick contain the same menu names, but some menu commands are grayed out when in Edit Quick mode.

First, take a look at the menus in the Organizer. Among the Organizer menus you find

✔ **File:** In the File menu, as you might expect, you find commands to open and browse files on your hard disk. You also find a number of options for saving files, such as writing images to CD-ROMs, DVDs, and removable media. Commands for managing catalogs, moving files, and printing images are also located in this menu.

✔ **Edit:** Many items you're familiar with — copy, undo, delete, and so on — are located in the Edit menu. In the Organizer, you also find many options for sorting files as well as options for managing color. In addition, you find a number of quick-access commands for editing photos similar to options you find in Edit Quick mode.

✔ **Find:** The Find menu is all about finding images on your computer. You have many choices for searching photos based on a wide range of criteria.

✔ **View:** The View menu handles commands related to viewing images in the Organizer window. You can choose what types of media to display in the Organizer, show and hide files, and show and hide certain data associated with files such as the filenames. Choices you make in this menu relate to the displays of images in the Organizer.

✔ **Window:** The Window menu contains commands that display some items in the Organizer such as the Timeline, where you can view photos according to date ranges. The Window menu also has commands for controlling the display of some panels in the Panel Bin, such as the Quick Share and Properties panels.

✔ **Help:** As you might expect, the Help menu contains menu commands that provide help when working in Elements. Certain help commands open your default Web browser and open help Web pages on Adobe's Web site.

Keep in mind that the Organizer is quite distinct from the two editing modes. It turns out, though, that the Edit Quick and Edit Full modes are identical in terms of menu names, and both contain many similar commands. What you find in the editing modes for the most part is very different from the menu items found in the Organizer. Both Edit Quick and Edit Full modes contain the following menus:

✔ **File:** You find file-opening and -saving options in the File menu as well as printing commands. The File menu also contains some options for combining images and batch-processing files.

 ✔ **Edit:** The Edit menu offers you a number of editing options, such as copy/paste, copy merged, paste into selections, setting up files, and using patterns and brushes. You also find color-management options identical to the commands in the Organizer Edit menu.

 ✔ **Image:** The Image menu contains commands that are used for changing images, such as cropping, resizing, changing color modes, converting color profiles, and transforming images/selections. Notice that there are no image corrections for brightness and color adjustments. These commands are contained in the Enhance menu.

 ✔ **Enhance:** The Enhance menu is all about working with images in terms of color and brightness corrections and altering the visual appearance of images.

 ✔ **Layer:** The Layer menu has to do with working with layers and gives you access to the many different things you can do with layers.

 ✔ **Select:** The Select menu has to do with creating and using selections. One of the most frequent phases of an edit is creating a selection, and the Selection menu provides you with a number of commands and tools to help you perfect your selection of image content.

 ✔ **Filter:** For artistic edits, take a look at the Filter menu and explore the many filter effects you can add to your pictures. You don't need to be a Photoshop Elements expert. The program makes it easy for you by keeping all the filters in one place so that with the click of the mouse button, you can create some dazzling effects.

 ✔ **View:** Viewing options in the Editors relate to zooming in and out of photos, showing rulers and guides, and creating new windows.

 ✔ **Window:** The Window menu displays a list of panels that can be opened and closed. You also find a list of all open files in this menu up to a maximum number of windows you determine in the Elements preferences.

 ✔ **Help:** The Help menu is identical to the Organizer Help menu in Windows. On the Mac, you have a Help menu with various help options in Adobe Bridge that are much different from the Help menu options in Elements.

Why review a brief explanation of the menus and the commands you find within the drop-down lists? For starters, the more you know about what a menu is used for, the easier it is for you to locate commands without a struggle. If your task is to color-correct a photo, you know from the list we describe here that you open one of the Editing modes and visit the Enhance menu. If you want to stack photos and organize them, you know that you need to open the Organizer and open the Edit menu. After you get a feel for what commands are contained within the drop-down lists, you move much faster in all your Elements editing sessions.

Using Context Menus

Context menus are found in just about every Adobe program. One of the great things about context menus is that if you want to perform an action using a menu command or tool, chances are you may find just what you're looking for in a context menu.

A context menu is opened by right-clicking the mouse button (Windows) or by Control-clicking (Mac). Depending on the tool and the mode you're working in, the menu commands change. For example, in Figure 1-15, we opened a context menu on a thumbnail image in the Organizer. As you can see in the figure, a number of menu commands are available that are similar to the menu commands you find in the top-level menu commands.

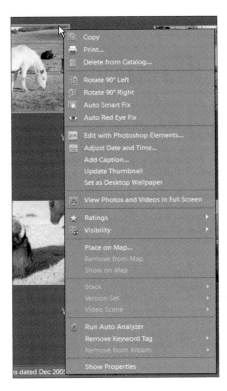

Figure 1-15: Context menus provide you quick access to menu commands.

Mac users with a two-button mouse can right-click to open a context menu.

In Figure 1-16, we opened an image in Edit Full mode and created a selection. When we right-click the mouse button, the context menu changes to reflect edits we can make relative to a selection.

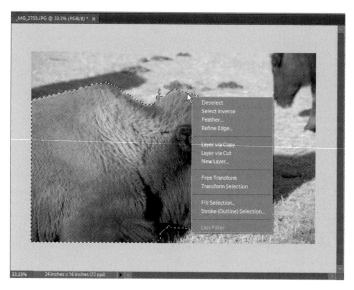

Figure 1-16: We created a selection in Edit Full mode and opened a context menu.

When you change tools and editing modes, the context menus you open change the menu choices to reflect what you can do with the selected tool and editing mode you're working in.

Selecting Settings in the Options Bar

A number of different tools and options exist in several places in each mode. One area you frequently visit when you edit pictures is the Options bar. The Options bar provides several choices for each tool you select in Edit Full mode. In Figure 1-17, we opened Edit Full mode and clicked the Rectangular Marquee tool. The Options bar changes to reflect a number of choices you can use when working with this tool.

Options bar

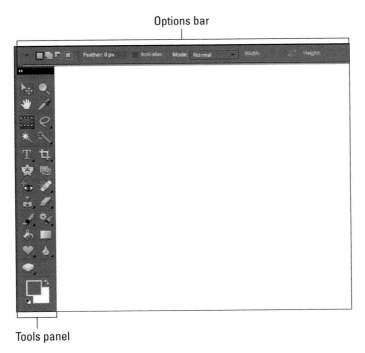

Tools panel

Figure 1-17: Click the Rectangular Marquee tool, and the Options bar changes to display settings options that can be used with the Rectangular Marquee tool.

As you click different tools in the Tools panel, the Options bar changes to offer a number of different choices for working with the selected tool.

Playing with Panels

The Panel Bin contains more choices for editing files, assembling projects, and working with different tools. Each mode you visit (Organizer, Edit Full, and Edit Quick) supports panels and a variety of options from panel menus and tools. In Edit Full mode, you see the default panels open, as shown in Figure 1-18.

At the top of the Panel Bin are tabs. In Edit Full mode, the tabs include Edit Full, Create, and Share. Click a tab, and the panel options change. Below the tabs are also other buttons that open different modes. For example, the panel shown in Figure 1-18 displays the Edit Full mode. Clicking the other panel buttons, such as Create and Share, changes the panels and the options.

Figure 1-18: The default panel view in Edit Full mode.

If you open the Organizer, you find different options in the Panel Bin, as shown in Figure 1-19. From this panel, you can easily open the other editing modes, perform some creation edits, or organize files using tags and keywords.

Getting choosy in the Favorites panel

The Favorites panel is used for adding your own favorite settings in Edit Full mode, such as different filters you like to apply to images. By default, you don't see the Favorites panel open. Open the panel by choosing Window➪ Favorites. When you make the menu choice, the panel opens as a *floating panel* in the middle of the Image window. A floating panel opens on top of the Elements window and can be dragged around to move the panel out of the way when editing photos.

Figure 1-19: Panel options change in the Organizer.

You can choose to keep the panel open in the Image window or dock the panel in the Panel Bin by dragging the Panel tab to the Panel Bin. In Figure 1-20, you see the Favorites panel as a floating panel with some favorite filters added to the panel.

Using panel buttons

Above the Panel Bin you have three buttons that you can click to work with the Editors, create projects, and share projects.

Expanded panels appear by default; however, new in Elements 8 is a method for collapsing panels. When panels are collapsed, panel buttons

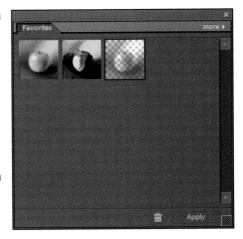

Figure 1-20: The Favorites panel opened as a floating panel.

replace the expanded panels with buttons in the Panel Bin. Click the right chevron in the top-right corner, and the panels collapse, as shown in Figure 1-21. When the panels are collapsed, you can expand the panels by clicking the left chevron.

When panels are collapsed, you have much more editing room for your images in a larger Image window while still being able to access the panels.

Resetting panels

Panels can be removed from the Panel Bin by clicking and dragging the panel tab where you see the name of the panel. You can scatter panels all over your Elements workspace.

If, after rearranging panels, you want to return to the default view, click the Reset Panels button appearing at the top of the Elements window.

Using the Project Bin

You may have several images you want to edit in Elements. You might have some image data you want to copy from one image and paste into another image or maybe you want to enhance a series of images so the brightness and color appear consistent for several images taken with the same lighting conditions.

The photos are added to the Organizer, and you can easily see the thumbnail images in the Organizer window. But you don't want to keep going back to the Organizer to open one image or another in an editing mode.

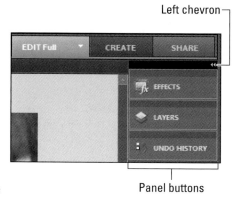

Figure 1-21: Click the left-pointing chevrons to collapse all panels.

Fortunately, Elements provides with you an easy way to load some images while in Edit Full mode and have the thumbnails displayed in the Project Bin, as shown in Figure 1-22.

Additionally, notice the top of the Image window. All the open files appear nested in the Image window with the filename displayed for each open image. You can close an image by clicking the X to the right of the filename.

Filename Close box

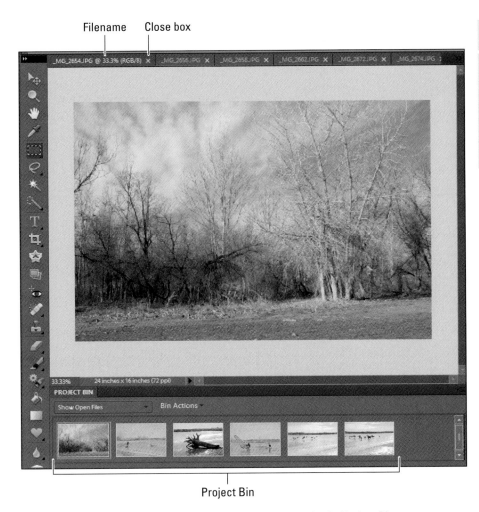

Project Bin

Figure 1-22: Several images opened in Edit Full mode appear in the Project Bin.

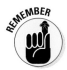

You can change the behavior of windows in the preferences. Options exist for making the panels default as floating windows or tabbed in the Panel Bin. See Book I, Chapter 4 for more on setting preferences.

The images shown in the Project Bin are easily accessed by clicking the respective filename appearing above the Image window. You can also open several files in Edit Full mode and create a project from the files, such as a calendar or photo book. What you see in the Project Bin are the files that are currently open in Edit Full mode.

You can easily change the view for all open images by opening the Arrange drop-down list and choosing an option, such as the Tile All in Grid option we chose in Figure 1-23.

Arrange drop-down list

Figure 1-23: Choose an option in the Arrange drop-down list to view files in different arrangements within the Image window.

Getting Productive with Shortcuts

Every Adobe program supports keyboard shortcuts, and Elements makes use of many different keystroke actions that open menus and select various tools. As a matter of fact, the keystroke commands available to you are so numerous that it'd take considerable time to commit them all to memory.

Fortunately, you have many hints provided by Elements as you organize and work on your photos. The hints you find for using keyboard shortcuts are found in

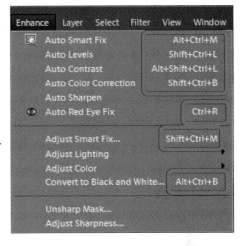

Figure 1-24: The items to the right of the menu commands display keyboard shortcuts.

🖛 **Menus:** When you open a menu and scan through the different commands, you find that many commands list a keyboard shortcut, as shown in Figure 1-24.

Look at Figure 1-24. If you want to use Auto Smart Fix (the first menu item), press Alt+Ctrl+M (Option+⌘+M on the Mac) to invoke the menu command. Using the keyboard shortcut results in exactly the same action as selecting the menu command.

🖛 **Tools:** When you move the cursor over a tool in the Tools panel, a pop-up tooltip opens, as shown in Figure 1-25. To the right of the tool name, you see a character within parentheses. Typing the character on your keyboard accesses the tool. For example, in Figure 1-25 you see the Horizontal Type Tool below the selection arrow. The character in the tooltip is T. If you press T on your keyboard, the Horizontal Type tool is selected. Each of the tools is selected by typing individual characters on the keyboard.

Figure 1-25: A tooltip displays the keyboard shortcut for the tool.

The best way to figure out keyboard shortcuts is to observe the menus and tools when you perform edits. For those edits you use frequently, try to commit the keyboard shortcuts to memory. As you figure out more shortcuts, you'll find working in Elements goes much faster.

Finding Help When You Need It

We hope this book provides you with some helpful information on using all the features you have available when working in Photoshop Elements. However, you won't want to keep paging through the book for every edit you make.

For speedy access to readily available help information or when you want to expand your knowledge of commands, tools, procedures, and so on, you have several sources of help information.

Using Help

The first place to explore is the Help menu. Open the Help menu and you find a menu command to access the Photoshop Elements help guide. The help guide is a Web-based file that's hosted on Adobe's Web site. You need an Internet connection in order to access the file.

After choosing Help➪Photoshop Elements Help or pressing the F1 key on your keyboard, you can search for keywords. Press the Enter key after typing the words you want to search for, and Elements opens a panel on the left listing areas where you can find answers. Double-click an item, and the right pane provides you with help information.

Reading PDFs from the Installer DVD-ROM

On the Installer DVD-ROM, you find several PDF documents. You need Adobe Reader installed on your computer to see these files. The Installer disc contains the Adobe Reader installer. Double-click the installer to install Adobe Reader. Then, take some time to browse the contents of the DVD-ROM for PDF documents.

Using tooltips

We cover tooltips earlier when we talk about keyboard shortcuts in Elements. As you place the cursor over tools and in panels, you can observe the tooltips. These contain some helpful information concerning the types of edits you want to perform or notification of an action that will take place when you click an object or command.

Dialog boxes

When you open many different dialog boxes, you find some text adjacent to a light bulb icon beginning with Learn More About: *followed by blue text,* as shown in Figure 1-26. Click the blue text, and again Adobe's Web site opens and takes you to Web pages where help information is found.

Each time you see a light bulb icon appearing in a dialog box, you're one click away from help information.

Figure 1-26: You can find links to help information in dialog boxes.

Chapter 2: Getting to Know the Tools

In This Chapter

✓ Looking at the Tools panel

✓ Understanding the tool groups

✓ Using automation tools

Y ou edit photos by using menu commands and tools. Elements knows that, so it provides you with a toolshed chock-full of different tools to perform all sorts of different editing tasks.

These tasks include selecting image content area, refining and sharpening photos, drawing and painting applications, adding text, and more.

In addition to using tools for manually changing the characteristics of a photo, you can use a number of different tools to magically automate tasks. In this chapter, you take a look at the Tools panel and all the different tools at your disposal for modifying photos in many different ways.

Examining the Tools Panel

The Tools panel opens by default when you enter Edit Full mode. As you may recall from Chapter 1 of this minibook, you can open Edit Full mode directly from the Welcome screen by clicking the Edit button or by choosing Editor⇨Edit Full in the Organizer (Windows) or by opening a context menu in Adobe Bridge and choosing Open With⇨Adobe Photoshop Elements 8.0 (Mac).

The tools you see in Figure 2-1 are listed by name and their keyboard shortcuts. If you press the key adjacent to the tools shown in Figure 2-1, you select the respective tool. See Chapter 1 in this minibook for more on keyboard shortcuts.

The tools in the Tools panel include the following, listed (basically) from top to bottom. To get you into the habit of using keyboard shortcuts, we've listed the shortcut associated with each tool.

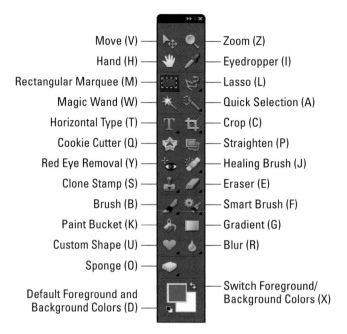

Move (V) —— Zoom (Z)
Hand (H) —— Eyedropper (I)
Rectangular Marquee (M) —— Lasso (L)
Magic Wand (W) —— Quick Selection (A)
Horizontal Type (T) —— Crop (C)
Cookie Cutter (Q) —— Straighten (P)
Red Eye Removal (Y) —— Healing Brush (J)
Clone Stamp (S) —— Eraser (E)
Brush (B) —— Smart Brush (F)
Paint Bucket (K) —— Gradient (G)
Custom Shape (U) —— Blur (R)
Sponge (O)

Default Foreground and Background Colors (D) —— Switch Foreground/ Background Colors (X)

Figure 2-1: The Tools panel.

Where you see a tiny right arrow on a tool, you find additional tools that open in a flyout menu. Pressing the same keyboard shortcut scrolls through the tools in the flyout menu.

V. Move tool: Use this tool to move either content within a selection or the entire image.

Z. Zoom tool: Click with this tool found in the Tools panel and you zoom in on an image. Press the Alt (Option on the Mac) key when the tool is selected and click to zoom out.

H. Hand tool: The Hand tool is used to move an image around the Image window without changing the image position on the canvas. If you zoom in on a photo and see scroll bars on the right and left side of the Image window, you can drag the image around the window to display the hidden areas.

I. Eyedropper tool: The Eyedropper is used to sample color in an image. Click anywhere in a photo and the foreground color swatch changes to the sample taken with the Eyedropper tool. Press the Alt (Option) key and click the Eyedropper tool to sample color for the background color.

M. Rectangular Marquee tool: The Rectangular Marquee tool is one of many different tools you use to select image data.

L. Lasso tool: Another selection tool, the Lasso tool is used to select image data in a freeform manner.

W. Magic Wand tool: Like the Eyedropper, the Magic Wand tool is used to sample color in an image, but it then allows you to travel out from the sampled area to automatically select similar pixels in a contiguous or noncontiguous area. The contiguity is determined from choices made in the Options bar.

A. Quick Selection tool: The Quick Selection tool is similar to the Magic Wand tool. It enables you to click and drag to select image data.

T. Horizontal Type tool: This tool is used to add text to a photo.

C. Crop tool: This tool is used for cropping images.

Q. Cookie Cutter tool: This tool is used to create a mask so the area outside the shape is removed from the photo.

P. Straighten tool: Use this tool to straighten images — particularly useful for scanned images.

Y. Red Eye Removal tool: Use this tool to remove red eye from photos.

J. Healing Brush tool: This tool is used to repair images by removing dust and scratches.

S. Clone Stamp tool: This tool is used to clone an image area.

E. Eraser tool: Use this tool for erasing part of your image.

B. Brush tool: A number of brush tips are available for use with this tool that permits you to paint over a photo.

F. Smart Brush tool: This tool is magical by design. You can use the tool to brighten or add contrast to areas you specify by "brushing over" the image.

K. Paint Bucket tool: The tool is used for filling an area with a foreground color.

G. Gradient tool: Use this tool to create gradients.

U. Custom Shape tool: This tool is used to add different shapes to a photo.

R. Blur tool: This tool is helpful to soften edges, particularly when you paste new image content in a photo and want to blur the edges of the pasted data slightly.

O. Sponge tool: The Sponge tool is used for adding or removing color saturation on a photo.

X. Switch Foreground and Background Colors: This tool switches the foreground and background colors.

D. Default Foreground and Background Colors: Use this tool to return the foreground color to default black and the background color to default white.

Getting to Know the Tools

The tools in the Tools panel can be grouped into several categories. Knowing a little about the categories can help you decide where to look first when you want to make some edits to a photo.

Using selection tools

The selection tools are used to create selections of pixels in a photo. Unlike the objects you'd find in programs like Microsoft PowerPoint, imported graphics in Microsoft Word, or artwork you create in illustration programs like Adobe Illustrator or CorelDraw, photos are comprised of tiny little pixels. In other programs where objects are available, you can just click the mouse button with the cursor placed on an object to select it. In Photoshop Elements, you need to surround pixels with a selection tool to select a part of a photo.

Clicking an object is easy, but selecting pixels requires some careful steps. It also requires using the best tool to make a given selection. You can easily run into problems when there's little contrast and color difference between the areas you want to select and those areas you want to remain unselected in a photo.

Geometric selection tools

The geometric selection tools include the Rectangular Marquee tool and the Elliptical Marquee tool. By default, the Rectangular Marquee tool appears "on top" in the Tools panel, whereas the Elliptical Marquee tool is kept out of view. So how do you get to the hidden tool? Easy. Notice the tiny arrow in the lower-right corner on several tools in the Tools panel? When you click and hold down the mouse button or right-click, a flyout menu opens, as shown in Figure 2-2. In Figure 2-2, we clicked and held the Rectangular Marquee tool to open the flyout menu where both the Rectangular Marquee tool and the Elliptical Marquee tool appear.

We talk about the keyboard shortcuts earlier in this chapter and mention that you can access the Rectangular Marquee tool from a shortcut by pressing the M key on your keyboard. If you press M and then press M again, you select the Elliptical Marquee tool. Continually pressing the M key on the keyboard toggles between the Rectangular and Elliptical Marquee tools.

Figure 2-2: Click and hold down the mouse button on the tiny arrow on a tool to open a flyout menu.

Using geometric selection tools is straightforward. Click either the Rectangular Marquee tool or the Elliptical Marquee tool and drag on a photo to create a rectangle or elliptical shape.

You can also use certain keyboard modifiers to manage selections when using a selection tool. Such modifiers include the following:

✔ **Shift key:** If you select a geometric selection tool and then press the Shift key while dragging the mouse, your shapes are constrained to a square/circle. Also, if you make a selection on a photo and then press the Shift key and drag a new selection, you get to add that selection to the one you've already made. If you have made a selection on a photo and don't use the Shift key when you create a new selection, by default the first area you chose becomes deselected.

✔ **Alt (Option on the Mac) key:** When you press the Alt (Option) key and drag a geometric selection tool, you draw the selection from the center outward. If you already have a selection and then press the Alt (Option) key and drag through the first selection, you remove that segment from the current selection.

✔ **Shift+Alt (Shift+Option on the Mac):** If you already have a selection drawn, pressing the Shift key and the Alt (Option) key while dragging through that selection creates a new selection at the intersection with the original selection.

✔ **Spacebar:** If you press the spacebar while you depress the mouse button, you can move a selection to another area in a photo without changing the size of the selection.

Lasso tools

Whereas the geometric selection tools restrict you to rectangles and elliptical shapes, the Lasso tools are used to create irregular selections — similar to freehand drawing with a pencil. The following three types of Lasso tools are shown in Figure 2-3:

✔ **Lasso tool:** Click this tool and draw on a photo in a freeform fashion to select pixels around irregular shapes.

✔ **Magnetic Lasso tool:** Click and drag around a shape, and Elements magically hugs the shape as you draw. If you have something like a foreground figure you want to

Figure 2-3: Click the tiny arrow on the Lasso tool to open the flyout menu where you find three Lasso tools.

isolate from the background, you can drag this tool around the shape. Elements automatically refines the selection to grab the shape you're selecting.

 ✓ **Polygonal Lasso tool:** This tool behaves like a Polygon tool that requires you to click and release the mouse button and then move the cursor to click to in another area on the photo. As you keep clicking, the selection shape takes the form of a polygon.

Magic Wand tool

The Magic Wand tool is truly magical. This tool performs a few different actions. For example, when you click the tool in an area of a blue sky, the area you click is sampled for the selected pixel value. Immediately following the mouse click, Elements travels outward in a contiguous area to find pixels of similar value and includes them in the selection.

To determine the amount of variance of the pixel values picked up by the Magic Wand tool, tweak the Tolerance value in the Options bar, as shown in Figure 2-4. You can change the value so the Magic Wand tool selects a wider range of pixels (a higher number) or narrower range of pixels (a lower value).

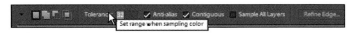

Figure 2-4: The Tolerance value can be changed to select a wider or narrower range of pixels.

By default, the Tolerance is set to 32, which means that the pixel you click produces a selection of 16 pixel values lower than the sample and 16 pixel values higher than the sample.

After you create a selection with the Magic Wand tool and you want to add another selection to the first selection, press the Shift key and click the Magic Wand tool in another area on the photo. If you grab too many pixels, you can press the Alt (Option) key and click the area you don't want selected. If you need to refine the selection, you can adjust the Tolerance value in the Options bar before clicking the mouse button each time you add to or subtract from a selection.

Quick Selection tool

 The Quick Selection tool is similar to the Magic Wand tool. Click the tool in an area of a photo, and three check boxes in the Options bar permit you to start a new selection, add to the current selection, or subtract from the current selection.

In Figure 2-5, we used the Quick Selection tool and clicked a few times in the sky area of the photo to create the selection.

Figure 2-5: Click the Quick Selection tool in a few areas with similar pixel values to create a selection.

After you have a selection — regardless of the tool you use to create the selection — other edits you perform in Elements apply only to the active selection. If no selection appears on your photo, edits are made to the entire layer.

Using Figure 2-5 as an example, we left the contrast alone on all areas but the sky to demonstrate editing a selection. We used the Quick Selection tool to select just the sky area and adjusted the contrast to make the sky appear a little brighter and with more contrast, as shown in Figure 2-6.

Figure 2-6: After you create a selection, you can apply edits to just the selected area.

Using drawing and painting tools

Drawing and painting tools provide you with a huge number of options for adding illustrations, paintings, effects, and modifying brightness and contrast in photos. Don't think of these tools strictly as tools you use to draw and paint with. They can also be used for color correction, adjusting contrast, and other kinds of brightness enhancements.

Brush tools

Several types of tools are tucked away in the Brush tools flyout menu. To view all the tools nested there, click and hold down the mouse button on the Brush tool to open the flyout menu, as shown in Figure 2-7.

Tools you have available from the flyout menu include the following:

Figure 2-7: The Brush tools.

✓ **Brush tool:** The Brush tool supports a number of different brush tips you can choose from the Options bar. You use the Brush tool as you would use a brush to apply paint to a canvas. You can paint within type selections, add color to selected areas, paint in selection channels, and more. For more information on selections, see Book IV, Chapter 1. For more on type selections, see Book V, Chapter 3. For more on selection channels and selection masks, see Book VI, Chapter 4.

✔ **Impressionist Brush tool:** This tool is designed to paint over your photo to make it look like a masterpiece by Renoir or Matisse. You can set various options that change the style of the brush strokes. Styles are chosen from a drop-down list in the Options bar.

✔ **Color Replacement tool:** As the name suggests, you use this tool to paint over areas where you want to replace color.

✔ **Pencil tool:** Like an analog pencil, the Pencil tool enables you to draw pencil-type marks on a photo. Also from the Options bar, you have a large number of tips to choose from for the pencil drawing shapes.

Smart Brush tools

These two tools, as shown in Figure 2-8, are located in the Smart Brush fly-out menu:

✔ **Smart Brush tool:** The Smart Brush tool is used to paint large areas of common pixel values. When you drag across a sky or a section of greenery, for example, you can select the area and apply different hue changes from choices in a drop-down list from the Options bar.

Figure 2-8: The Smart Brush tools.

✔ **Detail Smart Brush tool:** The Detail Smart Brush tool offers similar options to the Smart Brush tool, but you can continue to paint in the selected area, applying more hue changes to a given region.

Eraser tools

Three different Eraser tools appear in the flyout menu, as shown in Figure 2-9:

✔ **Eraser tool:** The Eraser tool actually paints a color on a photo. The current background color is used when you paint with this tool on the Background layer. If your photo appears on a layer, the Eraser tool behaves like a normal eraser, removing pixels as you drag across a photo.

Figure 2-9: The Eraser tools.

✔ **Background Eraser tool:** When you open a photo in Edit Full mode, the photo appears on a background. Certain objects and type are added in layers that appear above the background. Two things happen when you make your first edit with this tool: The background is converted to a layer and, as you drag the cursor, the image data is removed from the layer.

✐ **Magic Eraser tool:** The Magic Eraser tool is like a combination of the Quick Selection tool and the Eraser tool. When you click and draw on a background, the area where you click is selected just as with the Quick Selection tool. Also, the background is converted to a layer, and the selected area is removed from the photo.

Paint Bucket tool

The Paint Bucket tool performs two separate actions when you click the tool in a photo. First it creates a selection similar to the one you get with the Magic Wand tool. After the selection is created, the foreground color fills the selected area.

Gradient tool

The Gradient tool is used to create a gradient on a photo or within a selected area. You have a number of choices for the gradient colors from the Options bar, or you can add custom colors to create the gradient effect.

Using tools for cloning and healing

The cloning and healing tools are used for effects and when you need to clean up images. *Cloning* involves duplicating an image area to construct image content that wasn't in your original photo, whereas *healing* (in an Elements context) means removing dust, scratches, and imperfections in photos.

Cloning tools

Cloning tools are designed to duplicate image area. You can use them for artistic effects, reconstructing photos, repairing photos, and enhancing photos. The two tools (as shown in Figure 2-10) are

Figure 2-10: The Cloning tools.

✐ **Clone Stamp tool:** You use this tool by first sampling an area on a photo you want to clone. Sampling is performed by placing the cursor over the area to clone, pressing the Alt (Option) key, and then clicking the mouse button. You then move the cursor to an area where the clone image will appear and start painting with the cursor.

✐ **Pattern Stamp tool:** The Pattern Stamp tool is used to apply a pattern you select from a list of available patterns from the Options bar. Select a pattern and paint with the cursor to apply the pattern to an area on a photo.

Healing brushes

Healing brushes are designed for photo-repair tasks, such as removing dust and scratches. The two Healing Brush tools (as shown in Figure 2-11) are

* **Spot Healing Brush tool:** The Spot Healing Brush tool automatically samples neighboring pixels to correct image imperfections in one step. Unlike when you use the Healing Brush tool, you don't need to sample an area and then apply the brush strokes.

Figure 2-11: The Healing Brush tools.

* **Healing Brush tool:** You use the Healing Brush tool by first pressing the Alt (Option) key and sampling an area you want to use as a source for the repair. Then move the cursor to a scratch or other imperfection and paint over the area.

Creating text with typographical tools

Four different tools are used to add type to a photo. The tools (as shown in Figure 2-12) include

* **Horizontal Type tool:** Click the cursor and type text horizontally. You can choose from various type attributes in the Options bar.

* **Vertical Type tool:** Use this tool to add type vertically on a photo.

* **Horizontal Type Mask tool:** The Type Mask tools create selection outlines of type as you add text with the tools. The Horizontal Type Mask tool creates an outline selection of text horizontally.

Figure 2-12: The Type tools.

* **Vertical Type Mask tool:** Use this tool to create a selection mask vertically.

Using focus and toning tools

Focus and toning tools are used to edit image brightness, contrast, and color. Several tools for making these adjustments are contained within the Tools panel.

Red Eye Removal tool

The Red Eye Removal tool is used to scrub over red eye that commonly appears when taking pictures indoors with flash.

Toning tools

The toning tools are used to refine edges on pasted content by softening edges, sharpening up a photo in areas, and blending areas that might have been cloned or pasted into your photos. The tools, as shown in Figure 2-13, include

- ✔ **Blur tool:** Scrub over an area to blur the pixels.
- ✔ **Sharpen tool:** Scrub over an area to sharpen an area.
- ✔ **Smudge tool:** Scrub over an area to blend pixels.

Figure 2-13: The Toning tools.

Focus tools

Focus tools are used for making edits similar to those traditionally used in photo darkrooms. The tools, as shown in Figure 2-14, include

Figure 2-14: The Focus tools.

- ✔ **Sponge tool:** Use this tool to scrub over an area that you want to either saturate with more color or reduce saturation. The choices for saturation/desaturation are found in the Options bar.
- ✔ **Dodge tool:** The process of dodging in a traditional darkroom holds back light during a print exposure resulting in a lighter image. Use this tool to scrub over areas in a photo that you want to lighten up.
- ✔ **Burn tool:** Burning has the opposite effect as dodging. Use this tool to darken some image area.

Creating shapes

Shapes can be used to add artistic elements to photos or mask out some areas in a photo.

Cookie Cutter tool

The Cookie Cutter tool is used to mask out areas in a photo. By default, the Heart Cookie Cutter appears in the Tools panel. When you click and drag this tool on a photo, all the area outside the heart shape is eliminated from the layer. To change the Cookie Cutter shape, choose a different shape from the drop-down list in the Options bar.

Shape tools

The Shape tools, as shown in Figure 2-15, are used to add different shape objects to a photo. The tools include

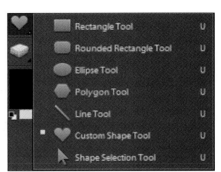

Figure 2-15: The Shape tools.

- ✔ **Rectangle tool:** Used to draw a rectangle.

- ✔ **Rounded Rectangle tool:** Used for rectangles with rounded corners.

- ✔ **Ellipse tool:** Used for drawing elliptical shapes.

- ✔ **Polygon tool:** Used for drawing polygonal shapes.

- ✔ **Line tool:** Used for drawing lines.

- ✔ **Custom Shape tool:** Used for drawing custom shapes from a choice of different shapes identical to those available for the Cookie Cutter tool. Again, you make shape choices from a drop-down list in the Options bar.

- ✔ **Shape Selection tool:** After a shape has been drawn, it appears as an object on a photo and can be moved by clicking and dragging with this tool.

Viewing, navigating, and sampling tools

Individual tools are used for zooming in and out of photos, moving a photo around the Image window, and sampling color.

Eyedropper tool

The Eyedropper tool samples color and places the sample color in the Foreground color swatch. If you press the Alt (Option) key and click the Eyedropper tool, the sampled color is placed in the Background color swatch.

Hand tool

Use this tool to move a photo around the Image window.

Zoom tool

Click this tool to zoom in on a photo. Press the Alt (Option) key to zoom out.

You find the same magnifying glass icon for the Zoom tool appearing in different dialog boxes. Whenever you see this tool icon, realize that to zoom out, you always need to press the Alt (Option) key and then click the photo.

When using any of the painting tools, pressing Alt (Option) gets you the Eyedropper tool. You can click to sample color; release the Alt (Option) key and you return to the selected painting tool.

Other editing tools

Some miscellaneous tools are contained in the Tools panel to perform additional edits.

Move tool

Click and drag with this tool to move the photo on the canvas. This tool is particularly helpful when moving layer content if you're creating layered files. If you press the Alt key (Option on the Mac) when you drag, you duplicate the photo.

Crop tool

This tool is used for cropping images.

Straighten tool

Use the Straighten tool to straighten crooked images — especially crooked scanned images.

Introducing the Automation Tools

Elements offers you some one-click steps to improve your images. Although these automated tasks aren't *tools* per se, we list them here as tools to simplify the message. In actuality, you use menu commands to automate some refinements for your photos.

To observe the automation tools available to you, click the Enhance menu and look over the first set of commands, as shown in Figure 2-16. The menu commands beginning with *Auto* in the command name indicate that the command has something to do with some sort of automated function.

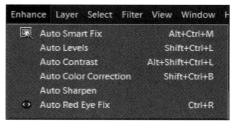

Figure 2-16: Some automated tasks in Elements are listed as menu commands in the Enhance menu.

The automated features you find in the Enhance menu include

- ✓ **Auto Smart Fix:** Auto Smart Fix is used to add more contrast, adjust brightness, and improve color with one menu choice.

- ✓ **Auto Levels:** The Levels adjustment is used to adjust image brightness. Elements takes a guess at the proper brightness and automatically boosts the white and black points in your photos to render a more pure white and rich black.

- ✓ **Auto Contrast:** Use this command when contrast is flat and without any snap.

- ✓ **Auto Color Correction:** Auto Color Correction is used to improve color in images by removing colorcasts.

- ✓ **Auto Sharpen:** Use the Auto Sharpen command to sharpen up dull images.

- ✓ **Auto Red Eye Fix:** You use this tool to remove red eye in photos. If you have a group shot taken with flash, you can use this command to remove red eye in all the subjects.

Chapter 3: Viewing and Navigating Images

In This Chapter

✓ **Examining the Image window**

✓ **Changing zoom views**

✓ **Navigating images**

✓ **Using grids and guides**

✓ **Getting information**

✓ **Working with the Content panel**

*O*ne of the most important aspects of working with images in an Editor is navigation — knowing how to move around the image (as well as between images) and how to use tools and menu commands to help you.

Many tools in Elements enable you to zoom in and out of images, acquire information about your photos, and examine them in detail. In this chapter, we talk about these tools and clue you in on the best methods to use for viewing files in an Editor.

Looking at the Image Window

The first thing you need to know about examining an image is how to get it into the Image window. The Image window in Edit Full mode is where your photos are opened and ready for editing. To open an image in Edit Full mode, you have a few options available to you.

Like any program, Elements supports choosing File⇨ Open. Click the menu command, and a dialog box opens enabling you to navigate your hard drive and select a photo. Click the Open button, and the photo opens in the Image window.

Another method for opening photos is to use the Organizer, where you select one or more photos you want to edit. Because we cover some of the essentials of using the Organizer in Book II, Chapter 2, we take a look at opening a file from the Organizer in Edit Full mode:

1. **Open the Organizer (Windows).**

 You can launch Photoshop Elements and click the Organize button in the Welcome screen to open the Organizer window; or if you're in an edit mode now, click the Organizer button in the top right of the Editor window.

2. **Click a photo thumbnail in the Organizer window.**

 Following this step presumes you have some photos in the default catalog, as we explain in Chapter 1 of this minibook and elaborate more on in Book II, Chapter 2.

 On the Mac, open Adobe Bridge, select a photo in the Bridge window, and choose File⇨Open With⇨Adobe Photoshop Elements 8.0.

3. **Open the Fix drop-down list and click Edit Photos or press Ctrl +I.**

 The photo opens in the Image window, as shown in Figure 3-1.

Filename Close button

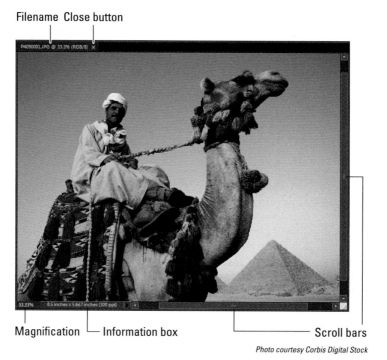

Magnification └─ Information box ───────────── Scroll bars

Photo courtesy Corbis Digital Stock

Figure 3-1: The Image window.

Figure 3-1 highlights several important items when you view photos in the Image window. Notice the following:

✔ The **filename** appears in the top-left corner of the photo. Double-check the name to be certain the photo you want to edit is the correct image.

✔ **Scroll bars** become active when you zoom in on an image. You can click the scroll arrows, move the scroll bar, or grab the Hand tool in the Tools panel and then drag within the window to move the image.

✔ The **Magnification box** shows you at a glance how much you've zoomed in or out.

✔ The **Information box** shows you the readout for a particular tidbit of information. You can choose what information you want to see in this area by choosing one of the options from the pop-up menu, which we discuss a bit later in this section.

When you're working on an image in Elements, you always want to know the physical image size, the image resolution, and the color mode. (We explain these terms in more detail in Book III, Chapters 1 and 2.) Regardless of which menu option you choose from the Information box, you can get a quick glimpse at these essential stats by clicking the Information box, which displays a pop-up menu like the one shown in Figure 3-2.

Width: 2550 pixels (8.5 inches)
Height: 1700 pixels (5.667 inches)
Channels: 3 (RGB Color, 8bpc)
Resolution: 300 pixels/inch

Figure 3-2: Click the readout on the Information box to see important information about your file.

✔ The **Size box** enables you to resize the window. Move the cursor to the box, and a diagonal line with two opposing arrows appears. When the cursor changes, drag in or out to size the window smaller or larger, respectively.

You can also resize the window by dragging any of the other corners in or out.

✔ You can click the **Close button** (it's shaped like an X) to close the active Image window and keep Elements open. Alternatively, you can use the keyboard shortcut Ctrl+W or choose File⇨Close to close the active window.

After you're familiar with the overall Image window, we want to introduce you to the Information box's pop-up menu, which enables you to choose the type of information you want to view in the Information box. Click the right-pointing arrow to open the menu, as shown in Figure 3-3.

Here's the lowdown of the options you find on the pop-up menu:

~ **Document Sizes:** Shows you the saved file size.

~ **Document Profile:** Shows you the color profile used with the file. For more on color profiles, see Book III, Chapter 2.

Figure 3-3: From the pop-up menu on the Information box, you select commands that provide information about your file.

~ **Document Dimensions:** Shows you the physical size in your default unit of measure, such as inches. (Refer to Figure 3-3, which has the Document Dimensions option selected.)

~ **Scratch Sizes:** Displays the amount of memory on your hard drive that's consumed by all documents open in Elements. The scratch space is the extension of RAM created by a space on your hard drive. For example, 20M/200M indicates that the open documents consume 20 megabytes and that a total of 200 megabytes are available for Elements to edit your images. When you add more content to a file, such as new layers, the first figure grows while the second figure remains static.

~ **Efficiency:** Indicates how many operations you're performing in RAM as opposed to using your scratch disk. When the number is 100%, you're working in RAM. When the number drops below 100%, you're using the scratch disk. If you continually work below 100%, it's a good indication that you need to buy more RAM to increase your efficiency.

~ **Timing:** Indicates the time it took to complete the last operation.

~ **Current Tool:** Shows the name of the tool selected from the Tools panel.

Don't worry about trying to understand all these terms. The important thing to know is that you can visit the pop-up menu and change the items at will during your editing sessions.

The Image window is just one small part of the user interface in Elements. To get the full picture, imagine that, when a photo opens in Edit Full mode within the Elements window, you're going to see the Image window contained within the workspace as a whole, where you have access to tools, panels, and menus to choose from a variety of edit options.

If you select multiple files in the Organizer and choose Edit Full from the Editor drop-down list, all the photos open in the Image window. Clicking the filename in the Image window brings a photo forward so you can edit it. In the workspace interface, you see something like Figure 3-4 when a photo is opened in the Image window and several other open photos appear in the Project Bin.

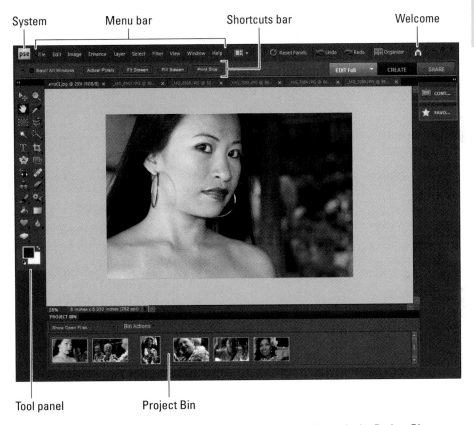

Figure 3-4: One photo in the Image window with several open photos in the Project Bin.

Zooming In and Out of Image Windows

Precision goes a long way when making good edits on photos. When you're working carefully on image detail, zoom in on any part of a picture where you want to (carefully) apply some fine-tuning. Nothing looks worse than photos with obvious edits that were clumsily done without precision.

Zooming with keyboard shortcuts

For some quick zooms in and out of photos, you can use keyboard shortcuts. Here are a few to keep in mind when you need to quickly change the zoom level:

- **Ctrl++ (⌘++ on the Mac):** Press the Ctrl (⌘) key and the plus (+) key on your keyboard and you zoom in on a photo. Keep pressing the same keys to continue zooming in. By default, when you press these keys, the photo and the Image window zoom together.

- **Ctrl– (⌘– on the Mac):** Press the Ctrl (⌘) key and the minus (–) key and you zoom out. Again, the Image window zooms along with the photo.

- **Ctrl+Alt++ (⌘+Option++ on the Mac):** Press both the Ctrl (⌘) and Alt (Option) keys and then press the plus (+) key. The photo zooms in, but the Image window stays fixed at one size.

- **Ctrl+Alt+– (⌘+Option+– on the Mac):** Press both the Ctrl (⌘) and Alt (Option) keys and then press the minus (–) key. The photo zooms out, but the Image window stays fixed at one size.

- **Ctrl+0 (⌘+0 on the Mac):** Press the Ctrl (⌘) key and then 0 (the zero key), and the photo zooms to fit the Image window.

- **Ctrl+spacebar (⌘+spacebar on the Mac):** This combination temporarily activates the Zoom In tool.

- **Ctrl+Alt+spacebar (⌘+Option+spacebar on the Mac):** This combination temporarily activates the Zoom Out tool.

Using the Zoom tool

The Zoom tool is used to zoom in and out of the Image window. You first click to select the Zoom tool in the Tools panel and then click the photo to zoom in. (To zoom out, press the Alt [Option] key when clicking the Zoom tool on the photo.)

While working on an image using another tool from the Tools panel, you can temporarily access the Zoom tool without clicking it in the Tools panel. Press Ctrl+spacebar (⌘+spacebar on the Mac), and the cursor changes to the Zoom In tool. To zoom out, press Ctrl+Alt+spacebar (⌘+Option+spacebar on the Mac). When you release the keys on the keyboard, you return to the tool last selected in the Tools panel.

When you select the Zoom tool in the Tools panel, the Options bar changes to reflect choices you can make when zooming views, as shown in Figure 3-5.

Figure 3-5: Click the Zoom tool, and the Options bar changes to provide more options when using the tool to zoom views.

The tools available in the Zoom tool Options bar include

- ✔ **+/–:** The plus and minus icons are used to zoom in and out of a photo in the Image window. Click one of the icons to zoom in or out.

- ✔ **Percent readout:** The number appearing in the text box can be edited to zoom to a percent size. Click the down-pointing arrow to open a drop-down list where you can select from fixed zoom percentages.

- ✔ **Resize Window to Fit:** When you click the check box, the zoom resizes the window to the size of the image or the maximum size to the window.

- ✔ **Zoom All Windows:** If you have multiple photos open in the Image window, all photos are zoomed together when you zoom views.

- ✔ **Actual Pixels:** The ratio is reported in this text box. When the photo is shown at 100% size, the ratio reads 1:1. The ratio changes as you change the zoom views.

- ✔ **Fit Screen:** Click the button, and the photo zooms to the maximum view to fit the Image window.

- ✔ **Print Size:** Click this button, and the photo zooms to the size the file will be when printed.

Moving the Hand tool

When you zoom in to a size larger than the Image window can accommodate, you see scroll bars appearing on the bottom and right side of the photo. You can click and drag scroll bars to see more of the image area, or you can use the Hand tool to drag the image around the Image window.

While working with other tools from the Tools panel, you can temporarily access the Hand tool by pressing the spacebar. Press the spacebar and drag the image; then release the spacebar and you return to the last tool selected in the Tools panel.

If you're typing text on an image, you can't use the spacebar to temporarily access the Hand tool. To move the Image window when typing text, click the Hand tool in the Tools panel and move the photo. Click the Type tool in the Tools panel, click in the text block you started, and continue typing.

Cruising with the Navigator Panel

The Navigator panel is a handy tool to keep open when you need to zoom in and out of a photo while editing images. All zooming can be performed in this panel — and you can keep it open during your editing session!

To open the Navigator panel, choose Window⇨Navigator. The panel opens as a floating panel, as shown in Figure 3-6.

Figure 3-6: The Navigator panel opens as a floating panel in the Image window.

In the top-left corner, you see a readout displaying the current zoom percentage. At the top right of the panel is a slider that you can move left to zoom out of a photo and right to zoom in on a photo. In the center of the panel, you see a view displaying the entire image and a red rectangle displaying the area corresponding to the zoom view in the Image window.

The rectangle in the center of the panel can be moved around the Navigator panel just as you use the Hand tool to move around an image. The lower-right corner is dragged out or in to size the panel larger or smaller, respectively.

Click the left chevron, and the panel collapses to a button to minimize the panel size.

You can quickly resize the zoom area in the Navigator panel by pressing the Ctrl key (⌘ on the Mac) and drawing a rectangle around the area you want to zoom.

Using the Grids and Guides

Grids and guides are helpful when adding text to a photo, when working with layers, and when working with selections. You can align content to guidelines for precise alignment. In addition, you can display rulers along the left and top sides of a photo.

To view the grid and guidelines, choose View➪Grid. A nonprinting grid appears in your photo, like the one shown in Figure 3-7. To display rulers, choose View➪Rulers.

Figure 3-7: To show a grid and rulers, choose the appropriate options from the View menu.

To snap layers and objects to the grid and guides, choose View➪Snap To. From the submenu, you can choose Guides and Grid. When the objects in your image are dragged, selected, or moved, they will snap to the items you have selected in the Snap To submenu.

Using the Info Panel

The Info panel provides some feedback related to the cursor position and color information as you move the cursor around a photo. In addition, you can quickly examine the file size and other document information in the panel.

To open the panel, choose Window⇨ Info. The panel opens as a floating panel, as shown in Figure 3-8.

Figure 3-8: The Info panel.

Click the down-pointing arrow in the top-right corner of the panel to open the drop-down list, as shown in Figure 3-9. Choose Panel Options from the menu, and the Info Palette Options dialog box opens, as shown in Figure 3-10. Here you can make some adjustments for the kind of information you want reported in the panel.

Figure 3-9: Click the down-pointing arrow to open the Info Palette Options dialog box.

The options you have available in the dialog box include

- ✔ **First Color Readout:** From the drop-down list, you can choose from Grayscale, RGB Color (the default), Web Color, and HSB (hue, saturation, and brightness) Color. The choice you make from the menu displays the values in the top-left quadrant (first readout) of the Info panel.

- ✔ **Second Color Readout:** The same choices appear from the drop-down list as you find for the First Color Readout. These values are displayed in the top-right quadrant (second readout) of the Info panel.

- ✔ **Mouse Coordinates:** Choose from several different units of measure from the Ruler Units drop-down list.

✔ **Status Information:** Check the items you want displayed in the Info panel in the lower-left quadrant. By default, the Document Sizes readout appears. You can add all items to display them in the panel. This item mirrors the same choices you have in the Information box.

Figure 3-10: The Info Palette Options dialog box.

Many panels have drop-down lists and several options when working with tools in the panels. Look for the down-pointing arrow in the top-right corner of a floating panel or just below the right chevron in panels contained in the Panel Bin. When you see the arrow, click it to open the drop-down list.

Working with Your Content

The Content panel provides you with a wealth of opportunity to change backgrounds on images and add photo frames, graphics, text, and shapes. You have a number of choices for the types of items you want to add to a photo (see Figure 3-11), as well as a list of categories you can apply, such as backgrounds, frames, graphics, shapes, and so on.

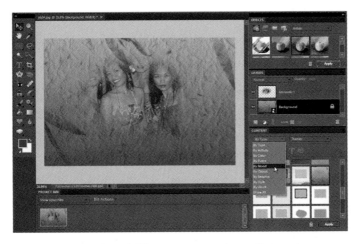

Figure 3-11: A number of different types can be applied as shapes, graphics, backgrounds, and frames.

To see how this works, assume you want to use one of the backgrounds Elements provides you in the Content panel. Follow these steps to begin an editing session:

1. **Create a new blank document.**

 Open Edit Full mode and choose File➪New➪Blank File.

2. **Set the file attributes.**

 When the New dialog box opens, as shown in Figure 3-12, choose a width and height for the file size. In our example, we use 445 x 284 pixels. Choose a resolution by typing a value in the Resolution text box. For a demonstration, we use 72 ppi (*p*ixels *p*er *i*nch). Select RGB Color for the color mode and choose Transparent for the Background.

Figure 3-12: The New dialog box.

3. **Click OK in the New dialog box.**

4. **Open the Content panel.**

 Choose Window➪Content to open the panel.

5. **From the first drop-down list in the Content panel, choose By Type. In the second drop-down list, choose Backgrounds, as shown in Figure 3-13.**

6. **Scroll through the list of thumbnail images in the Content panel and click the background you want to use.**

7. **Click the Apply button in the lower-right corner of the Content panel.**

 The new background image is applied to the background.

Figure 3-13: Choose By Type and Backgrounds in the Content panel.

After you have a background in place, you may want to copy and paste an image into your document, add text, create multiple layers of images that you organize into a design, or perform

other tasks. To effectively add images to the background, you need to know a bit about working with layers (covered in Book VI, Chapter 1) and working with selection masks (covered in Book VI, Chapter 4).

In Figure 3-14, we added a photo to a background that we selected from the backgrounds in the Content panel. For this type of look, we needed to feather a selection for the foreground image after moving it to the background document. For more on selections and feathering selections, check out Book IV, Chapters 1 and 2.

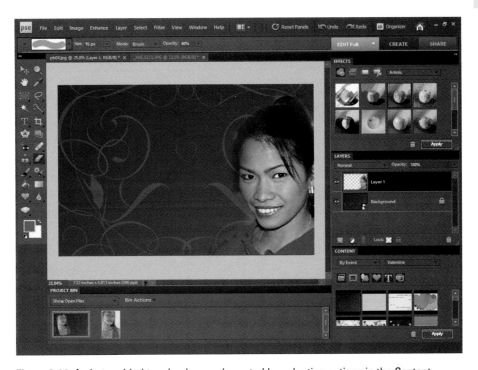

Figure 3-14: A photo added to a background created by selecting options in the Content panel.

Chapter 4: Setting Your Preferences

In This Chapter

✔ **Understanding your preferences**

✔ **Adjusting the Edit Full mode preferences**

✔ **Adjusting the Organizer preferences**

✔ **Working with Bridge preferences**

*P*hotoshop Elements is a program that accommodates a wide range of photographers with a wide range of needs. Not every individual who works in the program is likely to work the same way or use the same tools consistently. When you think of all the creative options you have for editing photos and then consider your hardware advantages and limitations, you can begin to design a personal working environment.

Elements understands a user's need to tailor the program to his or her specific needs. That's why it provides you with some methods for creating your personal work environment through a set of preferences you can adjust to your personal work style.

Understanding Preferences

A Preference setting is an adjustment in a Preferences dialog box that has some sort of effect on edits you make on pictures, on the behavior of tools and menus, and on the controls that affect Elements.

When you make a choice in a Preferences dialog box, the new setting takes effect after the adjustment is made and remains intact until you make a change in the Preferences dialog box. Most preferences adjustments you make are *dynamic* — meaning that the change in a setting takes place immediately after you click OK in the dialog box. In some cases, preference settings are *not dynamic* — meaning you must quit Photoshop Elements and relaunch the program for the new setting to take effect.

Preferences are adjusted separately in different dialog boxes for the Editors and another dialog box for the Organizer. Whether you use Photoshop Elements or any other computer program, it's a good idea to review the preferences available to you when you first begin working with it. In Elements, you want to review and understand all the preference options you have in Edit Full mode and in the Organizer.

Setting Edit Full Mode Preferences

Preferences are all contained in the nine panes of the Preferences dialog box. By default, when you open Edit Full mode and open the Preferences dialog box, the opening pane is the General pane. To open the Preferences dialog box, choose Edit⇨Preferences⇨General (Photoshop Elements⇨ Preferences⇨General on the Mac). Alternatively, press Ctrl+K (⌘+K on the Mac). Using either method opens the Preferences dialog box to the General pane, as shown in Figure 4-1.

In Figure 4-1, you see items that are common to all preference panes. Here's a quick introduction to what these items are and how they work:

Figure 4-1: The General pane in the Preferences dialog box.

✔ **Panes list:** Elements lists all the different panes in the Preferences dialog box along the left side of the dialog box. Click an item in the list to make the respective pane open on the right side of the dialog box. In earlier versions of Elements, you used a drop-down list to select the different panes.

✔ **OK:** Click OK to accept any changes made in any pane.

✔ **Cancel:** Click Cancel to return to the settings that were in effect when you opened a pane. If you hold down the Alt key (Option on the Mac), the Cancel button changes to Reset, and clicking that button performs the same action as clicking the Reset button.

✔ **Reset:** If you change any settings options, click OK. If you then change your mind, just click Reset. This action takes you back to the settings in effect when you opened the Preferences dialog box.

✔ **Prev:** Switch to the previous pane.

✔ **Next:** Switch to the next pane. You can also press Ctrl+1 through 9 keys (⌘+1 through 9 keys on the Mac) to jump to another pane.

Setting General preferences

The first pane you see when you open the Preferences dialog box is the General preferences. In the General preferences pane on the right side of the dialog box, you see many check boxes that relate to a variety of behaviors for tools and the Elements user interface. The items in this pane (reading left to right) include

- **Color Picker:** From the menu list, you can choose the Adobe Color Picker or your system Color Picker.

- **Step Back/Fwd:** The default keyboard shortcut for stepping back is Ctrl+Z (⌘+Z). To step forward the default is Ctrl+Y (⌘+Y). You can change the shortcuts by choosing other options from the drop-down list.

- **Export Clipboard:** When you copy image content in Elements to the Clipboard, you can make the content available for other applications by selecting this check box.

- **Save Panel Locations:** You may want to move panels to new permanent locations around the Editor workspace. If this check box isn't selected, the panels revert to the default locations each time you reopen the program. If the check box is selected, the panels remain in their new position when you open the Editor.

- **Show Tool Tips:** Select this check box to show tooltips.

- **Use Shift Key for Tool Switch:** When you press the M key on your keyboard, you activate the Rectangular Marquee tool. Press M again and you select the Elliptical Marquee tool. If this check box is selected, press the Shift key to switch tools while pressing the keystrokes.

- **Beep When Done:** Select this check box to play an audio sound when an edit is finished.

- **Zoom Resizes Windows:** When you zoom in on a picture, the photo zooms while the Image window remains fixed in size. If you want the window to zoom when the picture is zoomed, select this check box.

- **Select Move Tool after Committing Text:** When you type text, the Type tool is active when you complete your editing. If you want the Move tool selected after adding text, select this check box.

- **Relaxed Text Selection:** Clicking near text selects the text.

- **Allow Floating Documents in Edit Full Mode:** By default, open photos in the Image window appear as a nested group with filenames and close boxes at the top of the window. You can choose to view documents in a more traditional Elements view where multiple images appear as floating windows where the photos can be arranged within the Image window. When you select this check box and return to the Editor, click the

Arrange icon to open a drop-down list and choose Float All Windows from the menu commands. For more information on using the Arrange drop-down list, see Chapter 1 of this minibook.

✔ **Zoom with Scroll Wheel:** Select this check box if you have a mouse with a scroll wheel and want to zoom in and out when rotating the wheel.

✔ **Automatically Launch Adobe Bridge (Mac only):** Check this box, and Adobe Bridge launches when you launch Elements.

✔ **Appearance Options:** Click either Dark or Light to change the interface between a dark gray and white background.

Note that for the purposes of visual clarity, we changed the interface color from Dark to Light when capturing all the figures in this chapter.

✔ **Reset All Warning Dialogs:** Many warning dialog boxes have check boxes in them which, if selected, let you dismiss the dialog box, safe in the knowledge that you'll never have to bother with that particular dialog box again. If, however, you change your mind and want that dialog box popping up again, select this button to reset the dialog boxes to defaults.

Setting Saving Files preferences

The Saving Files preferences, as shown in Figure 4-2, relate to options available for saving files. The settings you have available include

✔ **On First Save:** From a drop-down list, you can choose Always Ask, Ask If Original, or Save Over Current file. These options apply to the first time you edit a photo. On the Mac, you have similar options, but the menu names vary a bit.

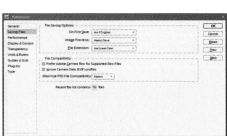

Figure 4-2: The Saving Files preferences.

✔ **Image Previews:** Image previews show you thumbnail previews of images. Adding a preview increases the file size. You can choose to Never Save, Always Save, or Ask When Saving. On the Mac, you have an assortment of check boxes that offer similar choices.

✔ **File Extension:** Filename extensions can be upper or lowercase. On the Mac, you find Append File Extension with choices for Always, Never, and Ask When Saving and a check box for Use Lower Case.

✔ **Prefer Adobe Camera Raw for Supported Raw Files:** For Camera Raw formats supported by Adobe Camera Raw, you can use Adobe Camera Raw as a default.

✔ **Ignore Camera Data (EXIF) Profiles:** Camera data can be added as metadata for photos for cameras that save the data. You can choose to keep the data or discard it.

✔ **Maximize PSD File Compatibility:** When you save files from Elements, you can save in a format compatible with Adobe Photoshop. For larger files, you may want to eliminate the compatibility to reduce the overall file size.

✔ **Recent File List Contains *XX* Files:** The File⇨Open Recently Edited File submenu lists ten files by default. You can reduce the number of files appearing in the list (as low as zero) or increase the number to a maximum of 30 files.

Setting Performance preferences

Check out the Performance preferences pane, as shown in Figure 4-3, for history states and memory settings, such as scratch disk settings. (See the sidebar "What's a scratch disk?" in this chapter for more on scratch disks.) The options include

✔ **Let Photoshop Elements Use:** This item deals with the amount of memory allocated to Elements. You can type values in the text box to change the memory allocation.

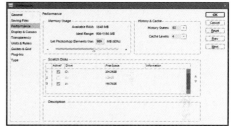

✔ **History States:** You can undo edits up to 50 undos, defined in the History States text box by default. This value can be edited to add more undos or to reduce the number. The more you add to the text box, the more memory is required in Elements.

Figure 4-3: The Performance preferences pane.

✔ **Cache Levels:** Some operations you perform are cached in memory so that they can be quickly accessed again. You can edit the text box to increase or decrease the cache levels.

✔ **Scratch Disks:** If you have external hard drives attached to your computer, you can extend the scratch disk space to external drives.

Don't use USB 1.1 external hard drives or other drives that have connections slower than USB 2 or FireWire. Using slower drives slows the performance of Elements.

What's a scratch disk?

Assume that you have 100 megabytes (MB) of free RAM (your internal computer memory) and you want to work on a picture that consumes 200MB of hard disk space. Elements needs to load all 200MB of the file into RAM. Therefore, an auxiliary source of RAM is needed in order for you to work on the image; Elements uses your hard drive. When a hard drive is used as an extension of RAM, this source is a *scratch disk.*

If you have more than one hard drive connected to your computer, you can instruct Elements to use all hard drives, and you can select the order of the hard drives that Elements uses for your extension of RAM. All disks and media sources appear in a list as 1, 2, 3, 4, and so on.

Setting Display & Cursors preferences

The Display & Cursors preferences are shown in Figure 4-4. These choices offer options for how certain tool cursors are displayed and how you view the Crop tool when you're cropping images.

Your choices include

- **Show Transition Effects:** When the check box is selected, you see transition effects when viewing photos in a slideshow.

- **Painting Cursors:** Your choices here include the following:

 - *Standard:* This setting shows a tool icon, such as the Lasso tool or the Brush tool, for when you edit an image.

Figure 4-4: The Display & Cursors preferences.

 - *Precise:* This setting changes the tool cursor to a crosshair for precise markings.

 - *Normal Brush Tip:* Displays a 50% tip on a brush for the cursor shape.

 - *Full Size Brush Tip:* Shows the tool cursor at the full size of a brush tip.

 - *Show Crosshair in Brush Tip:* Shows the tool cursor with a crosshair inside the tip.

- **Other Cursors:** Choose Standard that displays an icon of the tool being used or Precise that displays a crosshair for a more precise detail image of the cursor.

✔ **Crop Tool settings:** The following Crop Tool options are found in this section:

- *Use Shield:* If you select this option and then use the Crop tool, the inside area defining the crop region shows the photo at the normal appearance and the area outside the crop region appears with a shield, making it easier to see what will be eliminated and what will be retained when the photo is cropped.

- *Shield Color:* You can change the color of the Crop tool shield by making choices in the drop-down color palette.

- *Opacity:* The shield is semitransparent by default. You can change the opacity of the shield to make it more opaque or transparent by editing the text box or choosing options from the drop-down list.

Setting Transparency preferences

The Transparency preferences are shown in Figure 4-5. Using these settings requires an understanding of how Elements represents transparency. Imagine painting a portrait on a piece of clear acetate. The area you paint is opaque, and the area surrounding the portrait is *transparent* — invisible, in other words. To display transparency in Elements, you need some method to make transparent areas visible.

Figure 4-5: The Transparency preferences.

To accomplish that, open the Transparency preferences and make choices for how transparency is displayed in your 2-D Elements environment.

The settings available to you include

- ✔ **Grid Size:** The grid you see in the image in the top-right corner of the Transparency preferences pane displays the default settings for the grid size and color. You can change the grid size to None, Small, Medium, or Large.

- ✔ **Grid Colors:** From the drop-down list, you can choose from preset colors to display the transparency.

- ✔ **First transparency background color:** Click the swatch and you can make a custom color choice for one set of the pattern squares.

- ✔ **Second transparency background color:** Click the second color swatch and you can choose a custom color for the second set of pattern squares.

Units & Rulers preferences

The Units & Rulers preferences, as shown in Figure 4-6, let you specify settings for ruler units, column guides, and document preset resolutions. Your choices include

- ✔ **Rulers:** From the drop-down list, choose the unit of measure you want to use for your display.

- ✔ **Type:** From the drop-down list, choose the units you want to use when dealing with text.

Figure 4-6: The Units & Rulers preferences.

- ✔ **Print Sizes:** From the drop-down list, choose the units you want to work with when printing photos.

- ✔ **Width:** You can set up columns to create a layout in Elements. This item deals with the width you want to specify for the column width.

- ✔ **Gutter:** The gutter is normally the space between columns in a publication. Define the amount of space you want to have appear between the columns when you add columns to a layout.

- ✔ **Print Resolution:** When you create a new document, the print resolution default is determined by this setting.

- ✔ **Screen Resolution:** A new document's screen resolution is determined by this setting.

- ✔ **Photo Project Units:** When creating projects, such as photo calendars, photo books, and so on, you can specify units of measure for the book sizes from choices in the drop-down list.

Setting Guides & Grid preferences

The Guides & Grid preferences, as shown in Figure 4-7, offer options for guide colors and styles, and gridline color, divisions, and subdivisions. A *grid* shows you nonprinting horizontal and vertical lines. You use a grid to align objects, type, and other elements. You can snap items to the gridlines to make aligning objects much easier.

Your choices for Guides & Grid preferences include

- ✔ **Color:** Guides & Grids are displayed with colored lines. You can change line color by choosing Custom or a preset color from the drop-down list.

✔ **Style:** Guides & Grid lines can be regular lines, dashed lines, or dots. Make your choice by choosing an option from the drop-down list.

✔ **Gridline Every *XX* Inches:** Major guideline divisions can be spaced according to a value you type in the text box.

Figure 4-7: The Guides & Grid preferences.

✔ **Subdivisions:** Between each major subdivision, you can define the number of subdivision lines by typing a value in the text box.

Setting Plug-ins preferences

The Plug-ins preferences pane, as shown in Figure 4-8, isn't much to look at. It contains a single option for selecting an additional plug-ins folder for storing third-party utilities to work with Elements. If you have third-party utilities, though, it's a great help. Just select the check box and click the Choose button to locate another folder for storing your third-party plug-ins.

Figure 4-8: The Plug-ins preferences.

Setting Type preferences

The Type preferences, as shown in Figure 4-9, provide options for setting text attributes. You have options for using different quote marks, showing Asian character options, showing font names in English, and previewing font sizes. The full listing follows:

✔ **Use Smart Quotes:** So-called *smart quotes* — the typographically correct quotation marks found in most printed matter — are used instead of straight quotes when this option is selected.

Figure 4-9: The Type preferences.

✔ **Show Asian Text Options:** Options for text using Asian character sets are shown when this is selected.

✓ **Enable Missing Glyph Protection:** Selecting this check box enables font substitution for any missing characters within a given font.

✓ **Show Font Names in English:** Non-Roman fonts are shown with Roman font names when selected.

✓ **Font Preview Size:** Displays font previews in the Type tool font menus for Small, Medium, Large, Extra Large, and Huge.

Setting Up the Organizing Environment (Windows)

A whole different set of preferences appears when you open the Organizer and choose Edit⇨Preferences or press Ctrl+K. Initially, you may be confused because the dialog box that opens when you work in the Organizer is also named Preferences. However, a quick glance at the dialog box shows you a different set of preferences choices.

Open the Organizer and press Ctrl+K to open the Preferences dialog box, as shown in Figure 4-10.

Some items common to all panes in the Organizer Preferences dialog box include

Figure 4-10: The Organizer General preferences.

✓ **Restore Default Settings:** This button appears in all panes in the Preferences dialog box. Click the button, and all preferences return to defaults.

✓ **OK/Cancel:** Click OK to accept changes and Cancel to dismiss the dialog without changing settings.

✓ **Help:** Click the Help button to get online help information related to the preference options.

Setting General preferences

These items affect a miscellaneous group of settings for the user interface and apply to files when you're using the Create panel. The options include

✓ **User Interface Brightness:** This setting is similar to the setting of the same name in the Edit Full preferences. Changing the interface brightness changes only the brightness in the Organizer mode and has no effect on the Editor's workspaces.

✔ **Grid Brightness:** Select either Dark or Light to change the brightness of gridlines.

✔ **Print Sizes:** You can print photos directly from the Organizer without opening them in an edit mode. This setting is used for choosing a unit of measure for the print output.

✔ **Date (Newest First):** Choose from displaying images beginning with the oldest first or the newest first in terms of the dates the photos were taken.

✔ **Date Format:** Choose between two different format types when displaying dates.

✔ **Show Closely Matching Sets for Searches:** This option displays sets having close appearances to found results.

✔ **Allow Photos to Resize:** When selected, photos can be scaled over 100%.

✔ **Use System Font:** This option gives you a system font instead of an application font.

✔ **Adjust Date and Time by Clicking on Thumbnail Dates:** Click dates in the thumbnails to adjust them.

✔ **Show Fade Transitions:** This option displays fade transition effects in the Photo Browser.

✔ **Reset All Warning Dialogs:** This option resets all dialog boxes to defaults.

Setting Files preferences

The Files preferences, as shown in Figure 4-11, offer options for managing file data, connecting to missing files, prompting to back up your data, saving catalogs, choosing file and folder locations for saved files, rotating images, burning CD/DVDs, and handling preview sizes.

The options in these preferences include

✔ **Use "Last Modified" Date if EXIF Date Is Not Found:** If files don't have EXIF camera data, use the date the file was last modified.

✔ **Import EXIF Caption:** If EXIF camera data is available and includes captions, this results in importing the captions when you are adding files to the Organizer.

Figure 4-11: The Files preferences.

✓ **Automatically Search for and Reconnect Missing Files:** If you move a file to another folder or rename the folder in Explorer, the Organizer loses the connection from the Organizer window to the file location. Selecting this check box results in an automatic search for missing files.

✓ **Automatically Prompt to Backup Files and Catalog:** When selected, a dialog box opens automatically, prompting you to back up your files. You can choose to back up files or dismiss the dialog box and back up files/catalog at a later time.

✓ **Enable Multisession Burning to CD/DVD:** This option enables multisession burns to discs supporting multisession burning.

✓ **Rotate JPEGs using Orientation Metadata:** If the metadata includes orientation defaults, selecting this option rotates JPEG images to the orientation matched in the metadata.

✓ **Rotate TIFFs using Orientation Metadata:** If the metadata includes orientation defaults, selecting this option rotates TIFF images to the orientation matched in the metadata.

✓ **Folders for Saved Files (Browse):** Click the Browse button to select a target folder for saved images.

✓ **Preview File Size:** From the drop-down list, you can choose different preview resolutions. A preview is created when you double-click a photo in the Organizer.

Setting Folder Location View preferences

The Folder Location View preferences, as shown in Figure 4-12, provide options for showing files and folders in groups and selected folders. Basically, you can choose between the following two options:

✓ **All Files Grouped by Folder:** Shows all files in the Organizer sorted by folder.

✓ **Only Files in the Selected Folder:** Displays only those files in a specified folder in the Organizer window.

Figure 4-12: The Folder Location View preferences.

Setting Editing preferences

It is possible that you may have another editing application that has some features not found in Elements. With the Editing preferences, as shown in Figure 4-13, you can enable that other application to edit an image based on its file type.

Your options include

- ✔ **Use a Supplementary Editing Application:** Select the check box and click the Browse button to locate a supplemental editing application.

- ✔ **Show Photoshop Elements Options:** Shows options available for Photoshop Elements.

- ✔ **Show Premiere Elements Options:** Shows options available for Premiere Elements.

Figure 4-13: The Editing preferences.

Setting Camera or Card Reader preferences

The Camera or Card Reader preferences, as shown in Figure 4-14, handle how you acquire images from digital cameras and media storage cards. Your computer may have built-in card readers in which you can insert a media card, such as CompactFlash or Smart Media, or a USB card reader that supports a media card. You may have a cable that connects from your camera to a USB port on your computer. These preference options are used with media cards, camera connections, and download options.

The options include

- ✔ **Save Files In/Browse:** The directory where files are saved by default appears listed in the Camera or Card Reader preferences. Click the Browse button to choose another folder for the default location.

- ✔ **Automatically Fix Red Eyes:** As files are imported, red-eye removal is performed when the check box is enabled.

Figure 4-14: The Camera or Card Reader preferences.

✔ **Automatically Suggest Photo Stacks:** Photos appearing similar in image content can be stacked to minimize the space in the Organizer window. When this check box is enabled, Elements prompts you with suggestions for stacking the photos.

✔ **Make 'Group Custom Name' a Keyword Tag:** For custom group names of photo collections, you can have a Keyword tag added to the Keyword Tags panel.

✔ **Download Options (Edit/Remove):** Select the item listed in the list window and click the Edit button. You can choose from three different download options for the dialog box display when copying photos from cameras and card readers.

✔ **Begin Download:** Open the drop-down list and choose to download photos immediately or after several delay options.

✔ **Create Subfolder(s) Using:** Subfolders can be created automatically when copying photos to your hard drive based on several different date options for the folder names.

✔ **Delete Options:** Choose from several options to delete photos after copying to your hard drive.

Setting Scanner preferences

The Scanner preferences, as shown in Figure 4-15, hold all the options you may want to set when scanning photos. The options include

✔ **Scanner:** Choose a scanner model from the drop-down list when you have multiple scanners attached to your computer.

✔ **Save As:** Choose an image format for the saved scan (.jpeg, .tif, or .png).

✔ **Quality:** When saving files in JPEG format, choose compression options for the image quality.

✔ **Automatically Fix Red Eyes:** Auto red-eye removal is performed on scanned images when the check box is enabled.

✔ **Browse:** Click the Browse button to choose a target folder for saved scans.

Figure 4-15: The Scanner preferences.

Setting Date View preferences

The Date View preferences, as shown in Figure 4-16, let you determine which dates you want to add to the date view calendar. You can choose from a variety of holiday dates or customize your own. The options include

✓ **Use Monday as the First Day of the Week:** Select this box to use Monday as the first day of the week when viewing files in the Organizer in a date view.

✓ **Holidays:** A preset list of holidays appears in the list window.

✓ **Events (New/Edit/Delete):** Click the New button and you can add a custom holiday to the list in the list window — for example, something like Oktoberfest or an annual Greek Festival.

Figure 4-16: The Date View preferences.

Setting Keyword Tags and Albums preferences

The Keyword Tags and Albums preferences pane, as shown in Figure 4-17, offers options for sorting tags and icon views for tags. The choices include

✓ **Enable Manual Sorting Option:** A list of items can be sorted automatically or manually by choosing the respective radio buttons for each category.

✓ **Keyword Tag Display:** Choose from one of two icons to be used for keyword names in the Keyword Tags panel.

✓ **People Recognition Hints:** Elements can search through photos and find all photos that contain faces. Click Show to show hints for recognizing people or Hide to hide hints.

Figure 4-17: The Keyword Tags and Albums preferences.

Setting Sharing preferences

The Sharing preferences, as shown in Figure 4-18, relate to sharing files via e-mail. Options are available for setting an e-mail client and adding captions to e-mailed files. The options include

- ✔ **E-mail Client:** Choose the e-mail program you want to use from options in the drop-down list.

- ✔ **Write E-mail Captions to Catalog:** When using Photo Mail to e-mail your images, you can write the captions in the e-mail message back to the Organizer catalog.

Figure 4-18: The Sharing preferences.

Setting Adobe Partner Services preferences

The Adobe Partner Services preferences, as shown in Figure 4-19, offer choices for handling program updates and online service orders. You can choose to check for program updates automatically or manually, choose options for printing and sharing images, and specify how you want to update creations, accounts, and more. The options include

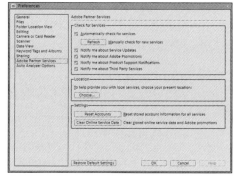

- ✔ **Automatically Check for Services:** Additional services are checked automatically. If you want to check services manually, deselect this item and click the Refresh button for manual checking.

- ✔ **Notify Me about Service Updates:** This item checks automatically for Photoshop Elements program updates.

- ✔ **Notify Me about Adobe Promotions:** You get special promotions from Adobe if this option is selected.

Figure 4-19: The Adobe Partner Services preferences.

- ✔ **Notify Me about Product Support Notifications:** Items related to product support are sent to you if this option is selected.

- ✔ **Notify Me about Third Party Services:** You'll hear about third-party vendor products that work with Elements if this option is selected.

✔ **Location:** Click the Choose button and choose the country where you reside to check for specific services in a given locale.

✔ **Settings:** Click the Reset Accounts button to reset all accounts for online services. Click the Clear Online Service Data button to clear online configuration data.

Setting Auto Analyzer Options preferences

Auto Analyzer Options is the last preferences pane in the Organizer Preferences dialog box. Auto Analyzer automatically searches your catalog for photos according to the filter options you choose in the Select Filters area of the dialog box, as shown in Figure 4-20.

Select the filters you want to use for searching for photos meeting the respective criteria. For example, to isolate all photos with a blur, you can select the Blur check box. After you run the Auto Analyzer, the photos appear in the Organizer window where you can tag them or remove them from the catalog.

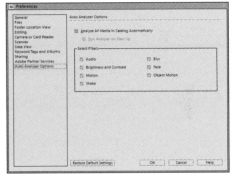

Figure 4-20: The Auto Analyzer Options preferences.

Setting Adobe Bridge Preferences

On the Mac, you can make preference choices in Adobe Bridge. Press ⌘+K or choose Adobe Bridge CS4⇨ Preferences, and the Preferences dialog box opens, as shown in Figure 4-21.

We include a chapter devoted entirely to Adobe Bridge. For more about preference options in Bridge, see Book II, Chapter 3.

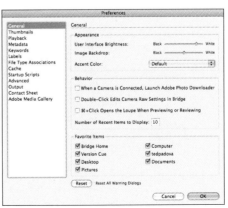

Figure 4-21: Adobe Bridge Preferences on the Mac.

Book II

Elements
Fundamentals

*G*etting photos into Elements, as well as orga-nizing and managing your photos, is the subject of this book. We start by talking about how you acquire photos from cameras, card readers, and scanners, and how you can use wizards to make the process easier. For Windows users, we talk about using the Organizer and all the features the Organizer has for managing and editing your photos in Chapter 2. For Macintosh users, we talk about managing and editing photos using Adobe Bridge in Chapter 3.

Chapter 1: Acquiring, Saving, and Exporting Images

In This Chapter

- Getting your images
- Using the Elements Downloader and AutoPlay
- Scanning photos
- Getting photos from cell phones, files, and folders
- Opening photos in an Editor
- Creating new blank images
- Converting the Clipboard
- Saving your files
- Processing multiple images
- Adding new pages
- Closing and quitting in Elements

*A*fter you install Photoshop Elements, the first thing you want to do is open some photos. It stands to reason that, before you can jump into all the editing opportunities you have with the program, you need to have something to work with.

You may have digital camera photos still on a memory card, or you may have copied files to your computer. You might have a photo print you want to scan, or you may want to get a photo off your cell phone. Regardless of where you have photos stored, you want to get them into Elements and start working on them.

In this chapter, we talk about getting your files into the Organizer (Windows) or Adobe Bridge (Mac) and opening them in an Editor. After you have your files in one workspace or another, you have a number of different options for sorting, finding, and arranging photos in the Organizer (Bridge). First, however, we look at acquiring images from a variety of sources and check out how to open them in an Editor. (Look over Book II, Chapter 2 if you just can't wait to find out more on working with the Organizer or Book II, Chapter 3 for Adobe Bridge.)

Getting Images from Your Camera

When you work with Elements, you most frequently use one of two workspaces, as we describe in Book I, Chapter 1 — the Organizer (or Adobe Bridge) or the Editor. The Organizer (Windows) or Adobe Bridge (Mac) is frequently used as your first stop in editing photos. Unless you have an image you want to edit in Edit Full mode and, therefore, open it immediately in the Editor, your typical first step is to look over a collection of photos you've taken with a digital camera or imported using a scanner. Therefore, when we talk about getting images from your camera, we're pointing you to the Organizer or Bridge workspace.

To load images from your camera in the Organizer window or Adobe Bridge, you open the Organizer (Bridge) and use a cable connected to your camera and your computer. Most digital cameras come with USB cables that can be connected to both camera and computer.

The process for acquiring images from a camera and a card reader are the same, and the Organizer (Bridge) has a single menu command you use to acquire your photos. To find out how to acquire the images, look over the next section.

Getting Images from Your Card Reader

Almost all cameras use memory cards to store photos. After shooting some images, you have a choice of either grabbing those images directly from the camera and shunting them to your computer via a USB or FireWire cable, or you can remove the memory card itself from the camera and place it in a card reader hooked up to your computer using one of the same cables.

Both methods — a direct hookup or a connection to a card reader — afford you an opportunity to load your photos in the Elements Organizer or Adobe Bridge. To add photos to the Organizer or Adobe Bridge, do the following:

1. **Either hook up your camera to your computer via a USB/FireWire cable, hook up a card reader via a cable, or insert a card if you have a built-in reader on your computer and insert the memory card in the reader.**

 Use the cable supported by your camera/card reader.

2. **Cancel the AutoPlay Wizard (Windows). If iPhoto or Image Capture opens on the Mac, close the application.**

 When you hook up your camera or card reader, the AutoPlay Wizard opens. Click Cancel in the wizard to proceed.

3. **Open the Organizer (Windows) or Adobe Bridge (Mac).**

 Launch Photoshop Elements and click Organize in the Welcome screen (Windows). On the Mac, launch Adobe Bridge.

4. **Get photos from the camera/card reader.**

 In the Organizer, choose File➪Get Photos and Video➪From Camera or Card Reader or press Ctrl+G. On the Mac, choose File➪Get Photos from Camera.

5. **Choose the media source.**

 The first wizard you see when you choose the menu command is the Adobe Photoshop Elements 8.0 – Photo Downloader (Windows). This wizard opens when you choose to get photos from within the Organizer. At the top of the wizard, you find a drop-down list that displays your hard drive and a source, such as a camera or card reader, attached to your computer. Choose a source, as shown in Figure 1-1. On the Mac, choose a source drive from the Source pop-up menu, as shown in Figure 1-2.

Figure 1-1: Choose a source from the Get Photos and Videos From drop-down list.

6. **Get the photos.**

 After you choose a camera or card reader, the Downloader appears with the Get Photos button active, as shown in Figure 1-3. Click Get Photos and leave the other settings at the defaults.

7. **Wait for the Downloader to complete downloading all images before continuing.**

 A progress bar displays the download progress, as shown in Figure 1-4. If you have many photos on your memory card, it may take a little time to complete the download. Be patient and wait for the download to finish.

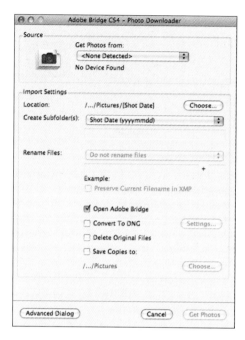

Figure 1-2: Adobe Bridge CS4 – Photo Downloader on the Mac.

Figure 1-3: Click the Get Photos button.

8. **Import the photos.**

 A dialog box opens when the download is complete. The download doesn't copy images to the Organizer. To import the copied images into the Organizer, click OK.

Figure 1-4: Wait for the download progress to complete.

9. **View the results.**

 After the photos have been imported in the Organizer or Adobe Bridge, you see thumbnail images for all the photos acquired from the memory card.

After the photos are added to the Organizer (Adobe Bridge), you can edit the images in Full Edit or Quick Fix mode. See "Opening an Image in Edit Full Mode," later in this chapter.

Using the Photoshop Elements Downloader

The Adobe Photoshop Elements 8.0 – Photo Downloader Wizard (as shown in Figure 1-5) has a number of settings you can use when getting photos from a media source. Among the options you have are

✔ **Location:** Click the Browse button to navigate your hard drive and select a target folder for saving the downloaded files. The directory path is shown in the wizard. In the advanced options shown later in Figure 1-5, you can create subfolders to further organize your photos.

✔ **Rename Files:** You can choose to preserve the filenames created by your camera or add an extension or custom name for the files. Open the drop-down list and make a choice for the naming convention you want to use.

✔ **Delete options:** You can copy images to your hard drive and retain the files on the media card, or you can delete the files after copying them. Choose an option from the drop-down list appearing below the Import into Album check box.

✔ **Advanced Options:** If it's in the Advanced Options section of the Advanced dialog box, it must be doubly advanced, right? Items listed here include

 • *Automatically Fix Red Eyes:* Red-eye removal is applied to all images where Elements detects a red-eye problem.

 • *Automatically Suggest Photo Stacks:* Images with similar content can be stacked so that only a single-image thumbnail appears in the Organizer. You can unstack the photos at any time by clicking a stacked group. Checking this box automatically suggests photo stacks that you can confirm or deny.

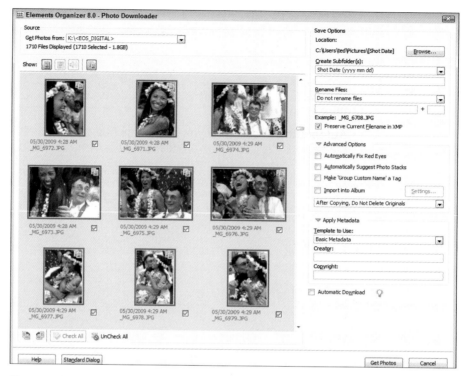

Figure 1-5: Elements Organizer 8.0 Downloader.

- *Make 'Group Custom Name' a Tag:* Photos can be tagged for sorting and organizing purposes. Checking this box adds a tag to the photos based on the group of photos imported.

- *Import into Album:* You can import a number of images into an existing Photo Album by checking this box.

✓ **Apply Metadata:** Metadata is information added to photos. Your camera can add metadata such as F-stop, date the shot was taken, ISO rating, and much more. You also have some custom options for adding metadata such as

 - *Template to Use:* Choose Basic Metadata for the template from the drop-down list and the other items in this group become active.

 - *Creator:* This is an open text field you can use to add something like a photographer's name.

 - *Copyright:* Another open text field where you can add the name of the copyright holder, such as a photo studio or a client.

✔ **Check All:** The button at the bottom of the dialog box is used to check all the images. When checked, all images are copied from the media card to your hard drive.

✔ **UnCheck All:** Check this box and you can individually check the box adjacent to the lower-right corner of each photo thumbnail. Only the checked items are copied to your hard drive when you click the Get Photos button.

✔ **Automatic Download:** If you check this box, the Adobe Photoshop Elements 8.0 – Photo Downloader Wizard automatically downloads images when a media card is inserted in a card reader or when your camera is connected to your computer. You can establish download options from the Organizer preferences (see Book I, Chapter 4 for more on customizing preferences).

Using the AutoPlay Wizard (Windows)

Earlier in this chapter, we cancelled the AutoPlay Wizard when we added photos in the Organizer. At times, you may want to use the AutoPlay Wizard to copy files to your computer.

To use the AutoPlay Wizard, connect your camera or card reader to your computer or insert a CD-ROM. The AutoPlay Wizard opens by default. In the AutoPlay Wizard shown in Figure 1-6, you have the following options:

✔ **Pictures Options:** In the list below Pictures Options, you find applications that can open images on the stored media device. If you want to open files in Elements, click the Organize and Edit link adjacent to the Elements icon.

✔ **General Options:** If you want to browse the media storage device, click the Open Folder to View Files link. The folder where your images are stored opens on the desktop. You can copy folders and images to your hard drive by dragging them from the media device to a folder on your hard drive.

Figure 1-6: Connect a camera or card reader or insert a CD-ROM, and the AutoPlay Wizard opens.

Scanning Images

Scanners connect through the same ports as cameras and card readers. Most of today's scanners use either USB or FireWire. Almost all low-end scanners sold now are USB devices.

Even the lowest-end scanners provide 16-bit scans that help you get a little more data in the shadows and highlights. Like a digital camera, a scanner's price is normally in proportion to its quality.

Preparing before you scan

Just as you'd clean a lens on a digital camera and set various menu selections before clicking the shutter button, you should prepare a few things ahead of time before scanning:

- **Connect the scanner properly.** Make sure that you have all connections made to your computer according to the user manual that came with your scanner. If you just purchased a scanner, check for any lock bolts or tape and remove them according to the instructions.

- **Clean the scanner platen.** Use a lint-free cloth and some glass cleaner (applied to the cloth) to remove all dust and particles on the glass. The more dust particles you remove, the easier it is to edit your image in Elements.

- **Clean the source material.** Be certain that the print or film you want to scan is free of dust and spots.

 If you have old negatives that are dirty or that have water spots or debris that you can't remove with a cloth and film cleaner, soak the film in *photo flo* (a liquid you can purchase at a photo retailer). Be certain that your hands are clean and then run the filmstrip between two fingers to remove the excess liquid. Turn on your shower full force with hot water only and hang film nearby to dry it. Remove the film when it's dry, and you should see a surprisingly clean filmstrip compared to your soiled original.

- **Get to know your scanner software.** When you scan in Elements, the software supplied with your scanner takes charge, and you use the options in this software before the image scan finally drops into an Elements Image window.

- **Prepare the artwork.** If you plan on scanning pages in a book or pamphlet, remove the pages or try to make photocopies so that the piece you scan lies flat on the scanner platen. Make sure that you observe

copyright laws if you're scanning printed works. For faxes and photocopies, try to improve originals by recopying them on a photocopier by using darker settings.

⌐ **Find the scanner's sweet spot.** Every scanner has an area where you can acquire the best scans. This area is often called the *sweet spot.* To find the scanner's sweet spot, scan a blank piece of paper. The sweet spot is the brightest area on the resultant scan. Other areas should be darker. The sweet spot is most often in the upper-left quadrant, the lower-right quadrant, or the middle of the page. Note the area and plan to place your source material within this area when scanning pictures.

Understanding image requirements

All scanning software provides you with options for determining resolution and color mode before you start a new scan. You should decide what output you intend to use and scan originals at target resolutions designed to accommodate a given output. For example

⌐ **Scan the artwork or photo at the size and resolution for the final output.** If you have a 3-x-5 photo that needs to be 1.5 x 2.5 inches on a Web page, scan the original with a 50-percent reduction in size at 72 ppi (pixels per inch). (See Book III, Chapter 1 for information about resizing images.)

⌐ **Size images with the scanner software.** If you have a 4-x-6 photo that needs to be output for prepress and commercial printing at 8 x 12 inches, scan the photo at 4 x 6 inches at 600 ppi (enough to size to 200 percent for a 300 dpi [dots per inch] image).

⌐ **Scan properly for line art.** *Line art* is 1-bit black and white only — something like a black-and-white illustration. When you print line art on laser printers or prepare files for commercial printing, the line art resolution should match the device resolution. For example, printing to a 600 dpi laser printer requires 600 ppi for a 1-bit line-art image. When you're printing to an image setter at a print shop, or it's going directly to plate or press, the resolution should be 1200 dpi.

⌐ **Scan grayscale images in color.** In some cases, it doesn't matter, but with some images and scanners, you can get better results by scanning in RGB (red, green, blue) color and converting to grayscale by using the Hue/Saturation dialog box or the Convert to Black and White dialog box, as we explain in Book III, Chapter 2.

⌐ **Scan in high bit depths.** If your scanner is capable of scanning in 16 or 32 bit, by all means, scan at the higher bit depths to capture the most data. See Book III, Chapter 2 for more information about working with higher-bit images.

Using scanner plug-ins

Generally, when you install your scanner software, a standalone application and a plug-in are installed to control the scanning process. *Plug-ins* are designed to work inside other software programs such as Photoshop Elements. When you're using the plug-in, you can stay right in Elements to do all your scanning. Here's how it works:

1. **After installing a new scanner and the accompanying software, launch Elements and then open the Organizer by clicking Organize in the Welcome screen (Windows) or click Import from Scanner on the Welcome screen (Mac).**

2. **From the Organizer, open the Preferences dialog box by pressing Ctrl+K (Windows). On the Mac, choose your scanner from the Import drop-down menu that appears in the Select Import Source dialog box.**

3. **Click Scanner in the left column and adjust the Scanner preferences, as we describe in Book I, Chapter 4 (Windows).**

When the Preferences dialog box sees your scanner, you know that the connection is properly set up and you're ready to scan. On the Mac, when you choose your scanner from the Import drop-down list, you're ready to scan when Elements recognizes the scanner. Assuming all your connections are properly set up, here's how to complete your scan:

1. **To open the scanner software from within Elements, choose File⇨Get Photos⇨From Scanner. On the Mac, launch Elements and click Import from Scanner in the Welcome screen.**

 You must be in the Organizer window (Windows) to access this menu command.

 Elements may churn a bit, but eventually your scanner software appears atop the Organizer window (Windows) or Elements window (Mac), as shown in Figure 1-7. The window is the scanner software provided by your scanner manufacturer. (Your window looks different from the one in Figure 1-7 unless you use the same scanner we use.) Regardless of which software you use, you should have similar options for creating a preview; selecting resolution, color mode, and image size; scaling; and other options.

2. **Adjust the options according to your output requirements and the recommendations made by your scanner manufacturer.**

3. **When everything is ready to go, click the Scan button.**

 The final image drops into an Elements Image window.

Figure 1-7: When you scan from within Elements, your scanner software loads on top of the Elements workspace.

Scanning many photos at a time

If you have several photos to scan, you can lay them out on the scanner platen and perform a single scan to acquire all images in one pass. Arrange the photos to scan on the glass and set up all the options in the scanner window for your intended output. When you scan multiple images, they form a single scan, as you can see in Figure 1-8.

After you scan multiple images, Elements makes it easy for you to separate each image into its own Image window, where you can save the images as separate files. Choose Image⇨Divide Scanned Photos to make Elements magically open each image in a separate window while your original scan remains intact. The images are neatly tucked away in the Project Bin where you can select them for editing, as shown in Figure 1-9.

Figure 1-8: You can scan multiple images with one pass.

Figure 1-9: After you choose Image⇨Divide Scanned Photos, the scan is split into separate Image windows.

Phoning In Your Images

With newer cell phones, you have several ways you can get photos from your phone to your computer. Elements doesn't have a menu command to import cell phone images directly. You first need to copy photos to your computer or connect your phone via a USB cable to your computer and from there, you can import them into the Organizer or open them in an Editor.

Here's what you find with cell phones and connection options:

 ✓ **Cable connection:** If your phone comes with a USB port, you can connect your phone to your computer and copy images from the phone's memory card or hard drive to your computer. Your computer should see the cell phone as an external device. In some cases, you may need to load software that was provided by your cell phone developer.

 ✓ **Bluetooth:** If your computer and your phone are equipped with Bluetooth, you can use your computer's Bluetooth interface to browse for a device to connect to your phone. On your phone, you accept the connection invitation and after you're connected, you can perform a wireless transfer of your files.

✔ **E-mail:** Phones equipped with Internet connection options and e-mail provide you with the ability to e-mail photos to your desktop e-mail client. After these are e-mailed to your client, you can save the files to a target folder.

After you copy photos to your hard drive, you can get the photos in the Organizer, as we explain in Book II, Chapter 2, or open them directly in an Editor.

Getting Files from Folders

We've covered several different options you might use to copy files to your hard drive. Whether you've opened a folder from a media device or copied cell phone images to your computer, after they are on your computer's hard drive, you want to work with them in Elements.

To load files copied to your hard drive into the Organizer on Windows, do the following:

1. **Copy files to a folder.**

 You can organize photos into separate folders on your hard drive, nest folders, or copy a bunch of photos to a single folder. When you use multiple folders, you repeat the steps here to import each folder's images into the Organizer. If you nest folders, you can get files from a parent folder and all subfolders.

2. **Choose File⇨Get Photos and Videos⇨From Files and Folders.**

 You can import a single file or a collection of images with this command. When you choose the menu command, the Get Photos and Videos from Files and Folders dialog box opens, as shown earlier in Figure 1-1.

3. **Select images to import.**

 If you want to import all photos within a given folder, click any file in the list and then press Ctrl+A to select all. Alternatively, you can click and Ctrl-click to select files individually in a noncontiguous order or click and Shift-click to select photos in a contiguous order.

4. **Specify your Fix Red Eyes and Photo Stacks options.**

 If you want to automatically correct red-eye problems or create photo stacks, check the check boxes respectively for these options.

5. **Get the photos.**

 Click the Get Photos button and wait for Elements to complete the import process. Your photos appear in a new Organizer window and you're ready to apply edits in either the Organizer or an Editor.

Opening an Image in Edit Full Mode

You might have a single photo you want to edit without adding it to the Organizer or viewing it in Adobe Bridge. Perhaps you just want to apply some edits to an image you have on a media source or on your hard drive and then send it off via e-mail or share the photo using one of several supported sharing services.

If this is the case, you can bypass the Organizer and start in Edit Full mode. To open an image in Edit Full mode, do the following:

1. **Launch Photoshop Elements.**

2. **Choose File⟿Open.**

3. **(Optional) If you want to search for photos saved within a given format, open the All Formats drop-down list (Format pop-up menu on the Mac) and choose the format for a file you want to open.**

 Selecting a format narrows down a collection of photos so that only files saved within the selected format are displayed. For example, if you have Camera Raw, JPEG, and TIFF images in a folder and you want to open only a JPEG file, you can select JPEG (*.JPG, *.JPEG, *.JPE) from the All Formats drop-down list (or JPEG from the Format pop-up menu [Mac]). Doing so displays only files saved in the format you choose from the drop-down list or pop-up menu.

 If you're not sure what format the file you want to open is, leave the default choice from the menu at All Formats.

4. **From the list of photo files displayed, click the photo you want to open.**

5. **Click the Open button in the Open dialog box.**

 The file opens in Edit Full mode.

Using Open As (Windows)

You may have a photo that was saved as a JPEG, TIFF, or some other format without a file extension or an incorrect file extension for the file type. You may not see the file listed in the Open dialog box, but you know it's there, and you know what format the file is. If this is the case, you can try to use the Open As command.

Choose File⟿Open As, and the Open As dialog box opens providing you the same options as the Open dialog box. Choose a format from the Open As drop-down list and click the file you want to open. Click Open and see if it works. In some cases, Elements may not recognize the file if it's damaged. In other cases, you may be able to resurrect a damaged file.

One advantage to using the Open As command is opening images in Camera Raw. You can open any photo (JPEG, TIFF, and so on) in the Camera Raw converter even if your camera didn't originally capture the photo in Camera Raw. We cover all you want to know about Camera Raw and why this would be an advantage when editing photos in Book III, Chapter 3.

Opening recently edited files

A quick way to open recently edited files is to choose File➪Open Recently Edited File. The submenu lists these files. The number of files appearing in the submenu is determined in Preferences, as we explain in Book I, Chapter 4.

If the file you want to open appears in the submenu, click the filename in the list and the file opens in Edit Full mode. On the Mac, a recent file list appears on the Welcome screen when you first launch Elements.

The Recently Edited Files list also appears in the Organizer. If you want to open a recently edited image while in the Organizer workspace, choose File➪Open Recently Edited File and select the file you want to open. The file opens in Edit Full mode.

Placing files

You may have a piece of artwork you want to add to a photo. The artwork can be of any file type you find for the supported formats that you can open in Elements. Quite often you may find a vector art drawing or a PDF file that contains the artwork you want to import; however, any of the supported formats can be used for placing content on a photo.

To place content in Elements, use the Place command as follows:

1. **Open a photo in Edit Full mode.**

 You must start with a file open in Edit Full mode in order to use the Place command.

2. **Choose File➪Place.**

 The Place dialog box opens. This dialog box has the same options you find in the Open dialog box.

3. **Select a file to place.**

 Your file can be an image format, EPS or other type of vector format, or PDF or any other file type you see listed in the Files of Type drop-down list (Windows) or Format pop-up menu (Mac). Click the file you want to place.

4. **Click Place.**

 When you place an image, you see handles around the image that can be used for sizing the image, as shown in Figure 1-10.

Figure 1-10: A placed image.

5. **Size and position the image.**

 If you import a vector art image or PDF file containing vector art, you can drag the corner handles out to size up the image without losing image quality. Press the Shift key when sizing the image to constrain proportions and press the Enter (Return) key to accept your resizing edits. After you press the Enter (Return) key, the image data are raster-ized and lose image quality if you decide to upsize the image. Click the image and move it to the desired position. (For more information on vec-tor versus raster art and upsizing images, see Book III, Chapter 1.)

Creating a New Image

You may want to start with a fresh, new canvas where you can copy and paste content from other pictures, place objects, add shapes, and/or add text to create your own scene. To begin the process, you create a new image.

In either Edit Full mode or the Organizer, choose File⇨New⇨Blank File. If you start in the Organizer, Elements switches workspaces from the Organizer to Edit Full mode and the New dialog box opens, as shown in Figure 1-11.

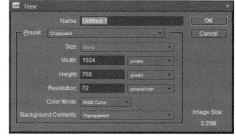

Figure 1-11: Choose File⇨New⇨Blank File to open the New dialog box from either the Organizer or Edit Full mode.

The options you have here are covered thoroughly in Book III, Chapter 2. Look over that chapter for details on the options you have for creating new, blank files.

Converting Clipboard Data to Images

Whatever you copy to the Clipboard in Elements can be converted to an image. If you copy data from somewhere else, such as text in Office applications, objects in Office applications, illustration programs, and other types of applications, the data on the Clipboard can be converted to a new Elements image.

After copying data from another application, choose File⇨New⇨Image from Clipboard. The data converted to a new document in Elements creates a new file at 72 ppi.

If you want to convert something like a vector object to an Elements file with a resolution higher than 72 ppi, create a new document in Elements at the desired resolution and then choose File⇨Place. When you accept the edits by pressing the Enter (Return) key, the data are rasterized at the resolution of the open file.

Saving Files

Photoshop Elements files can be saved in a variety of different formats. Some format types require you to convert a color mode before the format can be used. Therefore, a relationship exists between file formats and saving files. Additionally, bit depths in images also relate to the kinds of file formats you can use in saving files.

Before you go too far in Elements, you should really familiarize yourself with the file formats you use and the conversions you need to make in order to save in one format or another (as we explain in Book III, Chapters 1 and 2). If you do nothing to an image in terms of converting modes or changing bit depth, you can save a file after editing in the same format in which the file was opened. In many circumstances, you open an image and prepare it for some form of output, which requires more thought about the kind of file format you use in saving the file.

Using the Save/Save As dialog box

In most any program, the Save (or Save As) dialog box is a familiar place where you make some choices about the file to be saved. With Save As, you can save a duplicate copy of your image or a modified copy and retain the original file.

To use the Save (or Save As) dialog box, choose File➪Save for files to be saved the first time, or choose File➪Save As for any file. Either command opens a dialog box for you.

The standard navigational tools you find in any Save dialog box appear in the Elements Save/Save As dialog box. Here are some standard options you find in the Elements Save/Save As dialog box:

- **Filename (Windows) Save As (Mac):** This item is common to all Save dialog boxes. Type a name for your file in the text box.

- **Format:** From the drop-down list, select file formats. We explain the formats supported by Elements in Book III, Chapter 2.

A few options make the Photoshop Elements Save/Save As dialog box different from other Save dialog boxes you might be accustomed to using. The Save Options area in the Save As dialog box provides these choices:

- **Include in the Organizer (Windows):** If you want the file added to the Organizer, select this check box.

- **Save in Version Set with Original (Windows):** You can edit images and save a version of your image, but only in Edit Quick mode. When you save the file from Edit Quick mode, this check box is active. Select the box, and a version of the original is saved and appears in the Organizer.

- **Color:** Check the box for the ICC (*International Color Consortium*) Profile. Depending on which profile you're using, the option appears for sRGB or Adobe RGB (1998). When the check box is selected, the profile is embedded in the image. See Book III, Chapter 2 for more information on profiles.

- **Thumbnail (Windows):** If you save a file with a thumbnail, you can see a miniature representation of your image when viewing it in folders or on the desktop. If you select Ask When Saving in the Saving Files preferences, the check box can be enabled or disabled. If you're choosing an option for Never Save or Always Save in the Preferences dialog box, this box is enabled or disabled for you and is grayed out. You need to return to the Preferences dialog box if you want to change the option.

- **Use Lower Case Extension (Windows):** File extensions give you a clue to which file format was used when a file was saved. Elements automatically adds the extension to the filename for you. Your choices are to use uppercase or lowercase letters for the extension name. Select the check box for Use Lower Case Extension for lowercase or deselect the check box if you want to use uppercase characters in the filename.

Saving files for the Web

You save files for Web hosting in a different dialog box than you do when you're saving files for other output. Choose File➪Save for Web; the Save for Web dialog box opens. In Book III, Chapter 2, we explain all you need to know about how to use the Save for Web dialog box.

Batch Processing Files

Elements provides you with some automated features for processing batches of photos. You can export multiple files from one format to another file format, and you can export files changing file formats if you like. In addition, you have a limited number of other editing tasks you can automate.

The method you use and the features you want depend on whether you choose Export in the Organizer or Process Files in Edit Full mode.

Exporting files

When you open JPEG images and save back to a JPEG format, you're adding file compression to the saved images. JPEG is a lossy file format, which means that you lose image data when you save in this format. If you edit a JPEG image many times and save back to JPEG format each time, you continually lose more image data.

In some cases, you may want to convert multiple JPEG files to a file format that doesn't toss away data. You can use formats such as Photoshop PSD or TIFF, and no data are thrown away when you save the file.

For a single instance when you want to convert a JPEG image to a PSD or TIFF image, you can open the file in Elements and choose File➪Save As. From the Files of Type drop-down list (Windows) or Format pop-up menu (Mac), choose the desired format.

If you have multiple files and you want to convert the file type more efficiently, you can process a folder of files using a single command. To use a batch process type of action to convert multiple files from one format to another, do the following:

1. **Open the Organizer (Windows).**

 You should have a collection of photos in the Organizer saved as JPEG or some other format that you want to convert to a newer format.

2. **Select files in the Organizer you want to convert.**

 Click a file and press Shift and click the last file in a group or click and press Ctrl (⌘ on the Mac) and click all the photos you want to convert.

3. **Choose File⇨Export as New Files.**

 The Export New Files dialog box opens, as shown in Figure 1-12.

4. **Choose an Export file format.**

 If converting JPEG files, you might want to choose PSD for the file format. This format does not compress files.

5. **Choose a Size and Quality.**

 Choose Original if you want to maintain the same image dimensions and resolution. If you want a different size for the saved images, make a choice from the Photo Size drop-down list.

6. **Click the Browse button.**

 You can target a folder on your hard drive if you don't want to use the default folder shown in the Export New Files dialog box.

7. **Choose filenames.**

 You can save the files to a new folder with the same names without overwriting the original files or save to the same folder adding a common base name. If you click Common Base Name, you can type a base name in the text box. Type something like **Hawaii**, for example, and the files are saved as `Hawaii001`, `Hawaii002`, and so on.

Figure 1-12: The Export New Files dialog box.

8. **Click Add/Remove to add additional files or remove some from the list.**

 If you want to add more files, click the Add plus (+) icon. You can scroll the list of thumbnails, and if you find photos you want to remove, click the respective photo and click the Remove minus (–) icon.

9. **Click the Export button.**

 A progress bar is displayed in a dialog box, as shown in Figure 1-13. Wait for the progress to complete before moving on.

Figure 1-13: Wait for the progress bar to finish before moving on.

10. **Click OK.**

 After the export progress finishes, the Exporting Files Complete dialog box opens. Click OK, and the file export task is completed.

Processing multiple files

The Export as New Files command in the Organizer (Windows) or Process Multiple Files dialog (Mac) provides you a batch process for converting file formats with a rather limited set of options. For much more power and the ability to make several enhancements to the new files saved, you can use the Process Multiple Files command in Edit Full mode.

You need to switch from the Organizer to Edit Full mode to take advantage of the additional features provided in the Process Multiple Files dialog box. In Edit Full mode, choose Edit⇨Process Multiple Files (Windows) or File⇨Process Multiple Files (Mac) to open the dialog box shown in Figure 1-14.

As you can see in Figure 1-14, you have far more options available to you in the Process Multiple Files dialog box than you have in the Export New Files dialog box shown earlier in Figure 1-12.

Among some of the additional choices are

Figure 1-14: The Process Multiple Files dialog box.

Book II
Chapter 1

Acquiring, Saving, and Exporting Images

- ✒ **Image attributes:** In the left pane of the dialog box, you have all the attribute options you would have if you were exporting files. Make choices for file-naming conventions, locations for saved files, image size and resolution, and file formats.

- ✒ **Quick Fix:** From the options shown in the Quick Fix panel on the right, you can check the boxes for the image enhancements you want to make. For a complete description of these items, see Book VIII, Chapter 1.

- ✒ **Labels:** You can apply watermarks, custom labels, and choose a variety of font attributes for text added to the new saved files.

Select a folder of files and make your choices in the Process Multiple Files dialog box and click OK. Your files are converted and saved to the target folder you identify in the dialog box.

Adding Pages

You can add pages to images for use when creating projects, such as slide shows. Any pages you add to a document can be blank, new pages of the

exact same size and resolution as the current image or a duplicate of the current image added as an additional page.

To add new pages to a file, do the following:

1. **Open a photo in Edit Full mode.**

2. **Open a context menu on the image thumbnail in the Project Bin or open the Edit menu and choose Add Blank Page, as shown in Figure 1-15.**

 Alternatively, you can choose Edit⇨Add Blank Page.

 The Add Blank Page menu command adds a blank page to the current open document. If you want to copy the content in the file and duplicate it on a new page, choose Add Page Using Current Layout from either menu command.

3. **Click OK.**

 An application alert dialog box opens, informing you that the file must be saved as a Photo Creation Project (PSE) file type. Click OK, and your new page is added.

4. **Save the file.**

 Choose File⇨Save As, and the Save As dialog box defaults to a PSE file format. Locate a target folder and click Save.

Figure 1-15: Choose Add Blank Page from a context menu opened on a photo in the Project Bin.

Obviously, when adding new pages to an image and saving as a Photo Creation Project, you want to add content to the new page and perhaps add additional pages. We show you more on creating projects in Book IX, Chapter 1. For now, be aware that you can add additional pages to photos and that the files must be saved as PSE files in order to preserve the additional pages.

Closing and Quitting

It's important to understand a few things when closing files and quitting Elements. When you are in Edit Full mode and have an image open in the Image window, you can close the image without quitting the Edit Full mode workspace. Click the X button in the top-right corner of the Image window or the red button in the top-left corner (Mac) and the open file is closed.

If you click the X (red button) in the top-right (top-left on a Mac) corner of the Edit Full mode workspace, you quit Edit Full mode. Alternatively, you can press Ctrl+K (⌘+K on the Mac) or press Alt+F4 (Windows).

If you happen to have the Organizer and an Editor open and you quit one workspace, the other workspace remains open. For example, if the Organizer and Edit Full mode are both open and you quit the Organizer, Edit Full mode remains open and vice versa.

If you make an edit on a photo in Edit Full mode and decide to quit Edit Full mode, Elements prompts you to save the file before quitting.

If you also have the Welcome screen open as well as the Organizer and an Editor, quitting both the Organizer and the Editor doesn't get you out of Elements. The Welcome screen can remain open even though you've quit the workspaces.

To completely shut down Elements, take a look at the status bar (Windows) or the Dock (Mac). If you see one workspace open, click the respective item in the status bar (Dock) and then choose File➪Quit, press Ctrl+Q (⌘+Q on the Mac), or click the Close button.

**Book II
Chapter 1**

Acquiring, Saving, and Exporting Images

Chapter 2: Working in the Organizer

In This Chapter

✓ **Working with catalogs**

✓ **Locating and viewing images**

✓ **Sorting files**

✓ **Searching files**

✓ **Managing files**

✓ **Creating albums**

✓ **Showing and hiding files**

✓ **Backing up files**

*I*n Book II, Chapter 1, we talk about getting images from cameras, card readers, scanners, and other media sources. For good measure, we also talk about opening a file directly in an Editor, copying files to your hard drive, and loading up images in Elements.

To continue the story, be aware that any files loaded in Elements on Windows end up in the Organizer. Furthermore, when you add files to the Organizer, you have many options for managing files, sorting them, searching for files, tagging files with keywords, examining file properties, and using a host of different project-creation opportunities.

This chapter covers many of the features you find only when working in the Organizer on a Windows machine. It also offers tips on how best to manage photo collections in an Organizer catalog, and takes a closer look at some tasks you can perform that are unique to the Organizer. (The alternative for Mac users is working with Adobe Bridge. If you're a Mac user, look over Book II, Chapter 3, where we cover Adobe Bridge in depth.)

Cataloging Files

The default Organizer view — the view you're most likely to use in all your Elements work sessions — looks a lot like a slide sorter. The Organizer provides an efficient way to access the photos you want to open in one of the Editors. Just double-click a photo in the Organizer, and you see the image zoom in size to fill an Organizer window. You can carefully examine the photo to be certain that it's the one you want, and then just select an Editor to use — whether from the Editor drop-down list on the Menu bar, from the context menu you open on the image in the Organizer window, or by clicking the Fix button in the Panel Bin.

In addition to the default view in the Organizer, you can also examine your pictures one by one in a slide show or side by side to compare them.

Adding files to the default Organizer view

The first step to working in the Organizer involves loading up images in a new catalog. By default, when you launch Elements and open the Organizer, you arrive at an empty default catalog.

Before you can do anything in the Organizer, you have to import images into a catalog. As we explain in Book II, Chapter 1, you can copy images to your computer via a drag-and-drop method, using the AutoPlay Wizard, or by using the Photoshop Elements Downloader Wizard.

Presuming you copied photos to your hard drive (as we explain in Book II, Chapter 1), here's how you add them to the default empty catalog:

1. **Open the Organizer.**

 Launch Elements and click Organize in the Welcome screen.

2. **In the Organizer, choose File⇨Get Photos and Videos⇨From Files and Folders.**

 The Get Photos and Videos from Files and Folders dialog box opens, as shown in Figure 2-1.

3. **From the View menu (circled in Figure 2-1), choose Large icons (or Medium icons).**

 In Large icon (or Medium icon) view, thumbnail images of most of your files appear in a scrollable list large enough to see some detail. (***Note:*** You might not see Camera Raw files and some files saved in different formats.) This view makes it easy to locate the files you want to add to the Organizer. For example, if you want to load only Camera Raw images, you can easily see them represented as icons, rather than as image previews.

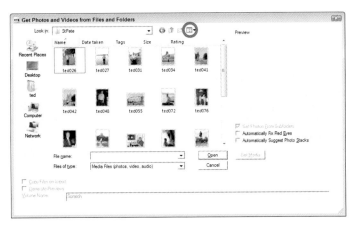

Figure 2-1: The Get Photos and Videos from Files and Folders dialog box.

4. **Select files to add to the Organizer window.**

 Click a thumbnail and use either the Shift key or the Ctrl key to select additional photos. When you hold down Shift and click, all photos between the first thumbnail and the thumbnail you Shift-click are selected. When you Ctrl-click, you can select additional noncontiguous photos.

5. **Click Get Photos to add the selected photos to the Organizer window.**

 Photos are imported into your default catalog.

6. **View all photos.**

 After you import your photos, a dialog box opens (as shown in Figure 2-2), displaying information related to viewing your photos in the Organizer. Click OK and then click the Show All button in the Shortcuts bar to view the photos in the catalog.

Adding additional photos to a catalog

To add additional photos to a catalog, use the same File➪Get Photos and Videos➪From Files and Folders or you can choose to get photos from a camera, a card reader, or a scanner (as we explain in Book II, Chapter 1).

You follow the same steps to import photos as you did when you created your new catalog. When you arrive at the same dialog box shown in Figure 2-1, the new imported images are displayed in a new Organizer view. After clicking OK, you click Show All to see the new imported images and the original files you imported into your default catalog.

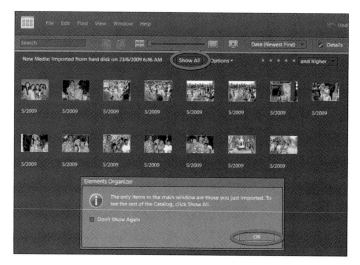

Figure 2-2: Click OK and then click Show All.

Importing images to a new catalog

If you have lots of pictures — perhaps numbering in the hundreds or even thousands — you can still add each and every one of these photos to a single catalog. However, doing so slows down the performance in the Organizer and makes searching for photos a bit more difficult. A better option for you when dealing with large numbers of photos is to create separate catalogs.

You might have a number of photos that were taken at some event or special occasion and want to create a separate new catalog to manage just those files. Here's how you go about creating a second catalog:

1. **In the Organizer, choose File⇨Catalog.**

 The Catalog Manager opens, as shown in Figure 2-3.

2. **In the Catalogs section of the Catalog Manager, choose an accessibility level.**

 By default, your catalog is accessible to all users. If you have several logons for different users, all users can access the catalog.

 If you want to make the catalog accessible only to you and not to others logging on to your

Figure 2-3: Choose File⇨Catalog to open the Catalog Manager.

computer, click the Catalogs Accessible by the Current User radio button.

3. **Choose a location.**

 By default, the catalog is saved to a default location. If you want to save the catalog to the folder of your choice, click the Custom Location radio button and click the Browse button to select a folder on your hard drive in which you want to store the catalog.

4. **Click New in the top-right corner of the Catalog Manager.**

 The Enter a Name for the New Catalog dialog box opens, as shown in Figure 2-4.

5. **Type a name for your new catalog.**

 If you want to import free music files for later use when creating slide shows, check the check box shown in Figure 2-4.

6. **Click OK.**

 You return to the Catalog Manager, and the new catalog is listed below your default catalog.

 Figure 2-4: Type a name for the new catalog and click OK.

7. **Click OK in the Catalog Manager.**

 The new catalog opens in the Organizer with an empty screen. From here, you can add photos by importing images, using any of the methods described in Book II, Chapter 1.

Importing legacy catalogs

If you're a Photoshop Elements user of a previous version of Elements, you may want to convert an older catalog created in an earlier version of Elements to one that can be recognized by Elements 8.

To convert a legacy catalog, open the Catalog Manager by selecting File⇨Catalog. Click the catalog you want to convert and then click the

Figure 2-5: Check Show Previously Converted Catalogs to expand the list.

Convert button in the Catalog Manager to open the Convert Catalog dialog box. Click the Show Previously Converted Catalogs check box, and the list expands to display older catalogs, as shown in Figure 2-5. Additionally, you can click the Find More Catalogs button and locate catalogs saved to your hard drive.

Click Done, and the catalogs are converted and displayed in the Catalog Manager.

Switching catalogs

As you create new catalogs, you'll want to switch back and forth between catalogs to view photos in the Organizer. If you make a catalog active, of course, you see only the photos you've previously added to that particular catalog.

To switch catalogs, choose File➪Catalog to open the Catalog Manager. From the list of catalogs that appears, click the catalog you want to open, as shown in Figure 2-6.

When the catalog you want to open is selected, click the Open button. The photos added to the catalog appear in the Organizer, and you're ready to edit the pictures.

Figure 2-6: Click the catalog you want to open.

Viewing images in the Organizer

The Organizer window shows you all files that have been added to a particular catalog. You can change the types of views you see in the Organizer to facilitate finding photos and managing them.

Thumbnail view

When you open the Organizer, the default view is a Thumbnail display. Your photos, videos, projects, audio files, and so on are shown as mini-images or icons that can be adjusted to different sizes. In the Shortcuts bar, you can move a slider left to create smaller thumbnail views or right to create larger thumbnail views in the Organizer window.

The icon on the left side of the slider (as shown in Figure 2-7) takes you to a default view of small thumbnail images in the Organizer window. The icon on the far right shows you a single image in the Organizer window. Move the slider left to see thumbnails at smaller sizes; move it to the right to view thumbnails at larger sizes.

If you double-click a photo, the image thumbnail zooms into view as a single photo in the Organizer. To return to a view where you see smaller thumbnails, click the icon to the left of the slider.

Figure 2-7: Move the slider to change the size of the thumbnails.

The Thumbnail display is one of many options for viewing photos and other files in the Organizer. A quick glance at the Display drop-down list shows some alternative views available to you, as shown in Figure 2-8.

Figure 2-8: Click Display in the Menu bar to see the options for alternative views in the Organizer.

Import Batch view

Below the default option for Thumbnail View, you find Import Batch. (To get there, open the Display menu and then select Import Batch, or press Ctrl+Alt+2.) The display in the Organizer keeps the view set to thumbnails, but the order of your files changes to a date order (according to the date you imported the files with the Get Photos and Videos command, as discussed in Book II, Chapter 1). This view can be helpful if you want to organize images according to the batch you imported on a given day.

Folder Location view

What's nifty about the Folder Location display is that you can peruse your hard drive for all files and folders while you remain in the Organizer window. Just select Folder Location from the Display menu or press Ctrl+Alt+3 to make an Explorer sidebar show you your hard drive(s), network locations, and offline media.

Choosing Folder Location changes the view to something approaching what you see in Figure 2-9. When you want to poke around in a folder, right-click and select Reveal in Explorer from the context menu that appears. A Windows Explorer window opens on top of the Organizer window and shows you all the files contained in that folder.

Figure 2-9: Choose Folder Location from the Display menu and then right-click to open a context menu.

When you find an image you want to edit, right-click and choose Open With⇨Adobe Photoshop Elements 8.0 (Editor). The image then opens in Edit Full mode in Elements.

When you want more of the screen window dedicated to seeing the files in the Organizer, hide the Panel Bin by clicking the separator bar. One click on the tiny right-pointing arrow on the separator bar hides the panel. Click the

arrow on a collapsed panel to reopen that panel. In Figure 2-9, you see the Organizer window with the Panel Bin hidden, so that more thumbnail images appear in the Organizer window.

Date view

Choose Date View (Ctrl+Alt+D) from the Display menu to change your Organizer window to a calendar showing you the dates on which your images were shot. The date information is derived from metadata imported with your images that are recorded by your camera. (For more information on metadata, see "Searching metadata" later in this chapter.)

If you shoot many pictures on a given date, the images are stacked on the calendar for that date. In the Project Bin in Edit Full mode, you find arrows that are used to scroll the stacked images left or right. Notice that a number appears in the lower-left corner of the image thumbnail in view. In Figure 2-10, for example, the numbers appear as 5 of 6 — meaning that on April 13, 2008 (the date at the top of the thumbnail), six photos were taken, and the current view is the fifth photo in the stacked order.

To return to the default Organizer thumbnail display, click the binoculars icon or press Ctrl+Alt+O (the letter O, not zero).

Figure 2-10: The Project Bin shows a thumbnail view of a photo with scroll arrows and numbers.

Show Map

How would you like to see a visual display of where your photos were taken geographically? Photoshop Elements 8 provides you the answer with Yahoo! Maps and an option for placing your photos on a world map.

To open Yahoo! Maps in Elements, open the Display menu in the Shortcuts bar and choose Show Map. The Map panel on the left side of the Organizer window opens, as shown in Figure 2-11.

You must have an Internet connection active on your computer to work with Yahoo! Maps.

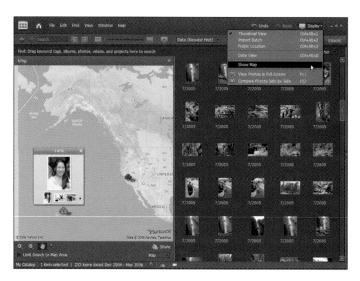

Figure 2-11: Choose Show Map from the Display menu to open Yahoo! Maps.

To map the location of photos shown in the Organizer to Yahoo! Maps, you can choose from a couple different options:

✔ **Select photos in the Organizer and drag them to a map location on the map in the Map panel.**

✔ **Select photos in the Organizer and right-click the selected photos.** From the menu options, choose Place on Map. In the dialog box that opens, type a city name and click the Find button. If more than one city is reported in the dialog box, click the city name you want to use for the mapped photos.

To move around the map, place the cursor inside the Yahoo! Map panel and drag the map with the Hand tool within the panel window. If you go too far left, don't worry; the Asian, Indian, and Eastern European countries are found by dragging right across the Atlantic and eastward. Dragging left stops somewhere around the International Date Line; if you live in Singapore, you have to keep dragging to the right to find your country.

Zooming in the Map panel is handled by the tools you see at the bottom of the map. Use the Zoom In tool to find cities and road maps in a detailed view. Use the Zoom Out tool after you find the location you want to use.

After you add photos to the map, you can view the images by clicking the red pin placed on the map whenever you add photos to a location. Click the red pin to open a pop-up window that shows a thumbnail view of the current photo, along with smaller photos, in a slide organizer below the primary

image thumbnail (as shown in Figure 2-12). Click the left and right arrows in the pop-up window to scroll the slides. Clicking the current image thumbnail in the pop-up window opens the image in a Slide Show view (there's more about Slide Show views in the next section).

In the Map panel, you can choose from several display options in the drop-down list on the bottom-right side of the panel. Choose from the default Map (the standard cartographic type), a Hybrid map (the topographic type), or Satellite map. Choose Satellite to locate Uncle Jeremy's house, where the last family reunion took place (and where you shot all those wonderful pictures).

To close the Map panel, return to the Display menu and choose Show Map again. The panel collapses, and you're back to the standard Organizer view.

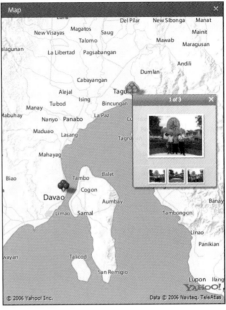

Figure 2-12: Click a red pin to open a pop-up window that shows the images placed on the map.

When you view panels in Elements, drag the vertical separator bar on a panel to widen the panel or reduce the panel size. Look for the arrowhead on the vertical bar separating the Organizer window from a panel, and click and drag left or right to change panel sizes.

Viewing images in a slide show

Are you ready for some exciting viewing in Photoshop Elements? Using an alternative view of your Organizer files, you can see your pictures in a self-running slide show (in Full Screen view), complete with transition effects and background music. Full Screen view takes you to a slide show view. For the purposes of clarity, think of Full Screen view and viewing a slide show as the same thing. Full-screen viewing temporarily hides the Elements tools and menus, and gives you the most viewing area on your monitor to see your pictures.

Viewing files in Slide Show mode can be helpful for quickly previewing the files you want to edit for all kinds of output, as well as for previewing photos you might use in an exported slide show (which we explain in Book IX, Chapter 1).

Taking a quick view of the slide show

To set up your slide show and/or enter Full Screen view, follow these steps:

1. **Open the Organizer.**

2. **Select images that you want to see in a slide show or use all the images in the Organizer for your slide show.**

 If no images are selected when you enter Full Screen view, all photos in the Organizer window are shown in Full Screen view.

3. **Choose Display⇨View Photos in Full Screen (or press the F11 key).**

 In previous versions of Elements, a dialog box opened where you could choose preferences for full-screen viewing. Now, in Elements 8, you jump right into the full-screen view with some panels and tools displayed, as shown in Figure 2-13.

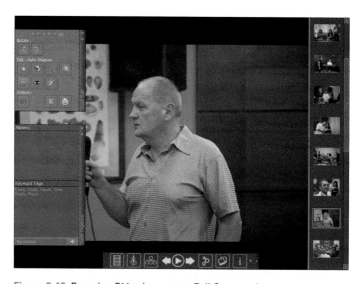

Figure 2-13: Pressing F11 takes you to Full Screen view.

4. **Click the arrow keys at the bottom of the screen to move forward and back through the slides. Click a slide, and the main window displays the slide.**

 You can also click the Toggle Film Strip icon (the first icon on the left at the bottom of the screen) to show a filmstrip on the right side of the screen displaying your slides, as shown in Figure 2-13.

5. **Press the Esc key on your keyboard to return to the Organizer window.**

You can also open Full Screen view by clicking the View, Edit, Organize in Full Screen icon in the Shortcuts bar. Look for the monitor icon with a right arrow.

Working with the toolbar

While in Full Screen view, you can play the slide show and move back and forth between slides. These options and more are available to you on the toolbar that opens when you first enter full-screen viewing. After the toolbar disappears, you can bring it back by simply moving the mouse.

The toolbar, as shown in Figure 2-14, contains tools for the following:

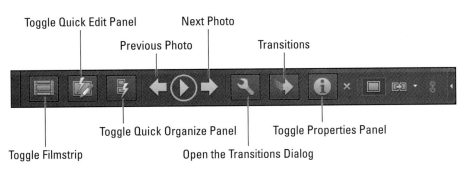

Figure 2-14: The Full Screen View toolbar.

- **Toggle Filmstrip:** Click this tool to show/hide the filmstrip on the right side of the window.

- **Toggle Quick Edit panel:** Click this tool to show/hide the Quick Edit panel.

- **Toggle Quick Organize Panel:** Click this tool to show/hide the Quick Organize Panel.

- **Previous Photo:** Click the left arrow to open the previous photo.

- **Play/Pause:** Click to play or pause a slide show.

- **Next Photo:** Click the right arrow to advance to the next photo.

- **Open the Transitions Dialog:** Click to open the Select Transitions dialog box (as shown in Figure 2-15).

- **Transitions:** Click the Transitions tool and the Select Transition dialog box opens, as

Figure 2-15: Click the Transitions tool and the Select Transition dialog box opens.

shown in Figure 2-15. When you enter Full Screen view, this tool is selected. Four different transition effects are displayed in the dialog box. You can preview a transition effect by placing the cursor over one of the images. When you find an effect you like, click the image and click OK to change the transition.

✔ **Toggle Properties panel:** Click this tool to open the Properties dialog box, where property attributes are assigned.

✔ **Show all controls (right arrow):** Click the tiny right-pointing arrow at the far right side of the toolbar, and the toolbar expands to reveal some additional tools. Here you find a large display icon used for showing the Full Screen default view. The double monitors icon to the right is used to show two slides adjacent to each other in the slide show.

The main thing to keep in mind is that the Full Screen view is a temporary viewing option you have in Elements. It's not permanent. You use the view for a quick display method on your computer when you want to show off some photos to family and friends. You do have more permanent options for saving files as slide shows that can be shared with other users, as we explain in Book IX, Chapter 2.

Setting Full Screen view preferences

When you open photos in Full Screen view, the Preferences dialog box is not immediately shown, as was the case in earlier versions of Elements. You need to click the Open Settings Dialog button in the toolbar (the icon shape that appears as a wrench). When you click the icon, the Full Screen View Options dialog box opens, as shown in Figure 2-16.

Figure 2-16: The Full Screen View Options dialog box.

The various adjustments you have available in the Full Screen View Options dialog box are detailed in Table 2-1.

Table 2-1	Using the Full Screen View Options Dialog Box
Option	*What You Can Do with It*
Background Music	Select a preinstalled sound file from the drop-down list or click the Browse button to locate sound files stored on your computer. The sound file formats you can use are `.mp3`, `.wav`, and `.wma`. Add sound files to the Organizer by choosing File➪Get Photos➪From Files and Folders and selecting sound files.

Option	*What You Can Do with It*
Play Audio Captions	Add audio captions to images. Select this check box to play these captions.
Page Duration	Specify the duration of each slide before the program advances to the next slide. The text box accepts durations ranging from 1 to 3600 seconds.
Include Captions	View text captions that you've added to images.
Allow Photos to Resize	View images at full-screen size. Make sure the resolution is sufficient before resizing the images to fit the screen. Image resolution is optimal at 72 ppi (pixels per inch) at 100-percent size, as we point out in Book III, Chapter 1.
Allow Videos to Resize	View video frames at full-screen size in the slide show. Be certain that the video supports a resolution sufficient to clearly see the video frames. When in doubt, test a movie clip in Full Screen view to see whether the quality is satisfactory.
Show Filmstrip	View a filmstrip along the right side of the full-screen window. Click a thumbnail in the filmstrip to jump to the selected slide.
Start Playing Automatically	Put the slide show into Play mode automatically. If you don't check this box, you must click a tool in Full Screen view to start the play manually.
Repeat Slide Show	Create a continuous loop. You could use this option for a self-running kiosk.

**Book II
Chapter 2**

**Working in the
Organizer**

Sorting Images

Considering all the Photoshop Elements modes and workspaces you have become familiar with, you need a consistent starting place to handle all your editing tasks. Think of the Organizer as New York's Grand Central Station. From this central location, you can take the Long Island Railroad to any destination you desire. In Elements terms, rather than head out to Port Washington, you travel to a specific editing mode. Rather than go to the Hamptons, you journey through all the creation areas. In short, the Organizer is the central depot on the Photoshop Elements map.

In addition to serving as a tool to navigate to other workspaces, the Organizer is a management tool you can use to organize, sort, search, and describe photos with identity information. In terms of sorting and organizing files, Elements provides many different options; we cover them all in the following sections.

Using sort commands

One quick way to sort images in the Organizer is to use the menu in the Shortcuts bar in the Organizer window for date sorting. Two options are available to you, as shown in Figure 2-17.

The sorting options available to you from the menu are

Figure 2-17: You can sort files quickly in Date Ascending or Date Descending order.

- **Date (Newest First):** Select this option to view images according to the date you took the photos, beginning with the most recent date.

- **Date (Oldest First):** This option displays photos in chronological order, starting with the oldest file.

 You can also view files according to the Import Batch date and Folder Locations, as we mention in the section "Viewing Images in the Organizer," earlier in this chapter.

Sorting media types

Photos can also be sorted according to media type. Elements supports viewing photos, video files, audio files, projects you create in Elements, and Adobe PDF files. To select different media types, choose View⇨Media Types, and when a submenu appears, choose one of the options it offers for viewing different media types (as shown in Figure 2-18). Select a menu item from the submenu to make all media types that match the menu command appear in the Organizer window.

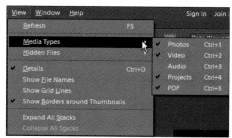

Figure 2-18: You can sort files quickly according to media types.

Using Search Options

The Organizer's Find menu is devoted entirely to searching for photos. From the Find menu, you can locate photos in albums, catalogs, and the Organizer window according to a variety of different search criteria.

To use the commands on the Find menu, you need to have photos loaded in the Organizer window or create albums or catalogs, which we explain in this chapter. The categories described in the following sections can be searched in the Organizer.

Searching by date

When you have a number of different files in an Organizer window including photos shot on different dates, you can narrow your search to find photos — and all other types of files supported by Elements — through a date search.

Be careful: The date is taken from the camera metadata, and if a date isn't available from the camera data, the date is taken from the file's creation date. The creation date is not likely to be the date you shot the photo.

To search files by date, follow these steps:

1. **If you haven't yet added photos to your default catalog, open files in the Organizer by first choosing File⇨Get Photos and then choosing a submenu command for acquiring files.**

 To open files stored on your hard drive, choose the From Files and Folders submenu command.

2. **To select a date range, choose Find⇨Set Date Range.**

 The Set Date Range dialog box (as shown in Figure 2-19) opens.

3. **Specify the dates.**

 Type a year in the Start Date Year text box. Select the month and day from the Month and Day drop-down lists. Repeat the same selections for the End Date.

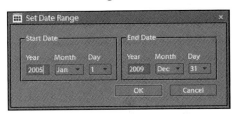

Figure 2-19: Open the Set Date Range dialog box and specify the start and end dates.

4. **Click OK.**

 The thumbnails shown in the Organizer window include only files created within the specified date range.

Book II
Chapter 2

Working in the Organizer

Searching for untagged items

You can tag files with a number of different criteria, as we explain later in this chapter (in the section "Organizing and Managing in the Organizer"). When tags are added to images, you can sort files according to tag labels. We cover sorting by tag labels later in this chapter, too. For now, take a look at the Find menu and notice the Untagged Items command. If you want to add tags to certain items, and so want to show only the untagged files, choose Find⇨Untagged Items or press Ctrl+Shift+Q. Elements displays all files without tags in the Organizer window.

Searching albums

You can create albums (as we describe later in this chapter in the section "Creating Albums") and then select an album in the Albums panel (contained in the Organize panel), as shown in Figure 2-20. Selecting an album is like having a first level of sorting. You can then search by date or other sort options (discussed in the preceding and following sections) to narrow your choices.

Searching captions and notes

When captions or notes are added to files, you can search for the caption name, contents of a note, or both. Before you can search for captions and notes, though, you have to add them to your images.

Figure 2-20: Select an album and then use other search options to narrow your search.

Adding captions and notes

A way to identify your files beyond the tagging capabilities, which we discuss in the section "Organizing and Managing in the Organizer," later in this chapter, is to add captions and notes. When you add a caption or note, you can search captions or notes by choosing the Find⇨By Caption or Note menu command. Captions and notes are also helpful when you create different keyword tags — such as those for slide presentations and photo albums — by using the Create panel (as we explain in Book IX, Chapter 1).

Text captions are easy to create. Although you can select a thumbnail image in the Organizer window and choose Edit⇨Add Caption, a better way is to use the Properties panel. Just follow these steps:

1. **To open the Properties panel, select a thumbnail image in the Organizer, right-click it, and choose Show Properties from the context menu that appears.**

 Alternatively, you can choose Window⇨Properties or press Alt+Enter. In either case, the Properties panel opens, as shown in Figure 2-21.

2. **Type a caption by adding text to the Caption text box.**

3. **Type text in the Notes area on the panel to add a note.**

 That's all there is to it. You can also record audio notes about an image.

Searching the captions and notes content

After you create captions and notes, you can search for the words contained in the descriptions.

To search for caption names and notes in your open catalog, follow these steps:

1. **Open the Organizer.**

 You should have images in a catalog and have files identified with captions and notes.

2. **Choose Find⇨By Caption or Note.**

 The Find by Caption or Note dialog box opens, as shown in Figure 2-22.

 Options in the dialog box are as follows:

 - *Find Items with Caption or Note:* In the text box, type the words you want to locate.

 - *Match Only the Beginning of Words in Captions and Notes:* Click this radio button when you know that your caption or note begins with words that you type into the text box.

 - *Match Any Part of Any Word in Captions or Notes:* Click this radio button if you're not sure whether the text typed in the box is used at the beginning of a caption or note, or whether it's contained in the caption's name or the note's text.

3. **Click OK.**

 Your results appear in the Organizer window.

Searching by history

Elements keeps track of what you do with your photos, such as printing, e-mailing, sharing, and performing various other tasks. If you want to base a search for files on the file history, choose Find⇨By History, as shown in Figure 2-23. If you select options on the By History submenu, you see files that meet your criteria by date.

Figure 2-21: The Properties panel.

Figure 2-22: Choose Find⇨By Caption or Note to open the dialog box in which search criteria for captions and notes are specified.

Your options in the By History submenu include

Figure 2-23: Choose Find⇨By History to search files according to the editing history.

- ✓ **Imported On:** Choose this option and you can select a date when files were imported into the current catalog. When you make this choice in the submenu, a dialog box opens where you can select the import date and click OK. (All options in the submenu display a dialog box similar to Figure 2-24 when the respective menu command is selected.)

- ✓ **E-Mailed To:** Click this menu item, and the list in Figure 2-24 changes to reflect all the photos you e-mailed from within Elements.

- ✓ **Printed On:** This option displays all files printed in a date order for the print date and time.

Figure 2-24: Choosing a By History submenu command displays a dialog box where you can select an item.

- ✓ **Exported On:** This choice displays files that were exported from the current catalog.

- ✓ **Ordered Online:** This item displays files that were submitted for an online service.

- ✓ **Shared Online:** This choice displays files that were shared online.

- ✓ **Used in Projects:** This option displays files that were used in projects. See Book IX, Chapter 1 for all the different types of projects you can create in Elements.

Searching metadata

Metadata includes not only the information about your images that's supplied by digital cameras, but also the custom data you can add to a file. *Metadata* contains descriptions of the image, including such data as your camera name, the camera settings you used to take a picture, copyright information, and much more.

Searching metadata is easy. Just choose Find⇨By Details (Metadata) in the Organizer. The Find by Details (Metadata) dialog box opens. The first two columns in the dialog box offer a number of different choices for search criteria and for options based on the criteria. In the third column, you type search criteria into a text box to specify exactly what you want to search for. You can click the plus button to add new lines to your search criteria, as shown in Figure 2-25. Clicking the minus button deletes a line.

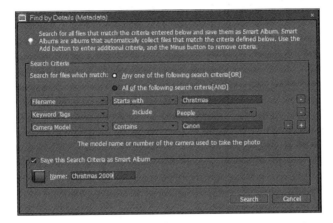

Figure 2-25: Choose Find⇨By Details (Metadata) in the Organizer to open the dialog box in which you specify metadata.

Finding people

In earlier versions of Elements, you had a menu command that permitted you to search through a catalog and find faces. Any photo where a person's face could easily be detected was displayed in the Organizer as a sorted group.

Elements 8 has a new menu command for finding people. Choose Find⇨Find People and Elements. Auto Analyzer kicks in and searches through a catalog to find photos of people.

When the Organizer window displays a photo with people, the faces are highlighted with a white border. If Elements misses a person, you can click the Add a Person button, as we did for the photo shown in Figure 2-26. The border shown with handles is a new frame added by clicking the Add a Person button.

As you move the mouse cursor over individual borders, a pop-up text box opens with the text *Who is this?,* as shown in Figure 2-26. Click the text and then type the name of the individual in the text box. Each time you open the

photo and move the mouse cursor over the individual faces, the pop-up text box displays the names of the individuals you recorded when you typed the names.

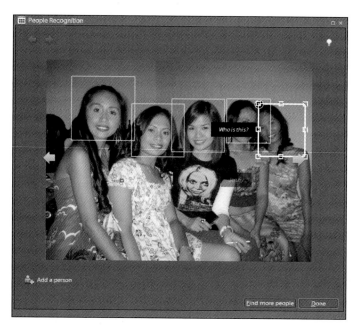

Figure 2-26: The People Recognition dialog box opens after searching for people in the Organizer.

Organizing and Managing in the Organizer

Elements provides you with a great opportunity for organizing files in the form of keyword tags. After you acquire your images in the Organizer and sort them, you can add some permanent keyword tags according to the dates you took the pictures, the subject matter, or some other categorical arrangement.

Keyword tags were referred to as *collections* in Elements 5 and earlier.

In the Organizer window, two panels help you sort your pictures and keep them well organized. You use the Keyword Tags panel (which we talk about in the section "Working with keyword tags," later in this chapter) to identify individual images by using a limitless number of options for categorizing your pictures. On the Keyword Tags panel, you can create keyword tags and collection groups to neatly organize files.

Keyword tags are handy when you want to use the many different project options, which we explain in Book IX, Chapter 1. You create a keyword tag from files stored in various folders on your hard drive and preview the images to be used in a creation. You can, for example, select images to use when you're creating slide shows and photo albums. When you finish your creations, go back and delete the keyword tag.

In the following sections, you can find out how to create and manage keyword tags.

Creating a new keyword tag

To create a new keyword tag and add photos to the tag, follow these steps:

1. **Open photos in the Organizer.**

 Open the Organizer window by clicking the Organizer button in an editing mode or by selecting Organize on the Welcome screen. Choose File↷ Get Photos and Videos↷From Files and Folders. (Note that you should've already copied some photos to your hard drive, as we explain in Book II, Chapter 1.)

2. **To create a new keyword tag, click the plus sign (+) icon in the Keyword Tags panel to open a drop-down list and then choose New Keyword Tag.**

 The Create Keyword Tag dialog box opens, as shown in Figure 2-27.

3. **Type a name for the tag in the Name text box and add a note to describe the keyword tag.**

 You might use the location where you took the photos, the subject matter, or other descriptive information for the note.

4. **If you want to assign the keyword tag to a map location on Yahoo! Maps, click the Place on Map button.**

 When you click Place on Map, a dialog box opens in which you type a city name for placing the image on Yahoo! Maps. Type a city name and select the correct city from options provided in a second dialog box.

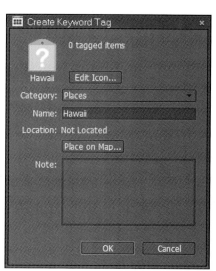

Figure 2-27: The Create Keyword Tag dialog box.

5. **Click OK in the Create Keyword Tag dialog box.**

 You return to the Organizer window.

6. **In the Organizer window, select the photos you want to give keyword tags.**

 Click a photo and Shift-click another photo to select photos in a group. Click a photo and Ctrl-click different photos scattered around the Organizer window to select photos in a nonconsecutive order.

7. **To add a new keyword tag to a photo (or selection of photos), click one of the selected photos in the Organizer window and drag the photo thumbnail to the New Tag icon in the Keyword Tags panel.**

 Alternatively, you can drag a tag from the Keyword Tags panel to the selected photos.

 When you release the mouse button, the new keyword tags are added to the selected photos.

8. **Repeat Steps 3 through 7 to create keyword tags for all the images you want to organize.**

9. **To view one or more keyword tags, click the empty square adjacent to a keyword-tag icon to show the photos marked with that particular keyword-tag icon.**

 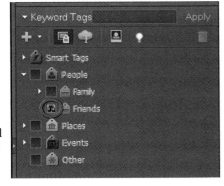

 When you click the empty square, an icon in the shape of a pair of binoculars appears inside the square, as shown in Figure 2-28. All photos matching the keyword tags are shown in the Organizer window.

 To return to viewing all photos in the Organizer, click the binoculars in the Keyword Tags panel. The square returns to empty and turns off viewing the tagged files.

Figure 2-28: A binocular icon appears when you click an empty square.

Working with keyword tags

You can manage keyword tags pretty easily by using the Keyword Tags panel. To access the major menu commands, either click the plus sign (+) icon in the Keyword Tags panel to call up the New drop-down list or right-click a keyword tag on the Keyword Tags panel and make your choice from the context menu that appears.

The New drop-down list offers you the following commands:

✔ **New Keyword Tag:** Create a new keyword tag, as we describe in the steps in the preceding section.

✔ **New Sub-Category:** A *subcategory* is like a nested bookmark. Create a sub-category by selecting New Sub-Category from the New menu; a dialog box opens, prompting you to type a name for the new subcategory. As an example of how you might use keyword tags and subcategories, you might have a keyword tag named Uncle Joe's Wedding. Then, you might create subcategories for Bride's Dressing Room, Ceremony, Family Photos, Reception, and so on.

✔ **New Category:** Choose New Category from the New menu in the Keyword Tags panel to open a dialog box that prompts you to type a name for the new category. By default, you find predefined category names for People, Places, Events, and Other. If you want to add your own custom category, use this menu command.

✔ **From File:** If you export a keyword tag, the file is written as XML (e*X*ten-sible *M*arkup *L*anguage). When you choose From File, you can import an XML file containing keyword tags as were added using the Keyword Tags to a File command.

✔ **Save Keyword Tags to a File:** You can save keyword tags to a file that can be retrieved with the From File command. This option is handy when you open a different catalog file and want to import the same collection names created in one catalog file to another catalog file. (See the section "Cataloging Files" earlier in this chapter.)

✔ **Collapse All Keyword Tags:** Keyword tags appear like bookmark lists that can be collapsed and expanded. An expanded list shows you all the subcategory keyword tags. Choose Collapse All Keyword Tags to collapse the list.

✔ **Expand All Keyword Tags:** This command expands a collapsed list.

When you create a new keyword tag, you see a large icon in the Keyword Tags panel. The default tags appear with small icons. You can access the items that appear below default tags by clicking the right-pointing arrow to expand the list.

Right-click a Keyword Tag name to make the following menu commands appear:

✔ **Change *<keyword tag name>* Keyword Tag to a Sub-Category:** Choose this menu command to change a specific keyword tag into a subcategory of keyword tags.

✔ **Edit *<keyword tag name>* Keyword Tag:** This menu command opens the Edit Keyword Tag dialog box. You can rename a keyword tag, change the note, or change the map location in this dialog box. Alternatively, you can click the Pencil tool on the Keyword Tags panel to open the same dialog box.

✔ **Delete <*keyword tag name*> Keyword Tag:** Select a keyword tag and then select this menu option to delete it. An alternative way to delete a keyword tag is to select the tag and then click the Trash icon in the panel.

Deleting a keyword tag doesn't delete files.

✔ **Place on Map:** Choose Place on Map to add images to a Yahoo! Map location.

✔ **Remove from Map:** Choose this command to remove tags from Yahoo! Maps.

✔ **Show on Map:** This command opens the Yahoo! Maps panel and shows the red pin at the map location with which the image(s) are associated.

✔ **New Search Using <*keyword tag name*> Keyword Tag:** This command searches through a catalog and displays all the photos assigned a particular keyword tag in the Organizer window.

✔ **Add Photos with <*keyword tag name*> Keyword Tag to Search Results:** If you select one photo in the Organizer, the number is one. Selecting more than one photo changes the number to the total number of selected images. When you open a context menu, the selected images are added to the keyword tag at the place where the context menu opened.

✔ **Exclude Photos with <*keyword tag name*> Keyword Tag from Search Results:** Select photos in the Organizer window and choose this command to exclude the selected photos from the search.

✔ **Attach <*keyword tag name*> Keyword Tag to <*n*> Selected Items:** Select a file in the Organizer window and choose this command to attach the keyword tag to the file.

Keyword tags are saved automatically with the catalog you're working in. By default, Elements creates a catalog and auto-saves your work to it. If you happen to create another catalog (as we explain earlier in the chapter), your keyword tags disappear. Be aware of which catalog is open when you create keyword tags so you can later return to them.

Getting your head in the clouds

Elements 8 introduces another way to view and search for photos in a catalog: the Tags Cloud feature. Click the View Tags Cloud icon in the Keyword Tags panel, as shown in Figure 2-29. When you click the icon, an alphabetical list of your tags appears in the panel.

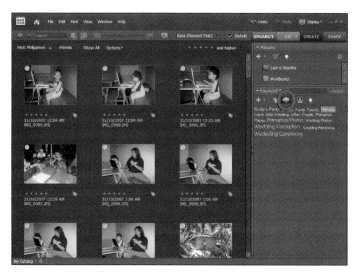

Figure 2-29: Click the Tags Cloud icon to display a hierarchical list of the tags categories.

Click a tag name in the list to select a tag and view all photos tagged with the respective name.

To return to the default tags view, click the View Tag Hierarchy icon to the left of the View Tags Cloud icon in the Keyword Tags panel.

Using the Timeline

When you choose Window⇨Timeline or press Crtl+L, a timeline appears in the Organizer window. The Timeline begins with those images you added to a catalog at the earliest date and stretches across the Organizer window to the photos taken most recently.

You can narrow a search to examine photos within a given time frame by dragging the Timeline slider left or right (see Figure 2-30). You can also move two other sliders on the Timeline. By dragging the left-facing arrowheads to the right and the right-facing arrowheads to the left, you can narrow the number of thumbnail images that appear in the Organizer window.

Figure 2-30: Drag the slider to narrow the timeframe.

When you move the two outside sliders toward each other, you hide image thumbnails appearing in the Organizer that are outside the dates on the Timeline relative to the slider positions. When you move the center slider, Elements displays the first photo on a given date with the date flashing below the respective image thumbnail.

Using the Properties panel

We introduced the Properties panel earlier in Figure 2-21 when we talked about adding captions and notes. In addition to adding this information to images, the Properties panel offers you some information about your files. The information includes

- **Rating files:** You can assign ratings to files, as we describe later in this chapter in the section "Rating images."

- **Date:** The panel reports the date the picture was shot (or scanned).

- **Directory path:** The panel displays the directory path for the file location on your hard drive.

- **Sound:** If the file contains a sound, the sound information is displayed.

Creating Albums

With keyword tags, you can organize files into categories and subcategories. Doing so keeps your files neatly organized within a catalog. Elements offers additional organizing control in the Albums panel. You might want to organize an album for sharing photos with others on Photoshop.com, assemble an album that rates each photo from one to five stars, create a slide show, or just use the Albums panel to further segregate images within different categories.

Be aware that you have an Album panel in the Panel Bin, and you have some options in the Create panel for designing projects similar to (but not the same as) photo albums. To avoid confusion, Elements refers to the projects not as photo albums but as Photo Books and Photo Collages. The term *Album* in Photoshop Elements nomenclature refers to a collection of images that are not yet integrated into projects. You can use the Album panel to organize and help manage your photo files.

Think of a catalog as a parent item and keyword tags as its children.

Within keyword tags, you can use the sort options we've talked about in this chapter to sort files according to date. If you still have a number of files in an Organizer window that are hard to manage, you can create tags that form

subcategories within the keyword tags. Additionally, you can create an album out of a number of photos within a given keyword tag. For example, you might have a huge number of photos taken on a European vacation. Your catalog contains all the images taken on that trip. You can then create keyword tags for files according to the country visited. You then might rate the photos according to the best pictures you took on your trip. The highest-rated images could then be assembled in an album and then later viewed as a slide show or integrated as part of a project such as a Photo Book.

Rating images

You can rate photos in the Organizer by tagging images with one to five stars. You might have some exceptional photos that you want to give a five-star rating. Poor photos with lighting and focus problems might be rated with one star.

To rate a file with a star rating, open a context menu by right-clicking a photo and select Properties from that menu. The Properties – General panel, shown in Figure 2-31, opens. Click a star to rate the photo. Alternatively, you can click a photo, choose Edit➪Ratings, and choose a star rating from the sub-menu that appears.

To return to a view in which all your photos are shown in the Organizer, including all photos you haven't rated, click Show All in the Shortcuts bar.

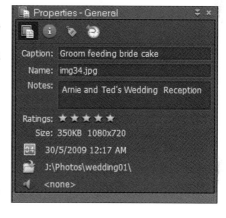

Figure 2-31: The Properties dialog box with a photo rated with five stars.

Adding rated files to an album

You might want to rate images with star ratings and then add all your images to an album. Within the album, you can still choose to view your pictures according to star ratings.

Creating an album

In the section "Working with keyword tags," earlier in this chapter, we discuss how creating keyword tags and assigning tags to photos help you organize a collection of photos — and how subcategories help you divide a

collection into more specific groups. With albums and star ratings, you can identify groups within a collection that you might want to print, share, or use in onscreen slide shows.

To create an album, follow these steps:

1. **Click the Organize panel, click the plus sign (+) icon in the Albums panel, and choose New Album from the drop-down list shown in Figure 2-32.**

 The Albums panel expands to show the Album Details.

2. **Name the new album.**

 Type a name for the album in the Album Name text box.

3. **View the Backup/Synchronization Help.**

 Click the light bulb to display the help information related to checking the Backup/Synchronize check box. Checking this check box protects your files by using backup services provided by Photoshop. com.

4. **Click the help note to dismiss it from view.**

 A help note is shown in Figure 2-33.

5. **Drag photos from the Organizer to the Items window in the Album Details panel, shown in Figure 2-34.**

 Alternatively, you can select photos in the Organizer and click the plus-sign (+) icon in the Album Details panel to add them to the album.

Figure 2-32: Click the plus sign (+) icon to open the drop-down list and then choose New Album.

Figure 2-33: Close the help-note window by clicking anywhere in the window.

6. **Click Done at the bottom of the panel — unfortunately not visible in Figure 2-34.**

Your new album now appears listed in the Albums panel.

That's it! Your new album is created, and any photos you drag to the album in the future are added to it. You can isolate all the photos within a given album by clicking the album name in the Albums panel.

Creating multiple albums uses only a fraction of the memory required to duplicate photos for multiple purposes (such as printing, Web hosting, sharing, and so on).

Creating a Smart Album

You can perform a search based on a number of different criteria. You can, for example, rate images with stars and choose to view all files with three or more stars, or maybe you changed camera models and want to show only the photos taken with your newest camera. You can search a catalog by metadata, location, or some other criterion. Furthermore, you can combine searches, first searching for (say) a location and then searching the files within a given date range.

Figure 2-34: Drag photos to the Items area in the Album Details panel.

Another option for searching files is performing a search and saving not only the search results but also a complex set of search criteria in the form of a Smart Album. You create a Smart Album by opening the New menu in the Albums panel and choosing New Smart Album.

The New Smart Album dialog box opens, as shown in Figure 2-35. Type a name for your new Smart Album and make selections for the search criteria below the Name text box. Click OK, and the Smart Album is listed above the albums in the Albums panel.

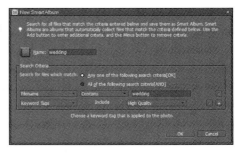

Figure 2-35: Type a name for your new Smart Album, add the search criteria, and click OK to add the album to the Albums panel.

Creating an Album Group

The Albums panel contains all the albums and Smart Albums you create in an organized list. By default, the albums are listed in alphabetical order. If you add many albums to the panel, the list can be long, making it difficult to find the album you want to use for a given editing session.

An *Album Group* is no more than a divider shown in the Albums panel. You don't add photos to the group. You nest albums within a group in a hierarchical order. To see how to create an Album Group, follow these steps:

1. **Create several albums.**

 To begin, you should have two or more albums added to the Albums panel. For example, suppose that you have many photos of a vacation trip to Hawaii. You want to divide the photos by images taken at a luau, a diving trip, a day on Waikiki Beach, or photos of other similar events that you want to group together. For each category — such as Luau, Diving, or Waikiki — you create a separate album.

2. **Create an Album Group by clicking the New menu (the + sign) in the Albums panel and choosing New Album Group.**

 The Create Album Category dialog box (as shown in Figure 2-36) opens.

3. **Type a name for the group in the Album Category Name text box.**

 You also have an option to choose a parent group from a drop-down list so you can nest albums in a hierarchical order.

4. **Click OK.**

 Your new Album Group is added to the Albums panel.

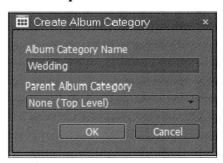

Figure 2-36: Type a name for your new Album Group in the Create Album Category dialog box.

5. Click and drag an album onto the Album Group name in the Albums panel.

The albums you drag to the Album Group are nested within the group, as shown in Figure 2-37.

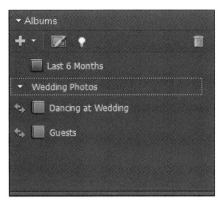

Figure 2-37 shows an expanded Album Group, as denoted by the list (below Wedding Photos) and the disclosure triangle. To collapse a group, click the down-pointing arrow. The group names remain visible and provide you with more viewing space in the Albums panel, making it easier to scroll long lists.

Figure 2-37: Albums are nested below an Album Group.

Like keyword tags, albums can be saved to an XML file, and the files can be loaded in the Albums panel. Open the New menu, where you find commands for Save Albums to File and From File. You can export an album to a file and then copy the file to another computer, making it easy to organize photos on several computers.

Hiding Files That Get in the Way

Elements offers a few ways to hide files so you can keep your images organized and easy to find.

With a simple menu command, you can mark selected files in the Organizer as *hidden*. You might have several files of the same subject and want to keep only one file visible in the Organizer window. However, you may not want to delete the other photos. You can hide files in the Organizer window — and show the hidden files later on by using menu commands.

Select files you want to hide, and from either the Edit menu or a context menu, choose Visibility➪Mark as Hidden. To see the files you marked as hidden, return to the same Visibility menu and choose Show Hidden. When you remove the check mark for Show Hidden, you hide the files. To toggle easily between showing and hiding files marked for hiding, choose View➪Hidden Files. Selecting this menu command toggles between showing and hiding the files you marked for hiding.

Stacking 'em up

Think of *stacks* like a stack of cards that are face-up. You see only the front card, and all the other cards are hidden behind that card. Stacks work the same way. You hide different images behind a foreground image. At any time, you can sort the images or display all images in the stack in the Organizer window.

To create a stack, follow these steps:

1. **In the Organizer, select several photos.**

 You can select any number of photos. However, you can't stack audio or movie files.

2. **Choose Edit⇨Stack⇨Stack Selected Photos.**

 Elements stacks your photos. The first image you select remains in view in the Organizer window. In the upper-right area, an icon that looks like a stack of cards appears on the image thumbnail when you've stacked some images. When you double-click the photo to open the stack in the Organizer, you find the same icon in the top-right corner, as shown in Figure 2-38.

Photo courtesy Leah Valle. www.13thwitch.com.

Figure 2-38: Viewing a stack in the Organizer.

After you stack a group of images, you can use the Stack submenu commands to manage the photos. Click a stack to select it and then choose Edit⇨Stack. The submenu commands that are available include

- **Automatically Suggest Photo Stacks:** Select this command to make Elements search the photos in the Organizer window for visually similar appearances. Photos that look similar are opened in a separate window, where you can select the photos you want to stack. Make a selection of two or more photos, and select Stack Selected Photos.

- **Stack Selected Photos:** This command remains grayed out unless you have several photos selected to create a stack.

- **Unstack Photos:** Click a stack in the Organizer and choose this command to return all images to the Organizer window and eliminate the stack.

- **Expand Photos in Stack:** This command expands the stack to show all thumbnail images in the Organizer window.

- **Collapse Photos in Stack:** This command collapses a stack to show only the top photo in the Organizer window.

- **Flatten Stack:** After you stack some photos, this command becomes available. When you flatten a stack, the top-level photo is retained and all other photos in the stack are deleted from the catalog.

 Be careful with this command. All photos except for the top photo *really are* deleted from the catalog — although not from your hard disk.

- **Remove Photo from Stack:** Choosing this command removes the selected photo from the stack. It does not delete the photo from your catalog but merely moves it outside the stack.

- **Set as Top Photo:** Before accessing this command, you first choose Expand Photos in Stack. If you don't like the topmost photo, select another and choose this menu command to move the selected photo to the top of the stack.

If you want to view all stacks in an Organizer window in expanded form, choose View⇨Expand All Stacks. Using this command, you don't have to select stacks individually in the Organizer before expanding them.

Creating versions

Versions are similar to stacks, but you create versions from only one file. You can edit an image and save both the edited version and the original as a version set. You can make additional edits in either of these editing modes and save them to a version set. To create a version set, follow these steps:

1. **Select an image by clicking it in the Organizer window.**

2. **Apply an edit.**

 For example, right in the Organizer, you can correct some brightness problems in your image. Choose Edit➪Auto Smart Fix to adjust contrast and brightness. See Book VIII, Chapter 2 for more details on adjusting contrast and brightness.

3. **View the items in the version set by clicking the image in the Organizer and choosing Edit➪Version Set➪Expand Items in Version Set.**

 Elements automatically creates a version set for you when you apply the Auto Smart Fix to the file. A new Organizer window opens and shows two thumbnail images — one representing the original image and the other representing the edited version.

4. **To open the original in Edit Full mode, select the original image and then select Full Edit from the Display drop-down list on the Organizer Menu bar.**

5. **Edit the image in Edit Full mode.**

 You can choose from many different menu commands to edit the image. For example, change the color mode to Indexed Color by choosing Image➪Mode➪Indexed Color, as we explain in Book III, Chapter 2.

6. **Save a version by choosing File➪Save As.**

7. **In the Save Options area of the Save As dialog box, select the Include in the Organizer and Save in Version Set with Original check boxes.**

8. **Click Save.**

 The edit made in Edit Full mode is saved as another version in your version set.

When you have a version set, you can open the Edit➪Version Set submenu and choose menu commands that are similar to the commands available with stacks. (See the preceding section for details.)

After you create a version set, you find additional submenu commands you can use to manage the version set. Choose Edit➪Version Set, or open a context menu on a version set and then choose Version Set. The submenu, as shown in Figure 2-39, opens.

Figure 2-39: Opening a submenu for a version set.

Items listed in the Version Set submenu include

- ✔ **Expand Items in Version Set:** Click a version set and choose this menu command to expand the items in the version set.

- ✔ **Collapse Items in Version Set:** When items are expanded, you can return them to a collapsed view by selecting this command.

- ✔ **Flatten Version Set:** Be careful here. If you choose this command, you lose all items in the version set except the top image.

- ✔ **Convert Version Set to Individual Items:** This command removes items from the version set and adds each version as a separate image to the Organizer window.

- ✔ **Revert to Original:** This command deletes the version set and returns you to the original, unedited version of the file.

- ✔ **Remove Item(s) from Version Set:** This option removes any selected item (or items) from a version set.

- ✔ **Set as Top Item:** When viewing an expanded version set, click one of the images and choose this item to move it to the top.

Protecting Your Assets

Computer users often learn the hard way about the importance of backing up a hard drive — and the precious data that took a lot of time to create and edit. We can save you some aggravation right now before you spend any more time editing your photos in Elements.

We authors are so paranoid when we're writing a book that we back up our chapters on multiple drives, CDs, and DVDs when we finish them. The standard rule is that if you spend sufficient time working on a project and it gets to the point at which redoing your work would be a major aggravation, it's time to back up your files.

Backing up your catalog

When organizing your files, adding keyword tags and albums, and creating stacks and version sets, you want to back up the catalog file in case your catalog becomes corrupted.

Here's how you can use Elements to create a backup of your data:

1. **Choose File⇨Backup Catalog to CD/DVD or Hard Drive to open the Backup Catalog to CD/DVD or Hard Drive Wizard.**

 This wizard has three panes that Elements walks you through; it's a pretty painless way to back up your files.

2. **Select the source you want to back up.**

 The first pane in the Burn/Backup Wizard offers two options:

 - *Full Backup:* Click this radio button to perform your first backup or when you're writing files to a new media source.

 - *Incremental Backup:* Use this option if you've already performed at least one backup and you want to update the backed-up files.

3. **Click Next and select a target location for your backed-up files.**

 Active drives, including CD/DVD drives attached to your computer, appear in the Select Destination Drive list, as shown in Figure 2-40. Select a drive, and Elements automatically assesses the write speed and identifies a previous backup file if one was created. The wizard also displays the total size of the files you have chosen to copy. This information is helpful so you know whether you need more than one CD or DVD to complete the backup.

Figure 2-40: You can choose your destination backup media in the wizard.

4. **If you intend to copy files to your hard drive or to another hard drive attached to your computer, click the Browse button and identify the path.**

 If you use a media source, such as a CD or DVD, Elements prompts you to insert a disc and readies the media for writing.

5. **Click Done, and the backup commences.**

 Be certain to not interrupt the backup. It might take some time, so just let Elements work away until you're notified that the backup is complete.

Backing up photos and files

With files stored all over your hard drive, manually copying files to a second hard drive, CD-ROM, or DVD would take quite a bit of time. Fortunately, Elements makes finding files to back up a breeze.

Choose File➪Make a CD/DVD, and then in the dialog box that opens, click Yes to confirm the action. The Make a CD/DVD dialog box then opens. Select a hard drive or a CD/DVD drive, type a name for the backup folder, and click OK. Elements goes about copying all files shown in the Organizer window to your backup source.

Book II
Chapter 2

Working in the Organizer

Chapter 3: Working in Adobe Bridge

In This Chapter

✓ **Understanding the Bridge workspace**

✓ **Sorting images**

✓ **Managing photos**

✓ **Working with stacks**

✓ **Creating slide shows**

✓ **Outputting files**

The Mac version of Elements doesn't include Organizer. On the Mac, you use Adobe Bridge to sort, organize, and manage your photos. Adobe Bridge doesn't have all the options you find with Organizer, but Bridge does offer some things you won't find in the Windows version of Organizer.

This chapter is all about the Mac and using Adobe Bridge. We offer some handy things you can do with Adobe Bridge and explain how Bridge handles some similar tasks as Organizer on Windows. An entire book could be written on Adobe Bridge; we can't hope to cover everything you have available in the program, but we can offer pointers for getting around the Bridge window — and demonstrate some standard features of the Elements Organizer running under Windows.

If you're a Windows user, feel free to skip this chapter. If you use Photoshop Elements on a Mac, read on and discover some great options you have with Adobe Bridge.

Looking at the Adobe Bridge Workspace

When you install Elements on the Mac, Adobe Bridge is installed automatically as a separate executable program. You can launch Bridge from within Edit Full mode while Elements is open, or you can launch Adobe Bridge by double-clicking the program icon or program alias that is automatically added to your desktop after installation.

When you launch Adobe Bridge, you see the Bridge workspace, as shown in Figure 3-1. A quick look at the Bridge window includes the following items:

- ✔ **Go Forward/Go Back:** Click the arrows to navigate the window where you find the image thumbnails.

- ✔ **Go to Parent or Favorites:** The menu lists recently viewed folders and items you've identified as Favorites.

- ✔ **Reveal Recent File or Go to Recent Folder:** Recently viewed images are listed in the menu as you view them in Bridge. In addition, you find a number of menu commands that link to other Adobe applications if installed on your computer.

- ✔ **Get Photos:** Click this icon to open Adobe Downloader to copy photos from your camera or card reader to your computer.

- ✔ **Refine:** Click this icon, and a menu offers several choices. You can view photos in Review mode (appearing like a slide show), batch-rename files, and obtain file information on a selected file in the Bridge window.

- ✔ **Open in Camera Raw:** You can open any file in Camera Raw as we explain in Book III, Chapter 3. Click this icon, and when you open a file, it opens in the raw converter.

- ✔ **Output:** Select photos in the Bridge window and click this icon to output your files as PDF or for a Web browser.

- ✔ **Content pane:** This area displays image thumbnails of photos within the selected folder.

- ✔ **Adobe Media Gallery 2 (F1):** Click this item, and the Bridge window changes to display panes titled Output, Document, and Layout. The new view offers some choices such as outputting as PDF or Web Gallery, document dimensions, layout options, overlay settings, playback options for video and slide shows, and adding watermarks to photos.

- ✔ **Essentials:** From the drop-down list, you can choose options to change the workspace view. You can view photos as a slide show, examine images in a light table, and choose from several other options. If you create a custom workspace view, you can save it, after which the new saved workspace appears in the menu.

- ✔ **Search:** Type search criteria in the Search text box. From the drop-down list, you can choose to search within Bridge or use Apple's Spotlight.

- ✔ **Switch to Compact Mode:** Compact mode is a much more simplified view of the Bridge window where folders on your hard disk appear in a left panel, images appear in the center panel, and a few tabs appear on the right. If the other views appear complicated, switch to Compact Mode for a simplified view of your photos.

✔ **Folders:** The Folders tab is like a Finder List View where you can navigate your hard disk and view contents of folders. Unlike the Windows version of Elements, you don't use a catalog to view photos. Any images you copy to your hard disk, you can view in the Bridge window.

Go Forward or Back

Go to Parent or Favorites

Reveal recent file or folder

Get Photos

Open in Camera Raw

Switch to Compact Mode

Refine | Output Content pane Essentials Search

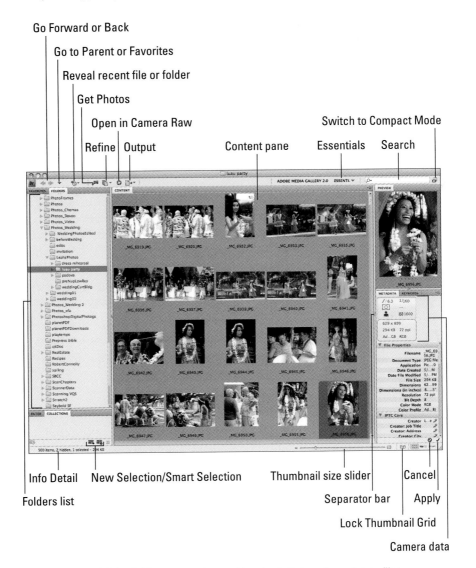

Info Detail New Selection/Smart Selection Thumbnail size slider | Cancel

Folders list

Separator bar Apply

Lock Thumbnail Grid

Camera data

Figure 3-1: Use Adobe Bridge to examine and locate digital media and data files.

✔ **Favorites:** The Favorites panel displays all folders and photos you identify as favorite items. You can view a folder of photos in the desktop view and drag the folder to the Favorites panel to add to your list of favorites.

✔ **Folders List:** This view shows the folders contained on your hard disk(s). You can scroll the panel and click folders to open the contents as image thumbnails in the Content pane (described later in this list).

✔ **Filter:** Click the Filter tab and make choices for viewing photos according to a vast number of different criteria.

✔ **Collections:** You can create different Collections to help you sort photos. When the collections are added, they appear in the Collections tab.

✔ **Info Detail:** This readout displays the number of items contained within a folder, the number of hidden items, and the file size for all photos selected in the Content tab.

✔ **New Collection/New Smart Collection:** Click these items to create a New Collection or a New Smart Collection. A New Collection is created by selecting photos and clicking the icon where the selected photos are included in the New Collection. A Smart Collection opens a dialog box where you can search photos based on several criteria. When the photos are found, they're added to a New Smart Collection.

✔ **Separator bars:** All the panes can be resized larger or smaller by dragging a separator bar. You find the separator bars appearing both vertically and horizontally between the separate panes in the Bridge window.

✔ **Thumbnail Size Slider:** Drag the slider left or right to resize the thumbnail images appearing in the Content pane.

✔ **Lock Thumbnail Grid:** Click to lock the view of the thumbnail images.

✔ **View Content as Thumbnails:** The default view is set to display the photos as thumbnail images, as shown in Figure 3-1.

✔ **View Content as Details:** Click this icon to change from the thumbnail view of images in the Content tab to a list of photo thumbnails with certain specifics about the images, such as date created, date modified, file size, file format, and so on. The text displaying the metadata appears to the right of each photo in the list.

✔ **View Content as List:** The view in the Content panel displays a list of mini-thumbnail views with creation date, file size, file type, dimensions, resolution, and color profile. The photos can be sorted in the list by clicking the heading name. For example, click Dimensions to sort photos according to physical size in ascending order.

- ✔ **Preview:** The Preview tab displays a larger preview of a selected photo in the Bridge window. You can zoom previews by clicking the cursor in the Preview tab.

- ✔ **Metadata:** File information such as the filename, file format, file dimensions, color mode, bit depth, f-stop, lens focal length, camera properties, location, and much more is considered metadata and recorded with your photos. In some cases, the metadata is customizable and added by the end user. All the metadata for a given photo can be viewed in the Metadata tab.

- ✔ **Keywords:** You can identify photos using keyword tags, as we explain in Book II, Chapter 2, on using the Organizer in Windows. Adobe Bridge on the Mac offers a similar feature for identifying and sorting images.

- ✔ **Camera data:** At the top of the Metadata tab, you find a quick at-a-glance view of the information related to taking a photo with your digital camera.

- ✔ **File Properties:** The File Properties pane displays information about the file; it's similar to the file properties you have with the Organizer.

- ✔ **Cancel:** Many items in the Metadata tab can be edited by clicking an item in a list and then typing information. If you type something and want to cancel your edits, click this icon.

- ✔ **Apply:** Click Apply when you're editing metadata and want to save your edits as part of the metadata.

Adding photos to the Bridge window

As we stated earlier in this chapter, Bridge doesn't support a catalog like the one you have with the Elements Organizer on Windows. You use Bridge on the Mac like a navigation tool when viewing thumbnail images of photos.

There are basically two ways you go about adding photos:

- ✔ **Adobe Bridge CS4 – Photo Downloader:** Click the Get Photos icon in the Bridge window (refer to Figure 3-1), and the Photo Downloader opens. From here, you can copy photos from a camera or card reader to your hard disk and open the folder in the Bridge window.

- ✔ **Copy photos in the Desktop view to your hard disk:** Mac users frequently copy files from card readers, CD-ROMs, and external media to a computer hard disk. This method is consistent with the way you typically work on the Mac. Drag a folder of photos from a card reader or camera to a location on your hard disk. In Adobe Bridge, open the folder, and thumbnail images immediately appear in the Bridge window.

After you've copied the photos to your computer, click the Folders tab in the Bridge window. The scroll bar on the right side of the Folders tab enables you to move up and down the list.

Adjacent to the folder names, you'll find a right-pointing arrow. Click the arrow to expand the folder. If you have several nested folders, each folder can be expanded by clicking the right-pointing arrows (as shown in Figure 3-2). To view photos in a given folder, click the folder name.

Adobe Bridge is not limited to displaying image previews. You can observe a complete set of contents in a folder. Some file types such as Microsoft Office files won't show you a preview, but other file types, such as PDF, are shown with previews.

Bridge is a great file organizer and locator for all your files. You can use the program whether you work with Elements or with other computer programs.

Figure 3-2: Click the right-pointing arrows to expand folders.

Setting Bridge preferences

Like those preferences we discuss in Book I, Chapter 4 for Edit Full mode and the Windows Organizer, Adobe Bridge has its own set of preferences. You locate the preference options by choosing Adobe Bridge CS4⇨ Preferences.

The first preference options appear as General, as shown in Figure 3-3. These preferences relate to options you can adjust for working with Elements and Adobe Bridge.

One of the important choices you have in the General Preferences is the Behavior item for launching the Photo Downloader. If you don't want the

downloader launched each time you connect to a camera or card reader, remove the check mark.

The Thumbnails pane enables you to describe options for viewing image thumbnails in the Bridge window.

Other settings in the Preferences relate to the images and some actions you have when working in Adobe Bridge. Take a few minutes to explore the settings. Most of what you find in the various prefer-ence choices is intuitive and self-instructive. When

Figure 3-3: Adobe Bridge Preferences.

you make a change to a preference item, click OK and the new preference choice is active.

Sorting Your Photos

Bridge makes it easy to sort photos according to a variety of different sort options and it's all easily handled with a menu. Click Adobe Media Gallery, and the window changes to offer more options. Look to the top of the Bridge window, and you find a Sort by Filename (the default) option with a down-pointing arrow. Click the arrow, and the Sort menu opens, as shown in Figure 3-4.

The options you have for sorting photos include

✔ **By Filename:** Choose this option to display photos in the Bridge window alphabetically by the name of the file. To change ascending to descending order, click the up-pointing arrowhead, shown in Figure 3-4.

✔ **By Type:** Choose this option to sort photos according to file type (JPEG, TIFF, PDF, PSD, and so on).

✔ **By Date Created:** Displays the list in ascending order, according to the date the images were shot.

Figure 3-4: The Sort menu.

✔ **By Date Modified:** Sorts the images according to the dates you last edited the photos.

✔ **By Size:** Sorts the photos by file size, with the smallest file sizes appearing first.

✔ **By Dimensions:** Sorts photos according to the physical size of the images.

✔ **By Resolution:** Sorts photos according to resolution.

✔ **By Color Profile:** Sorts photos according to color profiles. (See Book IX, Chapter 2 for more on color profiles.)

✔ **By Label:** You can add labels as we explain later in this chapter in the section "Labeling photos." After you've labeled photos, you can sort according to the label names.

✔ **By Rating:** You can rate photos with stars just like they can be rated in the Organizer, as we explain later in the section "Rating photos." After you apply star ratings to photos, you can sort according to the ratings.

✔ **Manually:** Photos can be moved around in the Bridge window and sorted manually.

To manually sort photos, do the following:

1. **Open Adobe Bridge.**

2. **Click a photo thumbnail in the Bridge window and drag it to a new location.**

 The Bridge window is like a slide sorter. You can click and drag photos to different locations, as shown in Figure 3-5.

3. **Open the Sort menu.**

 Notice that the menu choice switches automatically to Manually.

Figure 3-5: Click and drag photos in Bridge to sort them manually.

Organizing Your Pictures

In addition to the sorting options you have in Bridge, you have some manual options: You can add labels, rate images according to stars, and add keywords. Having more sorting choices helps you create a well-organized workflow.

Labeling photos

A menu command handles adding labels to photos. Labels provide you a means for sorting photos and a reminder to review, edit, or approve photos.

The process for labeling a photo is quite simple: You select one or more photos in Adobe Bridge, open the Label menu, and choose a label option. In the Label menu, you find commands for both ratings and labels. We talk about ratings in the next section, "Rating photos." For now, look over the options you have in the Label menu:

- **No Label:** By default, all photos are not labeled. If you label a photo and want to remove the label, choose this command.

- **Select (⌘+6):** This option is like a first-level label.

- **Second (⌘+7):** As the name implies, this is a second-level label.

✔ **Approved (⌘+8):** Use this command to label photos you've edited that are approved for output or distribution.

✔ **Review (⌘+9):** Use this command to mark photos you want to review.

✔ **To Do:** Use this command for photos you want to mark for editing.

As you label photos, you'll find a color bar appearing below the labeled photos, as shown in Figure 3-6. If you want to sort photos according to labels, open the Sort menu and choose By Label.

Figure 3-6: Photos labeled and ready for sorting by label.

For a quick at-a-glance view of available ratings for labels and stars, click the Filter tab in the lower-left corner of the Bridge window. You can apply labels and stars by clicking the respective items in this panel.

Rating photos

Rating photos is handled similar to labeling photos. To add star ratings to photos, do the following:

1. **Open Adobe Bridge.**

2. **Select one or more photos to which you want to give the same rating value.**

3. **Open the Label menu and choose a star rating.**

 For a quick-and-easy method use your keyboard. Use ⌘+1, 2, 3, 4, or 5 to add ratings 1 through 5 respectively.

4. **After rating several photos, open the Sort menu and choose By Rating.**

 The photos are sorted in ascending order, as shown in Figure 3-7.

Figure 3-7: Photos rated with stars and sorted according to rating.

You can increase a rating by choosing Label⇨Increase Rating or use ⌘+, (comma). To decrease a rating, choose Label⇨+. (period). Ratings are reordered for both labels and stars when you increase/decrease the ratings.

Creating collections

Collections offer yet another means for managing photos. You have two methods for creating collections. You can select photos and create a new collection; the photos are then added to your collection. A second method is to create a Smart Collection where you can use a variety of sorting options to find photos and add to a new collection.

You can use collections to divide an event you've photographed into several categories. For example, if you have wedding photos, you might create separate collections for the preceremony photos, the wedding ceremony, and

the wedding reception. All the wedding photos might be placed in a single folder on your hard drive, but you can divide the photos using the Bridge Collections options for a more-organized arrangement.

Creating a new collection

Creating a new collection is very easy in Adobe Bridge. You simply select the photos you want to add to a new collection and click the New Collection icon in the Collections tab. Here's how you do it:

1. **Open Adobe Bridge; in the Bridge window, select the photos you want to add to a new collection.**

2. **Click the Collections tab in the lower-left corner of the Bridge window.**

 The Collections pane opens.

3. **Click the New Collection icon.**

 The icon appears with a plus (+) symbol at the bottom of the Collections tab, as shown in Figure 3-8.

 A dialog box opens and asks whether you want to add the selected photos to a new collection.

4. **Click Yes in the dialog box.**

 A new collection icon appears in the list for collections in the Collections pane.

5. **Type a name for your new collection.**

 The photos are now part of a new collection, as shown in Figure 3-8.

6. **Click the Go Back button (the left arrow at the top of the Bridge window; refer to Figure 3-1).**

 You return to the view that displays all the photos in the selected folder.

When you've created a collection, you can add or remove photos as follows:

- **To add more photos to a collection,** select the photo thumbnails in the Bridge window and drag them to the new collection name in the Collections pane.

- **To remove a photo from a collection,** select the photo in the collection and click Remove from Collection in the top-right corner of the Content pane.

Figure 3-8: A new collection added to the Bridge window.

Creating a Smart Collection

You can create a Smart Collection by selecting a variety of filter options to locate and add the photos you want to include in a new collection. No need to select any images in the Bridge window. Just open the Collections tab and click the New Smart Collection icon (refer to Figure 3-1). The Smart Collection dialog box opens, as shown in Figure 3-9.

At the top of the dialog box, you find the Look In pop-up menu. Locate your hard disk(s) using this menu. In the Criteria section, choose from a vast list of criteria in the first pop-up menu. The second menu where you see *contains* in Figure 3-9 offers options for meeting the criteria (such as *contains*, *does not contain*, *equals*, and so on). The last item is either a text box or menu, depending on the criteria you used for searching. Type a value or choose a menu item similar to the examples shown in Figure 3-9.

Figure 3-9: The Smart Collection dialog box.

If you want to specify more criteria, click the + (plus) button. To delete a line, click the – (minus) button. When you're finished, click Save, and your new Smart Collection is added to the Collections pane (as shown in Figure 3-10). Name the collection. Then you can add photos to a Smart Collection by specifying criteria (as just described); delete photos just as you would do with any collection.

Figure 3-10: A new Smart Collection in the Collections tab.

Stack 'Em Up

With rapid-fire digital cameras and no need to concern yourself with film-processing costs, you might take five, ten, or more photos of the same scene. To help economize the space in the Bridge window, you can easily stack images so that only a single thumbnail appears in the window.

To create a stack, select several photos and choose Stacks⇨Group as Stack. When the stack is created, all the selected photos are tucked in behind the first image in the stack. To view photos after stacking, choose Stacks⇨ Ungroup from Stack.

By using keyboard shortcuts, you can expand and collapse stacks easily. Use ⌘+right arrow to expand a stack you select in the Bridge window, and all thumbnail images within the stack are displayed. To collapse a stack, select one of the images in the stack and press ⌘+left arrow.

If you want to remove the stack, choose Stacks⇨Ungroup from Stack or press Shift+⌘+G.

Creating Slide Shows

Slide shows in Adobe Bridge are handled by one of two options. You can view a slide show of selected files directly in the Bridge window — in which case the slide show is not saved as a file — or you can export photos to a PDF document. Using the latter option, you can save the slide show and add transitions so it looks like slide shows you're familiar with.

To view photos as a slide show in Adobe Bridge, select the photos you want to display and choose View➪Slideshow or press ⌘+L. Your selected photos jump into a full-screen view and scroll automatically according to settings you make for the slide show. To exit the slide show, press the Esc key.

By default, each slide is displayed for five seconds. You can change the duration (and other attributes of slide shows) by choosing View➪ Slideshow Options or by pressing Shift+⌘+L. The Slideshow Options dialog box opens, as shown in Figure 3-11.

Slide shows in Bridge are intended for your personal use. If you want to share slide shows with other users, you have to output the slides as a file.

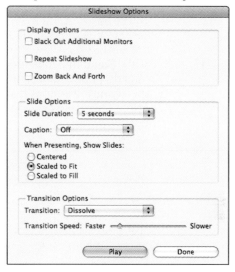

Figure 3-11: The Slideshow Options dialog box.

Outputting Files

You can output files from Adobe Bridge in either PDF format or as a Web Gallery. With PDF outputs, you have a few different choices. You can save your pictures as a PDF slide show or as greeting cards, contact sheets, and layouts that you specify with assorted options.

Your output options are selected in the Output pane in Adobe Bridge. Click the Output icon at the top of the Bridge window, and your workspace changes, as shown in Figure 3-12 (where the Output icon is also labeled). In the center of the Bridge window, you see an output preview. On the right side of the window, you find the Output tab. From the Template drop-down list, you choose the type of output you want.

There are a few general things to remember when saving files as Adobe PDF. You first select photos in the Bridge window and then open the Output tab by clicking the Output icon. You make choices for the output you want from the Template drop-down list. If you don't want the filename and filename extension to be displayed on your output, scroll down to the Overlays panel and uncheck Filename and Extension. Click the Refresh Preview button to

update previews as you make choices for the pictures used or the attributes assigned to the output. When finished, you scroll the tabs on the right side of the Bridge window and click the Save button at the bottom of the pane.

Output icon

Figure 3-12: The Output tab handles a variety of options for saving files as Adobe PDF.

Outputting slide shows

Slide shows are saved as PDF files from within Adobe Bridge; however, you can choose to output your images as a slide show from within Bridge or from within Edit Full mode in Elements. If you're working in Elements, you click the Create tab and click PDF Slideshow. Elements then switches you to Adobe Bridge, and the display changes from the current display to a Filmstrip display.

To compare the displays, look back at Figure 3-1. The display in Figure 3-1 is the Essentials view. Compare that view to Figure 3-12. The display in the Bridge window is the Filmstrip display.

To create a PDF slide show, do the following:

1. **Open Adobe Bridge or Elements.**

 If you're working within Elements, click the Create tab and click PDF Slideshow. You're switched to Adobe Bridge.

2. **Select photos you want to include in your slide show.**

3. **From the Template drop-down list, choose Maximum Size.**

 Choosing this option places a single photo on each page in your slide show. The name in the menu changes automatically to Custom. Uncheck the Filename and Extension check boxes.

4. **Scroll to the top of the Document pane and choose a page size and orientation.**

 From the Page Preset drop-down list, choose U.S. Paper and Letter (if using U.S. letter-size paper). Click the Landscape icon if displaying photos in landscape view. After you make the changes, the Page Preset and Size menus appear as a single *Custom* menu (as shown in Figure 3-13).

Book II
Chapter 3

Working in
Adobe Bridge

Figure 3-13: Choose a page size and orientation.

5. **Scroll down the Output pane to display the Playback and Watermark tabs.**

Leave the default options for Layout alone and move the pane down to view the Playback options, as shown in Figure 3-14.

6. **Adjust playback options.**

Choose the duration of the slides in the Advance Every text box and choose a transition from the Transition drop-down list. As another option, you can choose the transition direction (forward or backward) and the speed of the transition in (respectively) the Direction and Speed boxes.

7. **Click the Save button to save the output.**

If the View PDF After Save check box is enabled, the slide show opens automatically in Adobe Reader (or in Apple Preview). When the file opens in Adobe Reader, you're prompted to enter Full Screen mode. Then you click Yes to play your slides in sequence. At this point, you can host your PDF slide show online or e-mail it to family and friends.

Figure 3-14: Scroll the pane to display the Playback options.

Outputting to a Web Gallery

Web Galleries are collections of photos that you can export to HTML, complete with HTML code and the images you've chosen for Web hosting. Elements makes creating Web Galleries easy, even if you have no experience with creating Web pages.

You can create a Web Gallery by first clicking the Output icon in Adobe Bridge (refer to Figure 3-12) and then clicking the Web Gallery button in the Output pane. You can also start by clicking the Create button in Elements and then choosing Web Photo Gallery. If you start from within Elements, you're switched automatically to Adobe Bridge, where you create the Web Gallery.

Web Galleries in Adobe Bridge support a number of different templates and styles for creating the appearance of the end product. The best way to explore the options is to select photos in Bridge, and then choose a

Template from the Template drop-down list and a style from the Style drop-down list. After making your choices, click the Refresh Preview button, and the appearance changes in the Output Preview tab (as shown in Figure 3-15).

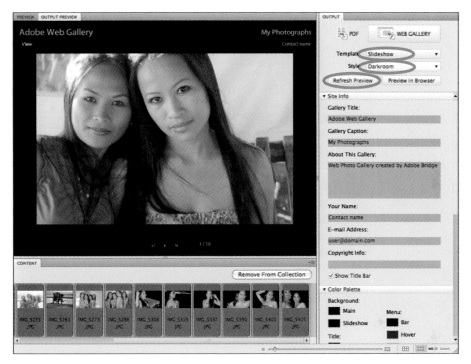

Book II
Chapter 3

Working in
Adobe Bridge

Figure 3-15: Choose a template and style and then click Refresh Preview to see a preview in the Output Preview tab.

After you decide on a template and style, fill in the Site Info tab text boxes. Choose options for color choices in the Color Palette tab. Note that you can make choices and preview the results before exporting the file by clicking the Refresh Preview button each time you change a setting.

After you make all your setting choices, you can preview the Web Gallery in a Web browser. Click the Preview in Browser button at the top of the Output pane, and your gallery opens in your default browser (Safari is shown in Figure 3-16).

When you're ready to export the gallery, you have two choices that appear at the bottom of the Output pane, as shown in Figure 3-17:

Figure 3-16: Open your gallery by clicking the Preview in Browser button.

✔ **Save the photos and HTML code to your hard disk:** Click the Save to Disk radio button and the Save button.

✔ **Immediately upload the gallery to your Web site:** Click the Upload radio button and fill in the text boxes for your server address, logon ID, and password. Click the Upload button, and Bridge handles the upload for you.

You have other output options available in Bridge, such as creating greeting cards and contact sheets. We talk more about these options in Book IX, Chapters 1 and 2.

Figure 3-17: Choose either Save to Disk or Upload.

Book III
Image Essentials

*W*e start this book by covering all the attributes of image files. Our goal is to help you understand how to approach your editing tasks. In Chapter 2, we move on to talk about color modes and file formats. In Chapter 3, we cover all the things you need to know about working with Camera Raw files.

Be sure to look over Chapter 4 carefully. There we cover color management, an issue that will become critically important to you when it comes to printing files.

In Chapter 5, we move on to all the undo possibilities you have with Elements.

Chapter 1: Specifying Resolution and Changing Image Sizing

In This Chapter

✔ **Understanding image attributes**

✔ **Sizing images**

✔ **Scaling images**

✔ **Setting print and screen resolutions**

✔ **Changing the canvas**

When you open a picture in Photoshop Elements, you're looking at a huge mass of pixels. These *pixels* are tiny, colored squares, and the number of pixels in a picture determines the picture's *resolution.* This relationship between pixels and resolution — important to understand in all your Elements work — relates to creating selections (as we explain in Book IV, Chapters 1 and 2), printing files (Book IX, Chapter 2), and sharing files.

This chapter explains some essential points about resolution and image sizes, especially in terms of how these aspects affect how you end up modifying your images.

Examining Images Closely

Files you open in Elements are composed of millions of tiny, square pixels. Each pixel has one, and only one, color value. The arrangement of the pixels of different shades and colors creates an illusion for your eyes when you're viewing an image onscreen. For example, you may have black and white pixels arranged in an order that creates the impression that you're looking at something gray — not at all those tiny black and white squares.

Just about everything you do in Elements has to do with changing pixels. You surround them with selection tools to select what appear to be objects in your image; you make pixels darker or lighter to change contrast and brightness; you change the shades and tints of pixels for color correction; and you perform a host of other possible editing tasks.

We also have another term to throw at you when talking about pixels and Elements files: Your pictures are *raster images*. When you have pixels, you have raster data. If you open a file in Elements that isn't made of pixels, Elements can *rasterize* the data. In other words, Elements can convert other data to pixels if the document wasn't originally composed of pixels.

In addition to raster data, there's also vector data, which we talk more about later in this chapter.

To use most of the tools and commands in Elements, you must be working on a raster image file. If your data isn't rasterized, many tools and commands are unavailable.

Understanding resolution

The number of pixels in a file determines its image resolution. If you have 72 pixels across a 1-inch horizontal line, your image is 72 pixels per inch (ppi). If you have 300 pixels in 1 inch, your image resolution is 300 ppi.

Image resolution is critical to properly outputting files in these instances:

- **When you print images:** If the resolution is too low, the image prints poorly. If the image resolution is too high, you waste time processing all the data that needs to be sent to your printer.

- **When you show images onscreen:** Just as an image has an inherent resolution in its file, your computer monitor has an inherent — fixed — resolution at which it displays everything you see onscreen. Computer monitors display images at 72 ppi (or 85 or 96 ppi). That's all you get. What's important to know is that you can always best view photos on your computer monitor at a 72-ppi image size in a 100-percent view.

 As an example, take a look at Figure 1-1: You see an image reduced to 50 percent and then at different zoom sizes. When the size changes, the resolution display on your monitor changes. When the size is 100 percent, you see the image exactly as it will print. The 100-percent size represents the image displayed on your monitor at 72 ppi, regardless of the resolution of the file.

This relationship between the image resolution and viewing the image at different zoom levels is tricky but vital. If (for example) you grab an image off the Web and zoom in on it, you may see a view like the 800-percent view shown in Figure 1-1. If you acquire a digital camera image, you may need to zoom out to a 16-percent view to fit the entire image into the Image window.

50% 100%

200% 400% 800%

Figure 1-1: The same image viewed at different zoom levels.

These displays vary so much because of image resolution. That Web page image you grabbed off the Web might be a 2-inch-square image at 72 ppi, and that digital camera image might be a 10-x-15-inch image at 240 ppi. You have to zoom in on the image if you want to fill the entire window with it — but when you zoom in, the resolution is lowered. The more you zoom in, the lower the resolution on your monitor.

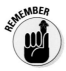

When you zoom into or out of an image, you change the resolution as it appears on your monitor. *No resolution changes are made to the file.* The image resolution remains the same until you use one of the Elements tools to reduce or increase image resolution.

Understanding image dimensions

Image dimensions involve the physical size of your file. If the size is 4 x 5 inches, for example, the file can be any number of different resolution values. After the file is open in Elements, you can change the dimensions of an image, the resolution, or both.

When you change only the dimensions of an image (not the number of pixels it contains), an inverse relationship exists between the physical size of your image and the resolution: As image size increases, resolution decreases. Conversely, when you raise resolution, you reduce the image size.

Understanding camera megapixels

Digital-camera image resolution is measured in *megapixels* (millions of pixels) and is a factor in image size. If you have a 6-megapixel camera, the full-resolution images from your camera are about 3000 x 2000 pixels. The file size for a 6-megapixel image is about 5.7MB.

On the screen, the resolution of many digital camera images is 72 ppi (pixels per inch). Using the 6-megapixel image as an example, the resolution at 72 ppi produces an image that measures a little more than 41 x 27 inches. Regardless of whether your camera takes pictures at 3, 5, or 8 megapixels, many images are captured at 72 ppi, but the dimensions vary according to the total number of pixels captured. With other cameras, you may find image resolutions like 230 ppi or some other variation. The higher resolutions typically produce images of smaller physical sizes.

Looking at raster versus vector images

Elements supports working with vector data in addition to raster data. Whereas raster data carries with it a fixed resolution, vector objects are not resolution dependent. What does this mean and, more important, what advantages come from working with vector data?

A vector object might be a line of text or a shape you add to a photo from an assortment of vector shapes. When you size text and shapes in Elements, the resizing has no effect on resolution. In other words, you can make a line of text or a shape as large as you want, and when the photo is printed, the text and shapes print clearly without distortion. Text and shapes remain resolution independent until you flatten the layers. Then the shapes are converted to pixels and appear as raster images.

Using the Image Size Command

In some cases, an image is too large, and you need to reduce its resolution, physical size, or both. In other cases, you might need a higher resolution to output an image at a larger size. This method of sizing — changing the size, as well as the number of pixels — is called *resampling* an image.

You can reduce resolution by sampling fewer pixels *(downsampling)* or raise resolution by adding more pixels to the sample *(upsampling)*.

Use caution when you resample images; when you resample, you're either tossing away pixels or manufacturing new pixels — and *neither activity particularly benefits image quality*. We discuss the sampling details in the section "Upsampling images," later in this chapter.

Downsampling images

You can change an image's size and resolution in a couple different ways. One method involves cropping images. You can use the Crop tool with or without resampling images. (For more information on using the Crop tool, see Book VIII, Chapter 1.) Another method involves the Image Size dialog box, which you use in many of your editing sessions in Elements.

When you use the Image Size dialog box to size an image down, you are *downsampling* the image. Follow these steps to see how downsampling is performed in Elements:

1. **Open a photo in Edit Full mode.**

 Any photo you have handy can be used to follow the steps here.

2. **Choose Image⇨Resize⇨Image Size.**

 Alternatively, you can use the keyboard shortcut Ctrl+Alt+I (⌘+Option+I on a Mac). The Image Size dialog box opens, as shown in Figure 1-2.

 The Pixel Dimensions area in the Image Size dialog box shows the file size (such as 18.2MB [megabytes]). This number is the amount of space the image takes up on your hard drive. The width and height values are fixed unless you click the Resample Image check box at the bottom of the dialog box.

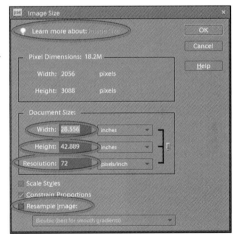

3. **In the Document Size area, you can redefine dimensions and resolution. The options are**

 • *Width:* Type a value in the text box to resize the image's width; then, to implement the change, press Tab to move out of the field. From the drop-down list to the right of the text box, you can choose a unit of measure: percent, inches, centimeters, millimeters, points, picas, or columns.

 • *Height:* The Height options are the same as the Width options except there is no column setting. If you keep the sizing proportional — by checking the Constrain Proportions check box — you typically edit either the Width or Height text box, but not both. When you alter either width or height, the resolution changes inversely.

Figure 1-2: Choose Image⇨Resize⇨Image Size to open the Image Size dialog box.

- *Resolution:* Edit the text box to change resolution, and press the Tab key to change the value. When resolution is edited, the Width and Height values are changed inversely (if the Constrain Proportions check box is checked).

4. **If you're okay with resampling your image to get the desired size, select the Resample Image check box.**

 With this check box selected, you can change dimensions and pixels at the same time, which results in reducing or increasing the number of pixels. When the box is unchecked, the values for dimensions are linked. Changing one value automatically changes the other values.

 Before you resample your image, however, be sure to check out the following section.

5. **If you select the Resample Image check box, you can choose a resampling method as well as other resampling options.**

 In the drop-down list, you find resampling-method choices. See Table 1-1 for details. The two check boxes above the Resample Image check box become active when you select the Resample Image box. Here's what they do:

 - *Scale Styles:* Elements has a Styles panel from which you can add a variety of different style effects to images. When you apply a style, such as a frame border, the border appears at a defined width. When you select the Scale Styles box and then resize the image, the Styles effect is also resized. Leaving the check box unselected keeps the style at the same size when the image is resized.

 - *Constrain Proportions:* By default, this check box is selected; keep it that way unless you want to distort an image intentionally.

6. **When you're done selecting your options, click OK to resize your image.**

Table 1-1	Resampling Methods	
Method	*What It Does*	*Best Uses*
Nearest Neighbor	This method is fastest, and the results produce a smaller file size.	This method is best used when you have large areas of the same color.
Bilinear	This method produces a medium-quality image.	You might use this option with grayscale images and line art.

Method	What It Does	Best Uses
Bicubic	This method is the default and provides a good-quality image.	Unless you find better results by using any of the other methods, leave the default at Bicubic.
Bicubic Smoother	This method improves on the Bicubic method, but you notice a little softening of the edges.	If sharpness isn't critical and you find Bicubic not quite doing the job, try this method. This method tends to work best if you have to upsample an image.
Bicubic Sharper	This method produces good-quality images and sharpens the results.	Downsample high-resolution images that need to be output to screen resolutions and Web pages.

Upsampling images

As a general rule, reducing resolution is okay, but increasing resolution isn't. If you need a higher-resolution image and you can go back to the original source (such as rescanning the image or reshooting a picture), try (if you can) to create a new file that has the resolution you want instead of resampling in Elements. In some cases, upsampled images can be severely degraded.

If you take a picture with a digital camera and want to add the picture to a Web page, the image needs to be sampled at 72 ppi. In most cases, you visit the Image Size dialog box, select the Resample Image check box, add a width or height value, and type **72** in the Resolution text box. What you end up with is an image that looks great on your Web page. In Figure 1-3, you can see an image that was downsampled in Elements from more than 14 inches horizontal width.

Figure 1-3: Downsampling images usually produces satisfactory results.

If you start with an image that was originally sampled for a Web page and you want to print a large poster, you can forget about using Elements or any other image editor. Upsampling low-resolution images often turns them to mush, as shown in Figure 1-4.

You might wonder whether upsampling can be used for any purpose. In some cases, yes, you can upsample with some satisfactory results. You can experience better results with higher resolutions of 300 ppi and more if the resample size isn't extraordinary. If all else fails, try applying a filter to a grainy, upsampled image to mask the problem. (Book VII, Chapter 1 has the details on filters.)

Figure 1-4: Upsampling low-resolution images often produces severely degraded results.

Some third-party tools do much better with upsampling images than the built-in sampling tools provided by Elements. For starters, take a look at OnOne Software's Genuine Fractals (www.ononesoftware.com). When it is absolutely necessary to upsample images, you'll find favorable results using this product.

Using the Scale Command

When you open a photo in Elements, the photo rests on an underlying layer called the *canvas.* The canvas and the photo are at a 1:1 ratio. In essence, the canvas is the physical size of your image. You can keep the canvas size fixed while upsizing or downsizing the photo image. To do so requires using the Transformation tools.

Choose Image⇨Transform⇨Free Transform or press Ctrl+T (⌘+T on a Mac), and you see a number of handles on the sides of the transformation rectangle. To scale a photo up or down, grab one of the four-corner handles by clicking one and holding down the mouse button; then you can move the handle in or out to size the image down or up, respectively.

If you open a context menu after you've selected Free Transform, you find several transformation commands as shown in Figure 1-5. Choose the Scale command to size an image up or down. As you drag the corner handles, the scaling is made while constraining proportions.

The end result of scaling images is the same as using the Image Size dialog box to upsample and downsample images. As you scale an image up, the image loses resolution. As you scale an image down, it gains resolution. Therefore, when scaling images up, be certain that the image resolution is sufficient to support the new size.

In Figure 1-6, we scaled the image up using the Scale command while maintaining the same canvas size. For more on transformations, see Book IV, Chapter 2.

Figure 1-5: Press Ctrl+T (⌘+T) and open a context menu to choose from different transformation commands.

Figure 1-6: The results after scaling an image up.

Choosing a Resolution for Print or Screen

The importance of resolution in your Elements work is paramount when printing files. Good ol' 72-ppi images can be forgiving, and you can get many of your large files scrunched down to 72 ppi for Web sites and slide shows. With output to printing devices, it's another matter. There are many different printing output devices, and their resolution requirements vary.

For your own desktop printer, plan to print a variety of test images at different resolutions. You can quickly determine the best file attributes by running tests. When you send files to service centers, ask the technicians what file attributes work best with their equipment.

For a starting point, look over the recommended resolutions for various output devices listed in Table 1-2.

Table 1-2	Resolutions and Printing	
Output Device	*Optimum*	*Acceptable Resolution*
Desktop color inkjet printers	300 ppi	180 ppi
Large-format inkjet printers	150 ppi	120 ppi
Professional photo lab printers	300 ppi	200 ppi
Desktop laser printers (black and white)	170 ppi	100 ppi
Magazine quality — offset press	300 ppi	225 ppi
Screen images (Web, slide shows, video)	72 ppi	72 ppi

For more information on printing photos, see Book IX, Chapter 2.

Changing the Canvas Size

When you scale images, you maintain the same canvas size. You might (for example) have a canvas size set up for printing a photo — say, 8 x 10 inches — and want to make an image a bit larger on the canvas. You might also add other images to create a photo collage and need to scale those added images up or down, again keeping the same canvas size.

For that matter, you might want to keep the image size the same but increase the canvas size to accommodate an area to include type, some content from the Content palette, or additional images.

To increase the canvas size, choose Image⇨Resize⇨Canvas Size. The Canvas Size dialog box opens (as shown in Figure 1-7). In this dialog box, you have several options to control, such as

- **Current Size:** The display for the Current Size shows you what your original canvas size is when you open the dialog box.

- **Width:** Type the new width in the text box.

- **Height:** Type the new Height in the text box.

- **Relative:** By default, the new size is absolute. Check this box if you want the new size relative to the dimensions.

- **Anchor:** By default, the canvas is increased from the center out. For example, if you have a 3 x 3-inch canvas area and you increase the size to 5 x 5 inches, one inch of canvas is added to all four sides of the photo. By clicking one of the arrows shown in the Anchor area, you can size the canvas relative to the photo from the top-left corner, top, top-right corner, left side, right side, bottom-left corner, bottom, or bottom-right corner.

- **Canvas Extension Color:** From the drop-down list, you can choose the current background, foreground, or some preset values for the color of the new canvas area. If you want a custom color, click the color swatch to the right of the drop-down list and make a new color selection from the pop-up color wheel.

Figure 1-7: The Canvas Size dialog box.

In Figure 1-8, we added some canvas area to make the total size of the photo 8 x 10 inches. The new canvas color is the same color as the background color.

Figure 1-8: A photo after new canvas area was added from the center out.

Chapter 2: Choosing Color Modes and File Formats

In This Chapter

✓ **Using color modes**

✓ **Converting images to different color modes**

✓ **Working with file formats**

✓ **Using audio and video formats**

Regardless of what output you prepare your files for, you have to consider color mode and file format. The most common color mode for photos taken with a digital camera is RGB (red, green, blue); you use it to prepare color files for printing on your desktop color printer or for sending to photo-service centers.

You can also use color modes other than RGB — bitmap or grayscale, for example. If you start with an RGB color image and want to convert to a different color mode, you have menu options for doing precisely that. Photoshop Elements uses an *algorithm* (a mathematical formula) to convert pixels from one mode to another. In some cases, the conversion that's made via a menu command produces good results; in other cases, you can use some different options for converting modes.

In this chapter, we introduce the modes that are available in Elements and explain how to convert from RGB to the mode of your choice: bitmap, grayscale, or indexed color. File formats are also somewhat dependent on which color mode you choose for your files, so we tossed in a discussion about saving files in this chapter.

Selecting a Color Mode

When you open an image from a digital camera or scan an image, the image file contains a color mode. Typically, digital camera images are in RGB color mode. When you scan documents and photos on a scanner, you can choose from among line art (bitmap mode), grayscale, or RGB color.

Another mode you may have heard of is CMYK. Although CMYK mode isn't available in Photoshop Elements, you should be aware of it and its uses. CMYK, commonly referred to as *process color,* contains percentages of cyan, magenta, yellow, and black colors. This mode is used for commercial printing and also on many desktop printers. If you design a magazine cover in Elements and send the file to a print shop, the file is ultimately converted to CMYK. Also note that most desktop printers use different ink sets within the CMYK color space.

If you start in Edit Full mode and create a new blank document, you have a choice for defining the color mode of the new document. Choose File⇨New⇨ Blank File, and the New dialog box opens, as shown in Figure 2-1. At the bottom of the dialog box, you make a choice for the color mode from the Color Mode drop-down list.

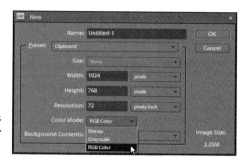

When choosing a color mode, the options you have for importing images from digital camera shots, scanning images, and creating new documents are limited to the modes discussed thus far. To explore other modes or change a mode, you have to work with menu commands for converting color.

Figure 2-1: Define the color mode for a new blank document with the New dialog box.

Converting Color Modes and Profiles

The most common scenario for photographers and users of Photoshop Elements is to start out with an RGB color image. This color mode is the center of your mode universe — and from here you can convert from RGB to other color modes.

Converting to Bitmap mode

Bitmap mode is most commonly used in printing line art, such as black-and-white logos, illustrations, or black-and-white effects that you create from your RGB images. Also, you can scan your analog signature as a bitmap image and import it into other programs, such as Microsoft Office programs. If you're especially creative, you can combine bitmap images with RGB color to produce many interesting effects.

The Elements Bitmap mode isn't the same as the Windows BMP file format. In Elements, Bitmap mode is a color mode with only two color values — black and white. A Windows BMP file can be an image in RGB, Grayscale, or Bitmap color mode.

When you're working with color modes, keep in mind that when you combine images into single documents (as we explain throughout Book VI), you have to convert bitmap files to grayscale or color if you want to merge those images with an RGB image. If you convert to grayscale, Elements takes care of converting grayscale to RGB mode.

For an example of what happens when you combine grayscale and color images, look over Figure 2-2: The original RGB image was converted to a bitmap and then saved as a different file. The bitmap was converted to grayscale and dropped on top of the RGB image. Adjusting the opacity produced a grainy effect with desaturated color. (For more information on how to merge files, create layers, and blend the opacity of layers, see Book VI, Chapters 1 through 3.)

You can acquire Bitmap mode images directly in Elements when you scan images that are originally black and white — such as line art, logos, your signature, or a copy of a fax — in Bitmap mode. Additionally, you can convert your RGB color images to Bitmap mode.

Converting RGB color to bitmap is a two-step process. You first convert to grayscale and then convert from grayscale to bitmap. If you select the Bitmap menu command while in RGB color, Elements prompts you to convert to grayscale first.

Figure 2-2: Combining the same image from a bitmap file and an RGB file.

Book III
Chapter 2

Choosing
Color Modes and
File Formats

To convert RGB mode to Bitmap mode, do the following:

1. **Open an image that you want to convert to Bitmap mode, using either Edit Full or Edit Quick mode.**

2. **Choose Image⇨Mode⇨Bitmap.**

 If you start in RGB mode, Elements prompts you to convert to Grayscale.

3. **Click OK.**

 The Bitmap dialog box opens, providing options for selecting the output resolution and a conversion method.

4. **Select a resolution.**

 By default, the Bitmap dialog box (as shown in Figure 2-3) displays the current resolution. You can edit the text box and type a new resolution value or accept the default.

5. **Under the Method heading, select one of the following settings from the Use drop-down list:**

 - 50% Threshold

 - Pattern Dither

 - Diffusion Dither

Figure 2-3: Type a resolution for your output; select a conversion method from the Use drop-down list.

For more about dithering color, see the "Converting to Indexed Color mode" section later in this chapter. Look over Figure 2-4 to see a comparison of the different methods used in converting RGB images to bitmaps.

6. **Click OK to convert your image to Bitmap mode.**

RBG Image

50% Threshold

Pattern Dither

Diffusion Dither

Figure 2-4: RGB image converted to bitmap by using 50% Threshold, Pattern Dither, and Diffusion Dither.

Converting to Grayscale mode

Grayscale images have black and white pixels and any one of 256 levels of gray. By converting an RGB image to grayscale, you can make it look like a black-and-white photo.

We talk about 256 gray levels in many chapters in this book. An RGB color image is divided into three separate channels (one for red, one for green, and one for blue). Each of these channels contains 256 levels of grays. Adjusting the levels of grays will affect the brightness and color in your images. (Look over Book VIII, Chapter 2 to understand more about the gray levels and adjusting them in Photoshop Elements.)

You can convert an image to grayscale in one of three ways, but we're here to tell you that one of these methods isn't as good as the others. In other words, avoid converting to grayscale by choosing Image➪Mode➪Grayscale. When Elements performs this conversion, it removes all the color from the pixels, so you lose some precious data during the conversion. You can't regain this color after conversion. If you use the Image➪Mode➪Grayscale command sequence to convert an image to grayscale and then save the file and delete the original from your hard drive or memory card, the color image is lost forever. You can save a secondary file, but this method is confusing and requires some more space on your hard drive. Here's a better way. . . .

As an alternative to using the menu command for converting images to grayscale, follow these steps:

1. **Open an RGB image in Elements.**

2. **Duplicate a layer.**

 The default Project Bin contains the Layers panel. In this panel, you find a pop-up menu when you click More in the upper-right corner. From the menu commands, choose Duplicate Layer. (For more information on working with layers, see Book VI, Chapter 1.) After duplicating the layer, you see a thumbnail of another layer in the Layers panel.

3. **Choose Enhance➪Adjust Color➪Adjust Hue/Saturation (or press Ctrl+U [⌘+U on the Mac]) to open the Hue/Saturation dialog box, as shown in Figure 2-5.**

4. **Drag the Saturation slider to the far left to desaturate the image.**

 All color disappears, but the brightness values of all the pixels remain unaffected. (For more information on using the Hue/Saturation dialog box and the other Adjust Color commands, see Book VIII, Chapter 2.)

5. Turn off the color layer by clicking the Eye icon.

In the Layers panel, you see two layers, as shown in Figure 2-6. You don't need to turn off the color layer to print the file in grayscale, but turning it off can help you remember which color layer you used the last time you printed or exported the file.

Figure 2-5: In the Hue/Saturation dialog box, move the Saturation slider to the far left to eliminate color.

Following the steps just given provides you with a file that contains both RGB and grayscale. If you want to print the color layer, you can turn off the grayscale layer. If you need to exchange files with graphic designers, you can send the layered file, and then the design professional can use both the color image and the grayscale image.

The other advantage of converting RGB color to grayscale by using the Hue/Saturation dialog box is that you don't cause any changes in the brightness values of the pixels. Moving the Saturation slider to desaturate the image affects only the color. The brightness values remain the same.

Figure 2-6: The Layers panel shows the grayscale and color layers. Click the Eye icon to turn layers on or off.

Another choice you have for converting color to black-and-white photos is to use the Convert to Black and White dialog box. Choose Enhance⇨Convert to Black and White in either Edit Full mode or Edit Quick mode, and you see the Convert to Black and White dialog box shown in Figure 2-7.

This dialog box contains many controls for adjusting brightness and contrast in images that you convert to grayscale. You can select from some preset options in the Select a Style list. You move the sliders in the Adjust Intensity area and see a dynamic preview displayed in the After thumbnail area.

Figure 2-7: The Convert to Black and White dialog box.

If you want to keep your original RGB image in the same file as the grayscale version, duplicate the background by right-clicking a layer in the Layers panel and choosing Duplicate Layer from the context menu. Alternatively, you can drag a layer to the Create new layer icon at the bottom-left corner in the Layers panel. Then click the background and choose Enhance➪Convert to Black and White. The conversion is applied only to the background, leaving the Background copy layer in the original color mode.

Converting to Indexed Color mode

Indexed color is a mode you use occasionally with Web graphics, such as saving in GIF format or PNG-8. When saving indexed-color images, you can often create smaller file sizes than using RGB. These are ideal for using in Web site designs.

RGB images in 24-bit color (8 bits per channel) can render colors from a palette of 16.7 million colors. An indexed color image is an 8-bit image with only a single channel. The total number of colors you get with indexed color can be no more than 256. When you convert RGB images to indexed color, you

can choose to *dither* the color, which displays the image with a dithered effect much like the effect you see with bitmapped images. This dithering effect makes the file appear as though it has more than 256 colors, and the transition between colors appears smoother than it would if no dithering were applied.

On occasion, indexed-color images have an advantage over RGB images when you're hosting the images on Web servers: The fewer colors in a file, the smaller the file size and the faster the image loads. When you prepare images for Web hosting, you can choose to use indexed color or RGB color. Whether you choose one over the other really depends on the quality of the image as it appears on your monitor. If you have some photos that you want to show on Web pages, you should use RGB images and save them in a format appropriate for Web hosting, as we explain in the section "Saving files for the Web," later in this chapter.

If you have files composed of artwork, such as logos, illustrations, and drawings, you may find that the appearance of images using indexed colors is no different from the same images as RGB. If that's the case, you can keep the indexed-color image and use it for your Web pages.

To convert RGB images to indexed color, choose Image↪Mode↪Indexed Color; the Indexed Color dialog box opens. Various options are available to you; fortunately, you can preview the results while you make choices. Get in and poke around. You can see the options applied in the Image window.

Converting color profiles

Because we're talking about color conversions in this chapter, we also cover a little bit about color profiles (and converting color profiles) here. But for a more thorough discussion of color profiles, jump to Book III, Chapter 4.

Some image files contain embedded color profiles; an example is the one shown later in Figure 2-8, where the embedded profile is shown in the Save As dialog box as ColorMatchRGB. That color profile isn't available in Photoshop Elements; it was embedded in another program that supported profile embedding for the ColorMatchRGB profile.

Photoshop Elements can embed either one of two different color profiles in a photo: RGB and sRGB. The Adobe RGB profile uses a slightly larger color gamut (more available colors) than sRGB. Some printing devices work best when converting sRGB color to the printer's color. Other printers offer better support for Adobe RGB. (This is a nutshell view of color profiling for printing. For more detailed information, see Book IX, Chapter 2.)

Going back to Figure 2-8, if you want to print the file to a printer, you might want to convert the color profile. To do so, you choose Image➪Convert Color Profile and then make a choice from the submenu. Your options include

✔ **Remove Profile:** Choosing this option removes the color profile from the image.

✔ **Convert to sRGB Profile:** This choice applies the sRGB profile to the image.

✔ **Convert to Adobe RGB:** This option applies the Adobe RGB color profile to the image.

Choosing one of these options either removes a color profile or converts to the selected color profile. When you save your file, you have the option to embed the profile in the image.

Using the Proper File Format

As you edit your image files, be sure you save frequently to update the work performed in your editing sessions. Continue saving as your work progresses to ensure against data loss.

Photoshop Elements files can be saved in a variety of different formats. Some format types require you to convert a color mode before the format can be used. Therefore, a relationship exists between the color modes present in files and saving those files in formats that support those color modes. Additionally, bit depths (see Book III, Chapter 4 for more information on bit depth) in images also relate to the kinds of file formats you can use when saving files.

Before you go too far in Elements, become familiar with file formats and the conversions necessary to save in one format or another. If you don't convert an image's modes or change its bit depth, you can save an edited file in the same format in which you opened it. Often, however, if you open an image and prepare it for some form of output, you have to give more thought to the kind of file format you should use when saving the file.

Using the Save/Save As dialog box

In almost any program, the Save (or Save As) dialog box is a familiar place where you make some choices about the file to be saved. With Save As, you can save a duplicate copy of your image or save a modified copy and retain the original file.

To use the Save (or Save As) dialog box, choose File⇨Save for files to be saved the first time, or choose File⇨Save As for any file, and a dialog box opens (as shown in Figure 2-8).

The standard navigational tools you find in any Save dialog box appear in the Elements Save/Save As dialog box. Here are some standard options you find in the Elements Save/Save As dialog box:

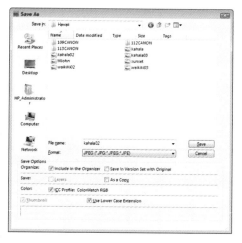

Figure 2-8: The Save As dialog box.

 - **File Name (Save As on the Mac):** This item is common to all Save dialog boxes. Type a name for your file in the text box.

 - **Format:** From the drop-down menu, you select file formats. We explain the formats supported by Elements in the section "Understanding file formats," later in this chapter.

A few options make the Photoshop Elements Save/Save As dialog box different from other Save dialog boxes that you might be accustomed to using. The Save Options area in the Save As dialog box provides these choices:

 - **Include in the Organizer (Windows):** If you want the file added to the Organizer, select this check box. (For more information about using the Organizer, see Book II, Chapter 2.)

 - **Save in Version Set with Original (Windows):** You can edit images and save a version of your image, but only in Edit Quick mode. When you save the file from Edit Quick mode, this check box is active. Select the box to save a version of the original, which appears in the Organizer.

 - **Color:** Check the box for ICC (International Color Consortium) Profile. Depending on which profile you're using, the option appears for sRGB or Adobe RGB (1998). When the check box is selected, the profile is embedded in the image. (See "Converting Color Modes and Profiles," earlier in this chapter.)

 - **Thumbnail (Windows):** If you save a file with a thumbnail, you can see a miniature representation of your image when viewing it in folders or on the desktop. If you select Ask When Saving in the Saving Files preferences, the check box can be enabled or disabled. If you select an option for Never Save or Always Save in the Preferences dialog box, this box is enabled or disabled (and grayed out). You have to return to the Preferences dialog box if you want to change the option.

✔ **Use Lower Case Extension (Windows):** File extensions give you a clue to which file format was used when a file was saved. Elements automatically adds the extension to the filename for you. Your choices are to use uppercase or lowercase letters for the extension name. Select the check box for Use Lower Case Extension for lowercase; deselect the check box if you want to use uppercase characters in the filename.

Understanding file formats

When you save files from Elements, you pick a file format in the Format drop-down list found in both the Save and Save As dialog boxes.

When you choose from the different format options, keep the following information in mind:

✔ File formats are especially important when you exchange files with other users. Each format has a purpose, and other programs can accept or reject files depending on the format you choose.

✔ Whether you can select one format or another for saving a file depends on the color mode, the bit depth, and whether layers are present. If a format isn't present in the Format drop-down list when you attempt to save a file, return to one of the edit modes and perform some kind of edit, such as changing a color mode or flattening layers, in order to save the file in your chosen format.

For a glimpse at all the file formats available to you, open a standard RGB color image in Standard Edit mode, choose File⇨Save As, and click the down arrow to open the Format drop-down list. As you can see in Figure 2-9, you have many format options.

In the following sections, we explain most of the file formats supported by Elements and the purpose for each format.

TIFF (*.TIF;*.TIFF) ▼
Photoshop (*.PSD;*.PDD)
BMP (*.BMP;*.RLE;*.DIB)
CompuServe GIF (*.GIF)
Photo Project Format (*.PSE)
Photoshop EPS (*.EPS)
JPEG (*.JPG;*.JPEG;*.JPE)
PCX (*.PCX)
Photoshop PDF (*.PDF;*.PDP)
Photoshop Raw (*.RAW)
PICT File (*.PCT;*.PICT)
Pixar (*.PXR)
PNG (*.PNG)
Scitex CT (*.SCT)
Targa (*.TGA;*.VDA;*.ICB;*.VST)
TIFF (*.TIF;*.TIFF)

Figure 2-9: Open the Format drop-down list in either the Save or Save As dialog box to make the formats supported by Elements appear.

Photoshop (*.PSD, *.PDD)

This format is the native file format for both Photoshop and Photoshop Elements. The format supports saving all color modes and bit depths, and you can preserve layers. Use this format when you want to save in a native format or exchange files with Photoshop users. Also use it for saving files

that you want to return to for more editing. When you save layers, any text you add to layers can be edited when you return to the file. (See Book V, Chapter 3 for more information on adding text to an image.)

Alias PIX (Macintosh)

This format was introduced by Wavefront Technologies to import geometric data from ASCII files.

BMP (*.BMP, *.RLE, *.DIB)

The term *bitmap* can be a little confusing. You have both a file format type that's bitmap and a color mode that's also bitmap. Don't confuse the two. The bitmap *format* supports saving in all color modes and in all bit depths. The Bitmap *color mode,* which we cover in the section "Converting to Bitmap mode," earlier in this chapter, is 1-bit black-and-white only.

Use the bitmap format when you want to add images to system resources, such as wallpaper for your desktop. Bitmap is also used with many different application programs. If you can't import images in other program documents, try to save them as BMP files.

CompuServe GIF (*.GIF)

Back when CompuServe was the host for our e-mail accounts, Barb was a college coed and Ted had a mustache and wore a green leisure suit. We exchanged files and mail on 300-baud modems. Later, in 1987, CompuServe developed GIF (*G*raphics *I*nterchange *F*ormat) to exchange files between mainframe computers and the ever-growing number of users working on Osborne, Kaypro, Apple, and Radio Shack TRS-80 computers.

GIF is now a popular format for hosting Web graphics. GIF images can be indexed color or animated images, and they support the smallest file sizes. Use this format when you need fewer than 256 colors and want to create animation in your images.

Photo Project Format (*.PSE)

Use this option when you create a project and want to save the file as a project. See Book IX, Chapter 1 for more on creating projects in Elements.

Photoshop EPS (*.EPS)

Photoshop EPS (*E*ncapsulated *PostScript*) files are sometimes used by graphic artists when they're designing jobs for commercial printing. The more popular format for creative professionals is TIFF, but Photoshop EPS has some advantages not found in other formats.

Depending on the color mode of your image, you have different options when you're using the Photoshop EPS file format. Select the format in the Save/Save As dialog box and click Save. If you're working on a bitmap image (1 bit), the EPS Options dialog box, as shown in Figure 2-10, opens. It offers an option to save transparency wherever white appears in your document.

Notice the Transparent Whites check box. A typical use for it is to put a transparent area around a circular logo; here's how it works: If you import the graphical image in another program, you can see the black in the image, but the entire white area is transparent and shows any background through what was white in the original bitmap image. If you save a file in a higher bit depth, the EPS Options dialog box doesn't provide an option for making whites transparent.

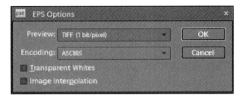

Figure 2-10: When you're working on 1-bit bitmap images, this dialog box offers an option to save transparency where white appears in the document.

IFF (Macintosh)

A generic file format introduced by Electronic Arts to ease the transfer of data between software produced by different companies.

JPEG (*.JPG, *.JPEG, *.JPE)

JPEG (*J*oint *P*hotographic *E*xperts *G*roup) is perhaps the most common file format now in use. JPEG files are used with e-mail attachments and by many photo labs for printing files, and they can be viewed in JPEG viewers or directly in Web browsers. Just about every program capable of importing images supports the JPEG format. Creative professionals wouldn't dream of using the JPEG format in design layouts, but everyone else uses the format for all kinds of documents.

**Book III
Chapter 2**

**Choosing
Color Modes and
File Formats**

You need to exercise some caution when you're using the JPEG format. JPEG files are compressed to reduce file size. You can scrunch an image of several megabytes into a few hundred kilobytes. When you save a file with JPEG compression, you experience data loss. You might not see this on your monitor, or it might appear noticeably on photo prints if you're using low compression while preserving higher quality. However, when you save with maximum compression, more pixels are tossed away, and you definitely notice image degradation.

Every time you save, open, and resave images in JPEG format, the image degrades more. When you submit JPEG images to photo labs for printing your pictures, keep saving in Photoshop PSD file format until you're ready to

save the final image. Save that one in JPEG format — only when you want to save the final file for printing — and use a low compression with high quality.

When you select JPEG for the format and click Save, the JPEG Options dialog box opens, as shown in Figure 2-11. You choose the amount of compression by typing a value in the Quality text box or by moving the slider below the Quality text box. The acceptable ranges are from 0 to 12 — 0 is the lowest

quality and highest compression, and 12 is the highest quality with the least compression.

Notice that you also have choices in the Format Options section of the JPEG Options dialog box. The Progressive option creates a *progressive* JPEG file commonly used with Web browsers: While the file downloads from a Web site, the image first appears in a low-quality view and then shows higher-resolution views as the download proceeds; the image appears at full resolution when it's completely downloaded in your browser window.

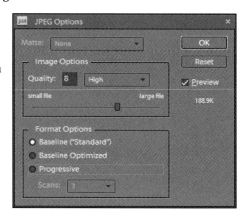

Figure 2-11: When saving in JPEG format, choose the amount of compression you want to apply to the saved image.

PCX (*.PCX)

PCX is a native PC format first used with PC Paintbrush. Most programs now support newer file formats, and you're not likely to need to save in PCX format. If you have legacy files from years ago, you can open PCX files in Elements, edit them, and save them in a newer format.

Photoshop PDF (*.PDF, *.PDP)

Adobe PDF (*P*ortable *D*ocument *F*ormat) is designed to maintain document integrity when exchanging files between computers. PDF is one of the most popular formats and can be viewed in the free Adobe Reader program available for installation on your Elements CD Installer or by downloading it from the Adobe Web site.

PDF is everywhere in Elements. When you jump into Organize mode and create slide presentations, cards, and calendars, for example, you can export your documents as PDF files. When you save in Photoshop PDF format, you can preserve layers and text. Text is recognizable in Adobe Reader (or other Acrobat viewers) and can be searched by using the Reader's Find and Search tools.

PDF files can be printed, hosted on Web sites, and exchanged with users of Windows, Macintosh, Unix, and Linux. All in all, this format is well suited for all the files you create in Elements that contain text, layers, and transparency. It is also ideal when you want to exchange files with users who don't have Elements or Photoshop.

Photoshop Raw (*.RAW)

This older format (introduced in 1989 with the first version of Adobe Photoshop) was specifically designed for exchanging files between the smaller computers of the day — microcomputers and personal computers (whether Windows or Mac) — and mainframe computers. Photoshop Raw isn't used much today. Unless you prepare files to be viewed on mainframes, don't bother saving in this format.

In recent years, with the advent of digital cameras, a different file format with "raw" in the name — Camera Raw — was introduced by Adobe and all the developers of digital cameras. The uses of *Camera* Raw (explained in Book III, Chapter 3) are completely different from those of *Photoshop* Raw. The two formats have nothing to do with each other.

PICT File (*.PCT, *.PICT)

PICT (Picture) format is an Apple file format similar to PCX on Windows. This format originated with the 1984 introduction of the Macintosh and the MacDraw program. This format is not used much today by any applications or output devices.

PICT Resource (Macintosh)

PICT images are stored as a Macintosh resource type. Apple Computer ended support for PICT and PICT Resource in 2009. The format is essentially not used with images today but is available for opening legacy files.

Pixar (*.PXR)

This format is used for exchanging files with Pixar workstations.

PNG (*.PNG)

PNG (*Portable Network Graphics*) is another format used with Web pages. PNG supports all color modes, 24-bit images, and transparency. Some older browsers, however, may need a plug-in to see PNG files on Web pages. One disadvantage of using PNG is that color profiles can't be embedded in the images, as they can be with JPEG. An advantage, however, is that PNG supports transparency.

Scitex CT (*.SCT)

The Scitex Continuous Tone (CT) format is used by Scitex workstations in commercial printing environments.

Book III
Chapter 2

Choosing
Color Modes and
File Formats

Targa (*.TGA, *.VDA, *.ICB, *.VST)

Targa is a format for describing bitmap images and is capable of representing bitmaps from black and white, indexed color, and RGB color. It's used for applications that can read Targa files, such as Truevision's hardware.

TIFF (*.TIF, *.TIFF)

TIFF (*T*agged *I*mage *F*ile *F*ormat) is the most common format used by graphic designers. TIFF is generally used for importing images in professional layout programs, such as Adobe InDesign and Adobe PageMaker. Commercial photo labs and print shops use equipment that supports downloading TIFF files directly to their devices. (***Note:*** Direct downloads are used in lieu of opening a Print dialog box.)

Inasmuch as creative professionals have used TIFF for so long, a better choice for designers using a program such as Adobe InDesign is saving in the native Photoshop PSD file format. A creative professional need only save one file in native format; no need to save the same file in both native and TIFF formats.

Those who prefer to work in TIFF format should know that TIFF, along with Photoshop PSD and Photoshop PDF, supports saving layered files and works in all color modes. When you save in TIFF format, you can also compress files in several different compression schemes. Compression with TIFF files doesn't lose data unless you choose a JPEG compression.

When you select TIFF for the format and click Save in the Save/Save As dialog box, the TIFF Options dialog box opens, as shown in Figure 2-12.

In the Image Compression area, you have these choices:

- ✓ **NONE:** Selecting this option results in no compression. You use this option when sending files to professionals who are creating layouts in programs such as Adobe InDesign.

Don't use any of the compression schemes in the following bullets for printing files to commercial printing devices.

Figure 2-12: Choose TIFF from the Format drop-down list and click Save to open the TIFF Options dialog box.

✔ **LZW:** This lossless compression scheme results in much lower file sizes without destroying data.

✔ **ZIP:** ZIP is also a lossless compression scheme. You can favor ZIP compression over LZW when you have large areas of the same color in an image.

✔ **JPEG:** JPEG is lossy — the tradeoff is that losing some data from the image results in the smallest file sizes. Saving a file you created in some other format as a JPEG image has the same result as when you apply JPEG compression to files saved in the JPEG format: some data loss.

File formats at a glance

Since its introduction in 1989, Photoshop has remained capable of saving all the formats listed in this section. To date, we have never used all the formats available in Photoshop Elements. At most, you might use three or four of them.

You don't need to remember all the formats and what each one does. Just pick the ones you use in your work, mark Table 2-1 for reference, and refer to it from time to time until you have a complete understanding of how your image files must be prepared and which formats you must use when you save them. If you happen to receive a file from another user in one of the formats you don't use, come back to the description in this chapter when you need some detail on what the format is used for.

Table 2-1	File Format Attributes Supported by Photoshop Elements			
Format	*Color Modes Supported*	*Embed Profiles* Supported*	*Bit Depth Supported*	*Layers Supported*
Photoshop PSD, PDD	Bitmap, RGB, Index, Grayscale	Yes	1, 8, 24, H	Yes
BMP	Bitmap, RGB, Index, Grayscale	No	1, 8, 24, H	No
CompuServe GIF**	Bitmap, RGB, Index, Grayscale	No	1, 8	Yes. Layers can be saved as frames for creating animated GIFs.
Photoshop EPS	Bitmap, RGB, Index, Grayscale	Yes	1, 8, 24	No

(continued)

Table 2-1 *(continued)*

Format	Color Modes Supported	Embed Profiles* Supported	Bit Depth Supported	Layers Supported
JPEG	RGB, Grayscale	Yes	8, 24	No
JPEG 2000	RGB, Grayscale	Yes	8, 24, H	No
PCX	Bitmap, RGB, Index, Grayscale	No	1, 8, 24	No
Photoshop PDF	Bitmap, RGB, Index, Grayscale	Yes	1, 8, 24, H	Yes
Photoshop Raw	RGB, Index, Grayscale	No	8, 24, H	No
PICT File	Bitmap, RGB, Index, Grayscale	Yes	1, 8, 24	No
Pixar	RGB, Grayscale	No	8, 24	No
PNG	Bitmap, RGB, Index, Grayscale	No	1, 8, 24, H	No
Photoshop Multiple Page Document	Bitmap, RGB, Index	No	1, 8, 24, H	No
Scitex CT	RGB, Grayscale	No	8, 24	No
Targa	RGB, Index, Grayscale	No	8, 24	No
TIFF	Bitmap, RGB, Index, Grayscale	Yes	8, 24, H	Yes

The letter H in Column 4 represents higher-bit modes, such as 16- and 32-bit images, which you might acquire from scanners and digital cameras. See Book III, Chapter 4 for more information on higher-bit images.

*Embedding profiles is limited to embedding either sRGB IEC61966-2.1 or AdobeRGB (1998).

**CompuServe GIF doesn't support saving layers, although it supports saving layers as frames. You use the frames when creating an animated GIF file used for Web pages.

Saving files for the Web

You save files for Web hosting in a special dialog box — the Save for Web dialog box. It offers other options than the dialog boxes you use to save files for other output. You can use the Save for Web dialog box to optimize files, but before you open it — in fact, before you even save a file, set the physical size and resolution of the image. Choose Image➪Resize➪Image Size. In the dialog box that appears, you can adjust the dimensions and resolution. For Web graphics, choose a resolution such as 72 ppi and downsample the image if necessary. (For more about downsampling, see Book III, Chapter 1.)

After your image is resized, choose File➪Save for Web or press Ctrl+Alt+Shift+S (⌘+Option+Shift+S on the Mac) to open the Save for Web dialog box, as shown in Figure 2-13. As you can see, you have a lot of things to control in this dialog box. The settings include

Eyedropper color

Eyedropper tool

Hand tool File Format

Zoom Preview menu Presets

Zoom level Previews Image Size Optimize to File Size

New Size | Animation

Default Web browser

Figure 2-13: The Save for Web dialog box.

Book III
Chapter 2

Choosing
Color Modes and
File Formats

✔ **Hand tool:** When you are zoomed in on the Preview, use the Hand tool to move the image around the Preview area.

✔ **Zoom tool:** Click the Zoom tool on one preview image to zoom in on both previews. Press the Alt (Option) key to zoom out.

✔ **Eyedropper tool:** Sample a color in the image shown in the Preview area.

✔ **Eyedropper Color:** This choice contains the current sampled color. Whatever color you sample can be used for the Matte.

✔ **Previews:** The first image displays the original image. The second pre-view displays a preview for how the file will look when saved. Notice, in Figure 2-13, the area of transparency in the top-left corner of the Original file preview. The second preview displays the transparent area as white. The file format is JPEG, which does not support transparency; hence the output preview displays the current selected color. You can change the color by sampling a color with the Eyedropper tool. You can choose a new Matte color by opening the Matte drop-down list and choosing Use Eyedropper Color.

✔ **Preview menu:** This option displays the output preview.

✔ **Presets (Named Optimized Settings):** A number of presets are available from the drop-down list.

✔ **Optimize to File Size:** Choose a preset or make custom settings and click this menu item. The file is optimized according to the settings cho-sen in the Save for Web dialog box.

✔ **File Format:**

- *GIF/Color reduction algorithm:* When you choose GIF as the file for-mat, the drop-down list below the GIF choice provides several options for color-reduction algorithms. Changes you make are reflected in the output preview. Choose the item that appears best in the preview.

 Interlaced: Check the Interlaced check box for progressive downloads of images.

 Colors: The number of colors in GIF files can be reduced, which also reduces the file size and download time. The choices you make are reflected in the output preview image.

 Dither: Dithering simulates color transitions. You can choose from several dithering options, and the results of your choices are shown in the output preview image.

Transparency: Check this box if you want to preserve transparency. All formats except JPEG support transparency.

Animate: For animated GIFs, check this box.

- *JPEG/Compression quality:* Choose JPEG and choose a compression quality from the drop-down list that appears below the JPEG choice.

- *PNG-8:* This option supports all the same choices available for GIF images except Interlaced and Animate.

- *PNG-24:* This choice supports all the same choices available for GIF images except Animate.

✓ **Quality (JPEG only):** Choose a quality setting for the compression applied to JPEG images.

✓ **Progressive (JPEG only):** This option allows progressive downloads.

✓ **Matte (All formats):** Choose a Matte color for images having transparency if you want a color to replace the transparent areas.

✓ **ICC Profile (JPEG only):** Check this box to embed a color profile.

✓ **Image Size:** This area of the dialog box displays the original dimensions of the file.

✓ **New Size:** This area of the dialog box permits you to change the original dimensions of the image.

✓ **Animation:** This option is available only with animated GIFs. You can preview the animation and set the frame rate.

✓ **Zoom level:** This choice displays the current zoom level.

✓ **Default Web browser for preview:** Click the icon and the image opens in your default Web browser.

✓ **Select Browser menu:** You can choose another Web browser from this drop-down list to preview your images.

This is a brief review of the options you have available in the Save for Web dialog box. For examples related to using the options, see Book IX, Chapter 3.

Book III
Chapter 2

Choosing
Color Modes and
File Formats

Chapter 3: Working with Camera Raw

In This Chapter

- ✓ **Getting familiar with Camera Raw**
- ✓ **Understanding the Camera Raw settings**
- ✓ **Opening files from the raw converter**
- ✓ **Saving files**

*W*hen you work with digital photos in Elements, the file format of your images is an important point to consider. You choose this format before you take your pictures, and the format is carried over to your computer when you pull images off your camera.

The most common file formats that digital cameras offer are JPEG, TIFF, and Camera Raw. Some cameras offer other options, but these formats are the most common. Low-cost, point-and-shoot cameras offer you only the JPEG format. The more expensive cameras, including the SLR types, offer you both JPEG and Camera Raw; some cameras offer JPEG and/or TIFF, and Camera Raw.

This chapter aims to give you an understanding of how to work with Camera Raw files.

Understanding Camera Raw

Cameras that produce JPEG images process images with JPEG compression *before* saving them. It's as though your camera performs a darkroom method of film processing when the shot is taken.

The Camera Raw format provides you with an optimum image for editing in Elements. When a Camera Raw image is saved to a media source, all the information that the sensor captured is saved with the file; you process the images *after* you open them. (See the "Opening Camera Raw Files" section, later in this chapter, to find out about opening Camera Raw images.)

For example, you can open a Camera Raw image and, before the image opens in Elements, you can adjust temperature, exposure, and a bunch of other settings — in effect, processing the photo after the shot was taken.

You can return to the original Camera Raw file and change the temperature or exposure (for example) to open the file with different settings to see how they affect the image. Just as chemical temperature and development time affect analog film processing, similar options affect post-processing Camera Raw images. The difference between analog film and Camera Raw is that after the analog film is processed, you can't change the processing attributes. With Camera Raw, you can go back and post-process the image 100 times or more — and change the processing attributes each time.

Camera Raw also supports higher bit-depth images than JPEG files do. In Book III, Chapter 4, we talk about 8-bit and 16-bit images, including some of the advantages of using 16-bit images. Camera Raw files typically produce these higher bit-depth images that give you more flexibility when editing brightness, contrast, and color.

If you have a choice between just JPEG and both JPEG and Camera Raw, always choose the latter. You have much more editing control over your images — and ultimately you get better results.

Processing Camera Raw files

If you don't have a camera capable of capturing Camera Raw images, you might want to look over the following sections to understand how this file format could benefit you. If you then end up purchasing a camera equipped with Camera Raw support, you already have some understanding of the advantages of using this format. (If you already have a Camera Raw-enabled camera, you don't need any convincing!)

Camera Raw images enable you to post-process your pictures. When you take a picture with a digital camera in Camera Raw format, the camera's sensor records as much information as it can. When you open a Camera Raw file in Elements, *you* decide what part of that data is opened as a new image.

Suppose your camera is set for exposure in tungsten lighting (tungsten flash photography is common in studios). If you take this camera outside in daylight and shoot an image without changing the settings, all your images appear with a blue cast because tungsten lighting requires a cooler color temperature than daylight.

If you acquire images that are saved in JPEG format, you have to do a lot of color correction after the image opens in Elements. If you shoot the image in Camera Raw format, you just process the image with a warmer temperature

(consistent with conditions when the shot was taken), and your color correction in Elements happens in a fraction of the time it takes to fix a JPEG image.

Post-processing Camera Raw images requires a plug-in that's installed with Photoshop Elements. When you open a Camera Raw image, the Camera Raw plug-in takes over and provides you with a huge set of options for post-processing the image before you open it in one of the Elements Editors.

Each camera developer uses a different flavor of Camera Raw; some developers use different Camera Raw formats in different models in their product line. Although Adobe tries to keep up with all the various Raw formats, you may find a camera using a format not supported by the Raw plug-in. Be sure to check for updates online for Photoshop Elements. As new developments occur, Adobe makes an effort to update plug-ins to support newer formats.

Acquiring Camera Raw images

If you read through Chapters 1 and 2 in Book II, you know how to acquire images from your camera and copy them to your hard drive. We don't bother going through those steps again; we just assume that you have some Camera Raw images on your hard drive. That's where you want them anyway. Opening files from your hard drive is much faster than working off media cards.

To open a Camera Raw image, follow these steps:

1. **From within Elements, open the image by pressing Ctrl+O (⌘+O on the Mac) and selecting it in the Open dialog box.**

 If you want to select several images in a row, click the first image, hold down the Shift key, and then click the last image. If you want to select several nonadjacent images, Ctrl-click (⌘-click) each image.

 As an alternative, if you imported images from a media card to your hard drive via the Organizer and have Camera Raw images in the Organizer window, select an image and choose Editor➪Edit Full (in the Options bar) or press Ctrl+I to open the converted raw file in Edit Full mode. In Adobe Bridge, you can open a Camera Raw image by choosing File➪ Open With➪Adobe Photoshop Elements 8.

2. **Click Open in the Open dialog box.**

 If you're selecting multiple images, only one image appears in the Camera Raw dialog box while thumbnails of all selected files appear in a scrollable list on the left side of the Camera Raw dialog box (as shown in Figure 3-1). When you click Open, the next image in the list opens in the Camera Raw dialog box.

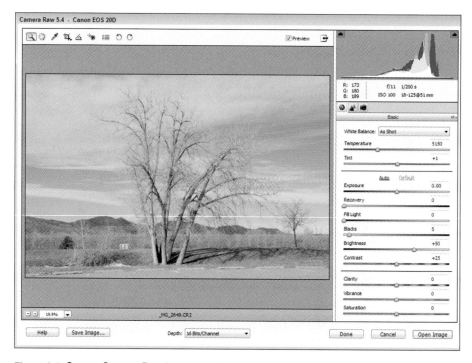

Figure 3-1: Open a Camera Raw image, and the image opens in the Camera Raw plug-in window.

As you can see in Figure 3-1, you can use a vast number of options to post-process your image before you drop it into Elements. This window is like a digital darkroom, where you can process the film and see what you're doing to the image before you accept the changes.

3. **Choose from the options to post-process your images.**

If you have your monitor properly calibrated (as we explain in Book III, Chapter 4), all the adjustments you make for Camera Raw format are dynamically updated in the Image preview. Don't be shy. Poke around and adjust settings to see the results in the Preview area. The more you play with the settings, the more you find out about how to get the best out of Camera Raw.

The Camera Raw window has a large number of settings, as the following list describes; mark this section to refer to when you work with Camera Raw images:

✓ **Tools:** Nine tools appear in the window:

 • *Zoom:* This tool zooms in and out of the Image preview.

- *Hand:* This option moves the image around, just as it does in the Elements Image window.

- *Eyedropper:* This samples color in the image. (We cover using the Elements Eyedropper tools in Book III, Chapter 2, and that information also applies to using the Eyedropper in the Camera Raw window.)

- *Crop tool:* Draw a marquee with the Crop tool and make your color and brightness adjustments. The adjustments are applied only to the area defined by the Crop tool. When you click Open Image, the photo opens, cropped to the area you marked with the Crop tool.

- *Straighten tool:* The Straighten tool enables you to draw a horizontal axis to straighten a crooked photo.

- *Red Eye Removal:* Click the Red Eye Removal tool to remove red-eye caused by flash lighting.

- *Open Preferences dialog box (Ctrl+K [⌘+K]):* Click this tool to open the Camera Raw Preferences dialog box, where you can make some choices for saving image settings, change default image settings, and use the Adobe Digital Negative (DNG) format.

- *Rotate Left:* Used to rotate the image counterclockwise.

- *Rotate Right:* The last tool you see below the Title bar is used to rotate the image clockwise.

The last two rotation tools are self-explanatory.

✔ **Preview:** Check the box to show dynamic previews of your edits.

✔ **Shadow/Highlight Clipping:** The Shadow and Highlight buttons above the histogram (denoted by the up-pointing arrows) show clipping in the *shadows* (dark areas of the image) and *highlights* (light areas of the image). *Clipping* means that, in a certain area, the image has lost some data (and, ultimately, some detail). Think of clipping as something that you don't want to appear in your pictures. When you make adjustments with these two check boxes selected, shadow clipping is shown in blue, and highlight clipping is shown in red in the Image preview. Take a look at Figure 3-2, in which we exaggerate clipping to show how the Clipping preview appears.

✔ **RGB values:** These values appear below the histogram (which is defined in the next list

**Book III
Chapter 3**

**Working with
Camera Raw**

Figure 3-2: Shadow clipping appears in blue, and highlight clipping appears in red.

item). When you first open an image, you don't see any values in the RGB area. Click the Zoom tool, the Hand tool, or the Eyedropper tool and move the cursor over the Image preview. When you move any of these tools around the image, the RGB values corresponding to the point below the cursor are reported in this area.

✔ **Histogram:** This graph displays all three channels (red, green, and blue) in an image simultaneously. The histogram changes when you change other options in the Camera Raw window.

The histogram graphs how pixels in an image are distributed. The distribution includes the number of pixels at each color-intensity level (one of the 256 levels you can find out about in Book VIII, Chapter 2).

If images have pixels concentrated in the shadows, you see the histogram skewed to the left. Conversely, images with pixels concentrated in the highlights reveal a histogram skewed to the right.

As you grow more familiar with histograms, eventually a quick glance at a histogram will suggest adjustments to make to improve an image.

✔ **Detail icons:** The three icons change the pane below the Histogram from Basic (as shown in Figure 3-1) to Detail where you apply sharpening and noise reduction (as shown in Figure 3-3) to Camera Calibration, where you can select a camera profile.

✔ **Settings (pop-up menu):** This pop-up menu opens when you click the small icon on the far right of the Basic tab. From this menu, you have choices for applying settings to the open image. If you change any setting, the menu option changes to *Custom.* If you've made setting choices on a Camera Raw image and want to return to the shot as it was taken by the camera, open the image and select Camera Raw Defaults.

Figure 3-3: Clicking the Triangle icon below the histogram opens the Detail tab, where you can adjust sharpness and reduce noise.

- *Previous Conversion:* This selection is handy if you have a collection of images that all require the same settings. After adjusting the first image, open additional images and select Previous Conversion. The Camera Raw plug-in applies the last settings you made to a Camera Raw image to the currently open file.

- *Sharpening images:* You can choose to sharpen images in the Camera Raw window or in Elements. Try to avoid sharpening here; instead, use the sharpening tools in Elements (as we explain in Book VIII, Chapter 1).

- *Noise Reduction:* Includes options for adjusting the brightness and color. You've probably seen images with a lot of noise; in extreme cases, the pictures look like they were printed on sandpaper. Noise in an image is okay if that's an effect you want to apply intentionally. If you want a smooth-looking image, however, you have to eliminate any noise introduced by the camera. Luminance Smoothing reduces grayscale noise. The next setting is Color Noise Reduction, which is used to reduce color noise.

✓ **White Balance:** White Balance settings (available under the Basic tab — the far-left icon below the histogram, as shown in Figure 3-1) are used to adjust the color balance of an image to reflect the lighting conditions under which the shot was originally taken. Remember that the sensor in a digital camera is capable of capturing the entire range of white balance that the sensor can see. You choose your settings not necessarily on the basis of what you see, but rather to match the white balance of the shot you took. Therefore, if you set up your camera to take pictures under one set of lighting conditions and then move to another set of lighting conditions but forget to change the settings, you can let the Camera Raw plug-in correct for the difference in white balance; that's because the sensor picked up the entire range, and the necessary data is contained in the file.

In Figure 3-4, you can see a picture taken with the camera set for tungsten lighting, but the shot was taken outdoors in daylight. By changing the White Balance in the Camera Raw dialog box, you can see how different settings affect the image color.

✓ **Temperature:** If one of the preset White Balance options doesn't quite do the job, you can move the Basic tab's Temperature slider or edit the text box to settle on values between one White Balance choice and another. Use this item to fine-tune the White Balance.

✓ **Tint:** Tint is another fine-tuning adjustment affected by White Balance. This slider and text box (again, found on the Basic tab) are used to correct any green or magenta tints that might appear in a photo.

✓ **Brightness adjustments:** Several adjustment sliders and text boxes in the Basic pane help you control the image brightness and tonal range. Notice the Exposure setting. This item lets you correct photos taken at

the wrong exposure. In analog darkrooms, you might ask technicians to *push* or *pull* film during processing, which results in (respectively) longer or shorter processing times. Changing exposure times compensates for under- and overexposing film. A nice advantage of using Camera Raw is that you can change the exposure for one image and then later open the original raw image and change to a different exposure value. Analog film can't be reprocessed, but with Camera Raw, you can reprocess over and over again.

Other options for the brightness and tonal controls are similar to the choices you have in the Elements Edit Full mode. (For more information on these adjustments, see Book VIII, Chapter 2.)

✓ **Cancel/Reset:** When you open the Camera Raw window, the button you see by default is Cancel. Press the Alt (Option on a Mac) key, and the button changes to Reset. If you want to scrub all the settings you made and start over, press the Alt (Option) key and click Reset.

Figure 3-4: Changing White Balance can dramatically change the image color.

✔ **Open Image/Open Copy:** This single button has two different purposes:

- *Open Image:* This button is the default. Click Open after you choose all your settings to process the photo and open it in Elements.

- *Open Copy:* Press the Alt (Option) key, and the button changes to Open Copy. Click Open Copy to open a copy of the raw image in Elements.

✔ **Done:** Clicking Done doesn't open the image in Edit Full mode. You click Done after changing the settings; the new settings then become the new defaults for your raw image. You can clear the defaults by opening the flyout menu (top-right corner) and selecting Camera Raw Defaults.

✔ **Zoom:** In this drop-down list (located in the bottom-left area of the Raw Camera plug-in window), you can choose from several zoom presets. You can also edit the text box, click the minus (–) button to zoom out, or click the plus (+) button to zoom in. Using any option from the menu zooms the Image preview.

✔ **Help:** Clicking the Help button opens a Help document to assist you in understanding more about Camera Raw.

✔ **Save Image:** Click the Save Image button to open the Save Options dialog box, where you can rename the image to save a copy and make choices for saving in Adobe's DNG format.

✔ **Depth:** If your camera is capable of shooting higher bit depths, they're listed here. If you want to convert to 8-bit images for printing, you can select the option from the drop-down list.

All we can hope to provide in this book is a simple cursory view for using Camera Raw. Several books have been written exclusively covering the Camera Raw format and how to open files in the Camera Raw plug-in window. For a more detailed look at using Camera Raw, see *Color Management for Digital Photographers For Dummies,* by Ted Padova and Don Mason (Wiley).

**Book III
Chapter 3**

**Working with
Camera Raw**

Opening Camera Raw Files

Your first step in converting Camera Raw files is to understand the settings you have in the raw converter. Having a general knowledge of what the settings do gets you started, but there's nothing like having a little practice with the settings and viewing your results.

The idea behind using the raw converter is that you want to get the tonal range and brightness values set to an optimum before opening the image in Elements. You'll find your editing tasks, such as adjusting color and brightness, much easier in Elements if your image starts somewhere in the ballpark of a good tonal range.

Take Figure 3-5 as an example. This Camera Raw file was opened in the Camera Raw dialog box. The image's white balance is way off the scale, the contrast is poor, the saturation is poor, and the photo needs a lot of adjusting to bring it within an acceptable range of color and contrast.

Figure 3-5: A poor-quality photo opened in the raw converter.

The first step to perform is to adjust the white balance. We moved the Temperature slider to the far left to bring the white balance into a proper setting. We then made some adjustments for the Exposure, Brightness, Contrast, Clarity, and Saturation, as shown in Figure 3-6.

Your clue for making proper adjustments is the histogram. While you move the sliders, you want to try to get an even tonal range across the histogram without clipping the image (showing spikes on either end). Compare the histogram in Figure 3-5 to the one shown in Figure 3-6.

More important than the color balance itself is the data you find in the histogram about the tonal range. You can make adjustments for brightness and color after you open the image in Elements.

After we made our adjustments in the raw converter, we clicked Open and the photo opened in the Image window in Edit Full mode, as shown in Figure 3-7. From here, all we need are a few adjustments using the Shadow/Highlight dialog box, the Levels, and the Hue/Saturation dialog box. (See Book VIII, Chapter 2 for using these image-enhancement settings.)

Figure 3-6: Making adjustments in the raw converter.

Figure 3-7: The file opened in Edit Full mode.

Opening any photo in Camera Raw

You can use the raw converter to work with any photo on your computer saved as JPEG, TIFF, or other formats that weren't originally saved as Camera Raw.

In Edit Full mode (Windows), choose Open As and choose Camera Raw from the Open As drop-down list. The file opens in the raw converter, where you can make adjustments before opening in Edit Full mode. You might use this method to open files that need temperature adjustments before attempting to edit the photos in Edit Full mode.

Opening photos in Camera Raw from Adobe Bridge

On the Mac, you won't find an Open As command in Edit Full mode. However, you can open files in the raw converter from within Adobe Bridge.

In Adobe Bridge, choose File⇨Open in Camera Raw. The same raw converter opens the image where you can make tonal adjustments before opening the file in Edit Full mode.

Saving Your Edits

After opening an image in Edit Full mode, choose File⇨Save As and save the file under a new filename. This way you preserve the original raw image, and you can return to the raw converter, make other adjustments, and open the file in Elements again to tweak the brightness and color. For the file format, choose either Photoshop (PSD) or TIFF (*.TIF) to prevent the sort of data loss that occurs when you save an image in JPEG format.

When you open a file in the raw converter and you want to return to the default image that your camera took, open the flyout menu on the far right of the Basic tab and choose Reset Camera Raw Defaults, as shown in Figure 3-8. The photo returns to the image that was originally taken with your camera.

Figure 3-8: Open the Basic flyout menu and choose Reset Camera Raw Defaults to return to the original, unedited image.

Chapter 4: Using and Managing Color

In This Chapter

↙ **Using foreground/background colors**

↙ **Understanding color**

↙ **Managing color**

↙ **Setting up the work environment**

↙ **Using color profiles**

To produce great output, you have to understand color and how Elements treats color. If you want to carry around a laptop computer to show off your photos, you can basically adjust color for this particular computer. However, sharing photos with other users, printing your pictures, and hosting photos on Web sites require that you know something about the way color is displayed on other devices and in photo prints.

There's a lot to know about managing color, including setting up color workspaces, managing color, and working with color profiles. In this chapter, we talk about these issues — and offer some key concepts for understanding color as it pertains to Photoshop Elements.

Dealing with Foreground and Background Colors

Foreground and background colors appear in the Tools panel as large color swatches. What you see in the two-color swatches represents the currently selected color for a foreground and the currently selected color for the background.

 By default, the foreground color is black, and the background color is white. By making color selections from the Color Picker (see the upcoming section "Poking around the Color Picker"), from the Swatches panel (see "Grabbing color from the Swatches panel" later in this chapter), or by clicking the Eyedropper tool and lifting a color from an image, you can change the foreground and/or background colors.

You can use colors appearing in the Foreground Color Swatch to fill type selections, shapes, and strokes, as well as when using tools to apply color. You can also use the current background color when using the Eraser tool to change background color.

A couple keyboard shortcuts are helpful when working with the foreground and background color swatches. Frequently used keyboard shortcuts that you want to commit to memory include

- ✔ **D:** Press the D key on your keyboard and you return to default black for the foreground color and default white for the background color.

- ✔ **X:** Press the X key on your keyboard and the foreground and background colors are reversed. You might want to use this keyboard shortcut when painting black and white areas with one of the marking tools.

You can also click the two arrows adjacent to the top right of the Foreground Color Swatch to reverse colors, or click the tiny icon adjacent to the lower right of the Foreground Color Swatch to return to default colors.

Defining Color

When you want to use a color for the foreground or background other than the default black and white colors, you make your color assignments using tools, panels, or dialog boxes.

All the colors available for a given color mode are accessible from the Swatches panel and the Photoshop Elements Color Picker. The range of colors shown in an image is also accessible through sampling color with the Eyedropper tool.

Poking around the Color Picker

The Color Picker provides you with a color spectrum displaying all the colors available within a given color mode. If you're in RGB mode, you can choose from a color panel of more than 16.7 million colors.

To open the Color Picker, click the Foreground Color Swatch in the Tools panel. The Color Picker pops up in a dialog box as shown in Figure 4-1. The choices you have for selecting color and the options available to you in this dialog box include

- ✔ **Color panel:** The large color swatch displays colors according to the position of the color spectrum slider.

- ✔ **New Color Choice:** Clicking the color swatch selects a new color for the foreground color.

Click to Select Closest Web Safe Color

Warning: Not Web Safe Color

Color panel New Color Choice

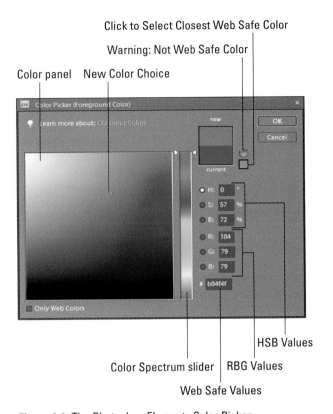

HSB Values

Color Spectrum slider | RBG Values

Web Safe Values

Figure 4-1: The Photoshop Elements Color Picker.

✓ **Warning: Not Web Safe Color:** Not all colors display equally on both the Mac and Windows operating systems in 8-bit mode when you are viewing Web pages. If a color is out of the Web Safe color palette, a warning icon appears.

The Web Safe palette was introduced more than 15 years ago to create a color palette that used common colors between computer systems with 8-bit video cards. It's almost nonessential today since almost all computer systems use 24-bit color.

✓ **Click to Select Closest Web Safe Color:** Click this icon to select the closest Web Safe color value relative to the new color.

✓ **Current Foreground Color:** When you open the Color Picker, the color appearing in the Foreground Color Swatch in the Tools panel is displayed here. The Current Foreground Color Swatch and the New Color Choice Swatch show you a *before/after* difference between the previous color and the new color.

✓ **HSB values:** This measure relates to Hue, Saturation, and Brightness. These values are the RGB equivalents for HSB.

✓ **RGB values:** The numeric values for Red, Green, and Blue. As you choose other colors in the large color swatch or by sliding the color spectrum slider, these values and the HSB values change to reflect new color choices.

✓ **Only Web Colors:** Check this box if you want to view only Web Safe colors.

✓ **Color Spectrum slider:** Move the slider up or down to change the hue and display a new hue range in the large color swatch.

✓ **Web Safe Hexadecimal Values:** Web Safe colors are defined using specific hexadecimal values. The hex value is displayed here for the current new color.

To define a new foreground color, do the following:

1. **Click the Foreground Color Swatch in the Tools panel.**

 The Color Picker opens.

2. **Move the color spectrum slider to the hue range you want to use for the new color.**

 For example, if you want to select a blue color, move the slider up to the range of blues.

3. **Click the cursor in the large Color Swatch to select a color.**

 The new selected color appears as a circle in the New Color area above the current foreground color, as shown in Figure 4-2.

Figure 4-2: A new color selected in the Color Picker.

4. **Click OK.**

 The new foreground color selected in the Color Picker appears in the Foreground Color Swatch.

If you want to change the background color, click the Background Color Swatch in the Tools panel, and the same Color Picker opens as shown in Figure 4-1. Any changes you make in the Color Picker are applied to the background color.

Grabbing color from the Swatches panel

Selecting color in the Color Picker is fine when you want to make a single color selection and use it once. However, if you want to create your own custom color panel and reuse colors, you want an easier method for choosing foreground and background colors — and a way to reuse the same colors easily.

The Color Swatches panel provides you with exactly what you need to create a personal color panel and easily access colors when painting on a canvas or filling selections on an image.

To open the Color Swatches panel, choose Window⇨Color Swatches. The Color Swatches panel (as shown in Figure 4-3) opens as a floating panel.

When you open the Color Swatches panel, you see a default panel of colors. Elements provides you with a number of different color panels that you can load into the Color Swatches panel. This enables you to create your own custom color panel.

Figure 4-3: The Color Swatches panel.

Using preset color panels

Open the Default drop-down list in the Color Swatches panel, and you find several preset color panels that you can load in the Color Swatches panel, as shown in Figure 4-4. Your choices include

- ✔ **Mac OS:** If you're using a Mac and looking at an image created on a Windows machine, choose this panel to load a color panel that displays color accurately on the Mac.

- ✔ **Photo Filter Colors:** This swatch set is a narrow range of colors consistent with those you apply using Photo Filters. (For a look at how Photo Filters are used, see Book VII, Chapter 1.)

✔ **Web Hues:** This swatch set displays hues that are Web Safe colors.

✔ **Web Safe Colors:** This set of swatches displays colors in a Web Safe panel.

✔ **Web Spectrum:** This swatch set displays the entire spectrum of Web Safe colors.

✔ **Windows:** This color set contains all the colors that display properly on a Windows machine.

Figure 4-4: Preset choices in the Color Swatches panel.

Creating a custom swatch set

The Color Picker has all the colors you can use in a given color mode. You may want to add more colors to one of the color swatch sets when you select different colors in the Color Picker. You might also want to delete some colors from a swatch set, or you may want to save your new swatch set as a library that you can load in Elements so you can use the new custom colors.

All this is possible in Elements, and here's how you go about creating your own custom panel of color swatches:

1. **Open the Color Swatches panel.**

 Choose Window➪Color Swatches to open the panel.

2. **Delete colors from the Default panel.**

 Choose a color you don't want to appear in your custom color panel. Press the Alt (Option) key and the cursor changes to a Scissors icon. Click a color swatch with the Alt (Option) key depressed to delete the color. Continue deleting all the colors you don't want in your custom color set.

3. **Select a new color to add to your custom color set.**

 Click the Foreground Color Swatch in the Tools panel. When the Color Picker opens, click a color you want to add to your new set. Click OK, and the new color appears as the foreground color.

4. **Add the foreground color to the set.**

 Click the panel menu icon in the Color Swatches panel to open a flyout menu. From the menu choices, choose New Swatch. The Color Swatch Name dialog box opens, as shown in Figure 4-5. The color is derived from the current foreground color to the left of the Name text box. Type a name for the color swatch and click OK. The new swatch is added to the Color Swatches panel.

Figure 4-5: Type a name and click OK to add a color to your Color Swatches panel.

5. **Add additional colors.**

 Continue using Steps 3 and 4 to add new colors to the Swatches panel.

6. **Save the swatches.**

 Open the panel menu and choose Save Swatches. A Save dialog box opens with the Color Swatches folder selected as the target folder. Be sure not to change the folder location. Type a name for your new swatches and click OK.

You have saved a set of swatches without disturbing the original Default set. You can always return to the Default set by selecting another preset from the drop-down list and then going back to the menu and choosing Default. The original set remains intact.

Loading swatches

If you created a custom set of color swatches and then chose one of the presets from the Default drop-down list, the custom colors you created are not visible in the Color Swatches panel. To see them there and use them, you have to load the swatches back into the Color Swatches panel.

To load swatches, open the panel menu and choose Load Swatches. A Load dialog box appears with the target folder pointing to the Elements Color Swatches folder. Here you find all the custom color swatches you saved from the Color Swatches panel. Select a file in the Load dialog box and click Open. The custom color swatches set opens in the Color Swatches panel.

Replacing swatches

If you want to replace colors in an existing Color Swatches panel, you can do so by selecting another menu command in the panel menu. Choose Replace Swatches in this menu, and the Load dialog box opens. Select a file in the Custom Colors folder, and the colors in the file you selected replace the existing swatches.

Lifting and sampling color

If you have a photo that has colors you want to add to your Color Swatches, you can sample colors in an open image.

 Click the Eyedropper tool and click anywhere on a photo in the Image window, and the Eyedropper samples the color. We call this technique *lifting* color, although the color is not removed from the photo (it merely replaces the current foreground color). If you want to replace the background color, press the Alt key (Option on the Mac) and click the Eyedropper tool on a color you want to sample.

In the Options bar, you find a few settings for the Eyedropper tool. Click the Eyedropper tool in the Tools panel and click the down-pointing arrow adjacent to Point Sample, and the drop-down list displays three menu choices, as shown in Figure 4-6. The menu items include

- ✓ **Point Sample:** This selection is the default. When you click the Eyedropper tool to sample color, the pixel you click is the sampled color.

- ✓ **3 by 3 Average:** This menu choice averages 3 pixels by 3 pixels, and the sampled color is the result of combining the color at the sample point with 8 surrounding colors.

- ✓ **5 by 5 Average:** This menu choice averages 5 pixels by 5 pixels, and the sampled color is the result of combining the color at the sample point with 24 surrounding colors.

Figure 4-6: Click the Eyedropper tool and open the Sample Size drop-down list.

Just as you add colors from the Foreground Color Swatch to a Color Swatches library, you can sample colors in a photo and use the sampled colors to create a custom Color Swatch library.

Understanding Color Management Essentials

In Elements, when it comes to color, the challenge isn't understanding color theory or definitions, but rather matching the RGB color you see on your computer monitor as closely as possible to your output. That output can be a printout from a color printer, a screen view on a Web page, or an image in a photo-slide presentation.

We say match "as closely as possible" because you can't expect to achieve an exact match; you have far too many printer and monitor variables to deal with. However, if you properly manage color, you can get a very close match.

To match color in your monitor and your output, you must calibrate your monitor and then choose a color workspace profile. In the following sections, you can find all the details on how to do just that.

Introducing color channels

Your first level of color mastery in Photoshop is to understand what RGB is and how it comes about. *RGB* stands for *red, green,* and *blue.* These are the primary colors in the computer world. Forget about what you know about primary colors in an analog world; computers see primary colors as RGB.

RGB color is divided into *color channels.* Although you can't see the individual channels in Elements, you still need to get a handle on color channels. Read on.

When you see a color *pixel* (a tiny, square dot), the color is represented as different levels of gray in each channel. (This may sound confusing at first, but stay with us for just a minute.) When you have a color channel, such as the red channel, and you let all light pass through the channel, you end up with a bright red. If you screen that light a little with a gray filter, you let less light pass through, thereby diluting the red color. That's how channels work — individually, they all use different levels of gray that permit up to 256 different levels of light to pass through them. When you change the intensity of light in the different channels, you ultimately change the color.

Each channel can have up to 256 levels of gray that mask out light. You can calculate the total number of possible colors you can create in an RGB model by multiplying the values for each channel ($256 \times 256 \times 256$). The result is more than 16.7 million; that's the total number of colors a computer monitor can display in RGB color.

This is all well and good as far as theory goes, but what does that mean in practical terms? Actually, you see some of this information in tools and dialog boxes you work with in Elements. As an experiment, open a file in Elements and choose Enhance➪Adjust Lighting➪Levels; the dialog box shown in Figure 4-7 opens.

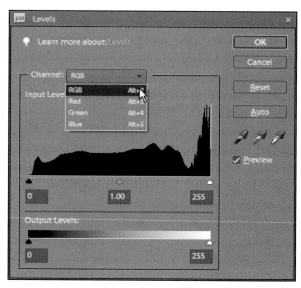

Notice that the Channel drop-down list shows you Red, Green, and Blue as individual channels, as well as a composite RGB selection. Furthermore, the Output Levels area shows you values ranging

Figure 4-7: Choose Enhance➪Adjust Lighting➪Levels to open the Levels dialog box.

from 0 on the left to 255 on the right. Considering that 0 is a number, you have a total of 256 different levels of gray.

What's important is that you know that your work in color is related to RGB images that make up three different channels. Each channel can let 256 different levels of gray through — that is, hold back different amounts of light — to change brightness values and color.

Understanding bit depth

Another important item to understand about channels is *bit depth*. A *bit* holds one of two values; one value is for black, the other for white. When you have 256 levels of gray, you're working with an 8-bit-per-channel image — 8 bits with 2 possible values each is 2^8, or 256, possible levels of gray. Multiply 8 bits per channel times your 3 channels and you get 24 bits, which is the common bit depth of images you print on your desktop printer.

Now take a look at the Image➪Mode menu. You should see a menu selection that says 8 Bits/Channel, as shown in Figure 4-8. When you open an image in Elements, if this menu command is grayed out, it means you're working with a 24-bit image — that is, an image of 8 bits per channel.

What does it mean when you can select the 8 Bits/Channel menu command? You can be certain that your image *isn't* an 8-bit-per-channel image. You may be able to select this command because some digital cameras and most low-end, consumer-grade scanners can capture images at higher bit depths. Using a scanner, you can scan a photo at 16 bits per channel. When you do, you end up with many more levels of gray. When you take a picture with a quality

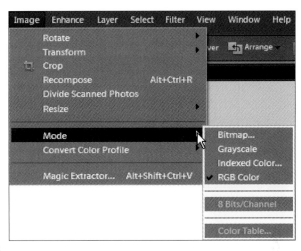

Figure 4-8: When you can choose 8 Bits/Channel, your image bit depth is higher than 8 bits per channel.

digital camera, you can capture 32-bit-per-channel images, and you end up with a file containing more than 4 billion levels of gray. That's a lot!

Now, here's the catch: All files have to be reduced to 8 bits per channel before you print them — because that's all the information any printer uses. In addition, many tools, commands, and panel options work *only* with 8-bit-per-channel images. So, you ask, "What's the benefit of acquiring images at higher bit depths than I can print?"

If you attempt to adjust brightness, contrast, or other image enhancements in an 8-bit-per-channel image, you often destroy some data. You can cause some noticeable image degradation if you move adjustment sliders too far while working with 8-bit-per-channel images. When you edit your 16-bit and 32-bit images, you don't destroy data — you simply inform Elements *which* 256 levels of gray (of the total number available) you want to use. The result is an image with more continuous gray tones than you can achieve in 8-bit-per-channel images.

Calibrating your monitor

Your monitor needs to be calibrated to adjust the gamma and brightness, correct any color tints or colorcasts, and generally get your monitor to display, as precisely as possible, accurate colors on your output. You have a few choices for which tool you can use to adjust monitor brightness, ranging

from a low-cost hardware device that sells for less than $100 to expensive calibration equipment of $3,000 or more — or you can skip the hardware and use tools provided by Adobe, by Windows, or by your Mac.

Gamma is the brightness of midlevel tones in an image. In technical terms, it's a parameter that describes the shape of the transfer function for one or more stages in an imaging pipeline.

We skip the high-end costly devices and software utilities that don't do you any good and suggest that you make, at the very least, one valuable purchase for creating a monitor profile: a *hardware profiling system.* On the low end of the price scale, some affordable versions of this device go a long way toward helping you adjust your monitor brightness and color balance. Here are some examples:

- **ColorVision Spyder2express:** For as low as $64, you can purchase an easy-to-use, three-step calibration device to balance the color on your monitor and adjust it for optimum brightness. This device is receiving five-star ratings at online resellers, including www.amazon.com.

- **Pantone Huey Monitor Color Correction:** This is another, low-cost system used for calibrating both CRTs and LCDs. This unit retails for $89 and sells for $63 at Amazon.com, as of this writing.

- **X-Rite Eye-One Display 2 (formerly GreTag MacBeth Eye-One Display 2):** This device, like the Spyder2express and Huey, is an easy-to-use profiling tool that works with CRT displays, LCDs, and laptop computers. It sells for around $195 to $250. You attach the suction cup to your monitor and click a few buttons in the software application accompanying the hardware, and Eye-One Display 2 eventually prompts you to save a monitor profile. The profile you create is used automatically by your operating system when you start your computer. When the profile kicks in, your monitor is balanced with the settings that were determined when the device performed the calibration.

On LCD monitors, you adjust some of the hardware controls to bring your monitor into a match for overall brightness with your photo prints. Make sure you run many test prints and match your prints against your monitor view to make the two as similar as possible.

You have a lot to focus on to calibrate monitors and get color right on your monitor and your output. (We talk more about color output in Book IX, Chapter 3.) For a good resource for color correction and printing using Photoshop Elements, we recommend that you look at *Color Management for Digital Photographers For Dummies,* by Ted Padova and Don Mason (Wiley).

Establishing Your Color Settings

After you get your monitor color adjusted by using a hardware profiling system, your next step is to choose your color workspace. In Elements, you have a choice between one of two workspace colors: either sRGB or Adobe RGB (1998). You access your color workspace settings by choosing Edit⇨ Color Settings. The Color Settings dialog box opens, as shown in Figure 4-9.

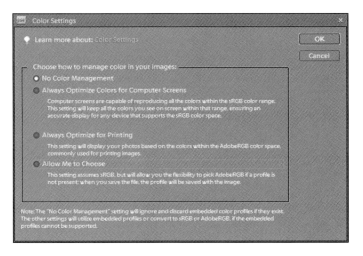

Figure 4-9: The Color Settings dialog box.

The options you have in the Color Settings dialog box include

- **No Color Management:** This choice turns off all color management. *Don't choose this option for any work you do in Elements.* You use No Color Management when you work with files that have color profiles embedded in the photos. Most likely you won't be using these types of photos. (For more about when you might use this option, see Book IX, Chapter 2.)

- **Always Optimize Colors for Computer Screens:** Checking this radio button sets your workspace to sRGB. sRGB color is used quite often for viewing images on your monitor. But this workspace often results in the best choice for color printing, as well. Many color printers can output all the colors you can see in the sRGB workspace. In addition, many photo services, such as the Kodak EasyShare services (discussed in Book IX, Chapter 2), prefer this workspace setting.

✔ **Always Optimize for Printing:** Checking this option sets your color workspace to Adobe RGB (1998). This workspace has more available colors than can be seen on your monitor. If you choose this workspace, you need to be certain that your printer is capable of using all the colors in this color space.

✔ **Allow Me to Choose:** When you choose this option, Elements prompts you for a profile assignment when you open images that contain no profile. This setting is handy if you switch back and forth between screen and print images.

Understanding How Profiles Work

You probably created a monitor color profile when you calibrated your monitor. You probably also selected a color profile when you opened the Color Settings dialog box and selected your workspace color. When you start your computer, your monitor color profile kicks in and adjusts your overall monitor brightness and correction for any colorcasts. When you open a photo in Elements, color is automatically converted from your monitor color space to your workspace color.

At print time, you use another color profile to output your photos to your desktop color printer. Color is then converted from your workspace color to your printer's color space. In Book IX, Chapter 2, we show you how to use color profiles for printing. For now, just realize that the proper use of color profiles determines whether you can get good color output. From here, you can jump to Book IX, Chapter 2 and understand how the color profiles are used at print time.

Chapter 5: Time Travel — Undoing in Elements

In This Chapter

✓ Understanding undoing in Elements

✓ Returning to unedited files

✓ Using the Undo History panel

Back in 1984, Apple Computer brought windowing interfaces to the masses with the introduction of the Macintosh computer. Also tucked into that interface was the Undo command. Both innovations revolutionized the way people use personal computers. Together with the Cut, Copy, and Paste commands, these features became a standard in all programs that followed.

Being able to Undo your most recent edit in a program like Elements gives you the freedom to experiment, as well as the chance to correct mistakes immediately. Adobe broadened that initial Undo feature in Photoshop Elements so you can retrace an entire series of editing steps with multiple undos, see a visual list of edits in the Undo History panel, and work with different editing states.

In this chapter, we explore the many options you have for branching out, experimenting a little, and retracing your editing steps (or overcoming a series of editing mistakes) without having to save multiple versions of your photos.

Undoing What's Done with the Undo Command

As you might expect, the Undo command is found in the Edit menu. To undo an editing step, you simply choose Edit⇨Undo or press the Ctrl+Z (⌘+Z on a Mac) keys on your keyboard. This simple command helps you correct a mistake or toss away an experimental edit that doesn't work for you.

When you open the Edit menu, you find the Undo command at the top of the menu. In addition, you find the name of the edit you last applied to the

image. In Figure 5-1, you can see that we just applied a fill within a selection. When we opened the Edit menu, the menu command appears as Undo Fill.

Adjusting the number of available undos

If you make several edits in Elements, you can take advantage of the Undo command several times. The number of undos you have available is determined in the Edit Full Preferences dialog box. To adjust the number of undos you want available, choose Edit⇨ Preferences (Windows) or Adobe Photoshop Elements 8.0⇨ Preferences (Mac) and the Preferences dialog box opens as shown in Figure 5-2. Alternatively, you can press Ctrl+K (⌘+K) to open the Preferences dialog box.

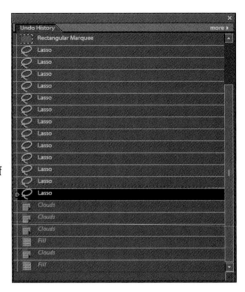

Figure 5-1: The Undo command appears listed in the Edit menu with the name of the last edit applied to the document.

Figure 5-2: The Preferences dialog box.

In the Preferences dialog box, you click the Performance item in the list on the left to open the Performance preferences panel. Below the History & Cache item on the right, you find History States, as shown in Figure 5-3. The setting you make here — by adjusting the slider or by typing a number in the

History States text box — determines the number of undos you have available when you choose Edit➪Undo or press Ctrl+Z (⌘+Z). By default, the number is set to 50, meaning you can step back to undo edits up to 50 times.

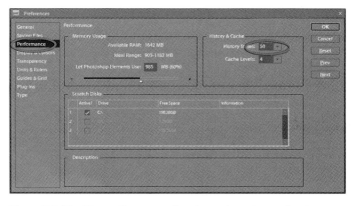

Figure 5-3: The History States number determines the total undos you have when editing a file.

The adjustment for History States also relates to the Undo History panel we talk about later in this chapter in the section, "Working with the Almighty Undo History Panel."

Redoing edits

You also have a command for Redo in the Edit menu. If you choose Undo from the Edit menu or press Ctrl+Z (⌘+Z) and then change your mind, you can always just redo that last undo: Choose Redo or press Ctrl+Y (⌘+Y), and the last undo returns to the state before you chose to undo the edit. The number of redos you have is the same as the number of undos. For example, if you set the History States to ten in the Performance preferences and make ten edits, and then successively press Ctrl+Z (⌘+Z) ten times, you can successively press Ctrl+Y (⌘+Y) to redo all ten undos.

Reverting to What's Saved

At times, rather than undo a bunch of edits, you just want to toss all the edits away and return to the last saved version of your file. The Revert command in the Edit menu returns you to the last saved version of your photo.

If you make several edits and you like what you see, you can choose File➪Save or press Ctrl+S (⌘+S) to save your edits. If you then make several more edits and you don't like the results, choose Edit➪Revert to revert to the last save.

In many Adobe programs, you find a Revert command listed under the File menu. In Photoshop Elements, however, the Revert command is listed under the Edit menu. Keep this in mind when you perform edits in Edit Full mode.

Working with the Almighty Undo History Panel

Using menu commands and keyboard shortcuts enables you to travel back and forward in time to undo and redo edits. When executing these actions, you don't have a visual clue to tell you which edit will be undone or redone. Instead, you have to choose a menu command or keyboard shortcut and then view the result in the Image window.

The Undo History panel, on the other hand, displays a visual of your editing history where you can travel back and forward in time to change your edits with a complete list of the edits made on a photo shown in the panel.

To open the Undo History panel, choose Window⇨Undo History. The Undo History panel opens as a floating panel. As you make edits on an image, each edit is shown in a list in the panel as you can see in Figure 5-4.

Figure 5-4: The Undo History panel.

Viewing an image's various states

The Undo History panel gives you a capability that menu commands don't: You can target an Undo (or Redo) to go back (or forward) *to a specific edit*. For example, if you create a selection, apply an enhancement edit (such as changing image brightness), and then apply a filter, you can return to the selection with one mouse click. Instead of choosing Undo to undo the filter and Undo again to undo the image brightness, you simply click the selection edit in the Undo History panel.

The number of history states is determined in the Performance preferences shown earlier in Figure 5-3. By default, you have 50 history states that appear in the Undo History panel. When you come to the 51st edit, the first edit in the sequence is deleted from the panel and you can't return to that state. As you make more new edits, you continually delete edits from the top of the panel.

If you want to add more states to the Undo History panel, open the Performance preferences and change the value in the History States text box.

As you increase history states in the Performance preferences, the amount of memory required by Elements is increased. You may find the program getting sluggish if you double the History States or add more than twice the default value.

Navigating through the history states

To return to an earlier edit in the Undo History panel, find the item you want to return to in the list and click it. You can also apply a number of edits to create a selection and, after the selection is created, apply another series of edits *to the selected area*. If you want to return to the selection edit, click the item in the Undo History panel, as shown in Figure 5-5.

As long as the items remain in the list, you can click backward or forward to undo and redo edits.

Figure 5-5: Click the item in the list that you want to return to so you can undo a series of edits.

Deleting and clearing states

You may have applied a series of edits to a document and then want to return to an earlier edit. Suppose you decide that all the edits made after the one you want to return to are no longer needed. (This might happen if you're experimenting with different edits and viewing the results.) If you know that the edits following a particular edit are no longer needed, you can delete them from the list.

To delete the last edit in the Undo History panel, click it in the list and then right-click to open a context menu. From the menu choices, select Delete. The selected edit is deleted from the list.

If you have a series of items you want to delete from the list, click the first item within a given list of edits to open a context menu. Then, when you choose Delete, all items in the list that follow the selected item are deleted.

Keep in mind that *all* edits following an edit you target for deletion are deleted when you open a context menu and choose Delete. If you want to delete a series of edits that are followed by edits you want to retain, it's a bit more complex: You have to delete the unwanted edits individually. Elements doesn't give you the capability to select a group of edits and then delete the whole group at once.

If you apply a number of edits and choose File⇨Save, the edits you made up to the time you save the file are kept and recorded as part of the new saved file. The Undo History panel maintains the list of edits applied to the document before you last saved it. Therefore, you can undo edits after saving a file as long as the file remains open. If you close the file and reopen it, the Undo History panel is cleared. You can also clear the Undo History panel after making edits by opening a context menu and choosing Clear History. The list is cleared and appears the same as when you first opened the file before you applied any edits.

Book IV
Selections

The 5th Wave By Rich Tennant

"I'm going to assume that most of you – but not all of you – understand that this session on 'masking' has to do with Photoshop Elements."

*A*fter you get beyond understanding color and file attributes, one of the most important editing tasks you can master is creating selections. As a matter of fact, we make the claim that when you do, you master Photoshop Elements.

This book takes you through all the various tools and methods for making selections. Be sure to get a handle on the concepts contained in this book before you tackle some of those major editing jobs.

Chapter 1: Making Selections

Sometimes you get lucky, and what you capture in the camera's view-finder is exactly what you want to edit, print, or share online. But at other times, you may want to work with just a portion of that image. Maybe you just need to adjust the contrast in a certain area. Or you want to combine part of one image with another. In these instances, you have to make a selection before you can go on to do the real editing work.

Being able to make accurate selections is a valuable skill. Fortunately, Elements offers an assortment of tools and techniques for making selections. In this chapter, we give you the foundation to use the basic selection tools. If, after you make a selection, you want to modify or transform that selection, check out Chapter 2 of this minibook. Finally, masking is yet another way to make a selection. Be sure to look at Book VI, Chapter 4, for the lowdown on masking.

Defining Selections

Defining a selection means that you specify which part of the image you want to work with. Everything within a selection is considered *selected*. Everything outside the selection is *unselected*. Seems simple enough. It is, except that you can also have partially selected pixels, which allow for soft-edged, diffused selections. You can create *partially selected* pixels by feathering, masking, or anti-aliasing the selection. We cover feathering and anti-aliasing in this chapter. Masking is covered in Book VI, Chapter 4.

When you make a selection, a moving dotted outline called a *selection border* (also called a *selection outline* or *selection marquee*) appears around the selected area. After you've made a selection, any adjustments or edits you apply affect only that portion. The unselected areas remain unchanged. You can also make a selection in one image and then copy and paste it into another image. If you can't squeeze in that trip to Europe this year, no worries. Select yourself from a family photo, choose Edit➪Copy, open a stock photo of the Eiffel Tower, and then choose Edit➪Paste. Nobody will know that you never made it to the City of Lights.

When making selections, be sure that you're working in the Editor, in Edit Full mode, and not in Edit Quick or Guided modes, or in the Organizer (or Bridge on the Mac). For more on various modes in Elements, see Book I, Chapter 1.

Selecting a Rectangular or Elliptical Area

The Marquee tools are the easiest selection tools to use. Basically, if you can use a mouse without much difficulty, you can become a marqueeing expert.

The Rectangular Marquee tool creates rectangular or square selections. Use this tool when you want to grab just a portion of an image and copy and paste it into a new, blank document or into another image.

Follow these steps to make a selection with the Rectangular Marquee tool:

1. **Select the Rectangular Marquee tool from the Tools panel.**

 The tool looks like a dotted square. You can also use the keyboard shortcut — press the M key.

2. **Click and drag from one corner of the area that you want to select to the opposite corner.**

 While you drag, the selection border appears. The border follows the movement of your mouse cursor (a crosshair or plus sign icon).

3. **Release your mouse button.**

 You now have a rectangular selection, as shown in Figure 1-1.

The Elliptical Marquee tool, which shares the same flyout menu as the Rectangular Marquee tool, creates elliptical or circular selections. You can select clocks, doughnuts, inner tubes, and other round objects with this tool.

Selection Marquee

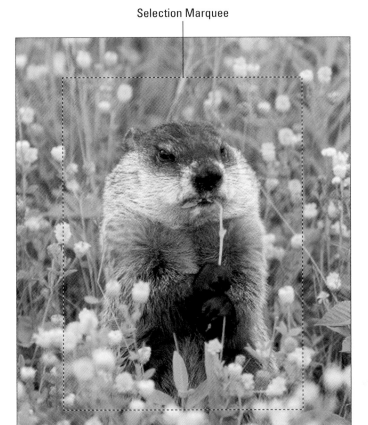

Purestock

Figure 1-1: The Rectangular Marquee selects part of your image.

Here are the steps to create an elliptical selection:

1. **Select the Elliptical Marquee tool from the Tools panel.**

 You can also use the keyboard shortcut. If the Elliptical Marquee tool is visible, press the M key. If the Rectangular Marquee is visible, press Shift+M.

2. **Position the crosshair near the area that you want to select, click the area, and then click and drag around the element.**

 While you drag, the selection marquee appears.

3. **When you're satisfied with your selection, release the mouse button.**

 Your elliptical selection is complete, as shown in Figure 1-2.

If your selection isn't quite centered around your element, move the selection border by clicking and dragging inside the border with either the Rectangular or Elliptical Marquee tool. You can also actually move a selection with either tool *while* you're drawing by pressing the spacebar.

Image 100 Ltd.

Figure 1-2: The Elliptical Marquee selects rotund elements.

Fine-tuning squares and circles

If you want to create a perfect square or circle, hold down the Shift key after you begin dragging your mouse. When you have your desired selection, release the mouse button first and then release the Shift key.

You may find it easier to create an elliptical selection by dragging from the center outward. To do so, click and hold down the mouse button in the center of your desired element. Then press the Alt key (Option key on the Mac) and drag from the center outward. After you have your desired selection, release the mouse button first and then the key.

If you want to draw from the center out and want a perfect circle (or square), hold down the Shift key as well. When you have your desired selection, release your mouse button first and then Shift+Alt (Shift+Option on the Mac).

You can also achieve a perfect circle or square by specifying a 1:1 aspect ratio in the Options bar.

Using the Marquee options

The Options bar provides oodles of other options when you're making Marquee selections. Some of these options allow you to make precise selections by specifying exact measurements. Others enable you to make soft-edged, feathered selections.

You must select the options on the Options bar, as shown in Figure 1-3, *before* you make your selection with the Marquee tools. The only exception is that you can feather a selection after you have created it.

Feather Anti-alias Mode Width Height

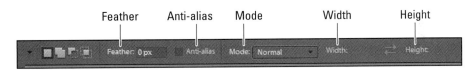

Figure 1-3: Specify Marquee settings in the Options bar.

Here's the scoop on each of the Marquee options:

✔ **Feather:** *Feathering* softens, or *feathers,* the edges of a selection. The amount of softening depends on the value — the higher the value, the softer the edge, as shown in Figure 1-4. The radius measures how far in all directions the feather effect extends. Small amounts of feathering can be used to create natural transitions between selected elements in a collage. Larger amounts are used to create a special effect where one image gradually fades into another. If you just want a selected element to have a soft edge without the background, choose Select⇨Inverse and then delete the background.

To feather while you're selecting, select the Feather option on the Options bar before you use the Marquee tools. You can feather a selection after the fact by choosing Select⇨Feather.

✔ **Anti-alias:** Whereas feathering completely softens edges, anti-aliasing just slightly softens the edge of an elliptical or irregularly shaped selection so that very hard, jagged edges aren't quite so prominent, as shown in Figure 1-5. An anti-aliased edge is always only 1 pixel wide.

We recommend keeping the Anti-alias option selected, especially if you plan on creating collaged images. Anti-aliasing helps create natural-looking transitions and blends between multiple selections. However, if you want a super-crisp edge, uncheck this option.

Book IV
Chapter 1

Making Selections

Feather 6 pixels Feather 30 pixels

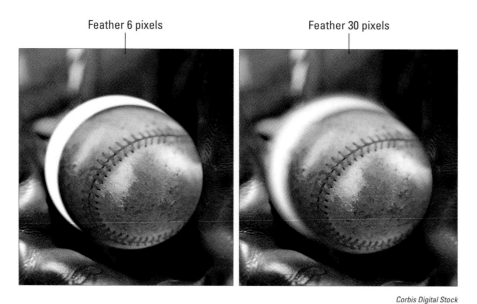

Corbis Digital Stock

Figure 1-4: Feathering a selection softens the edges.

Anti-aliased Not Anti-aliased

Figure 1-5: Anti-aliasing barely softens your selection edges.

✓ **Mode:** The Mode drop-down list contains three settings:

 • *Normal:* This option enables you to freely drag a selection to any dimension.

 • *Fixed Aspect Ratio:* This setting allows you to specify a fixed ratio of width to height in a selection. For example, if you enter 2 for width

and 1 for height, you *always* get a Marquee selection that's twice as wide as it is high, no matter what the size.

- *Fixed Size:* This setting lets you specify values for the Width and Height. This option comes in handy when you need to make multiple selections that must be the same exact size, such as in a school yearbook. Note that the marquee is immediately drawn when you click your canvas. The click point is the top-left corner of the marquee.

✔ **Width and Height:** When you select Fixed Aspect Ratio or Fixed Size from the drop-down list, you also enter values in the Width and Height text boxes. To swap the Width and Height values, click the double-headed arrow button.

Even though the default unit of measurement in the Width and Height text boxes is pixels (px), you can enter any unit of measurement that Element recognizes — pixels, inches (in), centimeters (cm), millimeters (mm), points (pt), picas (pica), or percents (%). Enter the value and then type the word or abbreviation of your desired unit of measurement.

Freeform Selecting with the Lasso Tools

Unfortunately, not much in life is perfectly rectangular or elliptical in shape. Most of the time, you have to deal with irregular shapes that have undulations of some kind or another. That's where the Lasso tools come in handy. This group of tools enables you to make any freeform selection your heart desires.

Elements offers three Lasso tools: the Lasso tool, the Polygonal Lasso tool, and the Magnetic Lasso tool. Each Lasso tool has its own special purpose in the world of freeform selections, and they're simple to use. You just have to drag around the part of the image that you want to select. All that's required is a decaffeinated, steady hand.

The selection you make is only as good as how accurately you can trace around your desired element. If you don't make an exact selection the first time around, don't worry. You can always go back and make corrections, as described in Book III, Chapter 5.

Book IV
Chapter 1

Making Selections

If, when making a selection, you find the mouse a little unwieldy, you may want to look into a digital drawing tablet, such as a Wacom tablet. Using a tablet makes using the Lasso tool — as well as other tools, like the Brush — much easier. Tablet lovers claim you'll never revisit mouse usage again.

The Lasso and Polygonal Lasso tools have three settings on the Options bar — Feather, Anti-alias, and Refine Edge. The first two options work exactly as they do with the Marquee tools. To find out about Feather and Anti-alias, see the earlier section, "Using the Marquee options." The Refine Edge option (brush button) does exactly that — cleans up the edges of your

selection. You also find this command in the Options bar for the Magic Wand and Quick Selection tools. Keep in mind that you can apply this option to any existing selection, no matter how you got that selection, by choosing Select⇨Refine Edge.

Here's the scoop on the settings for the Refine Edge option:

- **Smooth:** Smoothes out the jaggedness along the selection edge.

- **Feather:** Softens the edges of a selection. Move the slider to increasingly create a softer, more blurred edge.

- **Contract/Expand:** Decreases or increases your selected area.

- **Standard or Overlay mode:** Enables you to preview your selection in one of two modes. Click the Custom Overlay Color icon to preview your selection with your edges hidden and a semi-opaque layer of color (that shows onscreen only) in your unselected area. Double-click the icon to change the color and opacity of the overlay. Press F to cycle between Standard and Overlay views. Press X to hide your selection edges.

- **Zoom tool:** Enables you to zoom into your image to see the effects of your settings.

- **Hand tool:** Lets you pan around your document window to see the effects of your settings on various portions of your image.

Using the Lasso tool

Making a selection with the Lasso tool is basically like tracing an outline around an element on a sheet of paper.

To make a selection by using the Lasso tool, follow these steps:

1. **Select the Lasso tool from the Tools panel.**

 It's the tool that looks like a rope, hence the moniker "lasso." You can also use the keyboard shortcut by pressing the L key. If the Lasso isn't visible, press Shift+L to cycle through the various Lasso tools.

2. **Position the cursor anywhere along the edge of the element you want to select.**

 The *hot spot* (the leading point) of the Lasso cursor is the end of the rope. If you need a little visual help, press the Caps Lock key, which switches your cursor to a crosshair.

 Zoom in on the image a bit if you need to better see your edges.

 In our example, we started at the bottom of the butterfly wing, as shown in Figure 1-6.

3. **Hold down the mouse button and trace around the element, trying to include only what you want to select.**

While you trace, an outline forms that follows the movement of your mouse.

Don't release the mouse button until you complete the selection by closing the loop and returning to your starting point. When you release the mouse button, Elements assumes you're done and closes the selection from wherever you release the mouse button to your starting point.

4. **Continue tracing until you return to your starting point; release the mouse button.**

 Elements rewards you with a selection border that matches your Lasso line, as shown in Figure 1-7.

Lasso cursor

Selected area

PhotoDisc/Getty Images

PhotoDisc/Getty Images

Figure 1-6: The Lasso tool is for freeform selections.

Figure 1-7: After tracing around your object, release the mouse button to obtain a selection border.

**Book IV
Chapter 1**

Making Selections

Selecting straight sides with the Polygonal Lasso tool

The Polygonal Lasso tool is at its best when selecting straight-sided subjects, such as city skylines, buildings, and stairways. Unlike the Lasso tool, the Polygonal Lasso tool has rubber band–like qualities, and instead of dragging, you click and release the mouse button at the corners of the object that you're selecting.

Follow these steps to select with the Polygonal Lasso tool:

1. **Select the Polygonal Lasso tool in the Tools panel.**

 You can also use the keyboard shortcut by pressing the L key. If the Polygonal Lasso isn't visible, press Shift+L until you get the tool. It looks like the Lasso tool, but it has straight sides.

2. **Click and release at any point along the edge of the desired element.**

 We like starting at a corner.

3. **Move (don't drag) the mouse and click and release at the next corner of the element. Continue clicking and releasing at the various corners of the object.**

 The line stretches out from each corner that you click, like a rubber band.

4. **To close a selection, return to your starting point and click and release.**

 When you place the cursor over the starting point, a small circle appears next to the cursor, indicating that you're at the right place for closing the selection. A selection marquee that matches your Polygonal Lasso line appears, as shown in Figure 1-8.

Some objects have both curves and straight sides. No problem. Hold down the Alt key (Option key on the Mac) to have the Polygonal Lasso tool temporarily transform into the regular Lasso tool. Then, click and drag to select the curves. Release the Alt (or Option) key to return to the Polygonal Lasso tool. This trick also works with the other Lasso tools.

Hugging edges with the Magnetic Lasso tool

The last Lasso tool is the Magnetic Lasso, which works by analyzing the colors of the pixels between the elements in the foreground and the elements in the background. Then, it snaps to, or hugs, the edge between the elements, as if the edge had a magnetic pull.

Not always the easiest tool to manipulate, the Magnetic Lasso tool performs best when your image has a well-defined foreground object and good contrast between that object and the background — for example, a dark mountain range against a light sky or a black silhouette against a white wall.

Figure 1-8: Select straight-sided elements with the Polygonal Lasso tool.

The Magnetic Lasso tool has some unique settings, found in the Options bar, which you can adjust to control the sensitivity of the tool and thus aid in your selection task.

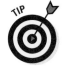

We recommend starting out by experimenting with the Magnetic Lasso tool using its default settings. If the tool isn't cooperating, play with the options.

The Feather, Anti-alias, and Refine Edge options work as they do with the Marquee and Lasso tools. Here are the remaining options:

- ✓ **Width:** This option, measured in pixels from 1 to 256, determines how close to the edge you have to move the mouse before the Magnetic Lasso tool snaps to that edge. Decrease the value if the object's edge has a lot of indentations and protrusions or if the image has low contrast. Increase the value if the image has high contrast or smooth edges.

- ✓ **Edge Contrast:** Measured in percentages from 1 to 100, this option specifies the contrast required between the object and its background before the Magnetic Lasso tool snaps to the edge. If the image has good

**Book IV
Chapter 1**

Making Selections

contrast between the foreground element and its background, use a high percentage.

✔ **Frequency:** This setting, measured in percentages from 0 to 100, specifies how many *fastening* points (points anchoring the selection line) to place on the selection line. The higher the value, the more fastening points used. If the element you want to select has a fairly smooth edge, keep the value low. If the edge is jagged or has a lot of detail, try a higher value to get a more-accurate selection.

✔ **Tablet Pressure (Pen icon):** If you own a pressure-sensitive drawing tablet, select this option to make an increase in stylus pressure to cause the edge width to decrease.

Follow these steps to use the Magnetic Lasso tool:

1. **Select the Magnetic Lasso tool in the Tools panel.**

 You can also press the L key if the tool is visible. If it isn't, press Shift+L to cycle through the Lasso tools. The tool looks like a straight-sided lasso with a magnet on it.

2. **Click and release on the edge of the element you want to select to place the first fastening point.**

 Start anywhere, but be sure to click the edge between the element you want and the background you don't want.

3. **Move your cursor around the object without clicking.**

 The Magnetic Lasso tool creates a selection line similar to the other lasso tools while placing fastening points that anchor down the selection line (see Figure 1-9). Think of it as the way you might cordon off an area of your yard with ropes and stakes.

 Here are a couple tips to keep in mind when working with the Magnetic Lasso tool:

 • *If the Magnetic Lasso tool starts veering off the edge of your object,* back up your mouse and click and release to force a fastening point farther down on the line.

 • *If the Magnetic Lasso tool adds a point where you don't want one,* simply press your Backspace (Delete on a Mac) key to delete it.

 • *If the Magnetic Lasso is misbehaving,* you can temporarily switch to the other Lasso tools. To select the Lasso tool, press the Alt key (Option key on the Mac), and then press the mouse button and drag. To select the Polygonal Lasso tool, press the Alt (or Option) key and click; don't drag.

4. **Continue moving the mouse around the object and then return to your starting point; click and release the mouse button to close the selection.**

A small circle appears next to your cursor, indicating that you're at the correct place to close the selection. The selection border appears when the selection is closed.

Fastening points

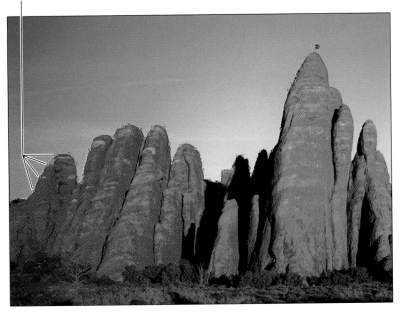

Corbis Digital Stock

Figure 1-9: The Magnetic Lasso tool snaps to the edge of your element.

Performing Wand Wizardry

The Magic Wand has been around since the beginning of the digital-imaging era. You'd think, with a name like Magic Wand, it'd grant your every selection wish with a mere click. Well, yes and no. The success of the Magic Wand really depends on your particular image.

It's a no-brainer to operate. Click the element you want within your image, and the Magic Wand makes a selection. This selection is based on the color of the pixel (the *target* pixel) directly under the cursor when you click. If other pixels are similar in color to your target pixel, Elements includes them in the selection. What's sometimes hard to predict, however, is how to determine *how similar* the color has to be to get the Magic Wand tool to select it. That's where the Tolerance setting comes in. First, here's a little info on Tolerance so you can better wield the Wand.

Talking about Tolerance

The Tolerance setting determines the range of color that the Magic Wand tool selects. The issue is that most images contain a few shades of a similar color. For example, consider an image of a field of grass. A few shades of green make up that field. Using the Magic Wand tool, if you click a darker shade of green, it selects all similar shades of green, but the lighter shades remain unselected. This is a sign that you need to increase the Tolerance level to select all the shades of the green grass. Tolerance is based on brightness levels that range from 0 to 255. That being said

✔ Setting the Tolerance to 0 selects one color only.

✔ Setting the Tolerance to 255 selects all colors, or the entire image.

The default setting is 32; so whenever you click a pixel, Elements analyzes the value of that base color and then selects all pixels whose brightness levels are between 16 levels lighter and 16 levels darker.

What if an image contains a few shades of the same color? It's not a huge problem. You can try different Tolerance settings. Try a higher Tolerance setting if you didn't quite pick up what you wanted in the first try, as shown in Figure 1-10. Conversely, if your wand selects too much, you can also lower your Tolerance setting. Or you can make multiple clicks of the Magic Wand to pick up additional pixels that you want to include in the selection.

Selecting with the Magic Wand tool

The Magic Wand tool works best when you have high-contrast images or images with a limited number of colors. For example, the optimum image for the Wand would be a solid-colored object on a white background. Skip the Wand if the image has a ton of colors and no real definitive contrast between your desired element and the background.

1. **Select the Magic Wand tool in the Tools panel.**

 It looks like, well, a wand. You can also press the W key.

2. **Click the portion of the image that you want to select, using the default Tolerance setting of 32.**

 The pixel that you click (the *target* pixel) determines the base color. Remember, the default value of 32 means that the Magic Wand tool selects all colors that are 16 levels lighter and 16 levels darker than the base color.

 If you selected everything you wanted the first time you used the Magic Wand tool, give yourself a pat on the back. If you didn't (which is probably the case), go to Step 3.

Tolerance of 32

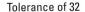

Tolerance of 64

Corbis Digital Stock

Figure 1-10: Finding the right Tolerance is the key to selecting with the Magic Wand.

3. **Enter a new Tolerance setting on the Options bar.**

 If the Magic Wand tool selected more than you wanted it to, lower the Tolerance setting. If it didn't select enough, raise the setting.

 Here are a few other options to specify:

 • *Anti-alias:* This option subtly softens the edge of the selection. See "Using the Marquee options" earlier in this chapter for details.

 • *Contiguous:* When this option is selected, the Magic Wand tool selects *only* pixels that are adjacent to each other. When this option is unselected, the Magic Wand tool selects all pixels within the range of tolerance, whether or not they're adjacent to each other.

- *Sample All Layers:* If you have multiple layers and enable this option, the Magic Wand selects pixels from all visible layers. If unselected, the tool selects pixels from the active layer only. For more on layers, see Book VI.

- *Refine Edge:* This option enables you to clean up the selection edges. See the earlier section "Freeform Selecting with the Lasso Tools" for details on this option.

4. **Click the portion of the image that you want to select.**

 Changing the Tolerance level doesn't adjust the current selection, so you must start again by clicking your image. The Magic Wand tool then deselects the current selection and makes a new selection — based on the new Tolerance setting, as shown in Figure 1-11. If it still isn't right, you can adjust the Tolerance setting again. Unfortunately, it's all about trial and error.

Purestock

Figure 1-11: Select a portion of your image with the Magic Wand tool.

Painting with the Selection Brush

If the action of painting on a canvas is more up your alley, try out the Selection Brush. Using two different modes, you can either paint over areas of an image that you want to select or paint over areas you don't want to select. The Selection Brush also lets you make a basic selection with another tool, such as the Lasso, and then fine-tune the selection by brushing additional pixels into or out of the selection.

Follow these steps to paint a selection with the Selection Brush:

1. **Select the Selection Brush from the Tools panel or simply press the A key (or Shift+A if the tool isn't visible).**

 This tool works in either Edit Full or Edit Quick mode.

2. **Specify your Selection Brush options in the Options bar.**

 Here's the scoop on each option:

- *Brush Presets:* Choose a brush from the presets drop-down panel. To load additional brushes, click the downward-pointing arrow to the left of Default Brushes and choose the preset library of your choice. You can select the Load Brushes command from the panel pop-up menu.

- *Brush Size:* Enter a brush size from 1 to 2500 pixels. You can also drag the slider.

- *Mode:* Choose between Selection and Mask. Choose Selection to add to your selection and choose Mask to subtract from your selection. If you choose Mask mode, you must choose some additional overlay options. An *overlay* is a layer of color (that shows onscreen only) that hovers over your image, indicating protected or unselected areas. You must also choose an overlay opacity between 1 and 100 percent. You can also choose to change the overlay color from the default red to another color. This option can be helpful if the image contains a lot of red.

- *Hardness:* Set the hardness of the brush tip, from 1 to 100 percent.

3. **If your Mode is set to Selection, paint over the areas you want to select.**

 You see a selection border. Each stroke adds to the selection. If you inadvertently add something you don't want, simply press the Alt key (Option key on the Mac) and paint over the undesired area. After you finish painting what you want, your selection is ready to go.

4. **If your Mode is set to Mask, paint over the areas that you *don't* want to select.**

 When you're done painting your mask, choose Selection from the Mode drop-down list or simply choose another tool from the Tools panel in order to convert your mask into a selection border.

 While you paint, you see the color of your overlay. Each stroke adds more to the overlay area, as shown in Figure 1-12. When working in Mask mode, you're essentially covering up, or *masking,* the areas you want to protect from manipulation. That manipulation can be selecting, adjusting color, or performing any other Elements

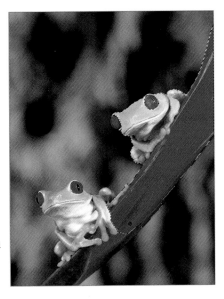

Digital Vision

Figure 1-12: The Selection Brush allows you to make a selection (right) by creating a mask (left).

command. Again, if you want to remove parts of the masked area, press the Alt key (Option key on the Mac) and paint.

If you painted the selection in Mask mode, the selection border is around what you *don't* want. To switch to what you *do* want, choose Select⊅Inverse.

The Mode you choose is up to you. One advantage to working in Mask mode is that you can partially select areas. By painting with soft brushes, you create soft-edged selections. These soft edges result in partially selected pixels. If you set the overlay opacity to a lower percentage, the pixels are even less opaque or "less selected." If this "partially selected" business sounds vaguely familiar, it's because this is also what happens when you feather selections, as we discuss earlier in this chapter.

Saving Time with the Quick Selection Tool

None of us ever have enough time, so any tool that can shave a few minutes off a selection task is welcome. The Quick Selection tool can do just that. Think of it as a combo Brush/Magic Wand/Lasso tool. Easy to use — and producing surprisingly good results — it's sure to become a favorite part of your collection of selection tools.

To make short work of selecting by using this tool, follow these steps:

1. **Select the Quick Selection tool from the Tools panel.**

 The tool looks like a wand with a marquee around the end. It shares the same flyout menu as the Selection Brush tool. You can also press the A key — or press Shift+A if the tool isn't visible.

 This is one of the few tools that works in either Edit Full or Edit Quick mode.

2. **Specify the options on the Options bar.**

 Here's an explanation of the options:

 - *New Selection:* The default option enables you to create a new selection. There are also options to add to and subtract from your selection.

 - *Brush Picker:* Choose your desired brush settings. Specify the diameter, from 1 to 2500 pixels. You can also specify hardness, spacing, angle, and roundness settings.

 - *Sample All Layers:* If the image has layers and you want to make a selection from all the layers, select this option. If this option is left unselected, you can select only from the active layer.

 - *Auto-Enhance:* Check this option to have Elements assist you with automatically refining your selection by implementing an algorithm.

3. **Click and drag over the desired areas of the image.**

 Your selection grows while you drag, as shown in Figure 1-13.

 If you stop dragging and click another portion of the image, your selection includes that clicked area.

Digital Vision

Figure 1-13: Paint a selection with the Quick Selection tool.

4. **Modify your selection, as needed.**

 You have three options to change your selection:

 * To add to your selection, press the Shift key while dragging across your desired image areas.

 * To delete from your selection, press the Alt key (Option key on the Mac) while dragging across the unwanted image areas.

 * You can also select the Add to Selection and Subtract from Selection options in the Options bar.

5. **If you need to further fine-tune your selection, click the Refine Edge option in the Options bar.**

 We explain the Refine Edge settings in detail in the "Freeform Selecting with the Lasso Tools" section, earlier in this chapter. If the object is

fairly detailed, you may even need to break out the Lasso or another selection tool to make some final clean-ups.

Resizing Smartly with the Recompose Tool

The new Recompose tool is like a combination crop and transform tool. You can move elements closer together or even change the orientation of a landscape shot from horizontal to vertical without eliminating your most important elements.

Follow these steps to recompose:

1. **In the Editor, in Edit Full mode, select the Recompose tool from the Tools panel.**

 This tool shares the same flyout menu with the Crop tool.

2. **Using the Brushes and Erasers in the Options bar, mark the areas you wish to protect and eliminate.**

 Although this step isn't mandatory, it yields better results.

 Here's a description of these options:

 • *Mark for Protect Brush:* Brush over the areas of the image you want to protect, or retain (strokes will be green). You don't have to be super precise; just provide Elements an idea of what you want to keep (or remove, in the case of the next brush).

 • *Mark for Removal Brush:* Brush over those areas you want to remove first (strokes will be red). Make sure to choose the area you don't mind deleting at all, as shown in Figure 1-14.

Figure 1-14: Mark areas that you wish to retain or remove.

- *Erase Highlight Marked for Protection:* Use this tool to erase any area you mistakenly marked to retain.

- *Erase Highlights Marked for Removal:* Use this tool to erase any area you mistakenly marked to remove.

3. **Specify the other options on the Options bar.**

 Here's a description of those options:

 - *Brush Size:* Adjust the Brush size by clicking the down-pointing arrow and dragging the slider to make the brush diameter smaller or larger.

 - *Suggest Skin Tone Region:* Select this option to preserve skin tones from being distorted when scaled.

 - *Presets:* Use a preset ratio or size to which to recompose your image. Or leave on the default of No Restriction.

 - *Width and Height:* Enter width and height scale percentages if desired.

 - *Amount:* Set a recomposition threshold to help minimize distortion. Start with a higher percentage and then adjust as needed.

4. **Grab the image handle and resize your image.**

 As you drag, you'll notice the red areas are removed first and the green areas remain intact. After all the red areas have been removed, Elements begins to "carve" out areas you didn't indicate to protect.

5. **After you recompose your image as desired, click the Commit (green) check mark icon to accept the composition.**

 Retouch any areas as needed with the Clone Stamp or Healing tools. For our example, shown in Figure 1-15, we retouched some of the background trees.

Figure 1-15: A recomposed image.

Chapter 2: Modifying and Transforming Selections

In This Chapter

✓ Adding and subtracting from a selection

✓ Using the Select commands

✓ Feathering selections

✓ Saving and loading selections

✓ Moving and cloning a selection

✓ Transforming selections

*F*or most people, getting the perfect, pristine selection on the first attempt is pretty difficult. A little too much caffeine or not enough shut eye, and that once steady hand is no longer so. Fortunately, Elements, being the compassionate digital-imaging friend that it is, understands this and doesn't make you settle for inaccurate selections. You have many ways to modify and transform selections to refine them to the point of near-perfect accuracy. You can add or remove pixels from your selection, scale the selection outline, smooth out jagged edges, or switch what's selected for what isn't. In this chapter, we'll show you how how to clean up and modify your selections and enable you to nail the desired element with precision.

If you haven't already checked out the first chapter of Book IV and gotten a good grasp of how to create selections in the first place, you may want to start there.

Modifying Selections

Although the selection tools, such as the Lasso, Quick Selection, and Magic Wand, usually do a fair job of capturing most of the desired selection, making a really accurate selection often requires some amount of modification and cleanup. If you give the selection a little extra TLC, you're rewarded with more accuracy and precision. By adding and subtracting from the selection, you can refine it and ensure that you capture only what you really want.

With the multitude of tools and features in Elements, you can usually execute the task in more than one way. In this section, we show you how to use keyboard operations (along with your mouse) to modify your selections. But note that you can also use the four selection option buttons on the left side of the Options bar to create a new selection, add to a selection, subtract from a selection, or intersect one selection with another. You just choose the selection tool, click the selection option button you want, and drag (or click and release, if you're using the Magic Wand or Polygonal Lasso tool). When you're using the Selection Brush, the Add to Selection and Subtract from Selection buttons are also available.

When adding to a selection, a small plus sign (+) appears next to your cursor. When subtracting from a selection, a small minus sign (–) appears. When intersecting two selections, a small multiplication sign (×) appears.

Adding to a selection

If your selection doesn't contain all the elements you want to capture, you need to add those portions to your current selection.

To add to a current selection, simply hold down the Shift key and click and drag around the pixels you want to include when using the regular Lasso or the Rectangular or Elliptical Marquee tool. If you're using the Polygonal Lasso, click and release around the area. (We wouldn't use the Magnetic Lasso tool to add to a selection; it's way too cumbersome.)

You can also hold down the Shift key and click the area you want when using the Magic Wand tool, or drag on the area you want when using the Quick Selection tool.

After your first drag with the Quick Selection tool, your selection option button should convert to the Add to Selection button automatically. When using the Selection Brush in Selection mode, the selection option button is also set automatically to the Add to Selection button.

You don't have to use the same tool to add to your selection that you used to create the original selection. Feel free to use whatever selection tool you think can get the job done. For example, it's common to start off with the Magic Wand and clean up your selection with the Lasso tool. See Book IV, Chapter 1 if you need more info on selection tools.

Follow these steps to add to a circular selection, such as the one shown in Figure 2-1:

1. **Make your first elliptical selection with the Elliptical Marquee tool, as shown in the top example in Figure 2-1.**

Be sure you hold down the Alt key (Option key on the Mac) to draw from the center out. Also, press the Shift key if you wish to constrain your selection to a circle.

2. **To add to your initial selection, hold down two keys at once: First hold down the Shift key to add to the selection and then hold down the Alt (or Option) key to draw from the center out.**

You must press and hold down the keys in this order.

Note that if you also need to constrain your selection to a perfect circle, you have a dilemma because the Shift key is already being used to add to the selection. See the upcoming section "Avoiding Keyboard Collisions" for a solution.

3. **Drag around the second selection by using the Elliptical Marquee tool.**

PhotoDisc/Getty Images

Figure 2-1: The original selection (top) is increased after including additional pixels (bottom).

We would have to do Steps 2 and 3 several times in order to select all the tennis balls. Figure 2-1 shows the steps repeated a few times.

Subtracting from a selection

Just as you can add to a selection marquee, you can also subtract from a selection. Here's how to subtract from a current selection using the following tools:

✐ **Using the Lasso or the Rectangular or Elliptical Marquee tool:** Hold down the Alt key (Option key on the Mac) and drag around the pixels you want to subtract.

✐ **Using the Magic Wand and Quick Selection tools:** Hold down the Alt key (Option key on the Mac) and click the area you want to remove.

✐ **Using the Polygonal Lasso tool:** To subtract a straight-sided area, hold down the Alt key (Option key on the Mac) and click and release around the area.

✐ **Using the Selection Brush tool:** Hold down the Alt key (Option key on the Mac) and drag.

In Figure 2-2, we first selected the frame by using the Polygonal Lasso tool. We didn't use the obvious tool of choice — the Rectangular Marquee tool — because the frame wasn't completely straight. To deselect the inside of the frame from the selection, we again used the Polygonal Lasso tool, holding down the Alt key (Option key on the Mac) and clicking at each corner of the inside of the frame to produce the selection shown.

Intersecting two selections

What happens when you hold down Shift+Alt (Shift+Option on the Mac) together? An *intersection,* that's what. Holding down both keys while dragging with the Lasso and Marquee tools, clicking and releasing with the Polygonal Lasso tool, or clicking with the Magic Wand tool all create the intersection of the original selection with the second selection.

PhotoDisc/Getty Images

Figure 2-2: Press the Alt (or Option) key to delete from the existing selection.

Avoiding Keyboard Collisions

Elements has a little conflict in its methods. With so many ways of doing things, sometimes you may have to fiddle with Elements to get it to do what you want. For example, when you press the Shift key, how does Elements know whether you want to create a perfect square or add to a selection? Or, what if you want to delete part of a selection while also drawing from the center outward? Both actions require the use of the Alt key (Option key on the Mac). There is a way out of this keyboard madness.

Adding a perfectly square or circular selection

To add a perfectly square or round selection to an existing selection, follow these steps:

1. **Hold down the Shift key and drag when using the Rectangular or Elliptical Marquee tool.**

 Your selection is unconstrained.

2. **While you drag, keeping your mouse button pressed, release the Shift key for just a moment, and then press and hold it again.**

 Your unconstrained selection suddenly snaps into a constrained square or circle.

3. **Release the mouse button before you release the Shift key.**

 If you don't release the mouse button before you release the Shift key, the selection shape reverts back to its unconstrained form.

You can bypass the above keyboard shortcuts by using the various selection buttons on the left side of the Options bar.

Deleting from an existing selection while drawing from the center out

To delete part of a selection while drawing from the center out, follow these steps:

1. **Position your mouse cursor in the center of your desired selection. Hold down the Alt key (Option key on the Mac) and drag when using the Rectangular or Elliptical Marquee tool.**

2. **While you drag, keeping your mouse button pressed, release the Alt key (Option key on the Mac) for just a moment, and then press and hold it again.**

 You're now drawing from the center outward.

3. **Release the mouse button before you release the Alt key (Option key on the Mac).**

Use this technique when you're selecting a doughnut, tire, inflatable swim ring, or other circular items that have holes in the middle, as shown in Figure 2-3.

Using the Select Menu

Although you can add, subtract, and intersect selections by using the Shift and Alt keys (Option key on the Mac) and the selection option buttons on the Options bar, you can do even more with the commands on the Select menu, as shown in Figure 2-4. In this menu, you find ways to expand, contract, smooth, and soften your selec-

ImageState

Figure 2-3: You can delete from an existing selection and draw from the center out simultaneously.

tion, and even turn your selection inside out. You can also use this menu to automatically select similar colors. If you use the Select menu, your selections should be ready and rarin' for action.

Selecting all or nothing

The All and Deselect commands are pretty self-explanatory. To select everything in your image, or if your image has layers, everything in the chosen layer, choose Select➪All or press Ctrl+A (⌘+A on the Mac). To deselect everything, choose Select➪Deselect, Ctrl+D (⌘+D on the Mac). Remember that you rarely have to use All. If you don't have a selection border in the image, Elements assumes that you want to apply whatever command you execute to the entire image (or layer).

Reselecting a selection

If you've taken some valuable time to carefully lasso a spiky iguana from its perch on a mangrove tree, the last thing you want is to lose your hard-earned selection border. But that's what happens if you inadvertently click the image when you have an active selection border — it disappears.

Figure 2-4: The commands on the Select menu.

Yes, technically, you can choose Edit➪Undo if you catch your error right away. And, you can access the Undo History panel to recover your selection. But a much easier solution is to choose Select➪Reselect, which retrieves your last selection.

The Reselect command works for only the last selection you made, so don't plan to reselect a selection you made last Wednesday — or even two minutes ago — if you've selected something else after that selection. If you want to reuse a selection for the long term, save it, as we explain in the section "Saving and loading selections," later in this chapter.

Inversing a selection

Sometimes, selecting what you don't want is easier than selecting what you do want. For example, if you're trying to select your cat Princess, photographed against a neutral background, why spend valuable time meticulously selecting her with the Lasso tool, when you can just click the background with the Magic Wand tool?

After you select the background, just choose Select⇨Inverse. *Voilà,* Princess is selected and obediently awaiting your next command, as shown in Figure 2-5.

Feathering a selection

In Chapter 1 of this minibook, we describe how to *feather* (soften or blur the edges of) a selection when using the Lasso and Marquee tools by entering a value in the Feather option in the Options bar. This method of feathering requires that you set your Feather radius *before* you create your selection.

A problem may arise with feathering before you select if later you want to modify your initial selection. When you make a selection with a feather, the selection border adjusts to take into account the amount of the feather. So, the resulting marquee outline doesn't resemble your precise mouse movement. As a result, modifying, adding, or subtracting from your original selection is pretty difficult.

PhotoDisc/Getty Images

Figure 2-5: Sometimes, you want to select what you don't want and then inverse your selection.

A much better way to feather a selection is to make your initial selection without a feather, as shown in the left image of Figure 2-6. Clean up your selection as necessary and then apply your feather by choosing Select⇨ Feather. In the dialog box, enter a radius value from .2 to 250 pixels and click OK. The resulting selection appears in the right image of Figure 2-6.

The *radius* is how far out in all directions the feather extends. A radius of 8 means the feather extends 8 pixels outward from the selection outline. A large feather radius makes the image appear to fade out.

The Refine Edge command, which appears right after Feather in the Select menu, enables you to fine-tune your selection edges using various options. For full details on this option, see the section "Freeform Selecting with the Lasso Tools" in Book IV, Chapter 1.

Using the Modify commands

The Select⇨Modify menu contains a group of modification commands that are lumped together categorically. You probably won't use these options every day, but sometimes they can come in handy. Here's the lowdown on each command:

✓ **Border:** Selects the area around the edge of the selection. You specify the width of the area from 1 to 200 pixels, and you get a border outline, as shown on the left in Figure 2-7. Choose Edit⇨Fill Selection and fill the border with color, as shown in the right image in Figure 2-7.

Book IV Chapter 2

Modifying and Transforming Selections

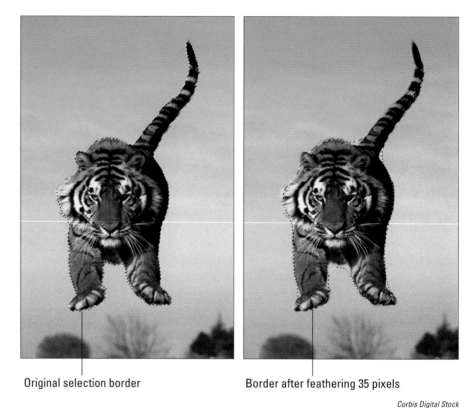

Original selection border | Border after feathering 35 pixels

Corbis Digital Stock

Figure 2-6: You can more easily clean up your selection prior to applying a feather.

✏ **Smooth:** Rounds off the nooks, crannies, and jagged edges. Enter a radius value from 1 to 100 pixels, and Elements looks at each selected pixel and then includes or deselects the pixels based on the radius value. If most of the pixels are selected, Elements includes the strays; if most of the pixels are unselected, Elements removes these pixels. Start with 2 pixels or so — and if that doesn't seem like enough, increase it by a few pixels.

Use this command with great caution. It's just too easy to get mushy, inaccurate selections.

✏ **Expand:** Increases the size of your selection by a specified number of pixels, from 1 to 100. This command comes in handy if you just miss the edge of an elliptical selection and want to enlarge it just a tad.

✏ **Contract:** Shrinks your selection by 1 to 100 pixels. When you're compositing multiple images, you can benefit by slightly contracting your selection if you plan on applying a feather. This enables you to avoid picking up a fringe of background pixels around your selection.

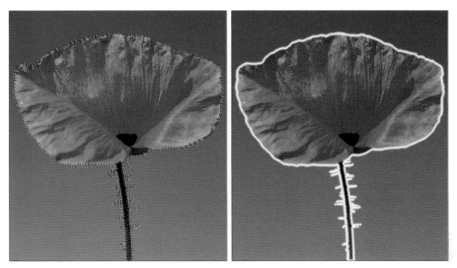

Figure 2-7: The Border command creates a selection outline, which you can then fill with color.

After you make a selection, contract it and then feather it before you drag it onto the canvas. This technique helps to create a natural-looking transition between the images in your composite. The amount you decide to contract and feather varies according to the resolution of the images. For example, if you're using low-resolution (72 pixels per inch [ppi]) images, you may want to use 1 pixel for the Contract amount and 0.5 pixels for the Feather amount; higher-resolution images may warrant 2 to 3 pixels for the Contract amount and 1 to 2 pixels for the Feather amount. If *resolution* makes you scratch your head, see Book III, Chapter 1.

Applying the Grow and Similar commands

The Grow and Similar commands are often mentioned in the same breath with the Magic Wand tool. If you didn't get the perfect selection on the first click — a very common occurrence, unfortunately — you can use the Grow command. For example, to include more in your selection, you increase the Tolerance setting and try again — hold down the Shift key and click the area to include. Or you can choose Select➪Grow. The Grow command increases the size of the selection by including adjacent pixels that fall within the range of Tolerance.

The Similar command is like Grow, only the pixels don't have to be adjacent to be selected. The command searches throughout the image and picks up pixels within the Tolerance range.

Both commands use the Tolerance value that's displayed on the Options bar when you have the Magic Wand tool selected. Adjust the Tolerance setting to include more or fewer colors by increasing or decreasing the setting, respectively.

Saving and loading selections

If you've invested valuable time perfecting a complex selection, we highly recommend that you save it for future use. It's extremely easy to do and will prevent you from having to start from square one again. Here's what you do:

1. **After you make your selection, choose Select⇨Save Selection.**

2. **In the Save Selection dialog box, leave the Selection option set to New and enter a name for your selection, as shown in Figure 2-8.**

 The option defaults to New Selection.

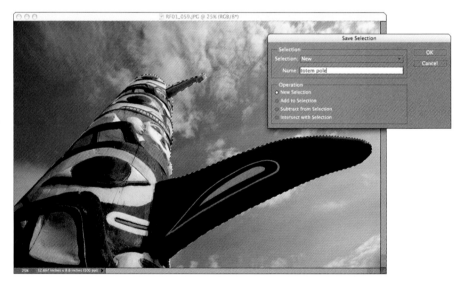

Jake Starley

Figure 2-8: Save your selection to load for later use.

3. **Click OK.**

4. **When you want to access the selection again, choose Select⇨Load Selection and choose a selection from the Selection drop-down list.**

 To inverse your selection, click the Invert box. Note that you also have options to add to, subtract from, or intersect with your selection. These

options can come in handy if you want to modify your existing selection. For example, you may select just the head of a person and not the full body. You later decide that you really need the whole person. Rather than make a whole new selection, you can select just the body and then choose Add to Selection, and you have your whole person. If you want, you can then save the whole person as a new selection for later use.

Moving and Cloning Selections

When you have your selection modified to perfection, you may then want to move it or clone it. To move a selection, simply grab the Move tool (the four-headed arrow) in the Tools panel and then drag the selection.

Sounds easy enough, right? When you move the selection, however, be warned that the area where the selection used to reside is now filled with the background color, as shown in Figure 2-9. It turns out, though, that the background color appears only if you decide to move both the selection outline and the image pixels. But you don't *have* to move both; you can move just the selection outline (without the pixels), as we explain in the section "Moving the selection outline, but not the pixels," later in this chapter. Also, if you're moving a selection on a layer, you're left with transparent pixels (see Book VI).

The Move tool has a few options residing in the Options bar that are mostly relevant when working with layers. For a description of these options, see Book VI, Chapter 2.

Cloning

If you don't want to leave a hole in your image, you can copy and move the selection, leaving the original image intact, as shown in Figure 2-10. Just hold down the Alt key (Option key on the Mac) and drag when using the Move tool. This action is often referred to as *cloning* because you're essentially making a duplicate of a selected area and then moving that duplicate elsewhere.

Moving the selection outline, but not the pixels

If all you want to do is move the selection outline without moving the pixels underneath, for example, to better center an elliptical selection around what you want, avoid using the Move tool. Instead, choose any selection tool — a Marquee or Lasso tool — and then click anywhere inside the selection and just drag. That way, you move only the outline of the element, not the pixels of the element itself. You can also use the arrow keys to nudge a selection marquee.

Figure 2-9: When you move a selection by using the Move tool, you leave a hole that reveals the background color.

Transforming Pixels

After you select an element, you may find you need to resize or reorient that element. *Transforming* involves scaling, rotating, skewing, distorting, flipping, or adjusting the perspective of your pixels. Although you may consider these types of transformations somewhat pedestrian, we're sure you'll find them practical and useful in your daily digital-imaging chores.

Follow these steps to transform a selection:

1. **Create your selection.**

 We leave this task up to you; just use your selection expertise (or refer to Book IV, Chapter 1 for assistance).

 You can also apply transformations to a layer or to multiple layers. (For more on this topic, see Book VI.)

Figure 2-10: Hold down the Alt (or Option) key while dragging to clone a selection without leaving a hole.

2. **If you need to rotate the selection, choose Image➪Rotate.**

 - *Free Rotate Selection:* Enables you to manually rotate the selection.

 - *Selection 180°, 90° Left, or 90° Right:* Rotates the selection by specified amounts.

 - *Flip Selection Horizontal or Vertical:* Flips your selection along the vertical or horizontal axis, respectively.

 The other rotate commands have to do with layers. See Book VI, Chapter 1 for more info.

3. **To scale the selection, choose Image➪Resize➪Scale.**

4. **To freely transform, skew, distort, or adjust the perspective of a section, choose Image➪Transform and then choose a transformation type from the submenu:**

 - *Free Transform:* Enables you to rotate, resize, skew, distort, and adjust perspective all within a single command. See the "Distorting

selected pixels with Free Transform" sidebar for more on this productive command.

- *Skew:* Distorts your selection on a given axis.

- *Distort:* Distorts your selection with no restrictions on an axis.

- *Perspective:* Applies a one-point perspective to your selection.

As soon as you select your desired distortion and release the mouse button, a *bounding box* or *transform box* surrounds your selection, complete with handles on the sides and corners. You don't get a bounding box when you select the Flip or Rotate (by degrees) transformations (these commands just get applied to your image).

5. **Depending on which transformation type you choose in Steps 2, 3, or 4, drag the appropriate handle:**

- *Free Rotate:* Move your cursor outside the bounding box. When the cursor becomes a curved arrow, drag clockwise or counterclockwise. Hold down the Shift key to rotate in 15-degree increments.

 Remember choosing Rotate 180°, 90° CW, or 90° CCW, or Flip Horizontal or Vertical just executes the command. Handle-dragging isn't necessary.

- *Scale:* Corner handles work best for this transformation. Hold down the Shift key to scale proportionately. Hold down the Alt key (Option key on the Mac) to scale from the center.

- *Skew:* Drag a side handle.

- *Distort:* Drag a corner handle.

- *Perspective:* Drag a corner handle.

Distorting selected pixels with Free Transform

An efficient way to apply multiple transformations is to use the Free Transform command. Like the Transform command, the Free Transform command surrounds the selection with a bounding box. Within the bounding box, you can scale, rotate, skew, distort, or apply perspective without having to choose the individual distortions. You just have to use the right keyboard shortcuts. To scale and rotate, use the same method as the Image⇨Scale and Image⇨Rotate⇨Free Rotate commands. Here's the scoop on the rest:

- ✓ **Skew:** Ctrl+Shift-drag (⌘+Shift-drag on the Mac) on a side or corner handle.

- ✓ **Distort:** Ctrl-drag (⌘-drag on the Mac) on any handle.

- ✓ **Perspective:** Ctrl+Shift+Alt-drag (⌘+Shift+Option-drag on the Mac) on a corner handle.

If you forget these tedious keyboard shortcuts, simply right-click with the mouse (Control-click on the Mac) to access a context-sensitive menu with the transform commands from which you can then select.

Elements executes all the transformations around a *reference point*. The reference point appears in the center of the transform box by default. You can move the reference point anywhere you want, even outside the bounding box. In addition, you can set your own reference point for the transformation by clicking a square on the reference point locator on the Options bar. Each square corresponds to a point on the bounding box.

You can also use the fields in the Options bar to perform most of your transformations. After choosing any of the transformation commands from the menu, fields for a numeric entry to scale, rotate, and skew appear in the Options bar.

Execute all your transformations in one fell swoop, as shown in Figure 2-11, if possible. In other words, don't scale a selection now and then five minutes later rotate it, and then five minutes after that distort it. Every time you apply a transformation to an image, you're putting it through a resampling process. You want to limit how many times you resample an image because it has a degrading effect — your image starts to appear soft and mushy. Only flipping or rotating in 90-degree increments is resample free. For more on resampling, see Book III, Chapter 1.

6. **After you transform the selection to your liking, double-click inside the bounding box or click the Commit button on the Options bar.**

 To cancel the transformation, press Esc or click the Cancel button on the Options bar.

Handle Bounding box

**Book IV
Chapter 2**

Modifying and
Transforming
Selections

Corbis Digital Stock

Figure 2-11: Apply all transformations at the same time to minimize interpolation.

Your selection is now magically transformed. If your image isn't on a layer, you can end up with a hole filled with the background color after your image is transformed. Check out Book VI on layers to avoid this calamity.

 When the Move tool is active, you can transform a layer without choosing a command. Select the Show Bounding Box option on the Options bar. This option surrounds the layer or selection with a box that has handles. Drag the handles to transform the layer or selection.

Putting It Together

Removing an Element from an Image

Sometimes, you remove a distracting element from a picture to provide a stronger focal point. Or maybe you just don't want the element in the image. But remember, if you simply delete an unwanted element without cloning, you leave a hole (colored with the background color or transparent) in place of the element. Probably not what you want.

Follow these steps to remove an unwanted element (in this case, a bystander) from an image:

 When you first attempt this technique, start with an image that has an element not physically attached to something you want to keep in the image.

1. **Open an image that contains something you want to remove.**

2. **Use the selection tool of your choice to select the element that you want to remove.**

In this step, you're creating a selection border that you use to clone another area of the image.

You don't have to be super-precise, so feel free to grab a Lasso tool. When you make your selection, be careful not to cut off any portion of the element. Otherwise, you leave some stray pixels — a dead giveaway that

Selection border

something was once there. Using the Polygonal Lasso tool, we made a rough outline around the bystander on the right, as shown in the preceding figure.

3. **Position your cursor inside the selection border, press and hold the mouse button, and drag your selection to move it horizontally (or vertically, if the image warrants it) to an area of the photo that you want to clone.**

 The selection border, shown in the figure on the left, is the only thing that we moved.

4. **With the Move tool selected, position your cursor inside the selection marquee, hold down Alt key (Option key on the Mac), and then drag to move the cloned area on top of the element that you're removing. Carefully match up the edges, as shown in the figure, release your mouse button, and then release the Alt key (Option key on the Mac).**

5. **Choose Select⇨Deselect.**

 The cloned area now covers the element that you want to remove, as shown in the figure on the right. In the example, the sky selection now covers the bystander.

 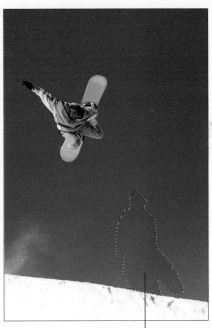

Area to be cloned Cloned area covers man

**Book IV
Chapter 2**

**Modifying and
Transforming
Selections**

continued

continued

Depending on your image, you may want to choose Select⇨Feather and enter a pixel or so before you move the cloned area. Feathering softens the edges and smoothes out the transition between the cloned area and the background. We didn't feather our selection because it wasn't necessary. Try it both ways to see which looks better. Use the Undo History panel to undo your steps, if necessary.

The final step is to clean up any telltale signs that the element was there.

6. **Select the Clone Stamp tool and select a medium-size feathered brush from the Brush Preset Picker on the Options bar, hold down the Alt key (Option key on the Mac), and click a good area next to a seam or flaw; release the Alt key (Option key on the Mac) and then click the flaw.**

If the Clone Stamp is a mystery to you, be sure to check out Book VIII, Chapter 1.

Repeat this step until you fix all the flaws and the clone blends in seamlessly with the background. Don't get carried away with the Clone Stamp tool, or you may end up with a smudgy mess. Being light-handed is a good thing, as we were in the now-retouched image. Nobody can tell that the awesome snowboarder had an audience at one time.

Book V
Painting, Drawing, and Typing

The 5th Wave · By Rich Tennant

"Are you using that 'clone' tool again?!"

*B*ring out your inner artist by traveling through the chapters in this book. We've packed a lot of material in it covering drawing, painting, and adding text to your photos. By following some of the simple steps we present, you can become the artist you never dreamed you could be.

Chapter 1: Painting and Drawing with Elements

In This Chapter

- Making pencil sketches and brush strokes
- Using Brush presets
- Creating basic and custom shapes
- Understanding vectors
- Setting Geometry options

Feel free to keep on your street clothes for this chapter on drawing and painting. The tools you work with in Elements are self-cleaning and don't require that you wear a smock. Painting is one of the basic skills you need to have down pat in Elements. After you get familiar with the technique of painting strokes and working with brushes, you're well on your way to mastering more-advanced skills, such as retouching, which come easier to you if you already have some strong painting skills under your belt.

In tandem with painting, of course, comes drawing. The Elements shape tools add an important dimension to your drawing capabilities. This chapter introduces you to a plethora of tools and techniques. We start with painting and then move on to drawing. Master both, and they can serve you well.

Introducing the Pencil and Brush Tools

The Pencil and Brush tools are like chocolate and mint. Not only do they work well together, but they also share many important attributes. Just as important, however, are their differences. You can access these tools in the Tools panel. Press the B key to make the Brush tool appear by default. By pressing Shift+B, you can toggle between the Brush tool, the Impressionist Brush, and the Color Replacement tools. Strangely enough, to access the Pencil, which shares the same flyout menu, press the N key.

Drawing with the Pencil tool

The Pencil and Brush tools are very much alike, except that the Pencil tool has hard edges whereas the Brush tool can have soft, feathered edges. In fact, the edges of a pencil stroke can't even be *anti-aliased.* Keep in mind that if you draw anything other than vertical or horizontal lines, the lines have some jaggies when they're viewed up close. But hey, don't dismiss the Pencil. Those hard strokes can work great for Web graphics because they lend themselves to producing crisp-edged images for display in a browser window. What's more, the Pencil tool can erase itself, and it's great for digital sketches, as shown in Figure 1-1.

Dover Publications

Figure 1-1: The Pencil tool draws hard-edged strokes and is used for digital sketches.

You can do all the following with the Pencil tool:

▰ Drag the mouse to draw freehand lines.

▰ Click at one point, release the mouse button, and then Shift-click at a second point to draw a straight line between the points. As long as you hold down the Shift key, you can keep clicking to draw straight lines between each of the points.

▰ Press the Alt key (the Option key on the Mac) and click any area of color in the drawing to switch the foreground color to that hue.

To try out the Pencil tool, follow these steps:

1. **Select the Pencil tool from the Tools panel.**

 The Pencil tool shares a flyout menu with the Brush tool. You can press the N key to make it appear if it's hidden underneath the Brush tool.

2. **In the Options bar, choose your pencil options. Options include**

 • *Brush preset:* By default, the Pencil tool's brush tip is the 1-pixel brush. Click the arrow and select your desired brush from the Brush Preset Picker drop-down panel that appears.

 • *Brush size:* A preset brush's pixel diameters are shown as text below a thumbnail image of the brush shape. If you want to change the size of that brush tip, drag the Size slider or enter a value.

- To load another preset library, click the Brushes pop-up menu at the top of the panel. You also find options to save, rename, or delete individual brushes and also save, load, and reset brush libraries.

3. **If you want to draw using anything other than Normal mode, select a mode from the Mode options menu in the Options bar.**

 Blend modes alter the interaction of the color you're applying with the color on your canvas. See more on blend modes in Book VI, Chapter 3.

4. **In the Options bar, specify an Opacity percentage for your pencil strokes.**

 If you want your background to show partially through your strokes, select an opacity of less than 100 percent by using the slider or by typing an opacity percentage directly into the text box. The lower the percentage, the more the background images show through.

 Your strokes must be on a separate layer above your images for you to be able to adjust the opacity and blend modes after you draw them. For more on layers, see Book VI, Chapter 1.

5. **Select Auto Erase to enable that option.**

 This option erases portions of your pencil strokes. For example, say that the foreground color is black and the background color is white, and you apply some black strokes. With Auto Erase enabled, you apply white if you drag back over the black strokes. If you drag over the white background, you apply black.

6. **Click and drag with the mouse to create your pencil lines.**

Painting with the Brush tool

The Brush tool is a popular tool used throughout Elements in various incarnations, so getting to know this tool and how it operates is a good idea.

The most important difference between the Brush and the Pencil tools is that, by default, the Brush tool produces soft-edged lines, as shown in Figure 1-2. How soft those strokes are depends on which brush you use. By default, even the hardest brush has a slightly soft edge because it's anti-aliased. *Anti-aliasing* creates a single

Pencil stroke

Anti-aliased brush stroke

Feathered brush stroke

Figure 1-2: Strokes from the Pencil and Brush vary in the softness of their edges.

row of partially filled pixels along the edges to produce the illusion of a smooth edge. You can also get even softer brushes, which employ feathering.

Although jagged edges are most apparent in diagonal lines, Elements applies anti-aliasing to brush-stroke edges, even in horizontal and vertical lines.

The Brush tool shares most of the basic options found in the Pencil tool, except that the Auto Erase feature isn't available.

Here are a few tips on working with the Brush tool and its unique options:

✔ Select the Brush tool from the Tools panel, or press the B key (or Shift+B) until you get the Brush.

✔ In the Options bar, click the arrow and select your desired brush tip from the Brush Preset Picker drop-down panel that appears.

✔ Select a mode and opacity from the options on the Options bar.

✔ Drag to paint, click and Shift-click to paint straight lines, and hold down the Shift key while dragging to constrain the Brush tool to horizontal or vertical lines.

✔ Press the Alt key (the Option key on the Mac) and click any area of color to switch the foreground color to that color.

The Brush tool has several other options to select from:

✔ **Airbrush:** Click the Airbrush button on the Options bar to apply the Airbrush mode. This mode produces the spray effect you get with a traditional airbrush. The longer you hold down the mouse button, the more paint pumps out of the tool, and the wider the airbrush effect spreads, as shown in Figure 1-3.

✔ **Tablet Options:** If you're using a pressure-sensitive digital drawing tablet, check the settings you want the tablet to control, including size, scatter, opacity, roundness, and *hue jitter* (switching of color between foreground and background colors). The harder you press with the stylus, the greater the effect of these options.

PhotoDisc

Figure 1-3: Using the Airbrush option with the Brush tool enables you to create varied strokes.

↙ **More Options:** In the Options bar, click the Brush icon to access additional options, referred to as brush dynamics. Brush dynamics enable you to change the brush strokes as you apply them. Here is a quick lowdown on each option (see Figure 1-4):

Fade

Hue Jitter

Scatter

Spacing

Hardness

Angle and
Roundness

Figure 1-4: Specify brush options to change the stroke's appearance.

- *Fade:* The lower the value, the quicker the stroke fades. Zero, however, creates no fade.
- *Hue Jitter:* This option varies the stroke between the foreground and background colors. The higher the value, the more frequent the variation.
- *Scatter:* The higher the value, the higher the number of brush marks and the farther apart they are.
- *Keep These Settings for All Brushes:* You can lock in these brush dynamics by selecting this check box, ensuring that every brush you select adopts these settings.
- *Spacing:* The higher the number, the more space between marks.
- *Hardness:* The higher the value, the harder the brush.

- *Angle:* If you create an oval brush by adjusting the roundness, this option controls the angle of that oval brush stroke. It's much easier to drag the points and the arrow on the diagram than to "guesstimate" values in the text boxes.

- *Roundness:* A setting of 100 percent is totally circular. The lower the percentage, the more elliptical your brush becomes.

Just as they do for the Pencil tool, more features for the Brush tool appear in the pop-up menu on the Brush Preset Picker drop-down panel (click the arrow at the top of the panel). Here's a quick explanation of each:

- **Save Brush:** Allows you to save a custom brush as a preset. See the following section for details.

- **Rename Brush:** Don't like the name of your brush? Give it a new one with this option.

- **Delete Brush:** Eliminate an unwanted brush with this option.

- **Reset Brushes:** Reverts your current brush library to the default.

- **Save Brushes:** Saves custom brushes in a separate library.

- **Load Brushes:** Loads a preset or custom brush library. They have names like Special Effect Brushes and Faux Finish Brushes. Select one to append the brushes to your current set or to replace the current set with the library you select. (A dialog box appears that offers a choice of either action.)

- **The display options:** A set of commands that enables you to change the way your brush tips are displayed in the drop-down panel. The default view is Stroke Thumbnail, which displays the appearance of the stroke. Other commands include Text Only (text names of brush tips), Small and Large Thumbnail (thumbnail images with diameter in pixels), and Small and Large List (thumbnail images with text names).

You can also manage brush tip libraries by using the Preset Manager (choose Edit➪Preset Manager).

Getting artsy with the Impressionist Brush

The Impressionist Brush is designed to paint over your photos in a way that makes them look like fine art paintings. You can set various options that change the style of the brush strokes.

Here's how to use this artistic brush:

1. **Select the Impressionist Brush from the Tools panel.**

 It looks like a brush with a curlicue next to it. You can also press the B key, or Shift+B, to cycle through the brushes.

2. **Set the brush options.**

 The Brushes, Size, Mode, and Opacity options are identical to those for the Brush tool, described in the previous section "Painting with the Brush tool." You can also find some unique options on the More Options panel, indicated by the Impressionist Brush icon:

 - *Style:* This drop-down list contains various brush stroke styles, such as Dab and Tight Curl.

 - *Area:* Controls the size of your brush stroke. The larger the value, the larger the area covered.

 - *Tolerance:* Controls how similar color pixels have to be before they're changed by the brush stroke.

3. **Drag on your image and paint with your brush strokes, as shown in Figure 1-5.**

 The best way to get familiar with the Impressionist Brush is to open your favorite image and experiment with the tool.

Creating a custom brush

After playing with all the various options, if you really like the personalized brush you've created, save it as a preset so that you can access it again and again. Click the arrow at the top of the Brush Preset Picker drop-down panel and choose Save Brush from the pop-up menu. Name the brush and click OK. Your new custom brush shows up at the bottom of the Brush Preset Picker drop-down panel.

There's one other way to create a brush. Elements enables you to create a brush from all or part of your image. The image can be a photograph or something you've painted or drawn.

Here's how to create a brush from your image:

1. **Select part of your image with any of the selection tools.**

 If you want to use the entire image or entire layer, deselect everything.

 For more on selections, see Book IV, Chapter 1.

Purestock

Figure 1-5: The Impressionist Brush transforms your photo into a painting.

2. **Choose Edit⇨Define Brush or Edit⇨Define Brush from Selection.**

 You see one command or the other, depending on what you do in Step 1.

3. **Name the brush and click OK in the dialog box.**

 The new brush shows up at the bottom of your Brush Preset Picker drop-down panel. Note that your brush is only a grayscale version of your image. When you use the brush, it automatically applies the color you've selected as your foreground color, as shown in Figure 1-6.

Purestock

Figure 1-6: Create a custom brush from a portion of your image.

Putting It Together

Colorizing Black-and-White Images

Just as there are artistic reasons for shooting a photo in black and white, there are also valid arguments for converting a grayscale image into a color one. Perhaps the picture is an old one, taken before color film was widely used, and you want to colorize it. Or you may come across a monochrome image that would look more interesting in color. Elements can let you add back the missing colors to your original black-and-white pictures or can give you free rein to create your own customized color image.

In our example, we chose a black-and-white photo of an adorable little girl. Rather than trying to duplicate a color photograph, we want to apply a technique that mimics the subtle, hand-colored look of the Marshall's Photo Coloring System of pigments, photo oils, spot colors, retouch pencils, and other products popular in the '50s and '60s. You may have also seen this look used in greeting cards featuring children.

1. **In the Editor, in Edit Full mode, open a grayscale image in Elements.**

2. **Choose Image➪Mode➪RGB Color to convert the grayscale image to a full-color image (even though it currently lacks color).**

3. **Choose Layer➪New➪Layer.**

continued

continued

This creates a new transparent layer to paint on, as shown in the figure. Although you can paint directly on an image, using a blank layer is safer — and gives you more flexibility in editing when you make a mistake. (For more information on working with layers, see Book VI, Chapter 1.)

IT Stock Free

4. **In the New Layer dialog box that appears, name the layer and then click OK.**

 You can paint all your colors on a single layer, but you may find that using a separate layer for each part of the face lets you fade that color in and out as required to blend smoothly with your other hues.

5. **Select the Color mode from the Blend Mode drop-down list in the Layers panel.**

 Elements uses this mode to combine the painting layer with the image layer, enabling you to apply color while retaining the details of the underlying image.

6. **Select a color you want to apply from the Swatches panel or use the Color panel to mix your own.**

For details on using color, see Book III, Chapter 4.

7. **Select the Brush tool from the Tools panel.**

8. **Click the down arrow next to the Brush Preset Picker on the Options bar and select a brush from the drop-down panel.**

Start with a soft-edged brush.

The Airbrush option on the Options bar creates a very subtle and soft effect. Just be sure you pick the kind of brush that works best for the area of the picture you're colorizing. (Use a small, fuzzy brush for smaller areas and use a bigger, sharper brush for more defined lines and wider areas.)

9. **Paint all the parts of the image where you want to apply color.**

If you make a mistake, you can use the Eraser tool (or the Undo History panel, see Book III, Chapter 5) to erase the bad strokes without affecting the underlying grayscale image because you're painting on a separate layer.

In our example, we chose a nice, light blue to change the color of the girl's eyes, as shown in the figure. A small, fuzzy brush is perfect for a small area such as the eyes.

IT Stock Free

Change brushes as necessary by clicking the Brush Preset Picker on the Options bar and selecting a larger or smaller brush.

10. **When you finish with that area of the image, create a new layer for each of the image's main components and repeat Steps 4–9 with an additional color.**

We painted the eyes, lips, cheeks, hair, and hair highlights separately because creating natural, subtle effects with people's skin, hair, and eyes takes a special touch:

- **Eyes:** When painting the eyes, paint only the irises and leave the pupils their original black color. Don't paint over the catchlights in the eyes, either. (*Catchlights* are reflections of light sources, such as windows or the flash.)

- **Lips:** Color the inner surface of the lips a darker, rosier pink than the outer surface. Lips look best when portrayed in at least two shades. Don't forget to color the gums with an even lighter pink.

continued

continued

- **Hair:** Hair looks best when the highlights and darker portions are slightly different colors.

- **Cheeks:** To put a little blush in the cheeks, choose the Airbrush option on the Options bar and work with a relatively large brush size. Apply a good dash of color to each cheek and a lighter bit of color to the forehead and chin, as shown in the figure.

IT Stock Free

We left the clothes and background uncolored to emphasize that the focal point is the girl's face.

11. **For the overall skin tone, choose a different technique, using the Hue/Saturation command.**

This technique works especially well with those who have naturally dark complexions. You can choose to paint the skin with a brush or use this technique:

- Duplicate the grayscale Background layer and then choose Enhance⇨Adjust Color⇨Adjust Hue/Saturation.

- Choose the Colorize option and move the Hue slider to the left to produce a sepia tone. We set our Hue to 36 and Saturation to 25 percent and then click OK to colorize this layer.

✔ Use the Eraser tool to remove everything in the colorized layer that isn't skin. In our example, we removed the hair, background, eyes, lips, teeth, and clothing. This result is a nice sepia tone to the face, as shown in the figure.

IT Stock Free

Be sure to pick a color that's as close to life as possible. If the subject has darker skin, you may need to move away from rosier blush tones.

12. **When you finish coloring your layers, experiment with different opacity levels for each colorized layer to see whether more-transparent hues might look better.**

Creating Shapes

Although we're big fans of photos and pixels, sometimes you have the need for a vector shape or two. Maybe you need to create a button for a Web page or a simple logo for a poster. In these instances, drawing a vector shape with one of the shape tools does the job.

Before we discuss the ins and outs of creating shapes, here's a little over-view that explains the difference between pixels and vectors (both types are shown in Figure 1-7):

- ✔ **Pixel images describe a shape in terms of a grid of pixels.** When you increase the size of a pixel-based image, it loses quality and begins to look blocky, mushy, and otherwise nasty. For more details on resizing pixel-based images and the ramifications of doing so, see Book III, Chapter 1.

- ✔ **Vectors describe a shape mathematically.** The shapes comprise paths made up of lines, curves, and anchor points. Because vector shapes are math based, you can resize them without any loss of quality whatsoever.

Figure 1-7: Elements images fall into one of two camps — vector or pixel.

When you create a shape in Elements, you're creating a vector-based element. Shapes reside on a special kind of layer called, not surprisingly, a shape layer.

Drawing a shape

Elements offers an assortment of shape tools for you to choose from. Follow these steps to draw a shape in your document:

1. **Select a shape tool from the Tools panel.**

 You can also press the U key, or Shift+U to cycle through the tools. You can select from the following shape tools (as shown in Figure 1-8):

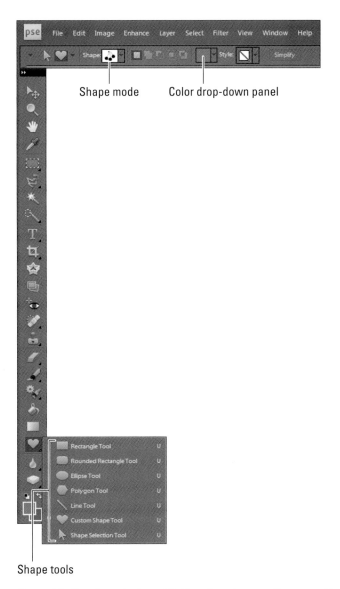

Shape mode Color drop-down panel

Shape tools

Figure 1-8: The shape tools and Options bar give you all you need to make shapes, from the simple to the ornate.

- *Rectangle/Ellipse:* The Rectangle and Ellipse shapes have no special parameters on the Options bar; however, they both behave much like their counterparts among the selection tools. Hold down the Shift key while dragging a shape to produce a perfect square or circle; hold down Shift+Alt (Shift+Option on the Mac) to additionally draw the shape outward from the center.

- *Rounded Rectangle:* This shape has the same options as the Rectangle, with the addition of a radius value used to round off the corners of the rectangle.

- *Polygon:* This tool creates a polygon with a specified number of sides, from 3 to 100.

- *Line:* Creates a line with a width from 1 to 1000 pixels. You can also add an arrowhead at either or both ends.

- *Custom Shape:* You can find numerous preset custom shapes to choose from. As with any shape, hold down the Shift key to constrain proportions or the Alt key (Option key on the Mac) to draw from the center out.

- *Shape Selection:* Use this tool to select and move your shapes.

2. **In the Options bar, click the down-pointing arrow just to the right of the shape tools to specify Geometry options.**

 Each shape has its own options. For a detailed explanation, see the section "Specifying Geometry options," later in this chapter.

 If you chose the Custom Shape tool in Step 1, click the down-pointing arrow to access the drop-down Custom Shapes panel and choose your desired shape. You can access more preset shape libraries via the pop-up menu at the top of the panel.

3. **Select your desired color from the Color drop-down panel on the Options bar.**

 Click the More Colors button (down-pointing arrow) to access the Color Picker for additional color choices.

4. **Select a style from the Style drop-down panel.**

 To spice up the shape with bevels and interesting edges, choose a style from the panel. For more on styles, see Book VII, Chapter 3.

5. **Drag in the document to draw the shape you've defined.**

 The shape appears in the Image window on its very own shape layer. Check out the Layers panel to see this phenomenon. Figure 1-9 shows our shape, an Elvis do.

Figure 1-9: Custom shapes run the gamut from the ordinary to the exotic.

Drawing multiple shapes in a shape layer

After you create a shape layer, you can draw additional shapes on that layer. You can add, subtract, exclude overlapping, and intersect shapes in exactly the same way you do with selections, as described in Book IV, Chapter 2. Follow these steps:

1. **After you create the first shape, as we explain in the preceding section, select a state button on the Options bar:**

 - *Add to Shape Area:* Combines and joins two or more shapes

 - *Subtract from Shape Area:* Subtracts one shape from another shape

 - *Intersect Shape Areas:* Creates a shape only from the areas that overlap

 - *Exclude Overlapping Shape Areas:* Creates a shape from only the areas that don't overlap

2. **Choose a shape tool and draw the next shape.**

 We finished our drawing, as shown in Figure 1-10, by adding a face to our Elvis impersonator.

Figure 1-10: Add to your shape layer.

 You can also hold down the Shift key to temporarily switch to Add to Shape Area while drawing a new shape. Hold down the Alt key (Option key on the Mac) to temporarily switch to Subtract from Shape Area. This works just like adding or subtracting selections.

Specifying Geometry options

Geometry options for your shapes help define how the shapes look. Click the down-pointing arrow at the end of the row of Shape tools on the Options bar to access the Geometry options described in the following sections.

Rectangle and Rounded Rectangle Geometry options

Here are the Geometry options for the Rectangle and Rounded Rectangle shapes:

✔ **Unconstrained:** Enables you to freely draw a rectangle of any shape or size.

- **Square:** Constrains the shape to a perfect square. (You can also hold down the Shift key to do the same thing on the fly.)

- **Fixed Size:** Lets you draw rectangles only in fixed sizes. Specify the exact size by entering a width and height.

- **Proportional:** Enables you to define an aspect ratio, or proportion, for the rectangle. Type **3** into the W box and **4** into the H box to constrain yourself to drawing any sized rectangle with fixed proportions in a 3:4 ratio.

- **From Center:** Enables you to draw the shape from the center outward.

- **Snap to Pixels:** Aligns the edges of a rectangle or rounded rectangle to the pixels on your screen.

- **Radius:** For rounded rectangles, uses an inscribed circle of the given radius to round off the corners of a rectangle.

Elliptical-shape Geometry options

The Ellipse shape has many of the same options available for rectangles. Of course, instead of being able to create a perfect square, you can restrain the shape to be a perfect circle. Also, the Snap to Pixels option (available for rectangles) doesn't exist for ellipses.

Polygon Geometry options

These are the Geometry options for the polygon:

- **Radius:** Controls the distance from the center of a polygon to its outer points.

- **Smooth Corners:** Rounds off the corners.

- **Star:** Creates a nonconvex polygon, also known as a star.

- **Indent Sides By:** Determines the amount the sides indent inward.

- **Smooth Indents:** Rounds off the inner of indented sides.

- **Sides:** Lets you indicate the number of sides for a polygon or the number of points for a star.

Line Geometry options

The Line shape's Geometry settings include whether to put arrowheads at the start or end of the line, neither, or both. You can also specify the width, length, and concavity settings, which affect the arrowhead shapes.

Custom Shape Geometry options

The Custom Shape options are similar to those you can find for the other shapes — with a couple of additions:

✓ **Defined Proportions:** Draws a shape based on the original proportions you used when you created it.

✓ **Defined Size:** Draws a shape based on its original size when you created it.

Editing shapes

You can edit shapes that you create by using a variety of tools and techniques. Here's a list of the things you can do to modify your shapes:

✓ **Select:** Choose the Shape Selection tool to move one or more shapes in their layers. This tool shares a flyout menu with the shape tools.

✓ **Move:** Choose the Move tool (press the V key) to move the entire contents of the shape layer.

✓ **Delete:** Select a shape and press Delete to remove it.

✓ **Transform shapes:** Choose the Shape Selection tool and select your shape. Choose Image➪Transform Shape and then choose your desired transformation.

✓ **Change the color:** Double-click the thumbnail of the shape layer on the Layers panel. This action takes you to the Color Picker, where you can choose a new color.

✓ **Clone a shape:** Hold down the Alt key (Option key on the Mac) and move the shape with the Move tool.

To convert your vector-based shape into a pixel-based shape, click the Simplify button on the Options bar or choose Layer➪Simplify Layer. Note that you can't edit a shape after you simplify it, except to modify the pixels. But you can now apply filters to the layer. See Book VII, Chapter 1 for more on fun with filters.

Chapter 2: Filling and Stroking

In This Chapter

- Filling and stroking selections
- Pouring with the Paint Bucket tool
- Working with gradients
- Creating and applying patterns

*E*lements offers several ways to create elements (say, geometric shapes) out of pixels. Filling and stroking such elements are two of the most popular commands at your disposal. The Fill command adds a color or a pattern to the entire selection, whereas the Stroke command applies the color to only the edge of the selection border.

This chapter shows you how to fill and stroke your selections. If filling and stroking with solid color is just too mundane for you, we also show you how to create and apply multicolored gradient blends as well as the best ways to make and use patterns. After reading this chapter, you'll have your "fill" of different fills and strokes.

You want to be in the Editor in Edit Full mode for your filling, stroking, gradient, and pattern activities.

Filling a Selection with a Solid Color

You won't find a Fill tool on the Tools panel. Elements avoids the crowded panel and places the Fill and Stroke commands on the Edit menu. When you want to fill your selection with just a solid color, you use either the foreground or background color, among other options. (These colors appear at the bottom of the Tools panel, as we explain in Book III, Chapter 4.)

The following steps show you the basics of filling a selection with either the foreground or background color:

1. **Choose the selection tool of your choice and create your selection on a layer.**

 Although you don't have to create a new layer, we recommend it. That way, if you don't like the filled selection, you can delete the layer, and the image or background below it remains safe. See Book IV for all you need to know about selections and Book VI for the scoop on layers.

2. **In the Tools panel, select either the foreground or background color and then choose a fill color.**

 If you need information on choosing a color, see Book III, Chapter 4.

3. **Choose Edit⇨Fill Selection.**

 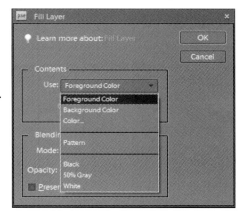

 Note that if you don't have an active selection border in your image, the command says Fill Layer and your entire layer is filled with your color or pattern.

 The Fill Layer dialog box, as shown in Figure 2-1, appears.

4. **Choose your desired fill from the Use pop-up menu.**

 You can select whether to fill with the foreground or background color.

 Figure 2-1: Fill your selection with color or a pattern.

 You also can choose Color, Black, 50% Gray, White, or Pattern. If you select Color or Pattern, you must complete a couple additional steps, described in the next section "Filling Options and Tips."

5. **In the Blending area, specify whether to preserve transparency.**

 This option enables you to fill only the portions of the selection that contain pixels (the nontransparent areas).

 Although you can also choose a *blend mode* (how the fill color interacts with colors below it) as well as an opacity percentage in the Fill Layer dialog box, we can't really recommend doing so. Make adjustments on your layer later using the Layers panel commands. This gives you more flexibility for editing.

6. **Click OK.**

 The color or pattern that you chose fills the selection.

Filling Options and Tips

After you make a selection, you're ready to use one of the filling options. You can use the Fill Layer dialog box (as described in the preceding section) to fill the selection with the foreground or background color; you can also choose to fill the selection with color, black, white, or gray. Elements is full of shortcuts and options.

Here are just a few. With the selection active

✏ Press Alt+Backspace (Option+Delete on the Mac) to fill it with the foreground color. All areas within the selection, including transparent areas, fill with the color.

✏ Press Alt+Shift+Backspace (or Option+Shift+Delete on the Mac) to fill only the pixels in a selection with the foreground color, leaving any transparent pixels untouched.

✏ If you're working on the Background layer, you can also fill the selection with the background color by pressing the Backspace (Delete on the Mac) key. (Pressing Backspace [Delete] on other layers creates a transparent area that shows the image in the layer underneath the selection.)

✏ By selecting the Color option from the Contents drop-down list in the Fill Layer dialog box, you access the Color Picker where you can select any color your heart desires to fill your selection. For more on using the Color Picker, see Book III, Chapter 4.

✏ Select the Pattern option from the Contents drop-down list in the Fill Layer dialog box to fill the selection with a pattern. Click the arrow next to the pattern swatch and select a pattern from the drop-down panel. Click OK. To access additional pattern libraries, click the Pattern panel pop-up menu to select more pattern libraries.

✏ Paint part or all the interior of the selection by using a Pencil or Brush tool. This option lets you partially fill a selection using a bit of flexibility and creativity. When you paint a selection using Brush tools, Elements confines the paint inside the boundaries of your selection, as shown in Figure 2-2. For more on painting, see Book V, Chapter 1.

✏ Pour color from the Paint Bucket tool into the selection. (See more details in the next section.)

Pouring with the Paint Bucket Tool

The Paint Bucket tool operates much like a combination of the Fill command tool and the Magic Wand tool. It makes a selection based on similarly colored pixels and then immediately fills that selection with color or a pattern. Just like the Magic Wand tool, this tool is used most successfully when you have a limited number of colors, as shown in Figure 2-3.

Selection marquee Brush cursor

Figure 2-2: The marquee confines your brush strokes to the selected area.

To use the Paint Bucket tool, select it and click the area you want to fill with color. If you want a more precise fill, first make a selection and then click inside the selection border. It's as simple as that. Before you click, however, specify your options, which are all on the Options bar:

- **Fill:** Select whether to fill with the foreground color or a pattern. If you want to use the foreground color, leave Pattern unchecked.

- **Pattern:** If you select Pattern, select a preset pattern from the drop-down panel. You can also load patterns from pattern libraries or create a pattern of your own. Find more information on patterns in the section, "Working with Patterns," later in this chapter.

- **Mode:** Select a blending mode to change how the fill color interacts with the color below it. Find details on these modes in Book VI, Chapter 3.

- **Opacity:** Adjust this value to make the fill more or less transparent.

Corbis Digital Stock

Figure 2-3: Select and fill simultaneously with the Paint Bucket tool.

✓ **Tolerance:** Just as you did with the Magic Wand tool, choose a Tolerance level (0 to 255) that specifies how similar in color a pixel must be before it's selected and then filled. For more on Tolerance, see Book IV, Chapter 1.

✓ **Anti-alias:** Choose this option to smooth the edges between the filled and unfilled areas.

✓ **Contiguous:** If selected, this option selects and fills only pixels that are touching within your selection. If the option is unselected, pixels are selected and filled wherever they lie within your selection and within your tolerance range.

✓ **All Layers:** This option selects and fills pixels within the selection in all layers that are within the tolerance range.

 As with other tools that fill, you can prevent the Paint Bucket tool from filling the transparent pixels. Just select the Transparency icon in the Lock area of the Layers panel.

Stroking a Selection

Stroking enables you to create colored outlines, or borders, of selections or layers. It's up to you to decide whether to put the border inside, outside, or centered on the selection.

To stroke a selection, follow these steps:

1. **In the Tools panel, choose a foreground color.**

2. **In the image, make a selection on a layer using the selection tool of your choice.**

 Although you don't have to create a new layer to stroke a selection, we recommend it. That way, if you don't like the stroked selection, you can just delete the layer and your document remains unadulterated.

3. **Choose Edit⇨Stroke (Outline) Selection.**

4. **In the Stroke dialog box, specify options, as shown in Figure 2-4:**

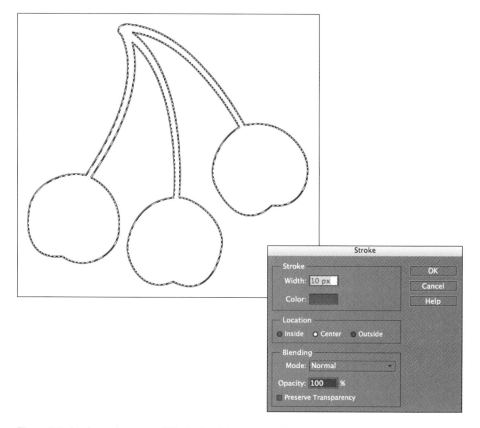

Figure 2-4: Apply strokes up to 250 pixels wide to your selection.

- *Width:* Enter a width of 1 to 250 pixels.

- *Color:* Click in the Color box to select the hue you want from the Color Picker.

- *Location:* Specify how Elements should apply the stroke in relation to your selection border. Note that the Inside option always gives you sharp corners on a rectangle. The Center and Outside options can result in blunt corners.

- *Mode:* This determines how the stroke color interacts with other colors on the same layer.

- *Opacity:* The default value is 100%. If you want the stroke to be semi-transparent, enter a lower value.

- *Preserve Transparency:* Select this option to apply the stroke only to nontransparent pixels. Note that if you choose this option on a new, blank layer, nothing will be stroked.

5. **Click OK to apply the stroke.**

 We gave a 10-pixel centered stroke to our selection, as shown in Figure 2-4.

Instead of using the Stroke dialog box to adjust the Mode and Opacity settings, we recommend creating a new layer for the stroke and then choosing different Mode and Opacity settings in the Layers panel. This approach gives you better flexibility in editing.

Working with Multicolored Gradients

If one color just doesn't get you fired up, you'll be happy to know that Elements enables you to fill a selection or layer with a gradient. A *gradient* is a blend of two or more colors that gradually dissolve from one into another. Elements provides a lot of preset gradients. But creating your own custom gradient is also fun and simple to do.

You can create the following gradient effects:

- **Foreground to background:** A transition from the current foreground color to the background color

- **Foreground to transparent:** A transition from the current foreground color to transparent, allowing whatever's under the transparent portion to show through

- **Black to white:** A transition from black to white

- **An array of colorful selections:** A transition including rainbows, coppery sheens, and other effects

You can load other libraries of gradients from those found in the menu of the Gradient panel. They have names such as Color Harmonies, Metals, and Special Effects.

In addition to being able to control the appearance and application of a gradient, you can also specify various Gradient options, which are all on the Options bar:

- **Mode:** Select a blending mode to change how the color of the gradient interacts with the colors below it.

- **Opacity:** Select how opaque or transparent the gradient is.

- **Reverse:** Reverse the order in which the colors are applied.

- **Dither:** Add *noise,* or random information, to produce a smoother gradient that prints with less *banding* (color stripes caused by the limitations of the printing process to reproduce a full range of colors).

- **Transparency:** Deselect this option to make Elements ignore any transparent areas in the gradient, making them opaque instead.

Applying a preset gradient to a selection

Here's how to apply a preset gradient:

1. **Select the layer from the Layers panel.**

 If you want the gradient to fill only a portion of that layer, make your desired selection.

 We recommend making the selection on a new layer so that you can edit the gradient later without harming the underlying image.

 If you don't make a selection, the gradient is applied to the entire layer or background.

2. **Select the Gradient tool from the Tools panel, or press the G key.**

3. **Select one of the preset gradients from the Gradient Picker drop-down list on the Options bar.**

 Remember that you can choose other preset libraries from the panel pop-up menu. Libraries, such as Color Harmonies and Metals, contain interesting presets.

4. **Select the gradient type by clicking one of the icons on the Options bar.**

 Figure 2-5 illustrates each gradient type:

 - *Linear:* Blends the colors of the gradient in a straight line

 - *Radial:* Blends the colors outward in a circular pattern

 - *Angle:* Creates a counterclockwise sweep around the starting point, resembling a radar screen

 - *Reflected:* Blends the colors by using symmetrical linear gradients on either side of the starting point

 - *Diamond:* Blends the colors outward in a diamond pattern

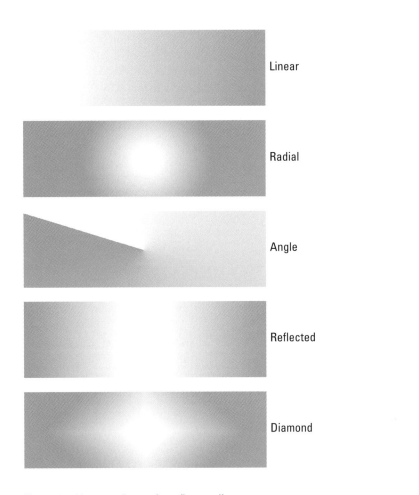

Linear

Radial

Angle

Reflected

Diamond

Figure 2-5: You can choose from five gradients.

5. **Choose any other options you want from the Options bar.**

 We explain these options earlier in this section.

6. **Place the cursor at the position in the layer or selection where you want to place the starting color of the gradient.**

7. **Drag in any direction to the end point for the gradient.**

Longer drags result in a subtle transition between colors, whereas shorter drags result in a more abrupt transition. Hold down the Shift key while dragging to constrain the direction of the gradient so it's perfectly horizontal or vertical or at an exact 45-degree angle.

8. **Release the mouse button to apply the gradient.**

 We applied a pastel radial gradient to a selection of an abstract symbol in Figure 2-6.

Figure 2-6: Fill your selection with a multicolored gradient.

Customizing and editing gradients

Although Elements includes dozens of different gradient presets, you may want to create your own. The Gradient Editor makes that task an easy one by letting you create your own custom gradient with as many colors as you want, which you can then save as a preset and reuse at any time.

The Gradient Editor has a lot of options, but it's easy to use when you know what all the controls and options do. Follow these steps to create a simple, smooth gradient:

1. **Select the Gradient tool from the Tools panel or press the G key.**

2. **Click the Edit button on the Options bar.**

 The Gradient Editor dialog box opens, as shown in Figure 2-7.

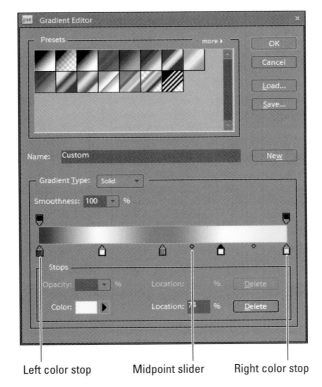

Left color stop Midpoint slider Right color stop

Figure 2-7: The Gradient Editor enables you to create custom gradients.

3. **Pick an existing gradient preset from the Presets area to use as the basis for your new gradient.**

4. **Choose Solid or Noise from the Gradient Type pop-up menu.**

 As soon as you start to edit the existing gradient, the name of the gradient changes to Custom. A Noise gradient is one containing random colors. Because the colors are random, each time you create a noise gradient, the result is different.

5. **If you chose a Solid gradient in Step 4, adjust the Smoothness percentage to determine how smoothly one color blends into another.**

6. **If you chose a Noise gradient in Step 4, specify the options that follow and then skip to Step 15 to finish the gradient.**

 - *Roughness:* Adjust this slider to determine how smoothly or abruptly the colors transition from one stop to another.

 - *Color Model:* Select the color model to set the range of color. See Book III, Chapter 4 for more on color models.

- *Restrict Colors:* Select this option to avoid oversaturated colors.

- *Add Transparency:* Select this option to include transparency in your gradient, if desired.

- *Randomize:* Use this option to change the colors in the gradient. Each time you click Randomize, you get a new set of colors.

7. **If you're creating a solid gradient, define the color of the starting point for your gradient. Click the left color stop under the gradient bar.**

 The triangle above the stop turns black to indicate you're working with the starting point of the gradient. Because Noise gradients are random, you can't define the colors.

8. **Select the starting color by using one of these methods:**

 - Double-click the left color stop and select a color from the Color Picker that appears.

 - Click the color swatch in the Stops area of the dialog box and choose a color from the Select Stop Color dialog box that opens.

 - Select Foreground, Background, or User Color from the Color pop-up menu in the Stops area of the dialog box.

 If you select Color with the Foreground or Background option, the color in the gradient changes automatically when you change the foreground or background color. The change doesn't affect any gradients you've already created, but it does affect any future gradients. However, when you open the Gradient Editor again, you can revert to the original foreground or background color by selecting the User Color option from the Color pop-up menu in the Stops area.

 - Position the cursor (it appears as an eyedropper icon) anywhere in the gradient bar to select a start color from the bar, or position the cursor anywhere within an image on your screen and then click to select the color under the cursor.

9. **Click the end point color stop at the right side of the gradient bar and use any of the methods described in Step 8 to choose the end color of the gradient.**

10. **Change the percentage of the amount of one color versus the other by moving the starting and ending points to the left or right. Drag the midpoint slider (a diamond icon that appears when you click an adjacent color stop) to adjust where the colors mix equally, 50–50.**

 You can also change the position of the midpoint by selecting it and typing a value into the Location box. The position of the color stops can also be changed this way.

11. **(Optional) To add another color, click below the gradient bar at the position you want to add the color. Define a color using the new color stop as you did in Step 8.**

12. **(Optional) Repeat Step 11 for additional colors.**

13. **For the additional color stops, move the stops to the left or right to adjust the location of the start and end points for each color. Then, adjust the midpoint sliders between the colors.**

14. **If you change your mind, redefine the color of the color stop or remove a color stop altogether by dragging it down or up from its position on the gradient bar.**

15. **After your edits are complete, enter a name for your gradient in the Name field and then click the New button.**

 Your gradient is added to the Presets menu. Figure 2-8 shows an example of a unique gradient that we created in the Gradient Editor.

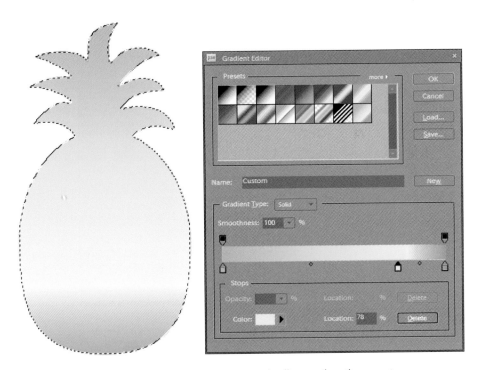

Figure 2-8: The Gradient Editor gives you more creative license than the presets.

Adding transparency to a gradient

By default, a gradient has 100-percent opacity in the start color and progresses to 100-percent opacity in the end color. If you like, you can have the gradient fade out to transparency so that the portion of the image under the gradient shows through. To add transparency to a gradient, follow these steps:

1. **Create a gradient, as described in the preceding section.**

2. **Select the left opacity stop.**

 This stop is located just above the gradient bar, as shown in Figure 2-9.

3. **Use the Opacity slider to specify the amount of transparency for the gradient at its start point.**

 You can also type a value into the Opacity box.

4. **Select the right opacity stop, and then slide the Opacity slider or enter a percentage in the text box to specify transparency for the gradient at its end point.**

 The lower the percentage, the less opaque the color.

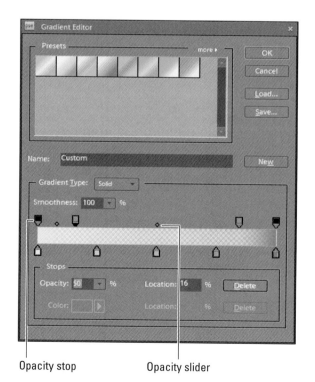

Opacity stop Opacity slider

Figure 2-9: Add transparency to your gradients by adjusting the opacity of your colors.

5. **Move the opacity stops to the right or left to adjust the location where Elements applies each stop's opacity setting.**

6. **Move the midpoint slider (diamond icon) to adjust how the color and the transparency blend.**

7. **Click above the gradient bar to add more opacity stops if you want to vary the transparency of the gradient at different points.**

 For example, you could fade transparency from 100 percent to 50 percent and back to 100 percent to produce a particular effect.

Gradients ordinarily proceed smoothly from one color to another. If you want a less-homogeneous appearance, adjust the Smoothness slider to a value of less than 100 percent (click the right-pointing arrow to access the slider).

Managing and Saving Gradients

After taking the time to create custom gradients, store them so that you can use or edit them again later. Before you save them, however, be sure to add them to the gradient presets. (See "Customizing and editing gradients" earlier in this chapter.) Here are some tips for managing your gradients:

- ✔ **To save your set of gradients,** click the Save button in the Gradient Editor dialog box. You save the current presets, including your new gradient, under the current library's name or another one that you choose.

- ✔ **To load gradient presets into the Gradient Editor,** click the Load button and select the name of the gradient library that you want to add to the Presets list.

- ✔ **To add to the current presets,** select the name of the new presets from the Gradient Editor's pop-up menu.

Working with Patterns

You may have spotted someone on the golf course with plaid shorts and a striped polo shirt. If so, you've been introduced to the power of patterns. Not always a pretty sight when used with abandon, patterns can be used to fill selections or layers. You can also stamp your image with the Pattern Stamp tool and retouch using a pattern with the Healing Brush tool. Elements offers a lot of preset patterns to keep you happy. But, you can create your own, of course.

You select patterns from panels that appear on the Options bar for many of the tools just mentioned, just as you do with brush tips and gradients. You also manage them in much the same way using the Preset Manager. The following sections show you how to apply a preset pattern and create your own.

Applying a preset pattern

Although you can apply patterns by using many different tools, this chapter sticks with applying patterns as fills. To fill a layer or selection with a preset pattern, follow these steps:

1. **Choose the layer from the Layers panel and/or make the selection you want to fill with a pattern.**

 We recommend making your selection on a new layer above the image for more flexible editing later on.

2. **Choose Edit⇨Fill Selection or Fill Layer, and select Pattern from the Use drop-down list, as shown in Figure 2-10.**

3. **Click the down-pointing arrow next to the Custom Pattern swatch and then from the Custom Pattern drop-down palette, select your desired pattern.**

4. **Choose any other fill options you want to apply, such as Mode, Opacity, or Preserve Transparency.**

 The Preserve Transparency option prevents Elements from filling the transparent areas on your layer with a pattern. Note that if you choose this option on a new, blank layer, nothing will be filled. For details on the other options, see the section "Filling a Selection with a Solid Color" earlier in this chapter.

 We recommend adjusting the Mode and Opacity settings in the Layers panel rather than in the Fill Layer dialog box. This approach allows you maximum flexibility if you want to make edits later.

5. **Click OK to fill the layer or selection with the chosen pattern.**

 Here are a few other tips to remember when working with preset patterns:

 • Replace the current patterns with new patterns by selecting Replace Patterns from the panel pop-up menu. (Click the right-pointing arrow on the right side of the panel.) Then, select the new pattern library from the dialog box that appears.

 • Append new patterns to the current set by selecting Load Patterns from the panel pop-up menu.

 • Append one of the preset libraries by selecting the library from the list at the bottom of the panel pop-up menu.

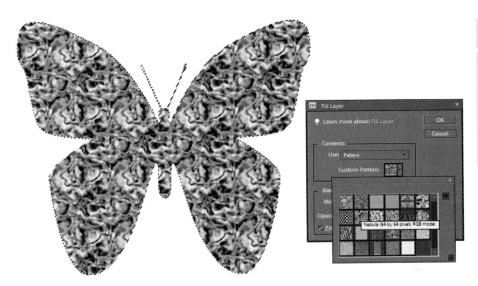

Figure 2-10: Fill the selection with one of the many other preset patterns.

Creating a new pattern

You can create your own pattern, basing it on an existing image or one you create yourself. Select a small portion of an image to build an abstract pattern or use a recognizable object to define that object as a pattern stamp. You can use anything, from a logo to your signature, as a pattern.

To create your own pattern, follow these steps:

1. **Open the image that contains the area you want to use as a pattern or create an image from scratch.**

2. **Make any modifications to the image to produce the exact pattern that you want.**

3. **Use the Rectangular Marquee tool to select the area you want to convert into a pattern.**

 If you don't make a selection, Elements uses your entire image as a basis for the pattern.

 If you're using a selection to define your pattern, you must use a rectangular selection. And, you can't use a feathered selection of any kind.

4. **Choose Edit⇨Define Pattern from Selection or Edit⇨Define Pattern.**

5. **Enter a name for your pattern in the Pattern Name dialog box.**

 Your new pattern appears in the Pattern panel for use.

In addition to filling your selection with a pattern, you can stamp on a pattern with the Pattern Stamp tool. For details, see Book I, Chapter 2.

Chapter 3: Working with Type

In This Chapter

- ✓ **Understanding type basics**
- ✓ **Getting to know the Type tools and modes**
- ✓ **Entering and editing text**
- ✓ **Making type follow a path**
- ✓ **Editing text**
- ✓ **Rasterizing a Type layer**
- ✓ **Exploring masking, shaping, and warping effects**

*Y*es, images are powerful. But so are words. In fact, humans tend to remember images better when they're combined with words. This is why we don't recall our dreams that well — no words are paired with the images. Enough psychobabble. You may never need to pick up a Type tool. But, just in case you need to add a caption, headline, or short paragraph, we want you to be comfortable using the Type tools.

Elements allows you to create, edit, stylize, and even distort type. Keep in mind that this capability is no substitute for a hard-core page-layout or word-processing program. But for small chunks of text here and there, it's surprisingly effective. This chapter is all about adding great-looking snippets of text to great-looking images — an unbeatable combo.

Understanding Type Modes

The text you create in Elements can be categorized in several different ways, but ultimately, you're either adding just a little text (such as a word or single line) or a lot (a paragraph or so). Accordingly, Elements can create type in two modes:

- ✓ **Point Type:** Use this mode to create a headline or label. You can create point type by clicking in your image and typing; the line appears while you type and grows to whatever length you need. In fact, it even continues past the boundary of your image! Point type never wraps around to a new line. To wrap to the next line, you must press Enter (Return on the Mac).

✔ **Paragraph Type:** Use this mode to enter longer blocks of text on an image. It's similar to the kind of type you're accustomed to working with in word-processing programs. In Paragraph Type mode, all the text goes into a resizable bounding box, and if a line is too long, Photoshop automatically wraps it around to the next line.

The Point Type and Paragraph Type modes each operate a bit differently, although they share many features and options. We explain each of them separately in the sections "Entering Point Type" and "Entering Paragraph Type," later in this chapter.

Understanding Different Kinds of Type

In addition to the two Type modes Elements offers (see Point Type and Paragraph Type modes in the preceding section), Elements is also capable of displaying and printing type in two different formats. Each format has its pros and cons, and which format you use depends on your needs. Here's a description of each one:

✔ **Vector type:** All text in Elements is initially created as vector type. *Vector* type provides scalable outlines that you can resize without producing jagged edges in the diagonal strokes. You can edit type in this mode, adding or subtracting characters or adjusting attributes, such as kerning and tracking. Vector type is always of optimum quality and appears crisp and clean. (See Book III, Chapter 1 for more details on vector and rasterized images.)

✔ **Raster type:** When Elements converts vector type into pixels, that text is rasterized. Elements refers to this rasterization process as *simplifying.* When text is simplified, it's no longer editable, but is converted into a raster image. In essence, it's a frozen graphic of the text. You usually simplify a vector type when you want to apply filters to produce a special effect or when you want to merge the type with the image. You can't resize simplified type without losing some quality or risking jagged edges. For more details, see the section "Rasterizing the Type Layer," later in this chapter.

Exploring the Type Tools

Elements has four Type tools (found in the Tools panel), but two of them are simply vertically oriented versions of the main two text implements, as shown in Figure 3-1. Don't worry about the Vertical Type tools. Although you can use them, they're really designed for the Asian market, to enter Chinese and Japanese characters. The Horizontal and Vertical Type tools are identical in their attributes, so we cover only the two Horizontal Type tools here, and for the sake of simplicity, we call them the Type tool and the Type Mask

tool. You can use either the Paragraph or Point Type mode with either of the Type tools:

Figure 3-1: Elements offers four Type tools.

✔ **Type tool:** Use this tool to enter point or paragraph type. This tool creates the type on its own type layer, except when used in Bitmap or Indexed Color modes, neither of which supports layers. For more on layers, see Book VI.

✔ **Type Mask tool:** This tool doesn't create actual type; instead, it creates a selection border in the shape of the type you want to enter. The selection border is added to the active layer. You can do anything with a type selection that you can do with any other selection. For details on selections, see Book IV.

Entering Point Type

Most of the type you add to Elements will probably consist of point type. Point type is great for headlines, captions, labels, and similar small amounts of text. You can also use it to create logos and headings for Web pages. *Point type* is so called because it's preceded by a single anchor point, which marks the starting point of the line of type. Remember that point-type lines don't wrap automatically, as shown in Figure 3-2.

To enter point type, just follow these steps:

1. **In the Editor, in Edit Full mode, open an image or create a new, blank document (or choose File⇨New).**

2. **Select either the Type tool from the Tools panel or press the T key to select it, if it's visible.**

 If the Type tool isn't visible, press Shift+T to cycle through the type tools. Your cursor looks like an I-beam, similar to the one you see in a word-processing program.

3. **Click the area of the image where you want to insert the text.**

 For horizontal type, a small horizontal line about one-third of the way up the I-beam shows the location of the baseline (on which the line of text rests).

4. **Specify your type options from the Options bar.**

 All the options are described in the upcoming section, "Using the Options Bar."

5. **Type your text and press Enter (or Return on the Mac) to begin a new line.**

Point type doesn't wra|

Figure 3-2: Point type doesn't automatically wrap, but can actually run off your image.

When you press Enter (or Return), you insert a hard return that doesn't move. You have to remove hard returns if you want to change the length of the lines you type.

6. **When you finish entering the text, click the Commit (the check mark icon) button on the Options bar.**

You can also commit the type by pressing Enter on the numeric keypad or by clicking any other tool on the Tools panel. A new type layer containing your text — indicated by the T icon — is created and appears in your Layers panel.

Entering Paragraph Type

If you have larger chunks of text, it's more practical to enter the text as paragraph type. *Paragraph type* is similar to the text you enter in a word-processing program, except that it's contained inside a text box or a *bounding box*. While you type into a text box, the lines of text wrap around to fit the dimensions of the box. If you resize the box, Elements adjusts the wrapped ends to account for the new size.

You can type multiple paragraphs, use typographical controls, and rotate or scale the type. You can easily resize paragraph type (and point type, too) by entering a new point size value in the Options bar without having to reselect all the text. Just make sure the text layer is selected in the Layers panel and the Text tool is active. This approach works for all the other text characteristics, as well.

To enter paragraph type, follow these steps:

1. **Open a saved image or create a new, blank Elements document in the Editor in Edit Full mode.**

2. **Select either the Type tool from the Tools panel or press the T key to select it, if it's visible.**

 If it isn't visible, press Shift+T to cycle through the Type tools.

 Your cursor looks like an I-beam, similar to the one you see in a word-processing program.

3. **On the image, insert and size the text box by using one of the following methods:**

 - *Drag to create a text box close to the size you want.* After you release the mouse button, you can drag any of the handles at the corners and sides of the box to resize the box.

 - *Hold down the Alt (Option on the Mac) key and click the image.* The Paragraph Text Size dialog box appears. Enter the exact dimensions of a bounding box. When you click OK, the specified box appears, complete with handles for resizing the box later.

4. **Select Type options from the Options bar.**

 Options are described in detail in the upcoming section, "Using the Options Bar."

5. **Enter the text. To start a new paragraph, press Enter (Return on the Mac).**

 Each line wraps around to fit inside the bounding box, as shown in Figure 3-3.

 If you type more text than fits in the text box, an over-flow icon (plus sign) appears in the bottom-right handle. You can resize the text box by dragging any of the bounding box handles.

Paragraph type wraps automatically without your assistance, so there's no need to enter a hard return as you type.

6. **Click the Commit button (check mark icon) on the Options bar (or press Enter on the numeric keypad).**

Figure 3-3: Paragraph text automatically wraps to conform to the bounding box.

Elements creates a new type layer, as indicated by the T icon displayed in the Layers panel.

Using the Options Bar

Several character and paragraph type settings are located on the Options bar, as shown in Figure 3-4. These options enable you to specify the type and pair it with your images.

Figure 3-4: The Type options on the Options bar.

Here's an explanation of each option, from left to right:

✏ **Font Family:** Select the font/typeface you want from the drop-down list. Elements provides you with a *WYSIWYG* (What You See Is What You Get) font menu. After the font name, the word *sample* is rendered in the actual font. You also find one of these abbreviations before the font name to let you know what type of font it is:

- *a:* Adobe Type 1 (PostScript) fonts
- *TT:* TrueType fonts
- *O:* OpenType fonts

Fonts with no abbreviation are bitmapped fonts.

✏ **Font Style:** Some font families have additional styles, such as light or semibold. And other styles are assigned as separate typefaces. Only the styles available for a particular font appear in the list. The font style also supports a WYSIWYG menu.

If a font you want to use doesn't offer bold or italic styles, you can simulate either or both by selecting a faux style in the Options bar (T icons).

✏ **Font Size:** Select your type size from the drop-down list or just type a size in the text box. Generally, text sizes are shown in points, with 72 points equaling approximately 1 inch.

If you don't like points, you can switch to millimeters or pixels by choosing Edit➪Preferences➪Units and Rulers (or Elements➪Preferences➪ Units and Rulers on the Mac).

✏ **Anti-aliased:** Select Anti-aliased to slightly smooth out the edges of your text. Anti-aliasing softens that edge by 1 pixel, as shown in Figure 3-5. For the most part, you want to keep this option turned on. The one occasion when you may want it turned off is if you're creating small type to be displayed onscreen, such as on Web pages. The soft edges can sometimes be tough to read easily.

✏ **Faux Bold:** Use this option to create a fake bold style when a real bold style (which you'd choose under Font Style) doesn't exist. Be aware that

Anti-aliased Not Anti-aliased

Figure 3-5: Anti-aliasing softens the edges of your type.

applying faux styles can distort the proportions of a font. You should try to use fonts with real styles, and if they don't exist — oh, well.

✔ **Faux Italic:** This option creates a phony italic style and carries the same warning as the Faux Bold option.

✔ **Underline:** This setting obviously underlines your type, like <u>this</u>.

✔ **Strikethrough:** Choose this option to apply a ~~strikethrough~~ style to your text. In legal applications, strikethrough is widely used to show sections that have been removed, in their original context.

✔ **Text Alignment:** From the Text Alignment drop-down list, choose an option to align horizontal text on the left, center, or right. Left-aligned text is even with the left margin and allowed to be ragged on the right side of the column. Centered text is evenly centered in its column and ragged on both right and left edges. Right-aligned text is even with the right margin and allowed to be ragged on the left side.

If you happen to have vertical text, these options rotate 90 degrees clockwise and change into top, bottom, and center vertical settings.

✔ **Leading:** *Leading* (pronounced "ledding") is the amount of space between the baselines of lines of type, usually measured in points. The *baseline* is the imaginary line on which a line of type rests. You can select a specific amount of leading or allow Elements to determine the amount automatically by choosing Auto. When you select Auto Leading, Elements multiplies the type size by a value of 120 percent to calculate the leading size. Therefore, Elements spaces the baselines of 10-point type 12 points apart. Elements adds that extra 20 percent so that the bottoms of the lowest letters don't "hook" onto the tops of the tallest letters on the line below them.

Wider line spacing can make text easier to read (as long as you don't go overboard!) or can be used for artistic effect. Tighter line spacing makes for more-compact text but can decrease readability if the tightening goes too far.

✔ **Text Color:** Click the color swatch to select a color for your type from the Color Picker. You can also choose a color from the Swatches panel.

✔ **Create Warped Text:** This option lets you warp and bend text by using 15 different types of distortion.

✔ **Change the Text Orientation:** Select your type layer in the Layers panel and then click this option to switch between vertical and horizontal type orientations.

✔ **Cancel:** Click this button (or press the Esc key) to cancel the text entry you're making. Use this option or the Commit option only after you click the Type tool on your canvas.

✔ **Commit:** Click this button to apply the text to a type layer.

Editing Text

You can apply all the options described in this chapter while you enter text, or later, when you're rearranging words or fixing typos and other errors. To make changes to the text itself, just follow these steps:

1. **Open your image in the Editor in Edit Full mode.**

2. **Select the Type tool from the Tools panel.**

3. **In the Layers panel, select the existing type layer you want to modify. Or click within the text to automatically select the type layer.**

Double-click the T icon in the Layers panel to simultaneously select all the text on that layer and activate your Type tool.

4. **After selecting your desired text, use the Options bar to make your changes:**

 - *Change the font family, size, color, or other type option:* If you want to change all the text, simply select that type layer on the Layers panel. To select only portions of the text, highlight the text by dragging across it with the I-beam of the Type tool, as shown in Figure 3-6.

 - *Delete text:* Highlight the text by dragging across it with the I-beam of the Type tool. Then press the Backspace key (Delete on the Mac).

 - *Add text:* Make an insertion point by clicking the I-beam within the line of text. Then, type new text.

Figure 3-6: Highlight selected text to modify attributes.

5. **When you're done modifying the text, click the Commit button.**

Occasionally, you may want to transform your text. To do so, make sure that the type layer is selected on the Layers panel. Then, choose Image⇨Transform⇨Free Transform. Grab a handle on the bounding box and drag to rotate or scale. Press Ctrl (⌘ on the Mac) and drag a handle to distort. When you're done, double-click inside the bounding box to commit the transformation. For more details on transformations, see Book VI, Chapter 2.

Rasterizing the Type Layer

The Type tool creates editable type layers. You can change the wording, spacing, font, font size, and other factors as much as you want as long as the type remains in a type layer, which retains the vector format. (See the section "Understanding Different Kinds of Type," earlier in this chapter for details.)

However, after you make all the changes you want, you may need to convert your vector type layer to pixels in the form of rasterized type. In Elements, this rasterization process is referred to as *simplifying*. After the type is simplified, you can apply filters, paint on the type, and apply gradients and patterns.

If you're working with layers and *flatten* your image (merge your layers into a single background image), the type layers are also simplified and merged with the other pixels in the image. By the way, if you try to apply a filter to a vector type layer, Elements barks at you that the type layer must be simplified before proceeding and gives you the opportunity to click OK (if you want to simplify) or Cancel.

To simplify your type, select the type layer on the Layers panel and choose Layer➪Simplify Layer. Your type layer is then converted (the T icon disappears) into a regular layer on which your type is now displayed as pixels against a transparent background, as shown in Figure 3-7.

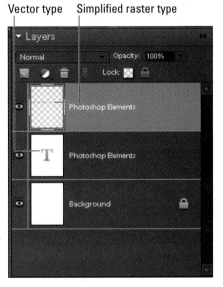

Vector type Simplified raster type

REMEMBER

After you simplify your type, you can no longer edit the type, nor can you resize the text without risking jaggies. Simplify your type only when you're certain you won't need to edit or resize it anymore. Another thing to remember about simplified type is that although it looks identical to vector type onscreen, it may not print as crisply and cleanly as vector type. So, if you're experimenting with painting or filters on type, just make a duplicate of the type layer before simplifying it and then hide that layer in the Layers panel. For details on working with layers, see Book VI.

Figure 3-7: Simplifying your type layer converts vector type into pixels.

Masking with Type

In addition to its Vertical and Horizontal Type tools that we've been discussing up to this point, Elements includes Vertical and Horizontal Type Mask tools. These tools function almost identically to their conventional counterparts, with one important exception: Type Mask tools don't create a new layer. Instead, they create a selection on the active layer, like the one shown in Figure 3-8.

Figure 3-8: Type Mask tools create selection borders from the letter shapes.

You can treat the selections created with the Type Mask tools just as you would any other selection. Try the following:

- Move type mask selections around your document when any of the selection tools are active.

- Store type mask selections for later use by choosing Select⇨Save Selection. See Book IV for details on selections.

- Use the selection to cut or copy portions of an image in text-shaped chunks, as shown in Figure 3-9. You can find out how this last technique works by following the steps in the Putting It Together project, "Carving Your Type out of Stone," coming up next, in which you find out how to literally carve your words in stone.

- On a separate layer, fill the selection with a Foreground to Transparent gradient to have your type gradually fade out over the image, as shown in Figure 3-10. For details on gradients, see Book V, Chapter 2.

PhotoDisc/Getty Images

Figure 3-9: Use a Type Mask to create type from an image.

Digital Visions

Figure 3-10: Gradually fade out type using a Foreground to Transparent gradient.

 Putting It Together

Carving Your Type out of Stone

You can use a Type tool to create selections shaped like text and then use images themselves as fills for the type. For example, if you're creating a floral-themed Web page, you can use pictures of flowers as the fill for the text. A type selection can cut out any part of a picture for use in any way you want.

Follow these steps to create letters made from stone:

1. **In the Editor, in Edit Full mode, open the stone texture image you want to use.**

We're using a sandstone wall, but you can use other kinds of stone, wood, or any texture that interests you.

2. **Convert your background into a layer by double-clicking the word *Background* on the Layers panel and then click OK.**

This step enables you to stylize the type later.

continued

continued

3. **Select the Horizontal Type Mask tool from the Tools panel and then click the area where you want to enter text.**

4. **Select the font, font style, font size, and other text attributes from the drop-down lists on the Options bar.**

5. **Click the image and type the text. Then, click the Commit button (the check mark icon) on the Options bar.**

 A selection border in the shape of the text appears on your image, as shown in the figure.

PhotoDisc/Getty Images

6. **Choose Select⇨Inverse, which deselects letter selections and selects everything else.**

7. **Press the Backspace (Delete on the Mac) key to delete everything outside your selection border. Choose Select⇨Deselect.**

 Your type is now filled with your stone texture.

8. **Choose Window⇨Effects and select the Layer Styles button (second from the left) in the upper-left area of the Effects panel.**

9. **Select the Bevels styles library from the drop-down list in the upper-right area of the Effects panel. Double-click the desired bevel.**

10. **Select the Drop Shadow styles library from the drop-down list in the upper-right area of the Effects panel. Double-click the desired shadow.**

We selected a Simple Inner bevel and Soft Edge drop shadow to produce our stone letters, as shown in the figure.

To get all the details on how to use the other options in the Layer Style dialog box, check out Book VII, Chapter 3.

If you want to admire your type against a solid background, create a new layer and then choose Edit⇨Fill Layer and choose a color from the Use drop-down list.

TIP

Stylizing and Warping Type

You can do a lot more with type than create conventional labels, captions, or paragraphs of text. Type can become an interesting part of your image, especially when you stylize, warp, or otherwise transform it in interesting ways. Your Elements text can help enhance the impact of your image. The text of a beach scene can appear to be wavy, or watery and translucent. Halloween type can take on a ghostly or spooky appearance. Text on a wedding photo can be elegant and romantic. It all depends on how you create and apply various effects.

The following sections show you some of the tricks you can perform by stylizing and warping your type so that your words come to life and add something special to your images.

Playing with type opacity

Layers are a digital version of the old analog transparency, or acetate, sheets. (Check out Book VI, Chapter 1 for the scoop on layers.) You can change the transparency of a Type layer — just as you can with any other layer in Elements — by reducing the *opacity* (transparency) of the type so that it enables the underlying layer to show through. Take a peek at Figure 3-11, which shows type at varying levels of opacity over an image.

The upcoming Putting It Together project, "Ghosting Your Type," shows you a way to use type opacity to create a ghostly effect.

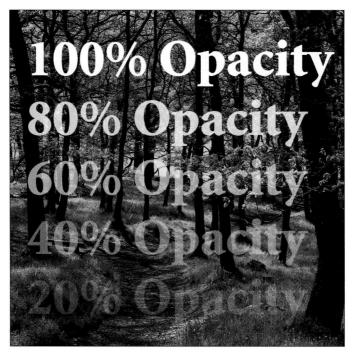

Corbis Digital Stock

Figure 3-11: Varying the opacity of type allows the underlying image to show through.

 Putting It Together

Ghosting Your Type

Need some ghostly, semitransparent type? Using Elements, you can twist, transmogrify, and transform your text. Create your type from scratch in an empty document or add the

type to an existing picture or background. Just for the heck of it, these steps show you how to add ghostly writing to an existing image:

1. **In the Editor, in Edit Full mode, open the image you want to use as a background for the ghost type.**

 Any image, ectoplasmic or not, will do. We chose a jack-o'-lantern, as shown in the figure.

2. **Click the Foreground color swatch in the Tools panel and select the color you want to use for your text from the Color Picker.**

 For info on using the Color Picker, see Book III, Chapter 4. Black and orange are good Halloween colors, but you can use any contrasting colors.

 You can also sample a color directly from your image by using the Eyedropper tool. Simply click your desired color and it then becomes your new foreground color.

3. **Select the Horizontal Type tool from the Tools panel and then click the area where you want to add the text.**

 The vertical cursor that appears is the size that the text will be.

4. **Select a font, style, and size from the drop-down lists on the Options bar, as shown in the figure.**

 Purestock

5. **Check the Anti-aliasing option on the Options bar to help smooth the edges of your type.**

6. **Type your text.**

 The text appears on top of the background.

7. **Click the Commit button (the check mark icon) on the Options bar to insert the text you've typed into a layer of its own.**

8. **To change the opacity of the type, adjust the Opacity setting of the Type layer in the Layers panel.**

continued

continued

To make additional changes to the text, you can apply a filter. For example, if you want to make the text wavy, select the Wave filter in the Filter⇨Distort menu. Or you can use other filters from the array discussed in Book VII, Chapter 1. Just remember, when you use a filter, a warning pops up informing you that the type layer must be *simplified* (converted from editable text to pixels) first. Click OK and then apply the filter.

9. **When you're satisfied with the look shown in the figure, save your image for additional editing later or choose Layer⇨Flatten Image to combine the text and background.**

Purestock

Applying filters to type

One of the most interesting things you can do with type in Elements that you can't do in a word-processing or page-layout program is apply special effects, such as filters. You can make type look as if it's underwater or on the move, as shown in Figure 3-12, where we applied a motion blur. The only caveat is that type has to be simplified before a filter can be applied. Be sure to do all your text-editing before you get to the filtering stage. Applying the filter is as easy as selecting the simplified type layer on the Layers panel and choosing a filter from the Filter menu. For more on filters, see Book VII, Chapter 1.

PhotoDisc/Getty Images

Figure 3-12: Applying a motion blur to type can make it appear as fast as the skaters.

Painting over type with color

Changing the color of text is as easy as highlighting it and selecting a color from the Color Picker. But what if you want to do something a little more unconventional, such as apply brush strokes of paint randomly across the type, as we did in the first image shown in Figure 3-13? It's really easier than it looks. Again, as with applying filters to text, the only criterion is that the type has to be simplified first. After that's done, select a color, grab the Brush tool with settings of your choice, and paint. In our example, we used a rough, dry brush found in the Brushes presets. We used a diameter of 39, 15, and 6 pixels and just clicked the type a few times.

If you want the color or gradient to be confined to only the type area, you can select the text by either Ctrl-clicking (⌘-clicking on the Mac) the layer containing the text or locking the transparency of the layer on the Layers panel.

You can also apply a gradient to your type. Here are the steps to follow after simplifying your type:

Figure 3-13: Add visual interest to type with color (top) or a gradient (bottom).

1. **In the Editor in Edit Full mode, select the Gradient tool from the Tools panel.**

2. **On the Options bar, click the down-pointing arrow next to the Gradient Picker to access the Gradient Picker drop-down panel.**

3. **Choose a gradient.**

 If you want to create a custom gradient, find out how in Book V, Chapter 2.

4. **Position the gradient cursor on the text where you want the gradient to start and drag to where you want the gradient to end.**

 If you're not happy, drag again until you get the look you want. Remember that you can drag at any angle and to any length, even outside your type. In the second image shown in Figure 3-13, we used the copper gradient and just dragged from the top of the letters to the bottom. We also locked the transparent pixels on the layer to confine the gradient to just the type area.

Warping your type

Elements's great automated Warp feature can twist your type in a variety of ways (see Figure 3-14) that are not only repeatable but, thanks to the controls in their dialog boxes, also customizable. The cool part is that even though type has been warped, it remains fully editable until you simplify it.

Type-warping is fun and easy to do. Select the Type tool in the Tools panel and then click the Create Warped Text button at the far-right end of the Options bar. (It's the T with a curved line below it.) This action opens the Warp Text dialog box, where you find a vast array of distortions on the Style pop-up menu with descriptive names such as Bulge, Inflate, and Squeeze.

You can adjust the orientation, amount of bend, and degree of distortion by dragging the sliders. The Bend setting affects the amount of warp, and the Horizontal and Vertical Distortions apply perspective to that warp. Luckily, you can preview the results while you adjust. We could give you technical explanations of these adjustments, but the best way to see what they do is to just play with them. Figure 3-14 shows some of the warp styles. The names speak for themselves.

joan of arc flytheflag

squeeze play twist&shout

battle of the bulge wavygravy

Figure 3-14: Choose from a number of warp styles.

Web designers take note: You can't warp text that has a Faux Bold style applied.

Book VI

Working with Layers and Masks

*A*fter you master creating selections, you'll want to do something with the selections you create. This is where Book VI helps you. We talk about creating selection masks, reusing selections, adding layers to a document, and creating layers from selections, and all the masking options you have in Edit Full mode. Next to mastering selections, understanding layers and how to use them is one of the most important aspects of working in Elements.

Chapter 1: Creating Layers

In This Chapter

✓ **Backgrounds versus layers**

✓ **Taking a look at the types of layers**

✓ **Working with the Layers panel and menu**

✓ **Creating layers**

✓ **Compositing with multiple layers**

✓ **Transforming layers**

✓ **Simplifying layers**

*U*sing Elements without the assistance of layers would be like trying to wash your car with a toothbrush and a pail of water instead of with a hose and a power-scrubber brush. Yes, it can be done. But it takes a lot longer and is downright tedious. The benefit to using layers is that you have tremendous flexibility. You can make endless edits as long as those layers exist. You can rearrange their order, and if you decide you don't want them anymore, you simply delete them. Layers make working in Elements a lot more forgiving, allowing you to make changes quickly and productively.

But hey, it's not just the technical and practical aspects that make layers so awesome. Layers also allow you to express your creative side: You can composite several images into one with just a drag of the mouse, for example. This chapter gives you the basics on working with layers. Chapter 2 of this minibook fills in the rest of the details. After you give layers a try, you'll find that they make your image-editing life so much easier. Now, if only they would go out and wash the car.

Getting Familiar with Layers

In terms of a real-world analogy, think of layers as sheets of acetate or transparency film, similar to those clear plastic sheets used with overhead projectors. You have drawings, photos, or type on the individual sheets. What you place on one sheet doesn't affect the other sheets. You can show just one sheet, or you can stack several on top of one another to

create a combination image, or *composite* (or *collage*). You can reshuffle the order of the sheets, add sheets, or delete sheets. Any space on the sheet that doesn't have an image, a drawing, or some type on it is transparent.

That's how layers work in Elements. You can place elements on separate layers yet show them together to create a composite. You can also add, delete, or rearrange layers. And, unlike using real sheets of acetate, you can adjust an element's *opacity,* or how opaque or transparent it is on the layer. You can also change the way the colors between layers interact by using Blend modes. Both opacity and Blend modes are covered in Chapter 3 of this minibook.

When you create a new image with a white or colored background, scan an image into Elements, or open a file from a CD or your digital camera, you basically have a file with just a *background.* You have no layers yet.

At this basic level, an image contains only the single background, and you can't do much to it besides paint on it and make basic adjustments. You can't rearrange the background in the stack of layers (after you have some) — it's always on the bottom of the Layers panel. You also can't change the opacity or Blend mode of a background. What you can do is convert a background to a layer, making it possible to shuffle, change the opacity, and change the Blend modes of your newly formed layer.

Keep in mind that to work with layers, you must be in the Editor in Edit Full mode.

To convert a background into a layer, follow these steps:

1. **In the Editor, in Edit Full mode, choose Window⇨Layers to display the Layers panel.**

 The Layers panel is explained in the upcoming section "Getting to Know the Layers Panel."

2. **Double-click *Background* in the Layers panel.**

 You can also choose Layer⇨New⇨Layer from Background. Note that the name *Background* is italicized in the Layers panel, as shown in Figure 1-1.

 The New Layer dialog box appears.

3. **Name the layer or leave it at the default name of Layer 0.**

 Note that you can also adjust the Blend mode and opacity of the layer in the New Layer dialog box. You should do so by using the Layers panel commands. We cover these techniques in Chapter 3 of this minibook.

Purestock

Figure 1-1: A newly opened image in Elements contains only a background.

4. **Click OK.**

 Elements converts your background into a layer, also known as an image layer. Note that the layer name is no longer italicized nor is it locked, as shown in Figure 1-2.

 When you create a new image with transparent content for the background, the image doesn't contain a background but instead is created with a single layer. If you so desire, you can convert a layer into a background by selecting it and then choosing Layer⇨New⇨ Background from Layer. Note that this option is available only when no background exists.

 Figure 1-2: Double-click the background to convert it into a layer.

Introducing Different Types of Layers

Although turning the background into a layer (discussed in the preceding section) is a popular activity, Elements refers to plural *layers* for a reason. You'll probably create image layers most of the time, but other types exist. Elements offers *five* types of layers. Some you may never use, and some you may use only occasionally, but you should be familiar with them all.

Working with image layers

The image layer is the one that most closely matches the acetate analogy (discussed in the section "Getting Familiar with Layers," earlier in this chapter). You put various elements on separate layers to create a composite image. You can create blank layers and add images to them, or you can create layers from images themselves. You can create as many layers as your computer's memory allows.

Because each layer in an image is a separate entity, you can edit, paint, transform, mask (described in Chapter 4 of this minibook), or apply a filter to a layer without affecting the other layers or the background. And, after an element is on a layer, you no longer have to make a selection to select it. (See Book IV for details on selections.) Just drag the element with the Move tool. The element freely floats in a sea of transparency.

Because showing *clear* areas, or transparency, is impossible on a computer monitor, Elements uses a gray-and-white checkerboard by default to represent the transparent areas of a layer.

Using adjustment layers

An *adjustment layer* is a special kind of layer used mostly for color and contrast correction. What's helpful about adjustment layers is that you can apply those corrections without permanently affecting any pixels on your layers. Adjustment layers are totally nondestructive. They apply the correction to all layers below them, without affecting any layers above them.

Because the adjustment resides on a layer, you can edit, delete, duplicate, merge, or rearrange the adjustment layer at any time. You have more flexibility in your image-editing chores and more freedom for experimentation. In addition, none of this experimentation harms your image because it takes place above the image on an adjustment layer.

Another unique feature of adjustment layers is that when you create one, you also create a layer mask on that layer. A *layer mask* is like a second sheet of acetate that hovers over the underlying layers. You use the layer mask to selectively apply the adjustment to the layers below it by applying shades of gray — from white to black — on the mask. For example, because the mask is, by default, completely white, you can fully apply the adjustment to the layers. If you paint on a layer mask with black, as shown in Figure 1-3, the areas under those black areas don't show the adjustment. If you paint with a shade of gray, those areas partially show the adjustment. The darker the shade of gray, the less these areas show the adjustment. Note that if your image has an active selection border in it before you add an adjustment layer, the adjustment is applied to only the area within the selection border. The

resulting layer mask also reflects that
selection: The selected areas are white,
and the unselected areas are black.

You can also use the layer mask to cre-
atively blend two layers. Be sure to see
Chapter 4 of this minibook to find out
how. It's definitely worth your while.

Elements has eight kinds of adjustment
layers, and you can use as many as
your heart desires. The adjustments
offered are the same ones you find on
the Enhance⬧Adjust Lighting and

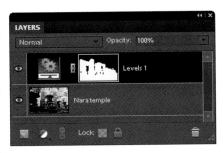

Figure 1-3: Layer masks are added by
creating an adjustment layer.

Enhance⬧Adjust Color submenus. For specifics on each adjustment and
what it corrects, see Book VIII, Chapters 1 and 2. Here's how to create an
adjustment layer:

1. **In the Editor, in Edit Full mode, open an image of your choice.**

 Because you're applying an adjustment layer, you may want to use an
 image that's in need of some color adjustment. Note that with adjust-
 ment layers, you don't need to convert your background into a layer.

2. **Click the Create Adjustment Layer icon in the Layers panel.**

 The Adjustment Layer drop-down list appears.

 Note that you can also choose Layer⬧New Adjustment Layer and then
 choose an adjustment layer from the submenu. Name the layer, leave
 the other options at their defaults, and click OK.

3. **From the drop-down list, choose an adjustment.**

 The dialog box pertaining to your adjustment appears in the new
 Adjustments panel.

4. **Make the necessary adjustments in the Adjustments panel.**

 The adjustment layer appears in the Layers panel, shown in Figure 1-4.
 The Adjustment Layer icon (sporting a few gears) and a thumbnail (rep-
 resenting a layer mask) appear on the adjustment layer.

In our example, the layer mask of the Levels adjustment layer — the central
layer of the three-layer sandwich — is all white, so the adjustment shows up
full strength over the image. Note that you can paint on the layer mask to
selectively allow only portions of your image to receive the adjustment, as
shown in our Hue/Saturation adjustment layer. Use the Brush or Pencil tool
to paint. Or, you can also make a selection and fill it with any shade of gray,

from white to black. Finally, you can use the Gradient tool on the mask to create a gradual application of the adjustment.

You can also adjust the opacity and Blend modes of an adjustment layer, just as with image layers. Reducing the opacity of an adjustment layer reduces the effect of the adjustment on the underlying layers.

Viewing and deleting adjustment layers

If you want to view your image without the adjustment, click the Eye icon in the left column of the Layers panel to hide the adjustment layer. If you want to delete the adjustment layer, simply drag it to the Trash icon in the Layers panel or choose Delete⇨Layer from the Layer menu or the Layers panel options menu. (Click More in the top-right corner of the panel to access the menu.)

Editing adjustment layers

After you create an adjustment layer, you can easily edit it. Simply double-click the Adjustment Layer icon in the Layers panel. You can also choose Layer⇨Layer Content Options. In the adjustment's dialog box, make any edits and then click OK. The only adjustment layer that you can't edit is the Invert adjustment layer. It's either totally on or totally off.

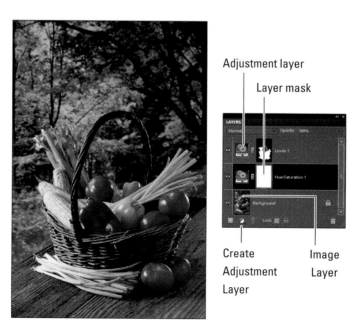

Figure 1-4: Applying your corrections with an adjustment layer, rather than directly on the image, allows for more editing flexibility.

Using the adjustments panel controls

Click an icon. From left to right, here's what the icons do:

- ✔ Have the adjustment layer clip to the layer below it (affects only the layer directly beneath it, not all underlying layers in the stack)

- ✔ Toggle the adjustment layer on and off

- ✔ View the previous state (how the image appeared before your most-recent step)

- ✔ Reset the adjustment layer settings to their defaults

Isolating your adjustments

If you don't use an adjustment layer when you make color corrections, the correction you apply affects only the *active layer* (the layer highlighted in the Layers panel). The correction doesn't affect all layers below it, as it would if you used an adjustment layer. But you can also isolate the adjustment layer to a single layer or a portion of a single layer.

Here are some tips for using and isolating adjustment layers:

- ✔ **Correct part (but not all) of a layer.** To enable the adjustment layer to correct only a portion of a layer, make a selection before you create the adjustment layer. The adjustment affects only the pixels within the selection outline. The adjustment affects the pixels within the selection outline *on each layer that resides below the adjustment layer.*

 Another way to correct part of a layer is to paint on the adjustment layer mask. Painting with black hides the adjustment, and painting with various levels of gray partially hides the adjustment. For more on masks, see Chapter 4 of this minibook.

- ✔ **Clip to the layer.** If you want the adjustment layer to affect only the immediate underlying layer and not those below that immediate layer, you can create a clipping group. To do so, press the Alt key (Option on the Mac) and click the line between the adjustment layer and your immediate, underlying image layer. For details on clipping groups, see Chapter 4 of this minibook.

Taking advantage of fill layers

A *fill layer* lets you add a layer of solid color, a gradient, or a pattern. Like adjustment layers, fill layers also have layer masks, as indicated by the Mask icon thumbnail in the Layers panel.

Just as with image layers and adjustment layers, you can create as many fill layers as you want. You can also edit, rearrange, duplicate, delete, and merge fill layers. And, you can blend fill layers with other layers by using the opacity and Blend mode options in the Layers panel.

You can confine the effects of a fill layer, as you can with an adjustment layer, to a portion of the image. Make a selection before you create the fill layer (see Book IV for more on selections) or paint on the mask later (described in the earlier section "Isolating your adjustments"). Editing a fill layer is similar to editing an adjustment layer. To edit a fill layer, double-click the Fill Layer thumbnail in the Layers panel.

Here's how to create a fill layer:

1. **In the Editor, in Edit Full mode, open an image of your choice.**

 In this case, open an image that would look good with a frame or border or even some type. Note that if you don't have an active selection, the fill layer encompasses your entire layer.

2. **Click the Create Adjustment Layer icon on the Layers panel. From the drop-down list, choose a fill of a solid color, gradient, or pattern.**

 Note that you can also choose Layer⇨New Fill Layer and then choose a fill layer from the submenu. In the New Layer dialog box, name the layer, leave the other options at their defaults, and click OK. Specify options such as Mode and Opacity within your Layers panel, where you have more editing flexibility.

 The dialog box specific to your type of fill appears.

3. **Specify your options, depending on the fill type you chose in Step 2:**

 • *Solid Color:* Select a color from the Color Picker. (For more on color, see Book III, Chapter 4.)

 • *Gradient:* Click the down-pointing arrow to choose a preset gradient from the drop-down panel or click the Gradient preview to display the Gradient Editor and create your own gradient. For details on gradients, see Book V, Chapter 2.

 • *Pattern:* Select a pattern from the drop-down panel, as shown in Figure 1-5. Choose a value from the Scale drop-down list, if you want. Click Snap to Origin to make the origin of the pattern the same as the origin of the document. Select the Link with Layer option to specify that the pattern moves with the fill layer if you move the layer.

4. **Click OK.**

 The fill layer appears in the Layers panel. Similar to what happens in adjustment layers, a layer mask is created on the fill layer. In our example, in Figure 1-6, the words *Dolphin Sanctuary* appear in white on the layer mask, thereby allowing our pattern to show through. The

remaining areas are black, hiding our pattern. We also added some layer styles (bevel and drop shadow) to jazz up our type. For more on layer styles, see Book VII, Chapter 3.

Figure 1-5: Choose from a variety of preset patterns for your fill layer.

If you want to delete the fill layer, first select the layer in the Layers panel; then either drag it to the Trash icon in the Layers panel, choose Delete⇨Layer from the Layer menu, or choose Delete Layer from the Layers panel options menu.

Purestock

Figure 1-6: Your chosen fill shows through your selected areas.

You can simplify a fill layer to convert it to a regular image layer. Choose Layer⇨Simplify. By doing so, you can use painting tools or filters on that layer. For more on simplifying layers, see Chapter 2 of this minibook.

Making use of shape layers

Believe or not, Elements isn't just about photos and painting. It also has a set of shape-drawing tools — six, to be exact. You can fill those shapes with solid color, gradients, or patterns. When you create a shape, you're creating a *vector-based* object: This term means that the shapes are defined by mathematical equations, which create points and paths, rather than by pixels. The advantage of using vector-based objects is that you can freely size these objects without causing degradation. In addition, they're always printed with smooth edges, not with the jaggies you're familiar with seeing in pixel-based elements.

To create a shape layer, grab a shape tool from the Tools panel and drag it on your canvas. When you create a shape, it resides on its own, unique shape layer, as shown in Figure 1-7. Although you can move and transform shapes and adjust the Blend modes and opacity, your ability to edit shape layers is limited. To apply filters and other special effects, you must first *simplify* the shape layers — that is, convert the vector paths to pixels. For more on shapes, see Book V, Chapter 1.

Using type layers

To create type, such as the type shown in Figure 1-8, click your canvas with the Type tool and type some text. After you commit your text by pressing Enter on the numeric keypad or clicking the Commit button (the check mark icon) on the Options bar, you've created a type layer. In the Layers panel, you see a layer with a T icon, indicating that it's a type layer. Initially, the name of the type layer corresponds to the text you typed (you can change the layer name, if you want). Like shapes, the text in Elements is vector-based type and, if left in that format, always prints smoothly and without the jaggies. For more information on vector images, see Book III, Chapter 1.

Another great thing about type in Elements is that it's *live:* You can edit the text at any time. Besides being able to change the font and size, you can change the orientation, apply anti-aliasing (softening of the edges), and even warp it into various distortions. You can transform, move, rearrange, copy, and change the layer options (opacity, fill, and mode) of a type layer just as you can for image layers. If, however, you want to apply filters, you must first *simplify* (convert into pixels) the text. For everything you need to know about type, see Book V, Chapter 3.

Shape Shape layer

Figure 1-7: A shape layer is a vector-based object.

Figure 1-8: Type layers automatically appear when you create and commit type.

Getting to Know the Layers Panel

Just like every other important aspect of Elements, layers are controlled in their very own panel. You might have seen bits and pieces of the Layers panel throughout this chapter, but now it's time for a full-blown discussion of its capabilities. To display the Layers panel, shown in Figure 1-9, choose Window⇨Layers in the Editor, in Edit Full mode.

The order of the layers in the Layers panel represents the order in the image. We refer to this concept as the *stacking order.* The top layer in the panel is the top layer in your image, and so on.

For some tasks, you can work on only one layer at a time. For other tasks, you can work on multiple layers simultaneously.

Here's the lowdown on how to work with the Layers panel:

- **Select a layer.** Click a layer name or thumbnail. Elements then highlights the *active layer* in the panel.
- **Select multiple contiguous layers.** Click your first layer and then Shift-click your last layer.

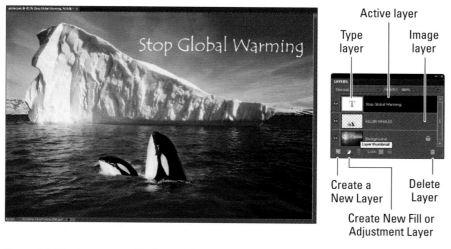

Figure 1-9: The Layers panel is Control Central for your layers.

✓ **Select multiple noncontiguous layers.** Ctrl-click (⌘-click on the Mac) some layers.

Only layers that are visible are printed. This can be useful if you want to have several versions of an image (each on a separate layer) for a project within the same file.

✓ **Select the actual element (the nontransparent pixels) on the layer.** Ctrl-click (⌘-click on the Mac) the layer's thumbnail in the panel.

✓ **Create a new, blank layer.** Click the Create New Layer icon (a dog-eared page) at the top of the panel.

✓ **Create an adjustment or fill layer.** Click the Create New Fill or Adjustment Layer icon (the black-and-white circle) at the top of the panel. See the earlier sections "Using adjustment layers" and "Taking advantage of fill layers" for more on these types of layers.

✓ **Duplicate an existing layer.** Drag the layer to the Create a New Layer icon at the top of the panel.

✓ **Rename a layer.** When you create a new layer, Elements provides default layer names (Layer 1, Layer 2, and so on). To rename a layer, double-click the layer name (the name, not the thumbnail) in the Layers panel, enter the name directly in the Layers panel, and press Enter (Return on the Mac). Although it may seem tedious to give your layers meaningful names, it can increase your productivity, especially when the number of layers in your file starts to increase.

✓ **Adjust the interaction between colors on layers and adjust the transparency of layers.** You can use the Blend modes and the Opacity drop-down menus at the top of the panel to mix the colors between layers and adjust the transparency of the layers. (Take a look at Figure 1-10, where we set the opacity at 30% and chose Lighten from the Blend mode drop-down menu.) For details, see Chapter 3 of this minibook.

✓ **Delete a layer.** Drag it to the Trash icon at the bottom of the Layers panel. You can also choose Layer⇨Delete⇨Layer or choose Delete Layer from the panel options menu.

You use the remaining icons at the top of the Layers panel to link layers and lock layers. Both actions warrant sections of their own. In addition, you can view, hide, rearrange, merge, and flatten layers. See Chapter 2 of this minibook for more details on all these features.

Figure 1-10: Control opacity and blending with the Layers panel.

Using the Layer and Select Menus

As with many features in Elements, you usually have more than one way to do something, especially when it comes to working with layers. Besides the commands on the Layers panel itself, you have two layer menus — the Layer menu and the Select menu — both of which you can find on the main Menu bar at the top of the Application window or at the top of the screen on a Mac.

The Layer menu

Much of what you can do with the Layers panel icons, you can also do by using the Layer menu on the Menu bar and the Layers panel pop-up menu. (Click the down-pointing arrow in the upper-right corner to call up that one.) Commands such as New, Duplicate, Delete, and Rename are omnipresent throughout. But you also find commands that are exclusive to the panel, the main Layer menu, and the Layers pop-up menu. So, if you can't find what you're looking for in one area, just go to another. Some commands require an expanded explanation and are described in other sections of this and other minibooks. Here's a quick description of most of the commands:

✔ **Delete Linked Layers and Delete Hidden Layers:** These commands delete only those layers that have been linked or hidden from display on the Layers panel.

✔ **Layer Style:** These commands manage the styles or special effects you apply to your layers. Find more on layer styles and effects in Book VII, Chapter 3.

✔ **Arrange:** You use this command to shuffle the layer-stacking order. See Chapter 2 of this minibook for more on this topic.

✔ **Group with Previous and Ungroup:** The Group command creates a *clipping group,* in which a group of layers is constrained to the boundaries of a base layer. Find more details in Chapter 4 of this minibook.

✔ **Type:** The commands on the Type submenu control the display of type layers. For more on type, see Book V, Chapter 3.

✔ **Rename Layer:** You use this option to give a layer a new name. You can also simply double-click the name on the Layers panel.

✔ **Simplify:** This command converts a type layer, shape layer, or fill layer into a regular image layer. In other words, it converts vector-based type and images to pixel-based type and images. See Chapter 2 of this minibook for details.

✔ **Merge and Flatten:** The various Merge and Flatten commands combine multiple layers into a single layer or, in the case of flattening, combine all layers into a single background. See Chapter 2 of this minibook for more info.

✔ **Palette Options:** Choose Palette Options from the Layers panel menu and select a thumbnail size. You can also choose whether to display just the boundary of the layer contents or the whole document in the thumbnail.

The Select menu

Although the Select menu's main duties are to assist you in making and refining your selections, it offers a few handy layer commands. Here's a quick introduction to each command:

✔ **Select All Layers:** Want to quickly get everything in your file? Choose Select➪All Layers. Note that this command doesn't select the background.

✔ **Select Layers of Similar Type:** This command is helpful if you have different types of layers in your document — such as regular layers, type layers, shape layers, and adjustment layers — and you want to select just one type. Select a layer and then choose Select➪Similar Layers.

✔ **Deselect All Layers:** Choose Select➪Deselect Layers.

Making Layers

Good old-fashioned image layers are the backbone of the world of layers. You can create multiple image layers within a single document. Even more fun is creating a composite from several different images. The creative possibilities are endless. The following sections take a look at the various ways to create these layers.

Creating a new layer

You can create a layer in a new file or an existing one. To go the new-file route, choose File⇨New in the Editor, in Edit Full mode. Then, in the New dialog box that appears, select Transparent for the Background Contents option. (**Note:** Your new file appears labeled as Layer 1 rather than as Background.)

If you have an open image and you want to create a new, blank layer, here's how to do so:

- In the Editor, in Edit Full mode, click the Create New Layer icon at the top of the Layers panel. A layer with the default name *Layer 1* appears in the Layers panel.

- In the Editor, in Edit Full mode, select New Layer from the Layers panel pop-up menu (located under *More* in the top-right area of the panel).

- Choose Layer⇨New⇨Layer.

 If you create a layer by using either of the preceding menu commands, you open a dialog box in which you name your layer and can specify other options for blending and opacity. Provide a name for your layer and click OK. You should specify the other options directly in the Layers panel later.

After your new transparent layer is ready to go, you can put content on the new layer in one of several ways:

- Use one of the painting tools, such as the Brush or Pencil, and paint directly on the layer.

- Make a selection on another layer or on the background within the same document or from another image entirely. Then choose Edit⇨Copy. Select your new, blank layer in the Layers panel and choose Edit⇨Paste.

- Make a selection on another layer (or on the background) within the same document or from another image and then choose Edit⇨Cut. Select a new, blank layer and choose Edit⇨Paste. Just remember that Elements deletes the selection from the source and adds it to your new layer, as shown in Figure 1-11.

✔ Transfer an entire image to your new layer by choosing Select➪All and then either Edit➪Copy or Edit➪Cut. Select a new, blank layer and choose Edit➪Paste.

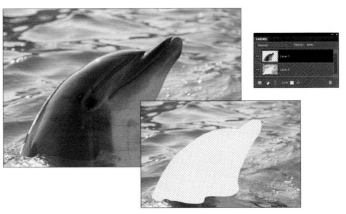

Figure 1-11: Cutting and pasting a selection from one layer to another leaves a transparent hole on the original layer.

Using Layer via Copy and Layer via Cut

Another way to create a layer is to use the Layer via Copy command on the Layer menu. Make a selection on a layer or background and choose Layer➪ New➪Layer via Copy. The copied selection is placed on a new layer with the default name *Layer 1*. You can do the same with the Layer via Cut command, but in this case Elements cuts, or deletes, the selected area from the source layer or background and places it on the new layer. The source layer is left with a gaping, transparent, or background-colored hole (refer to Figure 1-11). Remember that you can use these two commands only within the same image. You can't use them between images.

Duplicating layers

If you want to duplicate an existing layer, first select it in the Layers panel. Then drag the layer to the Create New Layer icon at the top of the Layers panel. You can also duplicate a layer by selecting Duplicate Layer from the Layers panel pop-up menu or by choosing Layer➪Duplicate Layer. As when you create a new layer, both menu methods prompt you with a dialog box to name your layer and specify other options. Provide a name for your layer and click OK. If you chose the first method, Elements provides the default name of the original layer with the word *Copy* appended to the name.

Duplicating layers can be especially handy when you want to experiment with a special effect but don't want to harm your original image.

Compositing with Multiple Images

Often, when working with layers, you're not using just a single image. Face it: You can only do so much to that family portrait taken down at the local photo studio. But pluck your family out of that stale studio and put them in front of the ruins at Pompeii or the summit at K2 and you have endless hours of fun. When you get the hang of working with several images, you find that it opens up a whole new realm of creative possibilities. And, you're not limited to snapshots. You can incorporate type, shapes, and scans of just about anything you can place on a scanning bed. Apply some effects, maybe a filter or two, and you have an image worthy of some major wall real estate.

Copying and pasting images

In the "Making Layers" section, earlier in this chapter, we explain how to use the Copy, Cut, and Paste commands within the same image or between two different images when you want to fill a new, blank layer with content. You can also use the Copy and Paste commands without having a blank layer ready. When you copy and paste a selection without a blank layer, Elements automatically creates a new layer from the pasted selection. You can go on your merry way and perform all your layer creations by using only those commands. However, we rarely use them when working with multiple images. We prefer the drag-and-drop method, which we describe in the following section.

The Copy Merged command on the Edit menu creates a merged, or *joined,* copy of all visible layers within the selection.

Dragging and dropping layers

Follow these steps to drag and drop layers from one file to another:

1. **In the Editor, in Edit Full mode, open two or more images.**

2. **In one of your images, select a layer in the Layers panel.**

3. **Grab the Move tool (the four-headed arrow) from the Tools panel.**

4. **Position the Move tool within an image and click it, and then drag and drop the layer onto your destination file.**

The dropped layer pops in as a new layer above the active layer in the image, as shown in Figure 1-12. You don't need to have a selection border to copy the entire layer. But, if you want to copy just a portion of the layer, make your selection before you drag and drop with the Move tool. If you want the selected element to be centered on the destination file, press the Shift key while you drag and drop.

PhotoDisc/Getty Images

Figure 1-12: Dragging and dropping a selection keeps your Clipboard lean and mean.

If you have multiple elements on one layer and want to select only one of the elements to drag and drop, simply grab the Lasso tool and draw around the object. You don't have to be superprecise, but don't include any portion of the other elements on the layer. Then hold down the Ctrl key (⌘ key on the Mac) and press the up-arrow key once. The element then becomes neatly selected. You can not only drag and drop the element but also move or edit it without affecting the other pixels on the layer. Flip to Book IV, Chapter 1 for help with making selections.

Be sure to check out the nearby sidebar, "Bypassing the Clipboard," for more on dragging and dropping.

Using the Paste into Selection command

The Paste into Selection command lets you put a copied or cut image on a separate layer while inserting that image into a selection border on another layer. That's where the Edit➪Paste into Selection command comes in handy.

Bypassing the Clipboard

Yes, you can always cut and paste or copy and paste a layer from one image to another, but we prefer to drag and drop, rather than copy and paste, between two images. By dragging and dropping, you bypass the temporary storage area for copied and stored data — the *Clipboard.* (Whenever you copy or cut a selection, Elements stores the selection on the Clipboard until you're ready to paste it to its new home.) So, what's wrong with that? Well, nothing, unless you're working with high-resolution images. Storing images on the Clipboard, even temporarily, can slow down your system. Keeping your Clipboard clear of data ensures that Elements is running lean and mean so that you can drag and drop more images, selections, and layers more quickly and more efficiently. If you want to perform a little spring cleaning on your Clipboard, you can always choose Edit➪Clear➪Clipboard Contents, which empties it of any stored data.

For example, if you want to make it appear as though a snake is poking its head out of the opening of a cave or a paintbrush is poking out of a can, Paste into Selection is your command (see Figure 1-13). Be sure to check out the Putting It Together project in this chapter to get more practice in using this practical technique.

Follow these steps to insert a copied or cut selected image into a selection outline:

1. **In the Editor, in Edit Full mode, make the selection on the layer that you want the image to fill.**

 It's the *destination* layer.

2. **Select the image that will fill that selection.**

 This *source* image can be within the same file or from another file.

3. **Choose Edit➪Copy.**

4. **Return to the destination image layer and choose Edit➪Paste Into Selection.**

 The pasted selection is visible only inside the selection outline (refer to Figure 1-13). If necessary, reposition your pasted selection with the Move tool. If you need to scale the pasted selection, choose Image➪Transform➪Free Transform. For more on transformations, see Chapter 2 of this minibook. In our example, our carrots are showing only inside our selection. The bottoms of the carrots are hidden, making it look as though they're sitting inside the Chinese takeout container.

Corbis Digital Stock

Figure 1-13: Use the Paste Into command to make one layer appear as though it's emerging from another.

 Putting It Together

Creating Layers and Using the Paste into Selection Command to Make a Collage

You probably remember from elementary school cutting out a bunch of pictures from magazines and pasting them on a piece of construction paper. Well, with Elements, the idea of a collage isn't much different, but the activity is a little more refined.

Maybe you want to unleash your artistic side. Or, maybe you need to combine several images into one as part of a job. Whatever your reason, you can use the steps here to get started on your first collage. And by the way, if *collage* is too prissy a word for you, you can substitute it with *composite* — which has the definition "derived from many components." We usually do.

continued

continued

Creating a collage takes many steps. Throughout this minibook, you can find several ongoing Putting It Together projects, all of which build on each other and lead you to a finished collage. Be sure to save your collage file so that you can work on it while you make your way through this minibook, if you like.

If you're short on photos, you can go to www.gettyimages.com. Be sure to register so that you have access to a huge gallery of free comping images. *Comping images* are small, low-resolution images used for internal corporate or personal noncommercial use only. You can also purchase high-resolution images for a song (from $1 to $20) at www.istockphoto.com or www.stockxpert.com. If that's too pricey for you, check out stock.xchng at www.sxc.hu, where you can find user-uploaded files and download them for free. Just be sure to ask for the photographer's permission if you want to use the images for anything other than practice.

To create the first layer of your collage, follow these steps:

1. **Decide on two images you want to use in your collage and open them in the Editor, in Edit Full mode, by choosing File⇨Open.**

You can pick an image to use as your main canvas and then open a supporting image that you can select and then drag onto that main image. However, if you want, you can also start with just a blank document, which is what we've done. We then filled our blank image with light green. See Book V, Chapter 2 for details on filling with color.

www.istockphoto.com, Corbis Digital Stock

2. **Choose Window➪Layers to open the Layers panel.**

 Always be sure that the Layers panel is visible whenever you're creating a composite from multiple images. You need to see what's happening while you drag and drop, and you need to be aware, at all times, of which layer you're working on.

3. **Select an element in the supporting image.**

 Feel free to use whichever selection method suits your fancy, but remember that the finished collage will look only as good as its individual selections. For more on making selections, see Book IV.

 We used the Quick Selection tool to select the girl. We then used the Lasso tool and cleaned up our selection border.

4. **Choose Select➪Modify➪Contract and, in the Contract Selection dialog box, enter a value. Then choose Select➪Feather and enter a value in the Feather Selection dialog box.**

 Contract the selections lightly (we chose a value of 1 pixel) before you apply a feather (we chose a 0.5 pixel value) to avoid picking up some of the background during the feathering process. Note that the values you choose depend on the resolution of your images; the lower the resolution, the smaller the value needed.

continued

continued

Using a small feather helps to avoid the harsh, I-cut-it-out-with-a-pair-of-pinking-shears look.

5. **With the Move tool, drag and drop the selection onto the background image.**

 The Layers panel shows that you've produced a layer. Notice that your main image remains as the background below the layer, as shown in the figure.

Don't worry if your element isn't the right size. You can find a Putting It Together project in Book VI, Chapter 2 that shows you how to scale the layer.

6. **Choose File⇨Save As. In the Save As dialog box, name the file collage and make sure the format is Photoshop.**

 Keep the file in a handy spot on your hard drive so that you can find it when you're ready to do more with your collage.

In the preceding steps, we show you how to create a layer by dragging and dropping an image onto a background image. The process we demonstrate in the following steps is a little different. It entails pasting one selection into another.

To paste one selection into another on your collage, follow these steps:

1. **In the Editor, in Edit Full mode, choose File⇨Open. Select the file you saved from the preceding exercise. Also, open a new supporting image.**

2. **Choose Window⇨Layers to open the Layers panel.**

 Always keep the Layers panel visible whenever you're creating a composite from multiple images.

3. **Select the part of the supporting image that you want to use.**

 Feel free to use whichever selection method you want, but try to get as accurate a selection as you can.

 We wanted to use the whole image, so we chose Select⇨All.

4. **Contract and feather the selection (as described in Step 4 in the preceding set of steps).**

 Unless you're going for a special effect, be consistent with the treatment of the edges of each of your elements in your composite.

continued

continued

We bypassed this step because we're using the entire image.

5. **Choose Edit⇨Copy.**

6. **In your saved collage file, use the Lasso tool (or any other selection tool) to create a selection in which to paste your new supporting image.**

 We selected the blank screen of the girl's laptop with the Polygonal Lasso tool.

7. **Choose Edit⇨Paste into Selection.**

 Use the Move tool to position the pasted image within the boundaries of the selection outline.

 If your image needs to be scaled or rotated, choose Image⇨Transform⇨Free Transform. For details on transforming layers, see Chapter 2 of this minibook.

8. **Choose File⇨Save.**

Chapter 2: Managing Layers

In This Chapter

✔ **Viewing, moving, and shuffling layers**

✔ **Transforming layers**

✔ **Simplifying layers**

✔ **Aligning and distributing layers**

✔ **Linking and locking layers**

✔ **Flattening and merging layers**

*H*opefully, you had the time and inclination to check out the first chapter of Book VI. That's where you get all the basic information on creating layers. In this chapter, you get all the details on how to manage the layers you've created. And, unlike some employees, clients, or children, layers are extremely agreeable to being managed — even micromanaged, for that matter. You can scale and rotate them, hide them, rearrange them, link and lock them, and even condense them into one loving, collective layer. Yes, Elements has a slew of ways to get your layers lined up in the orderly and organized fashion you deserve.

Viewing Layers

Often, hiding all layers in your image except for the layer you want to edit is useful. You can then focus on the element at hand without the distraction of seeing all the other elements of the image. You can hide layers with a single quick click of the mouse button, as we describe in the following list:

✔ **Hide all the layers but one.** Select the layer you want to display. Alt-click (Option-click on the Mac) the eye icon for that layer in the left column of the Layers panel and all other layers disappear from view. To redisplay all the layers, Alt-click (Option-click on the Mac) the eye icon again.

✔ **Hide an individual layer.** Click the eye icon for that layer, as shown in Figure 2-1. To redisplay the layer, click the blank space in the eye column.

Corbis Digital Stock/Purestock

Figure 2-1: You can hide and show individual layers to better focus your tasks.

Only visible layers print. Hiding layers for printing can be useful if you want to have several versions (each on a separate layer) of an image for a project within the same document. You can view selective layers and print them, get approval from the powers-that-be, and then delete the layers with the scrapped versions. Only one file to manage — even we can handle that.

Rearranging Layers

You can shuffle the order of layers like clear sheets of acetate used with overhead projectors. The *stacking order* of the layers in the Layers panel corresponds to the order of the layers in the document. If you want to move a layer to another position in the stacking order, drag the layer up or down in the Layers panel. While you drag, you see a fist icon. Release the mouse button when a highlighted line appears where you want to insert the layer.

Alternatively, you can change the order by selecting the layer and then choosing Layer⇨Arrange. Then select one of the following commands from the submenu:

- **Bring to Front** and **Send to Back:** Send the layer to the top or bottom of the stacking order.

- **Bring Forward** and **Send Backward:** Move the layer one level up or down.

- **Reverse:** Switch the order of your layer stack when you have two or more layers selected.

If your image has a background, it always remains the bottommost layer. If you need to move the background, first convert it to a layer by double-clicking the name in the Layers panel. Enter a new name for the layer and then click OK.

Moving Layer Elements

Rearranging layers is different from moving the content on the layer. Because the elements on a layer are free-floating on a bed of transparency, you can easily move the element whenever necessary. Moving the element on one layer has no effect on any of the other layers and doesn't harm the image.

To move an image on a layer, first select the layer in the Layers panel. Then position the Move tool (the four-headed arrow in the Tools panel) anywhere on the image and drag it to the position you want. It doesn't get any simpler than that. Here are a few more handy tips for moving an image and using the Move tool:

- **Move the image on the layer in 1-pixel increments.** Press an arrow key when you have the Move tool selected. To move the layer in 10-pixel increments, press Shift when you press the arrow key.

- **Find out which layer holds the image you want to move or edit.** If you have the Auto-Select Layer option selected in the Options bar, select the Move tool and click the element. Elements automatically activates the layer that the element resides on. If you don't have this option selected, Ctrl-click (⌘-click on the Mac) the image.

- **Switch to a layer when you click with the Move tool on any part of a layer.** To do this trick, select the Auto-Select Layer option on the Options bar. But be careful when using this option, especially if you have a lot of overlapping elements — you may inadvertently select a layer when you don't want to.

✔ **Display a *bounding box* (a rectangle that encloses a selection or an image on a layer) that has handles around the elements on your layer.** To do this one, select the Show Bounding Box check box on the Options bar. This box can be useful if all your elements are melting into one another in an indistinguishable conglomeration.

We recommend keeping this option selected so that you have essentially the same controls (scale, rotate, and so on) as when you choose Image⇨ Transform⇨Free Transform.

✔ **Show Highlight on Rollover:** Hover your mouse on any element found on the canvas and an outline magically appears around the element on your layer. Click the highlighted layer to select it and then move it.

Transforming Layers

When working with multiple images, you no doubt have to scale, or even rotate, some images to fit them into your composite. Fortunately, Elements makes scaling an easy chore by providing you with the Transform and Free Transform commands on the Image menu. When it comes to transforming layers and transforming selections, the methods are identical. After an element is on a layer, you can just choose the appropriate transformation command and off you go. In addition, you can apply a transformation to multiple layers simultaneously if you select the various layers first.

Here's how to transform a layer:

1. **In the Editor, in Edit Full mode, select a layer in the Layers panel.**

 You can also apply a transformation to multiple layers simultaneously by linking the layers first. For details, see "Linking Layers," later in this chapter.

2. **Choose Image⇨Transform⇨Free Transform.**

 A bounding box surrounds the contents of your layer, as shown in Figure 2-2. (In our example, the bounding box surrounds Layer 3.) Drag a corner or side handle to size the contents. Press Shift while dragging to constrain the proportions. You can also click the link icon between the W and H fields to do the same. To rotate the contents, move the mouse cursor just outside a corner handle until it turns into a curved arrow and then drag. To distort, skew, or apply perspective to the contents, right-click and choose a command from the contextual menu that appears. You can also click the Rotate, Scale, and Skew icons in the Options bar as well as enter your transform values numerically in the fields.

 If you want to apply just a single transformation, you can also choose the individual Distort, Skew, and Perspective commands from the Image⇨ Transform menu. Or, to rotate or flip, you can choose Image⇨Rotate.

3. **When your layer is transformed to your liking, double-click inside the bounding box.**

 The bounding box disappears, leaving behind your transformed layer.

Figure 2-2: Transform your layers.

Try to perform all transformations in one execution. Don't go back numerous times to apply various transformations. Each time you transform pixels, you put your image through the *interpolation* process (increasing, decreasing, or remapping pixels). Done repeatedly, this process can degrade the quality of your image, which is why it's prudent to use the Transform⇨ Free Transform command rather than individual commands — so that all transformations are executed in one fell swoop.

Simplifying Layers

When you *simplify* a layer, you're simply converting a type layer, shape layer, or fill layer into a regular image layer. You want to do this to apply filters or to edit the layers with painting tools. However, simplifying comes with a price: After you simplify a shape layer, for example, you no longer have access to the shape-editing options, only the editing options available to a regular image layer. And, when you simplify a type layer, your text is converted to pixels, so you can't edit your text anymore. The moral of the story? Be sure your type is spelled and formatted to your liking before simplifying.

Here's how to simplify a layer:

1. **In the Editor, in Edit Full mode, select a layer in the Layers panel.**

2. **Choose Layer⇨Simplify Layer. You can also choose the command from the Layers panel menu (click the down-pointing arrow in the upper-right corner of the panel). If you select a shape layer, you can also click the Simplify command in the Options bar.**

Putting It Together

Transforming and Moving Layers in a Collage

When you have a couple images in your collage (see the Putting It Together project in Book VI, Chapter 1), you can start transforming them to your liking. Moving and scaling are the manipulations you'll probably do the most. Elements enables you to transform layers without affecting any other layer within the image. To transform and move images in a collage, follow these steps:

1. **In the Editor, in Edit Full mode, choose File⇨Open. Select your saved collage file in the dialog box that opens.**

2. **Choose Window⇨Layers to open the Layers panel.**

3. **In the Layers panel, select the layer (or layers) you want to transform.**

 In our example, we chose the layers that have the girl and the picture on the screen of the laptop.

istockphoto.com

4. **Choose Image⇨Transform⇨Free Transform.**

 The Free Transform bounding box appears around your layer.

 By choosing Free Transform, you interpolate the image only once, rather than multiple times.

5. **Shift-drag a corner transformation handle to scale the image down to the size you want but maintain its proportions, which reduces the amount of distortion.**

 We reduced the girl and screen about 20%.

6. **Position the cursor just outside the handle until a curved arrow appears. Rotate the image the desired amount.**

 Our layers didn't need any rotation.

7. **After you scale and rotate your image, place the cursor inside the Free Transform bounding box and position your layer elements by dragging them to your desired location.**

 We positioned our layers at the bottom of the Image window.

<div align="right">Book VI
Chapter 2

Managing Layers</div>

istockphoto.com

8. **When you transform the selection to your liking, double-click inside the Free Transform bounding box or press Enter (Return on the Mac).**

9. **Transform any remaining layers, following Steps 3 through 8.**

 If you're transforming a layer with a layer mask, be sure to choose the layer's thumbnail and not the layer mask thumbnail. Otherwise, you transform the layer mask rather than the layer.

REMEMBER

continued

continued

10. As always, when you transform a selection to your liking, double-click inside the Free Transform bounding box.

11. Choose File⇨Save.

You probably already have a good sense of the possibilities (which are infinite) available to you when you create and change collages. Of course, you can always add more stuff to a collage and rearrange its layers, as needed. Just follow these steps:

1. In the Editor, in Edit Full mode, choose File⇨Open and select your collage file. Also open another image.

We chose an image of a temple in Kyoto.

2. Choose Window⇨Layers to open the Layers panel — if it isn't already visible.

3. Select an element in the new image you open.

It goes without saying that making the selection accurate can only enhance your composite. We want to use our whole image, so we didn't need to make a selection.

4. Contract and feather the image's edges (as described in the Putting It Together project in Chapter 1 of this minibook) and use the Move tool to drag the selection into the collage file.

For the most consistent appearance possible, use consistent values for modifying and feathering all selections in this composite.

5. Position and transform the selection, as needed.

Follow the directions provided in the preceding step list. In our example, we scaled the temple image about 50 percent smaller and positioned it in the upper-right corner.

istockphoto.com/Corbis Digital Stock

6. **In the Layers panel, rearrange your layers, if needed, by selecting a layer and dragging it above another layer.**

 In our image, we dragged the temple layer below the girl and screen layers, as shown in the figure.

 Because layers are independent entities, you can shuffle them indefinitely, like a deck of cards.

7. **Choose File➪Save.**

Aligning and Distributing Layers

If you're a precision junkie, like we are, you'll appreciate Elements's ability to align and distribute your layers. These commands can be especially useful when you need to align such items as navigation buttons on a Web page mockup or a row of head shots for a corporate publication.

Follow these steps to align and distribute your layers:

1. **In the Editor, in Edit Full mode, select the layers you want to align in the Layers panel, as shown in Figure 2-3.**

 Select your first layer and then Ctrl-click (⌘-click on the Mac) to select more layers.

Figure 2-3: Select the layers you want to align in the Layers panel.

2. With the Move tool selected from the Tools panel, click the Align option in the Options bar and choose an alignment option from the drop-down list.

Elements provides you with handy little icons that illustrate the various alignment types, as shown in Figure 2-4.

Figure 2-4: The Options bar offers different alignment buttons.

Note that, depending on which alignment type you choose, Elements aligns to the layer element that's the farthest from the top, bottom, left, or right. If you align to the center, Elements splits the difference among the various layers.

3. In the Layers panel, select three or more layers that you want to distribute evenly.

4. With the Move tool selected from the Tools panel, click the Distribute option in the Options bar and choose a distribution option from the drop-down list.

The Distribute commands evenly space the layers between the first and last elements in either the row or column.

As with aligning, you find an icon illustrating the distribution types. You can see the buttons from Figure 2-3 precisely aligned and evenly distributed in Figure 2-5.

Figure 2-5: The aligned and evenly distributed buttons.

Linking Layers

You'll probably find that you don't need to link layers in most cases. Simply select multiple layers and apply your command — moving, scaling, rotating, and so on. Occasionally, however, you may want to link layers so that they stay grouped as a unit until you decide otherwise.

To link layers, follow these short steps:

1. **In the Editor, in Edit Full mode, select some layers in the Layers panel.**

2. **Click the Link Layers icon at the bottom of the Layers panel, as shown in Figure 2-6.**

 A link icon appears to the right of the layer name in the Layers panel.

 To remove a link, click the Link Layers icon again.

Figure 2-6: Use the Link Layers command to group your layers.

Locking Layers

After you have your layers how you want them, you may want to lock them to prevent them from being changed, as shown in Figure 2-7. To lock a layer, select it in the Layers panel and select one of the two lock options at the bottom of the Layers panel. The checkerboard square icon locks all transparent areas of your layers: You're prevented from painting or editing any transparent areas on the layers. The lock icon locks your entire layer and prevents it from being changed in any way, including moving or transforming the elements on the layer. You can, however, still make selections on the layer. To unlock the layer, simply click the icon again to toggle off the lock.

Lock All

Lock Transparent Pixels

Figure 2-7: Locking prevents unwanted edits.

By default, the background is locked and can't be unlocked until you convert the background into a layer by choosing Layer⇨New⇨Layer from Background. In addition, by default, type and shape layers have the Lock Transparent Pixels option selected. These options are gray and can't be deselected. However, if you need to paint on the type or shape layer, you can always simplify it (as described earlier in this chapter), thereby removing the locked option.

Flattening and Merging Layers

True layers evangelists that we are, we tout the glories of layers in the first chapter of this minibook. And, although layers are wonderful, they have a dark side: They can make your file go from slim and trim to bulky and bloated. Not only do you get a larger file size that slows your computer system's performance, but you're also limited to the file formats that allow you to save layers: Photoshop's native format (.psd), TIFF (.tif), and PDF (.pdf). If you save your file in any other format, Elements smushes your layers into a background. This file limitation often forces users to save two versions of every layered file — one as a native Photoshop file and one as something else, such as EPS or JPEG, to import into another program. (For more on file formats, see Book III, Chapter 2.)

To curb large file sizes or to use your image in a nonlayer supporting format, you have a couple options:

✔ **Merge layers:** Combines visible, linked, or adjacent layers into a single layer (not a background). The intersection of all transparent areas is retained. You can also merge adjustment or fill layers, but they can't act as the target layer for the merge. Merging layers can help decrease your file size and make your documents more manageable. You're still restricted to the layer-friendly file formats, however.

✔ **Flatten an image:** Combines all visible layers into a background. Elements deletes hidden layers and fills any transparent areas with white. Flattening is usually reserved for when you're finished editing your image. We recommend, however, that before you flatten your image, you make a copy of the file with all its layers intact and save it as a native Photoshop file. That way, if you ever need to make any edits, you have the added flexibility of having your layers.

Merging layers

You can merge your layers in several ways. However, to use the first option, follow these steps:

1. **In the Editor, in Edit Full mode, ensure that all the layers that you want to merge are visible in the Layers panel, shown in Figure 2-8.**

2. **Choose Merge Visible from the Layers panel pop-up menu or the Layer menu.**

All visible layers merge into a single Background layer, as shown in Figure 2-8.

Hold down Alt (Option on the Mac) when choosing Layer⇨Merge Visible. Elements merges those layers onto a new layer.

You can also merge layers by following these steps:

1. **Position the layers that you want to merge adjacent to each other in the Layers panel.**

2. **Select the top layer of those you want merged.**

3. **Choose Merge Down from the Layers panel pop-up menu or the Layer menu.**

Note that Merge Down merges your active layer with the layer directly below it.

Flattening layers

To flatten an image into a single background, follow these steps:

1. **In the Editor, in Edit Full mode, ensure that all layers you want to retain are visible in the Layers panel.**

Elements discards all hidden layers.

2. **Choose Layer⇨Flatten Image or choose Flatten Image from the Layers panel pop-up menu.**

The transparent areas of flattened images fill with the background color and appear as a background in the Layers panel, as shown in Figure 2-9.

Figure 2-8: Merging layers can make your file size a lot smaller.

Figure 2-9: Flatten your layers only if you're sure that you no longer need individual layers.

If you mistakenly flatten your image, you can undo the command immediately by choosing Edit⇨Undo. If you go ahead and perform another action, undo your mistake by using the Undo History panel. However, note that if the flattening step is no longer in the Undo History panel, you have no way to undo the flattening.

Putting It Together

Checking Your Collage for Flaws and Consolidating Layers

When you begin a project, you may think you know what you want the result to look like. But when your creative juices start flowing, you may decide that something doesn't look right. For example, while we were working on our collage, we felt that our green background was a little boring.

1. **In the Editor, in Edit Full mode, open the saved collage file and open a new image that you want to incorporate into the collage.**

 In our example, we thought the green background needed some texture, so we opened an image that contained some Japanese characters we like.

2. **Select the part of the image that you want to add to your collage, as shown in the figure.**

 We wanted the whole image, so we didn't need to make a selection.

istockphoto.com/Corbis Digital Stock

3. **With the Move tool, drag and drop your new selection, or entire image, onto your collage image.**

4. **Choose Image⇨Transform⇨Free Transform.**

 Transform and position your new layer, as described in the earlier Putting It Together project.

istockphoto.com/Corbis Digital Stock

When you're close to finalizing your collage, you might want to consolidate layers. Minimizing the number of layers makes projects easier to manage and your file size smaller, which is helpful when you get ready to add the finishing touches to your collage.

Before you merge your layers, be sure that you'll never have to manipulate them separately again, especially if the elements on the layer overlap each other, as ours do.

To consolidate two layers, follow these steps:

1. **In the Editor, in Edit Full mode, select the layers in the Layers panel.**

2. **Choose Merge Layers from the Layers panel pop-up menu.**

 The two layers merge and become one.

3. **Choose File⇨Save.**

Chapter 3: Playing with Opacity and Blend Modes

In This Chapter

- ✓ **Adjusting opacity**
- ✓ **Applying blend modes for effects**
- ✓ **Setting the blend options**

*I*n this chapter, we show you how to have a little fun and get those creative juices flowing. This chapter, along with Chapters 1 and 3 in Book VII, gives you a few ways to tweak the layers you've so diligently created. Maybe you want to make one of your layers semitransparent so that you can see the layer beneath it; or you might want to try blending the colors between a couple layers in a way that's slightly offbeat. Look no further.

Take these techniques as far as you want. And remember: There's no substitute for good-old experimentation. Before you jump into these techniques, you should have a handle on the methods of layer creation and management that we explain in Book VI, Chapters 1 and 2.

Adjusting Layer Opacity

By far one of the easiest ways to make your image look interesting is to have one image ghosted over another, as shown in Figure 3-1. Creating this effect is an easy task with the Opacity option in the Layers panel. You adjust the opacity by selecting a layer in the Layers panel. Then either access the slider by clicking the right-pointing arrow or enter a percentage value in the Opacity text box.

The Opacity setting allows you to mix the active layer with the layers below it in varying percentages from 100% (completely opaque) to 0% (completely transparent). Remember that you can adjust the opacity only on a layer, not on the Background.

Corbis Digital Stock

Figure 3-1: Adjusting the opacity enables one image to ghost over another.

TIP

You can also change the Opacity percentage by using keyboard shortcuts. With any tool active, except a painting tool or an editing tool, press a number key. Press 5 for 50%, 25 for 25%. If you're entering a 2-digit value, just be sure to type the numbers quickly or else Elements interprets the numbers as two different values. You get the picture. Note that for the default of 100%, you must press 0.

Creatively Mixing with Blend Modes

Elements sports an impressive 25 Blend modes. *Blend modes* affect how colors interact between layers and how colors interact when you apply paint to a layer. Blend modes can produce a multitude of interesting, sometimes even bizarre, effects. What's more, you can easily apply, edit, or discard Blend modes without modifying your image pixels one iota.

Blend modes are located on a drop-down list at the top of your Layers panel in Edit Full mode. The best way to get a feel for the effect of Blend modes isn't to memorize the descriptions we give you in the following sections.

Instead, grab an image with some layers and apply each Blend mode to one or more of the layers to see what happens. In fact, try a few different images because the effects may be subtle or intense, depending on the colors in the image. Throw in some different opacity percentages and you're on your way to endless hours of creative fun.

You'll see these modes called *Blend modes, Painting modes, Brush modes, Layer modes, calculations,* or just plain *modes.* They're usually referred to as *Blend modes* or *Layer modes* when used with layers and painting modes, and as *Brush modes* when used in conjunction with a painting or an editing tool.

General Blend modes

Normal blend mode doesn't require an explanation. It's the one you probably use the most. Dissolve is the next one on the list and, ironically, is probably the one you use the least (see both at work in Figure 3-2):

- ✏ **Normal:** The default mode displays each pixel unadjusted.

- ✏ **Dissolve:** You can see this mode only on a layer with an opacity setting of less than 100%. The lower the opacity, the more intense the effect. Dissolve allows some pixels from lower layers, which are randomized, to show through the target (selected) layer.

Blend modes that darken

Overall, the Blend modes we cover in this section all produce effects that darken your image, as shown in Figure 3-3.

Here's one of our favorite uses for the Darken blend mode. Scan a handwritten letter or sheet of music and layer it over an image. Apply the Darken blend mode to the letter or sheet music layer. The white areas of the paper become transparent, and only the letters or musical notes display, creating a nice composite image.

- ✏ **Darken:** Turns lighter pixels transparent if the pixels on the target layer are lighter than those on layers below. If the pixels are darker, they're unchanged.

- ✏ **Multiply:** Burns the target layer onto the layers underneath, thereby darkening all colors where they mix. With layers, it's comparable to sticking two slides in the same slot in a slide projector. When you're painting with the Brush or Pencil tool, each stroke creates a darker color, as though you're drawing with markers.

- ✏ **Color Burn:** Darkens the layers underneath the target layer and burns them with color, creating an increased contrast effect, like applying a dark dye to your image. Blending with white pixels has no effect.

✒ **Linear Burn:** Darkens the layers underneath the target layer by decreasing the brightness. This effect is similar to Multiply but often makes portions of your image black. Blending with white has no effect.

✒ **Darker Color:** When blending two layers, the darker color of the two colors is visible.

Normal

Dissolve

Figure 3-2: The Dissolve blend mode enables pixels from one layer to peek randomly through another layer.

Darken Multiply

Color Burn Linear Burn

Darker Color

Figure 3-3: These Blend modes darken, or burn, your layers.

Blend modes that lighten

If you have Blend modes that darken, well, having modes that lighten just makes good sense. So, if you have the need to throw some digital bleach on your brightly colored pixels, try out a couple of these Blend modes, as shown in Figure 3-4:

✔ **Lighten:** Turns darker pixels transparent if the pixels on the target layer are darker than those on layers below. If the pixels are lighter, they're unchanged. This effect is the opposite of Darken.

✔ **Screen:** Lightens the target layer where it mixes with the layers underneath. Blending with black has no effect. Like putting two slides in different projectors and pointing them at the same screen. This effect is the opposite of Multiply.

✔ **Color Dodge:** Lightens the pixels in the layers underneath the target layer and infuses them with colors from the top layer. Blending with black has no effect. This effect is similar to applying a bleach to your image.

✓ **Linear Dodge:** Lightens the layers underneath the target layer by increasing the brightness. This effect is similar to Screen but often makes parts of your image pure white. Blending with black pixels has no effect.

✓ **Lighter Color:** When you're blending two layers, the lighter color of the two colors is visible.

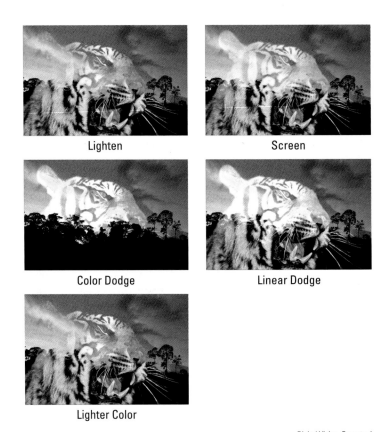

<div align="center">

Lighten Screen

Color Dodge Linear Dodge

Lighter Color

</div>

Digital Vision, Purestock

Figure 3-4: These Blend modes lighten, or dodge, your layers.

Lighting blend modes

This group of Blend modes plays with the lighting in your layers. Some of these Blend modes, such as Pin Light, are best reserved for the occasional wacky special effect. See the Blend modes in action in Figure 3-5:

✓ **Overlay:** Multiplies the dark pixels in the target layer and screens the light pixels in the underlying layers. Enhances the contrast and saturation of colors.

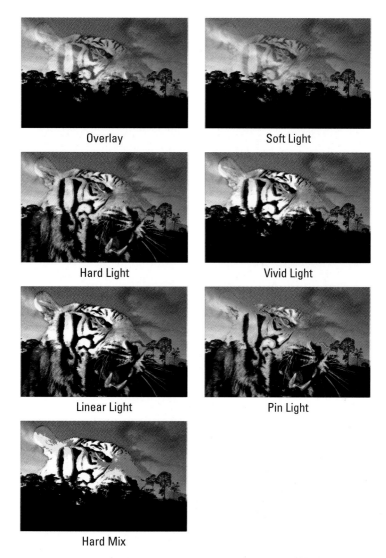

Overlay Soft Light

Hard Light Vivid Light

Linear Light Pin Light

Hard Mix

Figure 3-5: These Blend modes adjust the lighting between your image layers.

✓ **Soft Light:** Darkens the dark pixels (greater than 50% gray) and lightens the light pixels (less than 50% gray). Blending with black or white results in darker or lighter pixels, but doesn't make parts of your image pure black or pure white. It's similar to Overlay, but softer and subtler. The effect is like shining a soft spotlight on the image.

✒ **Hard Light:** This mode multiplies the dark pixels (greater than 50% gray) and screens the light pixels (less than 50% gray). It can be used to add highlights and shadows to an image. Blending with black or white gives you black and white. The effect is similar to shining a bright, hard spotlight on the image.

✒ **Vivid Light:** If the pixels on the top layer are darker than 50% gray, this mode darkens the colors by increasing the contrast. If the pixels on the top layer are lighter than 50% gray, the mode lightens the colors by decreasing the contrast. It's a combination of Color Burn and Color Dodge.

✒ **Linear Light:** If the pixels on the top layer are darker than 50% gray, the mode darkens the colors by decreasing the brightness. If the pixels on the top layer are lighter than 50% gray, the mode lightens the colors by increasing the brightness. It's a combination of Linear Burn and Linear Dodge.

✒ **Pin Light:** Replaces the colors of pixels, depending on the colors in the top layer. If the pixels on the top layer are darker than 50% gray, the mode replaces the pixels that are darker than those on the top layer and doesn't change pixels that are lighter. If the pixels on the top layer are lighter than 50% gray, the mode replaces the pixels that are lighter than those pixels on the top layer and doesn't change pixels that are darker. It's a combination of Darken and Lighten; useful for special effects.

✒ **Hard Mix:** Similar to Vivid Light, but reduces the colors to a total of eight — cyan, magenta, yellow, black, red, green, blue, and white. Although the results depend on the mix of existing colors on the top and bottom layers, this mode usually creates a highly posterized (a cartoon or flat illustration) effect.

Blend modes that invert

If the Blend modes discussed in the preceding sections are a little too sedate for you, you may want to experiment with the inverters — Difference and Exclusion. These Blend modes invert your colors and can produce some interesting special effects, as shown in Figure 3-6.

✒ **Difference:** Produces a negative, or inverted, effect according to the brightness values on the top layers. If the pixels on the top layer are black, no change occurs in the underlying layers. If the pixels on the top layer are white, the mode inverts the colors of the underlying layers. It can produce some intense effects.

✒ **Exclusion:** Like Difference, but with less contrast and saturation. If the pixels on the top layer are black, no change occurs in the underlying layers. If the pixels on the top layer are white, this mode inverts the colors of the underlying layers. Medium colors blend to create shades of gray.

Difference

Exclusion

Figure 3-6: The Difference and Exclusion blend modes invert colors.

HSL color model Blend modes

These Blend modes use the HSL (*h*ue, *s*aturation, *l*ightness) color model to mix colors, as shown in Figure 3-7.

🖙 **Hue:** Blends the *luminance* (brightness) and *saturation* (intensity of the color) of the underlying layers with the *hue* (color) of the top layer.

✓ **Saturation:** Blends the luminance and hue of the underlying layers with the saturation of the top layer.

✓ **Color:** Blends the luminance of the underlying layers with the saturation and hue of the top layer. This mode enables you to paint color while preserving the shadows, highlights, and details of the underlying layers.

Our favorite Blend mode in this group is Color; you use it to apply color to images without obscuring the tonality. Color mode is great for "hand painting" grayscale images. If you've ever admired those hand-tinted black-and-white photos used in greeting cards and posters, you can create the same effect fairly easily. First, make sure that your black-and-white image is in RGB (red, green, blue) mode so that it can accept color. Create a new layer on the Layers panel and set it to the Color blend mode. Grab the Brush tool (with a soft-edged tip), choose a color, and paint over your image. Adjust the opacity to less than 100% to create a softer effect. See details on this technique in Book V, Chapter 1.

✓ **Luminosity:** The opposite of Color, this mode blends the hue and saturation of the underlying layers with the luminance of the top layer. This mode also preserves the shadows, highlights, and details from the top layer and mixes them with the colors of the underlying layers.

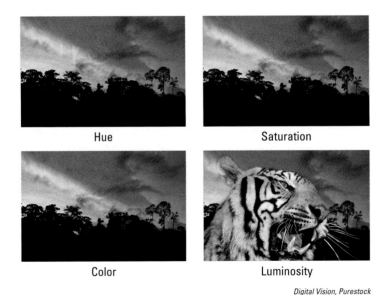

Hue

Saturation

Color

Luminosity

Digital Vision, Purestock

Figure 3-7: These Blend modes use the Hue Saturation Lightness color model to mix colors.

Putting It Together

Adjusting Opacity Settings in Your Collage

If you've followed along with the Putting It Together projects we discuss in Book VI, Chapters 1 and 2, you may have a collage that you're pretty satisfied with. You just need to make the final tweaks to get it to the state of perfection.

One of the most important tweaks you can make concerns opacity. Follow these steps to adjust the opacity settings on some of the layers:

1. **In the Editor, in Edit Full mode, open your saved collage file.**

2. **If the Layers panel isn't already visible, choose Window⇨Layers to open it.**

3. **Select a layer in your collage and move the Opacity slider, located at the top of the Layers panel, to the left or right.**

 If you want the layer to be more opaque, move the slider to the right. If you're interested in making the layer more transparent, move the slider to the left.

 We chose our Japanese characters layer and adjusted the opacity to 10%. We wanted the characters to create just a subtle texture, not to appear full strength.

istockphoto.com, Corbis Digital Stock

4. **Save the file and then move on to the next layer that you want to adjust.**

 If you have more complicated opacity settings to adjust, keep reading.

5. **Select another layer and then choose Duplicate Layer from the Layers panel pop-up menu. Click OK to close the Duplicate Layer dialog box.**

 Making a copy of a layer is useful because you can add a Blend mode and then adjust it to create just the right amount of the effect.

continued

Book VI
Chapter 3

Playing with Opacity and Blend Modes

continued

For example, if you want to define an element in your collage but applying it directly on the layer makes the effect too intense, make a copy of the layer. We made a copy of our temple layer.

6. **Select the duplicated layer and choose a mode (such as Soft Light) from the Blend Mode pop-up menu in the Layers panel.**

 Leaving our duplicated and blended layer at 100% opacity is a little too garish.

7. **Adjust the opacity to tone it down as much as you want.**

 We brought ours down to 25%.

8. **When you're satisfied with the opacity and contrast, save the collage file.**

 Oh, by the way, we added a dark green border and a lucky cat to our collage.

istockphoto.com, Corbis Digital Stock

Chapter 4: Cutting, Extracting, and Masking

In This Chapter

✔ **Using the Cookie Cutter tool**

✔ **Working with the Magic Extractor**

✔ **Selective erasing with the Eraser tools**

✔ **Working with layer masks**

✔ **Creating clipping groups**

In Book IV, we present you with lots of information about making selections with the many tools that Elements provides for that very purpose, such as the Marquee and Lasso tools, the Magic Wand, the Quick Selection tool, and the Selection Brush. But we left the discussion of a few tools until this chapter. The tools in Book IV involve making selections by dragging around, clicking, or painting over. And though the result is similar — selecting what you want or don't want in an image — the tools in this chapter are a little different in their methodology. They involve cutting out, extracting from, and erasing around.

To add to your selection repertoire, we give you details on layer masking, a feature that is the most versatile way to get what you want out of an image. Layer masking is essentially just another way of making a selection. Instead of defining your selection with a selection outline or by erasing away what you don't want, you can use masks to define your selection with up to 256 levels of gray. This gives you varying levels of selection. You can choose to fully show your layer, partially show it, or hide (or *mask*) certain areas. The nice thing about layer masks is that you can creatively blend one layer into another in a multitude of different ways.

We round out this chapter by showing you how to create a clipping group, yet another way to blend your layers by masking your layers to the opaque areas of a base layer. Don't worry: It may sound complicated, but it's a piece of cake.

Working with the Cookie Cutter Tool

The Cookie Cutter tool is a cute name for a pretty powerful tool. Think of it as a Custom Shape tool for images. But, whereas the Custom Shape tool creates a mask and just hides everything outside the shape, the Cookie Cutter cuts away everything outside the shape, much like a traditional cookie cutter does with dough. The preset libraries provide you with a variety of shapes, from animals and flowers to symbols and faces.

Here's how to use the Cookie Cutter:

1. **In the Editor, in Edit Full mode, choose the Cookie Cutter tool from the Tools panel.**

 The tool icon looks like a star. You can also press the Q key.

2. **Specify the following options on the Options bar.**

 - *Shape:* Click the down-pointing arrow and choose a shape from the preset library in the drop-down panel. To load other libraries, click the panel pop-up menu and choose one from the submenu.

 - *Shape Options:* Draw your shape using certain parameters:

 Unconstrained: Draw freely using the default, Unconstrained.

 Defined Proportions: Keep the height and width proportional.

 Defined Size: Crop the image to the original, fixed size of the shape you choose. You can't make it bigger or smaller.

 Fixed Size: Enter a width and height.

 From Center: Draw the shape from the center outward.

 - *Feather:* Create a soft-edged selection.

 - *Crop:* Crop the image into the shape. The shape fills the Image window.

3. **Click and drag your mouse on the image to create your desired shape. Size the shape by dragging one handle of the bounding box. Position the shape by placing the mouse cursor inside the box and dragging.**

 You can also perform other types of transformations, such as rotating and skewing. For more on transformations, see Book IV, Chapter 2.

 Take a gander at the Layers panel. Notice the temporary creation of a Layer Mask icon. See the section "Working with Layer Masks," later in this chapter, for details on layer masks.

4. **Click the Commit button on the Options bar and press Enter or double-click inside the bounding box to complete the cut.**

 Figure 4-1 shows our image cut into a flower. If you change your mind and don't want the cut, click the Cancel button on the Options bar or press Esc.

Corbis Digital Stock

Figure 4-1: Cut your photo into an interesting shape.

Using the Magic Extractor

When you see a name like *Magic Extractor,* you may wonder whether you have to do anything except utter a mystical incantation to have your desired element cleanly plucked from its background. Unfortunately, it isn't quite that easy, but it's pretty close. You use the Magic Extractor command to make selections based on your identification of the foreground and background portions of your image. Specify your foreground and background by clicking these areas with the Brush tool and "marking" them. Click the magic OK button, and your object or objects are neatly and painlessly extracted.

Make a rough selection first before selecting the Magic Extractor command. This technique, which isn't mandatory, restricts what's extracted and can result in a more accurate selection.

Follow these steps to magically extract your element:

1. **In the Editor, in Edit Full mode, choose Image⇨Magic Extractor.**

 The Magic Extractor dialog box appears.

2. **Choose the Foreground Brush tool from the dialog box and then click or drag to mark *foreground* areas — the areas you want to select.**

 The default color of the Foreground Brush is red, as shown in Figure 4-2.

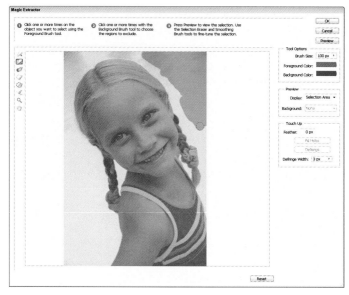

Corbis Digital Stock

Figure 4-2: Identify foreground and background areas with the Magic Extractor.

The more accurate the data you provide to the command's algorithm, the more accurate your extraction. Be sure to use the Zoom and Hand tools to help magnify and move around your image as needed.

You can also change the size of your brush tip (from 1 to 100 pixels) in the Tool Options area on the right side of the dialog box. If necessary, change the color of your foreground and background colors by clicking the swatch and choosing a new color from the Color Picker.

3. Select the Background Brush tool from the dialog box and then click or drag to mark the *background* area — the portions you don't want to select.

The default color of the Background Brush is blue.

4. Click Preview to view your extraction.

You can change the preview by going to the Preview section of the Magic Extractor dialog box and choosing either Selection Area or Original Photo from the Display pop-up menu.

If you want to see your selection against a different background, choose one from the Background pop-up list. (A black matte for a black background is nice.)

5. **If the extraction needs more accuracy, you can refine the selection with the help of the Magic Extractor tools set, located along the left side of the dialog box:**

- *To erase any markings:* Select the Point Eraser tool and click or drag over the offending areas.

- *To add areas to the selection:* Click or drag over your desired areas with the Add to Selection tool.

- *To delete areas from the selection:* Drag with the Remove from Selection tool.

- *To smooth the edges of your foreground selection:* Drag over the edges with the Smoothing Brush tool.

The following editing tricks use options found on the right side of the dialog box:

Book VI
Chapter 4

Cutting, Extracting,
and Masking

- *To soften the edges of your selection:* Enter a value in the Feather box — the higher the value, the softer the edge.

- *To fill a hole:* Click the Fill Holes button.

- *To remove the halo of pixels between the foreground and background areas:* Click Defringe and enter a value in the Defringe Width box.

If things start to go awry, you can start over by clicking Reset at the bottom of the dialog box.

6. **When you're pleased with the results, click OK to finish the extraction process and close the Magic Extractor dialog box.**

Your newly extracted image appears as a new file, as shown in Figure 4-3.

Corbis Digital Stock

Figure 4-3: A girl selected with the Magic Extractor.

Selective Erasing with the Eraser Tools

The eraser tools let you erase portions of an image. The three eraser tools are the regular Eraser, the Magic Eraser, and the Background Eraser, which all share a flyout menu in the Tools panel.

The eraser tools look like real erasers, so you can't miss them. But just in case you do, press E and then Shift+E to toggle through the three tools.

When you erase pixels, those pixels are gone. For good. Before using the eraser tools, you should make a backup of your image. You can save the image as either a separate file or another layer. That way, if things run amok, you have some cheap insurance.

Using the Eraser tool

The Eraser tool allows you to erase areas on your image. If the image contains just a background, you erase to the background color. If the image is on a layer, you erase to transparency. Both instances are shown in Figure 4-4.

To use this tool, simply select the image and then click and drag through your desired area on it, and you're done. Because it isn't the most accurate tool on the planet, remember to zoom way in and use smaller brush tips to do some accurate erasing.

Corbis Digital Stock

Figure 4-4: The Eraser tool erases to either the background color (left) or, if you're on a layer, transparency (right).

These options on the Options bar control the Eraser tool:

- **Brush Presets:** Click the drop-down panel to access the Brush presets. Choose the brush you want. Again, additional brush libraries are available from the Brushes pop-up menu.

- **Size:** Click the down-pointing arrow to access the Size slider. Choose from a brush size between 1 and 2500 pixels.

- **Mode:** Select from Brush, Pencil, and Block. When you select Brush or Pencil, you have access to the Brush Preset Picker panel on the far-left side of the Options bar. When you select Block, you're stuck with one size (a 16-x-16-pixel square tip). But because the block size remains constant, if you zoom way in, you can perform some detailed erasing.

- **Opacity:** Specify a percentage of transparency for the erased areas. The lower the Opacity setting, the less it erases. This option isn't available for Block mode.

Selecting and erasing by color

The Magic Eraser tool works like a combination Eraser and Magic Wand tool. It selects and erases similarly colored pixels simultaneously. Here's how it works:

- **When you click a layer:** The Magic Eraser tool erases pixels of a similar color based on a specified range and leaves the area transparent, as shown in Figure 4-5.

Corbis Digital Stock

Figure 4-5: Clicking with the Magic Eraser simultaneously selects and erases similarly colored pixels.

✓ **When you click the background:** The Magic Eraser tool automatically converts the background to a layer and then does the same pixel-erasing thing.

✓ **When you click a layer with locked transparency:** The Magic Eraser tool erases the pixels and replaces the area with the background color.

Here are the options for using the Magic Eraser tool:

✓ **Tolerance:** Defines the range of colors that Elements erases, just as it does with the Magic Wand tool. The value determines how similar a neighboring color has to be to the color that you click. A higher value picks up more colors, whereas a lower value picks up fewer colors.

✓ **Anti-alias:** Creates a slightly soft edge around the transparent area.

✓ **Contiguous:** Selects only similar colors that are adjacent to each other. Deselect this option to select and then delete similarly colored pixels wherever they appear in your image.

✓ **Sample All Layers:** Samples colors using data from all visible layers, but erases pixels on the *active* layer only.

✓ **Opacity:** Works like it does for the regular Eraser tool, described in the previous section.

Removing the background from an image

The Background Eraser tool is probably the most sophisticated of the eraser-tool lot. It erases the background from an image, and should leave the foreground untouched. But if you're not careful in using the Background Eraser tool, it can erase the foreground and anything else in its path.

Like the Magic Eraser tool, the Background Eraser tool erases to transparency on a layer. If you drag on the background, Elements converts the background into a layer.

To use the Background Eraser tool successfully, carefully keep the crosshair, or *hot spot,* that appears in the center of the cursor, on the background pixels while you drag. The hot spot samples the color of the pixels and deletes pixels of that color wherever they fall under the brush circumference. But, if you get close to a foreground pixel with the hot spot, that pixel is gobbled up as well. This tool works better with images that have good contrast in color between the background and foreground objects, as shown in Figure 4-6. Also, if your image has very detailed or wispy edges (such as hair or fur), you're better off using the Magic Extractor command, which we describe earlier in this chapter.

Here's the rundown on the options, found on the Options bar, for the Background Eraser:

✓ **Brush Preset Picker:** This option provides various settings to customize the size and appearance of your eraser brush tip. The Size and Tolerance settings at the bottom are for pressure-sensitive drawing tablets. You can base the size and tolerance on the pen pressure or position of the thumbwheel.

Corbis Digital Stock

Figure 4-6: Be careful when using the Background Eraser because you can inadvertently eat up pixels.

✓ **Limits:** The Contiguous setting erases similar colors that are adjacent to one another under the brush circumference. The Discontiguous setting erases similar colors whenever they're under the brush circumference, regardless of whether they're adjacent.

✓ **Tolerance:** Works just like the Magic Eraser Tolerance setting, described in the previous section.

Working with Layer Masks

Unfortunately, one of the areas where Photoshop has a leg up on Elements is in the area of layer masks. To create a layer mask in Photoshop, you merely have to click a button in the Layers panel. To get layer masks in Elements requires a clever work-around. And, fortunately, though it's clever, it's also very easy to do. But before we get ahead of ourselves and tell you how to get a layer mask, you may want to know what one is and why in the world you would ever need one.

A *layer mask* is like a second sheet of acetate that hovers over a layer. You can use layer masks with image layers and adjustment layers. In the case of an image layer, the layer mask allows you to selectively show, hide, or partially show portions of your image. With adjustment layers, the layer mask lets you selectively apply the adjustment to the layers below it. You do this by painting on a layer mask with black, white, and various shades of gray. Any black areas on the mask hide the image or the adjustment; any white areas show the image or adjustment; and anything in between (gray) partially shows the image or adjustment, as shown in Figure 4-7.

Layer masks are excellent for blending layers of images and creating soft transitions between elements. You can gradually brush in transparency and opacity on a selective-pixel basis. You can even apply gradients and filters to your layer masks to create interesting special effects.

Corbis Digital Stock, Purestock

Figure 4-7: A layer mask uses varying shades of gray to selectively apply the adjustment to the underlying layers.

By default, the mask is completely white. This allows the image or adjustment to be fully applied to the layers. If you paint on a layer mask with black, the areas under those black areas don't show the image or adjustment. If you paint with a shade of gray, those areas partially show the image or adjustment. The darker the shade of gray, the less it shows the image or adjustment. Note that if you have an active selection border in your image before you add an adjustment layer, the adjustment is applied only to that area within the selection border. The resulting layer mask also reflects that selection: The selected areas are white, and the unselected areas are black.

Now comes the clever part. We mention in the first paragraph in this section that Elements doesn't have a layer mask option in the Layers panel. The only way to get a layer mask in Elements is to create an adjustment layer. When you create an adjustment layer, you also create a *layer mask* on that layer at the same time. If you don't need any adjustments and just want the layer mask, after you create the adjustment layer just don't make any adjustment settings. Then use the layer mask to blend two layers.

Just to make things crystal clear, follow these steps to create a layer mask:

1. **In the Editor, in Edit Full mode, open or create your layered image.**

2. **In the Layers panel, select the bottommost layer of the two layers you want to blend.**

 You want to sandwich the adjustment layers between the two layers you want to blend.

3. **Choose Layer⇨New Adjustment Layer⇨Levels.**

 You can choose any of the adjustments because you don't specify any settings. Remember that creating an adjustment layer is the only way to get the layer mask.

4. **Click OK in the New Layer dialog box.**

 The Levels dialog box appears. Don't specify any settings in the dialog box. Just click OK.

5. **Select the topmost layer that you want to blend in the Layers panel and then choose Layer⇨Create Clipping Mask.**

 This command creates a clipping mask. For a detailed explanation of clipping masks, see the next section in this chapter.

6. **With the painting tool of your choice (we recommend the Brush tool), paint on your layer mask.**

 Apply a foreground color of black where you want to hide the portions of the topmost layer. Leave the mask white where you want the topmost layer to show. Adjust the Opacity setting in the Options bar to paint with

a less-opaque black, which is essentially like painting with gray. The higher the Opacity, the darker the gray and the more it partially hides the topmost layer. If you want subtle blending between layers, use a large, feathered brush tip and vary your opacity settings accordingly.

If things start to run amok, just choose Edit➪Fill and fill your entire layer mask with white to start again.

 Note that you can also use the Gradient tool on the layer mask. Using foreground and background colors of white and black, you can create a nice transition from showing and hiding the layer, as shown in Figure 4-8. The darker areas of the gradient gradually hide the image, whereas the lighter areas gradually show the image. For more on gradients, see Book V, Chapter 2.

Corbis Digital Stock, Purestock

Figure 4-8: Layer masks enable you to softly blend two layers.

Creating Clipping Masks

In a *clipping mask,* the bottommost layer (also known as the *base layer*) acts as a mask for the layers above it. The layer or layers above clip to the opaque areas of the base layer and don't show over the transparent areas of the base layer.

Creating a clipping mask works well if you want to fill a shape or some type with different images on multiple layers.

Using the steps that follow, we created a new document with a white background. We then used the Custom Shape tool to create a bird shape on a second layer. We added two layer styles — a drop shadow and a simple inner bevel — to the shape for added dimension, but this step isn't mandatory. We then opened an image of some clouds and then dragged and dropped that image onto our composite.

Follow these steps to create your own clipping mask:

1. **In the Editor, in Edit Full mode, open or create an image that has several layers.**

 To see best how this technique works, try creating a shape layer for your base layer. For more on shape layers, see Book V, Chapter 1.

2. **Arrange your layers so that your base layer is the bottommost layer.**

 See Book VI, Chapter 2 for more on rearranging layers.

3. **Hold down Alt (Option on the Mac) and, in the Layers panel, position your mouse cursor over the line dividing the base layer and the layer above it.**

 Your cursor changes to two overlapping circles with a small arrow icon. You can also choose Layer⇨Create Clipping Mask.

4. **Click your mouse button.**

 Repeat Steps 3 and 4 for any remaining layers you want clipped to the base layer. Notice how our sky image clips to the base layer (the bird shape) in the Layers panel (appears indented).

 Nothing outside the boundaries of the bird shape is visible on the layer in the clipping mask, as shown in Figure 4-9. The down-pointing arrow icon beside the layer on the Layers panel indicates that the layer is clipped. The clipped layers take on the opacity and Blend mode of the base layer.

<div style="float:right">**Book VI**
Chapter 4

Cutting, Extracting, and Masking</div>

Corbis Digital Stock

Figure 4-9: In a clipping mask, layers mask to the opaque areas of a base layer.

A couple other tips to keep in mind when working with clipping masks include these:

 ✓ To remove a layer from the clipping mask, you can simply Alt-click (Option-click on the Mac) the line between the two layers in the Layers panel. Or, you can select the layer and choose Layer⇨Release Clipping Mask. Both commands remove from the clipping group the selected layer and any layers above it.

 ✓ You can also apply clipping masks to adjustment and fill layers. If you clip between a regular layer and an adjustment layer, or between a regular layer and a fill layer, the adjustment or fill layer affects only the pixels of the adjacent underlying layer, rather than all the underlying layers.

Book VII

Filters, Effects, Styles, and Distortions

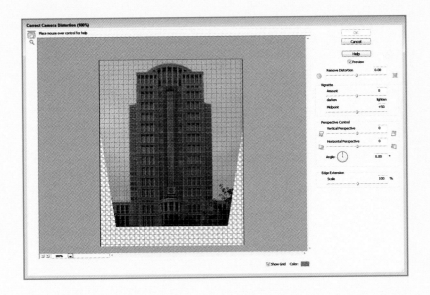

When it comes to having fun with Elements, nothing beats playing with filters and effects. Even if you think you have no talent as an artist, with a few mouse clicks you can add some interesting effects to images.

In this book, we cover using all the filters you have available in Elements, fixing files with blemishes, and applying styles and transformations.

Chapter 1: Making Corrections and Having Fun with Filters

Filters have a long and glorious history, ranging from performing essential tasks (such as removing abrasive particles from the oil in your car's engine) to even more important tasks involving the pixels in your images in Elements. In both cases, filters (also called *plug-ins* because they can be installed and removed independently) take your pixels and manipulate them in both useful and just frivolous and fun ways. They can correct less-than-perfect images by making them appear sharper or by covering up flaws. Or, they can enhance your images by making them appear as though they're painted, tiled, photocopied, or lit by spotlights. The results are something to be admired.

This chapter introduces you to the basics of Photoshop's filter facilities and starts you on the road to filter proficiency.

Understanding Filter Basics

All filters do a simple thing in a seemingly complicated way. Deep within a filter's innards is a set of instructions that tells Elements what to do with a particular pixel in an image or selection. Elements applies these instructions to every pixel in the relevant area by using a process that the pixelheads call *convolution* (creating a form or shape that's folded or curved in tortuous windings), but which we normal humans simply refer to as *applying a filter.*

Applying filters

You can apply a filter in three ways:

- **In either Edit Full or Edit Quick mode:** From the Filter menu, choose your desired filter category and then select a specific filter.

- **In Edit Full mode only:** Choose Window⇨Effects to open the Effects panel. Click the Filters button at the top of the panel. Select your filter category from the drop-down list in the upper-right corner of the panel. Double-click the thumbnail of your desired filter or drag the filter onto your Image window.

- **In either Edit Full or Edit Quick mode:** Choose Filter⇨Filter Gallery to apply one or more filters in a flexible editing environment. The Filter Gallery is described in the section "Working in the Filter Gallery," later in this chapter.

You can't apply filters to images that are in Bitmap or Index Color mode. You also can't apply them to type or shape layers. And some filters don't work on images in Grayscale mode. For a refresher on color modes, see Book III, Chapter 2.

Corrective and destructive filters

Most digital imagers classify filters into two basic categories:

- **Corrective filters:** Usually used to fix problems in an image. They fine-tune color, add blur, improve sharpness, or remove such nastiness as dust and artifacts. Remember, pixels are still being modified; it's just that these filters don't change the basic look of an image. They just improve it a little.

 Be sure to check out the important techniques of sharpening and blurring, covered in Book VIII, Chapter 2. Sharpening and blurring are the king and queen of the corrective filters.

- **Destructive filters:** Tend to obliterate at least some of an image's original detail while they add special effects. They may overlay an image with an interesting texture, move around pixels to create brush strokes, or distort an image with twists, waves, or zigzags. You can often tell at a glance that a destructive filter has been applied to an image: The special effect often looks like nothing that exists in real life.

An unaltered image (such as the image on the left in Figure 1-1) can be improved by using a corrective filter such as Unsharp Mask (center) or changed dramatically with a destructive filter such as Rough Pastels (right).

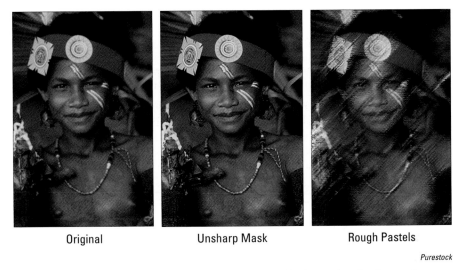

| Original | Unsharp Mask | Rough Pastels |

Figure 1-1: Filters come in a wide variety from the corrective (center) to the destructive (right).

Single and multistep filters

Whether a filter is corrective or destructive, it falls into one of two camps. Here they are:

 ✔ **Single-step filters:** The easiest filters to use, single-step filters have no options and use no dialog boxes. Just select the filter from the menu and watch it do its stuff on your image or selection.

 ✔ **Multistep filters:** Most filters come complete with at least one dialog box, along with (perhaps) a few lists, buttons, and check boxes. And almost every multistep filter has sliders you can use to adjust the intensity of an effect (see Figure 1-2). These filters are marked in the menus with an *ellipsis* (a series of dots) following their names.

The controls themselves are easy to master. The tricky part is figuring out what the various parameters you're

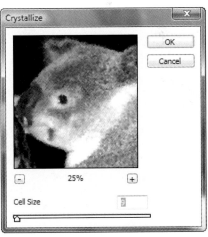

Figure 1-2: Multistep filters require you to specify various settings before applying your filter.

using actually do. How does changing brush size affect your image when you're using a brush-stroke filter? What happens when you select a particular pattern with a texturizing filter? You can read descriptions of how various filter controls affect your image, but your best bet is to simply experiment until you discover the effects and parameters that work best for you. Just be sure that you save a copy of the original image; filters do permanent damage to files — modifying, adding, and deleting pixels.

Reapplying a filter

You can reapply the last filter you worked with — using the same settings — by pressing Ctrl+F (⌘+F on the Mac). (It's also the first command on the Filter menu.) You might want to do this to strengthen the effect of a filter on a particular image, layer, or selection. Or you simply may want to apply the same filter to a succession of images or selections.

To bring up the dialog box for the last filter you applied, press Ctrl+Alt+F (⌘+Option+F on the Mac). This shortcut can be very useful when you apply a filter and then decide you don't like the results and want to go back and try different settings. After applying the filter, press Ctrl+Z (⌘+Z on the Mac) to undo and then press Ctrl+Alt+F (⌘+Option+F on the Mac) to bring up the filter's dialog box. The dialog box opens with the settings you used last time, allowing you to make adjustments and then reapply the filter.

Fading a filter

Sometimes, you don't want the full effect of a filter applied to your image. Sometimes, fading a filter a bit softens the effect and makes it look less "digitized," as shown in Figure 1-3. Here's what you can do to dial-down a filter:

1. **In Edit Full mode, choose Layer⇨Duplicate Layer and then click OK when the dialog box appears.**

2. **Make sure your duplicated layer is selected in the Layers panel and then apply your desired filter to the duplicate layer.**

 We applied a Palette Knife filter. (You'll find it under the Artistic category.)

3. **Use the Blend modes and Opacity settings located on the Layers panel to merge the filtered layer with the original unfiltered image.**

Purestock

Figure 1-3: Fading a filter allows you to mix the filtered and unfiltered images.

We brought our Opacity down to 65%. If you need more details on working with layers, see Book VI.

4. (Optional) With the Eraser tool, selectively erase portions of your filtered image to enable the unfiltered image to show through.

For example, if you applied a Gaussian Blur filter to soften a harshly lit portrait, try erasing the blurred portion that covers the subject's eyes to let the unblurred eyes of the layer below show through. The sharply focused eyes provide a natural focal point.

Selectively applying a filter

You don't need to apply filters to an entire image or an entire layer. You can achieve some of the best effects when you apply a filter to only a portion of an image — say, to an object in the foreground, but not on the background. For example, you can blur a distracting background so that the person in your image gets due attention. Or, as you see in Figure 1-4, we applied a Twirl filter to the water, leaving the girl unfiltered to avoid that overly "Photoshopped" effect. (Not surprisingly, you'll find Twirl under the Distort category.)

Corbis Digital Stock

Figure 1-4: Selectively applying a filter can prevent an image from looking overly manipulated.

**Book VII
Chapter 1**

Making Corrections and Having Fun with Filters

Working in the Filter Gallery

When you apply a filter, you may be presented with a huge dialog box. This editing window is officially called the Filter Gallery. You can also access it by choosing Filter⊃Filter Gallery. In the flexible Filter Gallery, you can apply multiple filters, delete them, and edit them to your heart's content. This feature has made filters more flexible, more user-friendly, and easier to apply.

Even when you're using the Filter Gallery, make a backup copy of your image — or at least create a duplicate layer — *before* you apply filters. Filters change the pixels of an image permanently, and when you exit the Filter Gallery, the filters that are applied can't be removed.

Follow these steps to get up-and-running in the Filter Gallery:

1. In either Edit Full or Edit Quick mode, choose Filter⊃Filter Gallery.

The Filter Gallery dialog box appears, as shown in Figure 1-5.

Filter category
folders

Show/hide
applied layer

New┘ └Delete
Effect Effect
Layer Layer

Figure 1-5: The Filter Gallery enables you to apply and edit multiple filters within a single dialog box.

2. **In the center of the editing window, click the folder for the desired filter category.**

 The folder expands and displays the filters in that category. A thumbnail illustrating the filter's effect accompanies each filter. To collapse the filter category folder, simply click the folder again.

3. **Select your desired filter.**

 You get a large preview of your image in the left side of the dialog box. Use the magnification controls to zoom in and out of the preview. To preview a different filter, simply select that filter.

4. **In the rightmost section, specify any settings associated with the filter.**

 The preview is updated accordingly.

5. **When you're happy with the filter, click OK in the top-right corner of the dialog box to apply the filter and exit. But if you want to apply another filter, leave the dialog box open and proceed to Steps 6–8.**

6. **If you want to apply another filter, click the New Effect Layer button at the bottom of the dialog box.**

 Clicking this button duplicates the existing filter.

7. **Select your new filter, which then replaces the duplicate in the Applied Filters area of the dialog box.**

 Elements lists each of the filters you apply to the image in the bottom-right of the dialog box.

8. **When you're done, click OK to apply the second filter and exit the dialog box.**

 You can apply as many filters as you want to your image. But often, less is more.

Here are some other helpful tips to keep in mind when you're using the Filter Gallery:

- To delete an applied filter, select it in the list in the lower right of the dialog box and click the Delete Effect Layer button (the trash can icon) at the bottom of the dialog box.

- To edit an applied filter's settings, select it in the list and make any necessary changes. Click OK to reapply. Although you can edit a particular filter's settings, that edit affects any subsequent filters you've added after applying that particular filter.

- You can rearrange the order of the applied filters. Simply select and drag the filter up or down within the list.

 Rearranging the order of the filters you're using changes the results of applying the filters.

- To resize the Filter Gallery dialog box, drag the lower-right corner.

- To hide the Filter menu and provide the maximum real estate for the preview box, click the arrow to the left of the OK button.

- You can choose any of the filters found in the Filter Gallery from the Filter menu itself. Choosing a Filter menu filter launches the Filter Gallery automatically — but not all filters are available in the Filter Gallery. You have to access some of them individually from the Filter menu.

Filters change the pixels of an image permanently, and after you apply one, you can't remove it. So, be sure that you really like what you've done and that you have a backup copy of that precious family photo or critical project image.

Having Fun with Filters

Now that you're familiar with what filters are, how they're applied, and how they can be modified and toned down, it's time to experiment and have some fun. This is something you can do on your own when you have an hour or so and some willing images laying around. Create a composite with multiple layers and apply some filters. Add some different Opacity settings and Blend modes and you've got yourself a party.

To get your party started, we give you a few tips on a few of our favorite filters.

Correcting camera distortion

If you've ever tried to capture a skyscraper or other imposing piece of architecture in the lens of your camera, you know that it often involves tilting your camera and putting your neck in some uncomfortable position. And then, after all that, what you end up with is a distorted view of what was an impressive building. The Correct Camera Distortion filter fixes the distorted perspective created by both vertical and horizontal tilting of the camera. As a bonus, this filter also corrects other kinds of distortions caused by lens flaws.

Here's how to fix those lens issues:

1. **Choose Filter⇨Correct Camera Distortion in either Edit Full or Edit Quick mode.**

2. **In the Correct Camera Distortion dialog box, be sure to select the Preview option, as shown in Figure 1-6.**

Figure 1-6: The Correct Camera Distortion filter fixes distortions caused by camera tilt and lens flaws.

3. **Specify your correction options:**

- *Remove Distortion:* Corrects *lens barrel,* which causes your images to appear spherized or bloated. This distortion can occur when you're using wide-angle lenses. It also corrects *pincushion* distortion, which creates images that appear to be pinched in at the center, a flaw that's found when using telephoto or zoom lenses. Slide the slider while keeping an eye on the preview. Use the grid as your guide for proper alignment.

- *Vignette:* Adjusts the amount of lightening or darkening around the edges of your photo that you can sometimes get from incorrect lens shading. Change the width of the adjustment by specifying a Midpoint value. A lower Midpoint value affects more of the image. Then, move the Amount slider while viewing the preview.

- *Vertical Perspective:* Corrects the distorted perspective created by tilting the camera up or down. Again, use the grid to assist in your correction. We used the Vertical Perspective to correct the building shown in Figure 1-6.

- *Horizontal Perspective:* Corrects halos and blurs caused by moving the camera (or if your subject can't sit still). For better results, set the angle of movement under the Angle option.

- *Angle:* Enables you to rotate the image to compensate for tilting the camera. You may also need to tweak the angle slightly after correcting the vertical or horizontal perspective.

- *Edge Extension:* When you correct the perspective on your image, you may be left with blank areas on your canvas. You can scale your image up or down to crop into the image and eliminate these "holes." Note that scaling up results in interpolating your image up to its original pixel dimensions. Therefore, if you do this, be sure to start with an image that has a high-enough pixel dimension or resolution to avoid severe degradation.

- *Show Grid:* Shows and hides the grid, as needed. Choose the color of your grid lines.

- *Zoom:* Zooms in and out for your desired view.

4. **Click OK to apply the correction and close the dialog box.**

The Facet filter

The Facet filter breaks up an image by using a posterizing effect. It gathers up blocks of pixels that are similar in brightness and converts them to a single value, using geometric shapes. (When you posterize an image, you reduce it to a very small number of tones.)

The geometric shapes make the image look more randomly produced, while eliminating much of the banding effect you get with conventional posterizing filters.

The effects of the Facet filter are subtle and best viewed at close range. The image in Figure 1-7 originally contained some dust, scratches, and a few other defects. Instead of retouching them one by one, we used Facet.

Facet is a single-step filter, so you don't need to adjust any controls. Just choose Filter⇨Pixelate⇨Facet and evaluate your results. You can apply the filter multiple times. However, even one application smoothes out the picture and eliminates the worst of the artifacts.

If you apply the Facet filter multiple times, your image takes on a kind of pointillist, stroked look that becomes more and more obvious. Using the filter over and over on the same image can yield quite interesting special effects.

Figure 1-7: The Facet filter can simply eliminate annoying artifacts or convert your image into a "painted" piece.

Getting artsy

Several filters produce great artistic effects. You can find a large collection of them in the Artistic, Sketch, and Stylize submenus.

Many users employ these filters to create images that look as if they were painted. What those users might not tell you, unless pressed, is that filters can make less than best-quality photos look better. These filters can disguise a multitude of photographic sins, turning shoebox rejects into pretty decent digital transformations.

Try out one of the following artistic filters:

 ✔ **Poster Edges:** Gives the picture an artsy, poster-like look, but also enhances the edges to make the outline of the object appear sharper, as shown in Figure 1-8.

Figure 1-8: Making a mediocre image more interesting with the artistic filters.

✔ **Rough Pastels:** Gives the look of a fine-art piece created with oil pastels.

✔ **Dry Brush:** This filter can add an even more stylistic effect, reducing details down to a series of broad strokes.

✔ **Colored Pencil:** This filter crosshatches the edges of your image to create a pencil-like effect.

✔ **Cutout:** This effect assembles an image from what looks like cut-out paper shapes, which resemble a kid's art project.

✔ **Film Grain:** This photographic effect diffuses an image with thousands of tiny dots that simulate clumps of film grain. (Think of old home movies.)

✔ **Fresco:** This effect looks (supposedly) like pigments applied to fresh, wet plaster. Okay, we guess . . . if you squint.

✔ **Paint Daubs:** This effect uses smears of color from your choice of a half-dozen different brush types. Very Jackson Pollock.

✔ **Plastic Wrap:** This filter can produce a wet look, particularly when you apply it to a selection and then fade the filter so it doesn't overpower the detail in your image.

✔ **Watercolor:** This nice pastel effect diffuses an image while adding an interesting, watery texture.

Stroking your image

The filters under the Brush Strokes submenu try to mimic the appearance of art created with pen, brush, airbrush, ink, and paint. Here are a few of our favorites:

- **Ink Outlines:** Adobe describes this filter as producing the look of a corroded ink drawing, as shown in Figure 1-9.
- **Spatter:** This filter generates the look you might get from a sputtering airbrush.
- **Accented Edges:** Use this filter to make a subject jump out from its background by emphasizing the edges of all the objects in the picture.

PhotoDisc

Figure 1-9: Brush stroke filters mimic effects created with analog tools like paint brushes.

Distorting for fun

With a couple exceptions, the Elements Distortion filters twist, turn, and bend your images in surprising ways, turning ordinary objects into wavy images, pinched shapes, and bloated spheres.

The first exception? The Diffuse Glow filter distorts images only to the extent that it imbues them with a soft, romantic, fuzzy look that can make the sharpest image look positively ethereal, as shown in Figure 1-10.

Purestock

Figure 1-10: Give your photo a heavenly aura with the Diffuse Glow filter.

The Glass filter can add a glass-block texture or a frosted-glasslike fuzziness to your image. Other filters under this submenu produce wavy images, add pond ripples, pinch images, or transform them into spheres.

Getting noisy

Noise in images consists of any graininess or texture that occurs, either because of the inherent quality of the image or through the editing process. Noise filters, such as Add Noise, produce random texture and grain in an image. If you're new to image editing, you might wonder why you'd want to add noise to an image in the first place. Wouldn't it be smarter to remove it? Well, sometimes. In practice, you can find a lot of applications that call for a little noise here and there:

✔ **Adding texture:** Objects that become too smooth, either because of blurring or other image editing you may have done, often look better when you add some noise to give them a texture, as shown in Figure 1-11. This technique is particularly useful if one object in an image has been edited, smoothed, or blurred more than the other objects in the image.

Figure 1-11: Adding some noise can give an image some needed texture.

✏ **Blending foreign objects into a scene:** When you drop a new object into the middle of an existing scene, the amount of grain or noise in the new object is often quite different from the objects it's joining.

For example, say you've decided to take a photo of your house and want to insert a certain luxury car in your driveway. Unfortunately, the photo of your in-law's car is a lot sharper than the picture of your house. Adding a little noise can help the two objects blend more realistically. You may even forget that the car isn't yours.

✏ **Improving image quality:** Images that contain smooth gradients often don't print well because some printers can't reproduce the subtle blend of colors from one hue to another. The result is *objectionable banding* in your printed image: You can see distinct stripes where the colors progress from one to another. Adding a little noise can break up the gradient enough that your printer can reproduce the blend of colors, and the noise/grain itself is virtually invisible on the printed sheet.

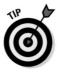

The other filters in the Noise submenu don't add noise at all; instead, they make noise and *artifacts* (flaws, such as the dust and scratches on old film) less noticeable.

Breaking your image into pieces

The Pixelate filters break up your images into bits and pieces, providing more of those painterly effects you can get with brush strokes and artistic filters. The Pixelate submenu includes the Crystallize filter, as shown in Figure 1-12, as well as filters that produce color halftone effects, fragmented images, and a pointillism effect.

Purestock

Figure 1-12: The Crystallize filter breaks your image into polygonal shapes.

Rendering

In computer lingo, *rendering* means creating something from a set of instructions, in a way. That's why rendering filters all produce special effects by creating a look, object, or lighting effect that's melded with your original image. Here are a few favorite render filters.

✓ **Clouds:** Enables you to create a sky full of clouds using random values taken from a range between the foreground and background colors, as shown in Figure 1-13. To create a cloud effect with more contrast, hold down the Alt key (Option key on the Mac) quickly when choosing the command. If you don't like the first set of clouds you get, apply the filter again and again until you do. If you want a more "realistic" sky, try using a dark sky blue for your foreground color and a very light blue or white color for your background color.

Corbis Digital Stock

Figure 1-13: Make your own clouds.

Need a quick Web background image? Create a 128-x-128-pixel (or some multiple of that size) image and apply the Clouds filter. It tiles seamlessly on your Web page.

✓ **Difference Clouds:** Use this filter to create puffy objects in the sky (or foggy clouds at lower levels). The Difference Clouds filter uses image information to figure the difference in pixel values between the new

clouds and the image they're joining. The result is a unique cloud effect. Try applying the filter repeatedly to create a marbleized effect.

- **Lens Flare:** This filter creates the reflection effect that plagues photographers when they point their cameras toward a strong light source, such as the sun. The filter mimics several different kinds of photographic lenses, giving you useful flares that can spice up concert photos and add a sunset where none existed. Specify a location for the center of the flare by clicking the image thumbnail or by dragging the crosshair.

- **Lighting Effects:** As a sort of photo-studio lighting setup, this filter uses pixels to do its work. You can set up 16 different lights and manipulate how they illuminate your photo.

Getting organic with the Sketch filters

If you've ever envied people who can crank out a beautiful pen sketch in a matter of minutes, this is the filter menu for you. The Sketch submenu includes plenty of traditional media artistic effects, such as Graphic Pen (as shown in Figure 1-14), Conté Crayon, Note Paper, chalk, charcoal, and so on. Here's a brief rundown of a few effects that aren't quite so traditional:

- **Photocopy:** Gives that infamous, anachronistic look (dating back to the days when photocopiers didn't do a very good job of reproducing halftone images). Creates areas of black and white with little gray value when the default foreground and background colors of black and white are selected.

- **Plaster:** Creates a look that resembles molten plastic more than it looks like plaster. The filter uses the foreground and background values to color the image.

- **Stamp:** Mimics a rubber or wooden-block stamp.

- **Reticulation:** Adds texture by reproducing a veritable photographic disaster — the wrinkling of film emulsion that occurs when you move film from one developing chemical to another that has an extremely different temperature (think hot developer followed by a bath in cold water). The highlights look grainy; the shadow areas look thick and goopy.

- **Torn Edges:** Creates the look of ragged paper and colorizes the image using the foreground and background colors.

- **Water Paper:** Creates the look of paint-like daubs on fibrous, wet paper.

Figure 1-14: Give your digital photos a more organic feel with the Sketch filters.

Adding texture

Elements lets you add a lot of interesting textures to your image, such as the cracked canvas effect generated by the Craquelure filter (see Figure 1-15) or the pixel effect produced by the Patchwork filter.

You can find other filters on this menu to help you create mosaic effects, add yet another kind of film grain, and create stained-glass effects in your images. But the most versatile filter in this set is surely the Texturizer, which

enables you to apply various kinds of textures to your images or selections, including Canvas, Sandstone, Burlap, or Brick.

PhotoDisc

Figure 1-15: The Craquelure filter gives an Old World-painting feel to your image.

You can select the relative size of the texture compared to the rest of your image by using the Scaling slider. You can even select the direction of the light source that produces the 3-D look, selecting from top, bottom, either side, or any of the four corners of the image.

Putting It Together

Creating an Angelic Glow

Sometimes, a little blur can add a soft, romantic mood or an angelic glow that can improve glamour photos, pictures of kids, or even something as mundane as a flower. The secret is to apply only enough blurring to provide the soft effect you want without completely obliterating your original subject. This assumes, of course, that your subject doesn't *deserve* obliteration, that the kids are your own (or those of a close friend or relative), and that they are, in fact, of that rare angelic variety.

You don't want to use this effect on other subjects, such as men, who generally like a rugged, masculine appearance. Many senior citizens regard the age lines on their faces as badges of distinction earned over a long, rewarding life. Don't try softening them up with glowing effects, either.

continued

continued

To add an angelic glow to your little angel, just follow these steps:

1. **In Edit Full mode, open your desired image.**

 We used one of a pair of cute little girls.

Purestock

2. **Choose Layer⇨Duplicate Layer to create a copy of the image layer.**

3. **With the duplicate layer selected in the Layers panel, choose Filter⇨Blur⇨ Gaussian Blur.**

 Gaussian Blur softens the upper layer, producing an airy glow.

4. **Move the Radius slider to the right to pro- duce a moderate amount of blur and then click OK to apply the blurring effect, as shown in the figure.**

 We used a value of 7.

5. **In the Layers panel, choose Lighten from the Modes pop-up menu.**

Purestock

6. **Use the Opacity slider (click the right- pointing arrow to access the slider) to reduce the amount of glow (if it's too much for your tastes).**

 We reduced the Opacity to 70%.

7. **Choose Layer⇨Flatten Image to combine all the layers.**

 Experiment with different amounts of Gaussian Blur until you find the perfect glow- ing effect, as we did in our figure.

Chapter 2: Distorting with the Liquify Command

*L*iquify is the only Elements filter that garners a chapter of its own. That's because Liquify is not your run-of-the-mill filter. Truth be told, it is the ultimate distortin' fool, with a bevy of tools, modes, and options that make it a good deal more complex than most of its kin on the Filter menu. The Liquify filter lets you push and pull on parts of your image, twist, turn, and pinch other parts, and bloat and reflect yet others. You can basically manipulate an image as though it were pliable saltwater taffy. And although this would be worthwhile entertainment on its own, you can actually use the Liquify filter to perform some productive tasks. Pick up any fashion magazine and we guarantee you that many of images of models and celebrities you see there have made their way through the Liquify filter for nips, tucks, and overall body sculpting. Yes, even those blessed with natural beauty are given a dose of digital beautification for good measure.

Exploring the Liquify Window

At first glance, the Liquify window is a little daunting. It's a little daunting on second, third, and fourth glances, too. But when you quit glancing and dive into this versatile filter, you find that the tools and options make a lot of sense.

Open the Liquify window by choosing Filter⇨Distort⇨ Liquify. The Liquify Tools panel appears on the left, as shown in Figure 2-1. The other options available with Liquify appear on the right side of the window. The Tools panel includes a dozen tools that you can use to paint and distort your image.

Figure 2-1: The Liquify window is quite user-friendly after you get familiar with its tools and settings.

As with the main Elements Tools panel, you can activate each tool by pressing a keyboard shortcut letter associated with its name.

The distortion painting tools

The first group of tools is used to paint distortions on your image. The following list describes each tool, with its keyboard shortcut in parentheses. To see what the tool icon looks like, refer to Figure 2-1. To see what each tool does to pixels, check out Figure 2-2.

✐ **Warp (W):** This tool is faintly reminiscent of the Smudge tool, but it doesn't obliterate details in the pixels quite as much as it pushes them forward while you drag, creating a stretched effect. Use the Warp tool to push pixels where you want them to go, using short strokes or long pushes. This is the main tool to use when you want to body-sculpt the person in an image.

✐ **Turbulence (T):** This tool adds a random jumbling effect to pixels when you click and hold down the mouse button. It acts similarly to the Warp tool when you click and drag. Adjust how smooth the effect is by dragging the Turbulent Jitter slider in the Tool Options area. The higher the value, the smoother the effect. You can use the Turbulence tool to create maelstroms of air, fire, and water with clouds, flames, and waves.

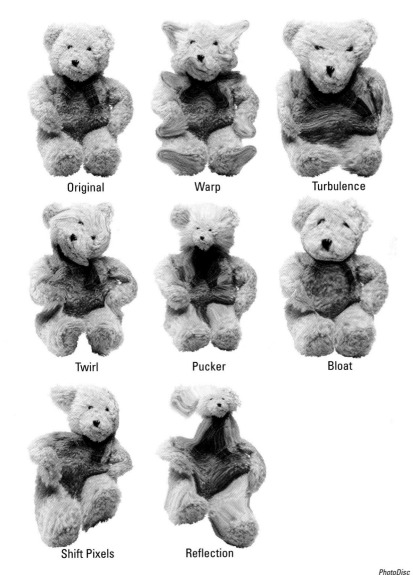

Original Warp Turbulence

Twirl Pucker Bloat

Shift Pixels Reflection

PhotoDisc

Figure 2-2: The tools in the Liquify filter transform the ordinary into the extraordinary.

**Book VII
Chapter 2**

**Distorting with the
Liquify Command**

✔ **Twirl Clockwise (R) and Twirl Counterclockwise (L):** Place the cursor in one spot, press the mouse button, and watch the pixels under your brush rotate like a satellite photo of a tropical storm. Or drag the cursor to create a moving twirl effect. Pixels move faster in the center than along the edges of the brush.

Try this technique with the other tools we describe in this list (with some tools, the effect is more obvious than with others). Simply hold down the mouse button. The longer you hold it down, the more prominent the effect becomes.

 ✔ **Pucker (P):** This tool is the equivalent of the Pinch filter, squishing pixels toward the center of the area covered by the brush while you hold down the mouse button or drag. To reverse the pucker direction, which essentially applies a bloat, hold down the Alt key (Option key on the Mac) while you hold down the mouse button or drag.

 ✔ **Bloat (B):** Think of this tool as a kind of Spherize filter, pushing pixels toward the edge of the brush area while you hold down the mouse button or drag the mouse. To reverse the bloat direction — doing so applies a pucker — hold down the Alt key (Option key on the Mac) while you hold down the mouse button or drag.

 ✔ **Shift Pixels (S):** This odd tool moves pixels to the left when you drag the tool straight up. Drag down to move pixels to the right. Drag clockwise to increase the size of the object being distorted. Drag counterclockwise to decrease the size. To reverse any of the directions, hold down the Alt key (Option key on the Mac) while you hold down the mouse button or drag.

 ✔ **Reflection (M):** This tool drags a reversed image of your pixels at a 90-degree angle to the motion of the brush. Hold down the Alt key (Option key on the Mac) to force the reflection in the direction opposite the motion of the brush (for example, to the left of a brush moving right, or above a brush moving down). This tool is a good choice for making reflections on water.

The other tools

The three remaining tools on the panel help with undoing distortions you may no longer want and also with navigation. These tools (shown here with their keyboard shortcuts) are

 ✔ **Reconstruct (R):** This is a variation on the old standby Undo. It lets you reverse or alter — completely or partially — the distortions you've made. You can retrace your steps if you went overboard in your distortion activities.

 ✔ **Hand (H):** The Hand tool works exactly like the standard Elements Hand tool. Click and drag the image to move it around within the Preview window. You can find more about the Hand tool in Book I, Chapter 2.

 ✔ **Zoom (Z):** This tool works exactly like the Elements Zoom tool, which zooms you in and out. Just click the image to zoom in. Hold down the Alt key (Option key on the Mac) and click to zoom out. You can also zoom by selecting a magnification percentage (from 6 to 1600 percent) from the pop-up menu in the lower-left corner of the dialog box. Or, if you like buttons, click your way to magnification by using the +/– zoom control buttons. See Book I, Chapter 2, for more on using the Zoom tool.

The Options Area

On the right side of the Liquify window (refer to Figure 2-1), you can find some menus and buttons that let you specify options for the tools. We point them out to you here and cover how to use them in the rest of this chapter:

 ✔ **Brush Size:** Specifies the width of the brush.

 ✔ **Brush Pressure:** Specifies the speed at which you distort while you drag. The lower the value, the slower the distortion is applied.

 ✔ **Turbulent Jitter:** Determines how tightly the brush jumbles pixels. When you use the Turbulence tool, this option gives the stroke a more natural, organic look.

 ✔ **Stylus Pressure:** If you're lucky enough to have a graphics tablet and stylus, click this option to select the pressure of the stylus, which then controls the width of your brush stroke.

Distorting an Image with Liquify

Liquify is as easy to apply as finger paint after you play with it a little. Here's a step-by-step scenario of the things you might do to apply some distortion to your own image:

1. **Select and open an image you want to transmogrify in the Editor, in either Edit Full or Edit Quick mode.**

2. **In the Layers panel, select a layer. If you don't want to distort the whole layer, you can select part of it.**

 For more on selections, see Book IV. For info on layers, see Book VI.

3. **Choose Filter⇨Distort⇨Liquify.**

 The Liquify dialog box appears with the image in the preview area, as shown in Figure 2-3.

4. **Choose a distortion weapon of choice.**

 For a detailed description of each tool, see the preceding section, "The distortion painting tools." Figure 2-4 shows you what a little Pucker can do. (To visually see what each tool does, take another gander at Figure 2-2.)

5. **Specify options in the Tool Options area.**

 Remember to adjust the brush size and pressure to get the exact coverage you want. For a description of each option, see the preceding section, "The Options Area."

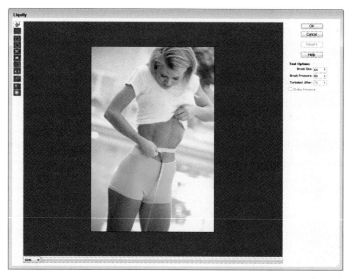

Figure 2-3: The Liquify dialog box is where the magic happens.

Figure 2-4: Use the various Painting tools to apply your desired distortions.

6. **If you take the distortions a little too far, select the Reconstruct tool to partially or fully reverse or modify your distortions.**

 Note that the reconstruction occurs faster at the center of the brush's diameter. To partially reconstruct your image, set a low brush pressure and watch closely while the mouse drags across the distorted areas.

7. **Apply the distortion to your image by clicking OK and exiting the Liquify dialog box.**

If you mucked up things and want to start again, click the Revert button to get the original, unaltered image back. This action also resets the tools to their previous settings. Figure 2-5 shows the Before (and the Extreme After) of our image.

Purestock

Figure 2-5: Perform a digital nip-and-tuck using Liquify.

Chapter 3: Adding Pizzazz with Styles and Effects

In This Chapter

✔ **Working with the Effects panel**

✔ **Taking photo effects for a spin**

✔ **Stylizing layers**

✔ **Tweaking layer styles**

After you have all the basic elements lined up in your layered composite image, you may want to give it a little pizzazz. Elements provides a lot of different effects that you can apply to enhance your images. Maybe a headline would pop out a little more if you beveled the edge, or maybe that silhouetted image would take on a little more dimension if you placed a drop shadow behind it. This chapter is where you find out how to do all these things.

Seeing What the Effects Panel Can Do

Elements has organized all its various effects in one neat panel. In the Editor in Edit Full mode, choose Window⇨ Effects. On the right side of the application window, you see the Effects panel, as shown in Figure 3-1. Buttons for the various categories of effects — Filters, Layer Styles, and All — are at the top of the panel. Subcategories (or *libraries*) of Filters, Layer Styles, and Filters are just to the right, accessible via a drop-down list. Individual effects, styles, and filters are located in the bottom portion of the panel and are displayed by thumbnail and/or name.

Click the down-pointing arrow in the upper-right corner (just below the close button) of the Effects panel to change the view of your effects, filters, and styles as thumbnails or as names. You'll also find a fast track to Styles and Effects help, if you need it.

The upcoming sections explain how to apply photo effects and styles. We go into a hefty discussion about filters in Book VII, Chapter 1.

Enhancing with Photo Effects

Elements provides a variety of photo effects that you can apply to your photos. Note that some effects automatically create a duplicate of the selected layer, whereas other effects work only on flattened images. You can't preview how the effect will look on your image or type, as you can when you apply filters. Also, you have no options to specify.

Here are the steps to follow when applying a photo effect:

1. **In the Editor in Edit Full mode, select your desired image layer in the Layers panel.**

 Or, if you're applying the effect to only a single a selection, make the selection before applying the effect.

2. **Choose Window⇨Effects.**

3. **In the Effects panel, select the Photo Effects button (blue screen with white dots around it) at the top.**

 Refer to Figure 3-1.

4. **Select your desired subcategory, or library, of Photo Effects from the drop-down list in the upper-right area of the panel:**

Layer Styles

Filters | Photo Effects | Effects libraries

Individual Effects

Figure 3-1: Add effects, styles, and filters via the Effects panel.

 - *Frame:* Includes photo effects that enhance the edges of the layer or selection.

 - *Faded Photo, Monotone Color, Old Photo, and Vintage Photo:* This group of photo effects makes your image fade from color to grayscale, appear as a single color, or look like an old pencil sketch or a photo on old paper.

 - *Misc Effects:* This group includes a wide variety of effects to make your image appear as though it's snowing, made of lizard skin or neon tubes, or painted with oil pastels.

 - *Show All:* Shows all the photo effects described in this list.

5. **On the Effects panel, double-click an effect or drag the effect onto the image.**

 In our example, in Figure 3-2, we applied the Oil Pastel photo effect in the Misc Effects library.

 You can also apply a photo effect to type. Select a type layer in the Layers panel and follow Steps 2–5 in the preceding list. Note that a dialog box alerts you that the type layer must be simplified before the effect can be applied. Remember that simplifying the layer means the text can no longer be edited, so be sure your type is exactly as you want it. For more on working with type layers, see Book V, Chapter 3.

 Unlike layer styles, note that photo effects can't be edited. Photo effects automatically create another layer, so if you don't care for the effect, simply delete that layer by dragging it to the trash can at the top of the Layers panel.

Figure 3-2: Enhance your images by adding photo effects to your image and type layers.

Book VII
Chapter 3

Adding Pizzazz with Styles and Effects

Working with layer styles

Layer styles range from simple shadows and bevels to more-complex designs, such as buttons and patterns. The wonderful thing about layer styles is that they're completely nondestructive. Unlike filters, layer styles don't change your pixel data. You can edit them or even delete them if you're unhappy with the results, so feel free to use them with abandon.

Here are a few fun facts about layer styles:

- **Layer styles can be applied only to layers.** Therefore, if all you have in your image is a background, be sure to convert it to a layer first. See Book VI for details on working with layers.

- **Layer styles are dynamically linked to the contents of a layer.** If you move or edit the contents of the layers, the results are updated.

- **When you apply a layer style to a layer, an fx icon appears next to the layer's name on the Layers panel.** Double-click the fx icon to bring up the Style Settings dialog box and make any adjustments that are necessary to get the look you want.

✔ **Layer styles are stored in different libraries.** You can add shadows, glows, beveled and embossed edges, and more-complex appearances, such as neon, plastic, chrome, and other manmade textures. See Figure 3-3 for a layer style sampler.

✔ **Delete a layer style or styles.** Choose Layer⇨Layer Style⇨Clear Layer Style or drag the fx icon on the Layers panel to the trash can in the panel.

✔ **Copy and paste layer styles onto other layers.** Select the layer containing the layer style and choose Layer⇨Layer Style⇨Copy Layer Style. Select the layer or layers on which you want to apply the effect and choose Layer⇨Layer Style⇨Paste Layer Style. You can also just drag and drop an effect from one layer to another while holding down the Alt key (the Option key on the Mac). Note that if you drag and drop an effect without holding down the Alt or Option key, you move the layer style from one layer to another.

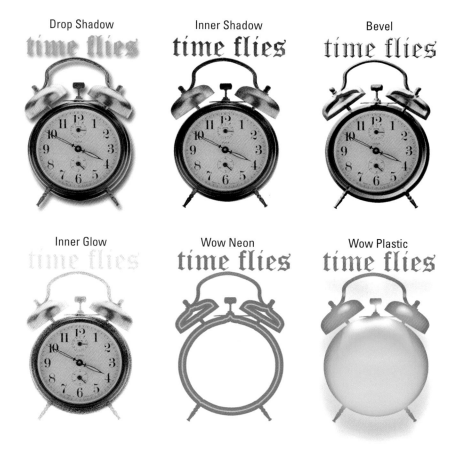

Figure 3-3: Add dimension by applying styles like shadows, glows, and bevels to your object or type.

✎ **Hide or show layer styles.** Choose Layer➪Layer Style➪Hide All Effects or Show All Effects.

✎ **Scale a layer style.** Choose Layer➪Layer Style➪Scale Effects. Select Preview and enter a value between 1 and 1,000 percent. This allows you to scale the style without scaling the element.

Here are the steps to apply a style and a description of each of the style libraries.

1. **In the Editor, in Edit Full mode, select an image or type layer on the Layers panel.**

2. **Choose Window➪Effects.**

3. **Select the Layer Styles button (an icon of two overlapping screens) at the top of the Effects panel.**

 Refer to Figure 3-1.

4. **Select a library of styles from the drop-down list in the upper-right area of the panel:**

 • *Bevels:* Adds a three-dimensional edge on the outside or inside edges of the contents of a layer, giving the element some dimension. Emboss styles make elements appear as though they're raised off of or punched into the page. You can change the appearance of these styles, depending on the type of bevel chosen. Adjust attributes, such as the lighting angle, distance (how close the shadow is to the layer contents), size, bevel direction, and opacity.

 • *Drop and Inner Shadows:* Add a soft drop or inner shadow to a layer. Choose from an ordinary shadow or one that includes noise, neon, or outlines. You can adjust the lighting angle, distance, size, and opacity, as desired.

 • *Outer and Inner Glows:* Add a soft halo that appears on the outside or inside edges of your layer contents. Adjust the appearance of the glow by changing the lighting angle, size, and opacity of the glow.

 • *Visibility:* Click Show, Hide, or Ghosted to display, hide, or partially show the layer contents. The layer style remains fully displayed.

 • *Complex and others:* The remaining layer styles are a group of different effects ranging from simple glass buttons to the more exotic effects, such as Groovy and Rose Impressions. You can customize all these layer styles somewhat by adjusting the various settings, which are similar to those for other styles in this list.

5. **On the Effects panel, double-click a layer style or drag the layer style onto the image.**

 The style, with its default settings, is applied to the layer. Note that layer styles are cumulative. You can apply multiple styles — specifically, one style from each library — to a single layer.

Note that you can also apply layer styles to type layers, and the type layer doesn't need to be simplified. This is an advantage over Photo Effects because it enables you to retain the type's editability, as shown in Figure 3-4.

Figure 3-4: Layer styles are advantageous because they don't alter your pixels.

Editing layer styles

Layer styles are very agreeable. Not only are they easy to apply, they are equally easy to edit. Here's how:

1. **In the Layers panel, double-click the fx icon on the layer.**

 The Style Settings dialog box opens, as shown in Figure 3-5.

2. **Be sure to check Preview so you can view how your edits are affecting the layer style.**

3. **Expand the options for any layer style category by clicking the arrow just to the left of the layer style name.**

 Note that you can toggle the layer style on and off by checking and unchecking the style.

4. **Depending on what category of layer styles you use, you have various options you can specify.**

 Here's a rundown:

 • *Lighting Angle:* Specify the angle of your light source. If you've decided to put together a

Figure 3-5: Layer styles such as shadows are live, enabling you to edit them at any time.

realistic composite of a number of different images, make sure that all the shadows and highlights of all the different elements are consistent. You don't want one layer to look like it's 6 a.m. and another to look like it's 2 p.m.

- *Size:* Specify the size of your shadow, glow, bevel, or stroke from 0 to 250 pixels.

- *Distance:* Adjust how far the shadow or glow is offset (0 to 30000 pixels) from your element.

- *Opacity:* Adjust the Opacity setting to change how transparent the shadow, glow, or stroke appears — from 0% to 100%.

- *Inner/Outer:* Specify whether your glow is an inner or outer glow.

- *Color:* Click the color swatch and choose a glow color from the Color Picker. Click OK to close the Color Picker dialog box.

- *Direction Up/Direction Down:* Specify whether your bevel (the raised or sunken-in edge) direction is up or down. Direction Up positions the highlight along the edge closest to the light source and the shadow on the opposite edge. Direction Down does the opposite, positioning the shadow near the light source.

5. After you refine your layer style settings, click OK.

The layer style is edited and ready to go, as shown in Figure 3-6. Note that there are also options for *Reset,* to start over; or *Cancel,* to bail out entirely.

lovin' layer styles
loving layer styles

Figure 3-6: An original and edited layer style.

Putting It Together

Adding Photo Effects and Layer Styles to a Collage

If you like your images and text simple and unadorned, more power to you. But if you feel a sudden urge to add an embellishment or two, make sure you're prepared to do that.

continued

continued

In this exercise, we show you how to add some type to a collage and apply effects and styles to the various elements. Just follow these simple steps:

1. **In the Editor, in Edit Full mode, open a previously created and saved collage file.**

Make sure that the Layers panel is also open.

2. **Select the Eyedropper tool from the Tools panel. Click a color in the collage that you like.**

The color you sampled is now the foreground color, as you can see from your swatches at the bottom of the Tools panel.

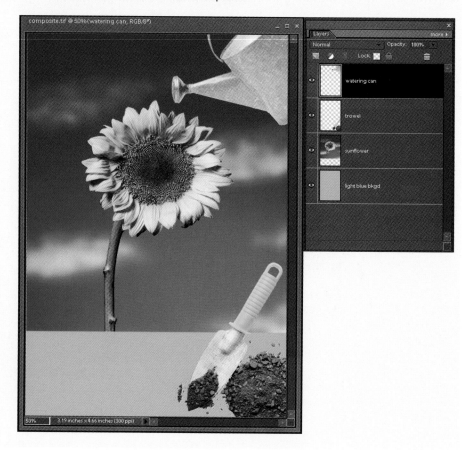

3. **Select the Type tool and then select a font, style, point size, and other formatting options from the Options bar.**

 We recommend choosing an easy-to-read font and applying a bold style to it. We're using Times New Roman Bold, and we set the point size to 30 and the leading to 24 points.

 We checked the Anti-alias option so that our text transitions nicely with the image elements.

4. **Click inside the image and type some text.**

 We typed **Organic Gardening** for our garden collage. We also added a second line of text with the day and time.

5. **Select the Move tool from the Tools panel and position the type in the collage.**

 We put the text in the bottom-left corner.

6. **With the type layer selected in the Layers panel, choose Window⇨ Effects. In the Effects panel, click the Layer Styles icon at the top and choose Drop Shadows from the library drop-down list. Double-click the Low drop shadow.**

 If you need to edit the layer style, double-click the fx icon in the Layers panel and specify settings. For details on how to do this, see the earlier section "Editing layer styles." We edited the drop shadow to make it a little smaller in size, less opaque, and closer to the type.

continued

**Book VII
Chapter 3**

**Adding Pizzazz with
Styles and Effects**

continued

7. **Choose Bevels from the library drop-down list. Double-click the Simple Inner bevel. Make any necessary edits to the bevel layer style.**

 We reduced the size of our bevel to make the effect crisper.

8. **Repeat Steps 6 and/or 7 on any other of your layers, if desired.**

 We added a Low drop shadow to our trowel and dirt pile layer.

9. **To add an effect, in the Effects panel, click the Photo Effects icon at the top and choose Misc Effects from the library drop-down list. Double-click the Soft Flat Color effect.**

10. **Choose File⇨Save.**

 You're all done. If you feel like it, keep adding to or refining the collage when you discover new tricks.

Book VIII

Retouching and Enhancing

Almost every photo you take needs a little polish before you share or print it. In this book, we talk about the automated features in Elements that help you quickly adjust brightness and color, and we cover many advanced image-correction features.

If you have some photos that were taken with poor lighting, have low contrast, or are a little bit fuzzy, this book can help you resurrect some images you thought were destined for the waste bin.

Chapter 1: Quick Image Makeovers

In This Chapter

✓ **Cropping and straightening images**

✓ **Working with the Divide Scanned Photos command**

✓ **Using one-step auto fixes**

✓ **Editing with Edit Quick**

✓ **Cloning realistically**

✓ **Healing wrinkles, spots, and blemishes**

✓ **Fixing small flaws**

One of the strongest assets of Elements is the capability to fix images quickly, painlessly, and effectively. When you work with digital imaging, you find that cropping away unwanted clutter, cloning an image with a shadow, adjusting the color or contrast of a photo, or eliminating flaws from that otherwise perfect portrait are all fixes that you can do successfully whatever your skill level. With these simple image-makeover tools, Elements makes these tasks as easy to perform as clicking a button or making a few swipes with a brush.

Cropping an Image

Even a novice photographer knows that cropping an image can make a composition stronger. *Cropping* cuts away background clutter or empty space in order to focus in on a certain subject.

This simple process can transform a mediocre image into an interesting and even exciting one. Take a look at our example in Figure 1-1. It doesn't take a pro photographer to figure out which image is better composed.

Figure 1-1: Cropping is one of the easiest ways to improve the composition of your image.

Cutting away with the Crop tool

The most popular way to crop an image is by using the Crop tool. This simple tool is as easy and effective to use as a ruler and an X-Acto knife — without the possibility of slicing any fingers. Here's how to use this popular tool:

 1. **In the Editor, in either Edit Quick or Edit Full mode, select the Crop tool. Or you can press the C key.**

2. **Specify your aspect ratio options on the Options bar.**

 Here are your choices:

 - *No Restriction:* Allows you to freely crop the image at any size.

 - *Use Photo Ratio:* Retains the original aspect ratio of the image when you crop.

 - *Preset Sizes:* Offers a variety of common photographic sizes. When you crop, your image assumes those specific dimensions.

 When you crop an image, Elements retains the original resolution of the file. Therefore, to keep the image at the same resolution while also eliminating portions of the image, Elements must resample the file. Consequently, your image must have sufficient resolution so that the effects of the resampling aren't too noticeable. This is especially true if you're choosing a larger preset size. Be sure to see Book III, Chapter 1 for more details on resolution.

 - *Width and Height:* Enables you to specify a width and height to crop your image.

3. **With the Crop tool, click and drag around the part of the image you want to keep and then release your mouse button.**

 While you drag, a *marquee* (a dotted outline) bounding box appears, displaying the cropping boundaries. Don't worry if your cropping marquee isn't exactly correct. You can adjust it in Step 4.

 The area outside the cropping marquee appears darker than the inside in order to frame your image better. Adobe calls this a *shield*. If you want to change the color and opacity of the shield, or if you don't want it at all, change your Crop preferences. (Choose Edit➪Preferences➪Display & Cursors; on the Mac, choose Photoshop Elements➪Preferences➪ Display & Cursors.)

 Figure 1-2 shows a great example of way too much background clutter. We dragged around the only thing we wanted to retain.

4. **Adjust the cropping marquee by dragging the handles of the crop marquee bounding box.**

 The small squares on the sides and corners of the cropping marquee are called *handles*. When you hover your mouse pointer over any handle or over the marquee itself, your cursor changes to a double-headed arrow, indicating that you can drag.

 To move the entire marquee, position your mouse pointer inside the marquee until you see a black arrowhead cursor and then drag. Adjust the marquee until you're satisfied.

 You can also drag the origin point (the circle icon in the center) to change the axis of rotation.

Cropping marquee Origin point Shield

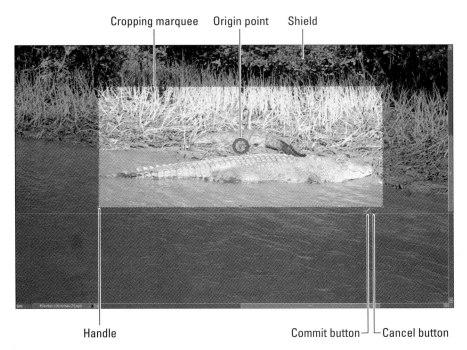

Handle Commit button⌐ ⌐Cancel button

Figure 1-2: The area around your cropping marquee appears darker so that you can better frame your image.

If you move your mouse outside the marquee, the cursor changes to a curved, double-headed arrow. Dragging with this cursor rotates the marquee. This feature can be extremely useful to rotate and crop a crooked image. By using the Crop tool, you can perform both commands in one step, quickly and accurately. Just be aware that rotation, unless it's in 90-degree increments, resamples your image. If this is done repeatedly, it can damage your image. Getting the rotation right the first time is best.

5. **Double-click inside the cropping marquee.**

 You can also just press Enter (Return on the Mac) or click the green Commit button next to the marquee. Elements then discards the area outside the marquee, as shown in Figure 1-3. To cancel your crop, click the red Cancel button or press the Esc key.

Cropping with a selection border

If you get bored using the Crop tool, you can also crop a selected area by choosing Image⇨Crop in either Edit Full or Edit Quick mode. Simply make a

selection with any of the tools and then choose this command. Although it makes the most sense to use the Rectangular Marquee tool for your selection, you don't have to.

Figure 1-3: Eliminating background clutter allows you to home in on your subject.

You can choose Image➪Crop with any selection — round, polygonal, free-form, even feathered. Elements can't crop to those odd shapes, but it gets as close to the outline as it can, as shown in Figure 1-4.

Figure 1-4: Elements can crop to any selection border shape.

Book VIII
Chapter 1

Quick Image
Makeovers

Straightening Images

Strive to capture a straight horizon in your photo. You don't want people to feel like the water is going to pour right out of your frame in that shot of the beach or sailboat. Or, maybe when you scanned a photo, it wasn't quite centered in the middle of the scanning bed. No worries. Elements gives you several ways to straighten an image.

Using the Straighten tool

This tool enables you to specify a new straight edge, and it then rotates the image accordingly. Here's how to use the Straighten tool:

1. **With the Editor in Edit Full mode, select the Straighten tool from the Tools panel (or press the P key).**

2. **Specify your desired setting from the Canvas Options on the Options bar.**

 Here are your choices:

 - *Grow or Shrink Canvas to Fit:* Rotates the image and increases or decreases the size of the canvas to fit the image area.

 - *Crop to Remove Background:* Trims off background canvas outside the image area. This is helpful if you want to remove white areas that appear around an image when you scan it.

 - *Crop to Original Size:* Rotates your image without trimming any background canvas.

3. **(Optional) Select Rotate All Layers.**

 If you have an image with layers and you want them all them rotated, select this option.

4. **Using the Straighten tool, draw a line in your image to represent the new straight edge, as shown in Figure 1-5.**

 Your image is then straightened and, if you chose either of the crop options in Step 2, also cropped.

Using the Straighten menu commands

In addition to using the Straighten tool, you can straighten your images by using two commands on the Image menu, in either Edit Full or Edit Quick mode:

✔ **To automatically straighten an image without cropping:** Choose Image⇨ Rotate⇨Straighten Image. This method of straightening leaves the canvas around the image.

✔ **To automatically straighten and crop the image simultaneously:** Choose Image⇨Rotate⇨Straighten and Crop Image.

Figure 1-5: Straighten your image.

Using the Divide Scanned Photos Command

The Divide Scanned Photos command is fabulous if you want to save time by scanning multiple images initially into one document (and the command works on single images as well). This command is a real manual-labor time-saver, and we endorse it. Position all the photos you can on your scanning bed and get one initial scan. Just make sure that a clear separation exists between images. Then choose Image⇨Divide Scanned Photos in either Edit Full or Edit Quick mode. Elements divides the images and places each one in a separate file, as shown in Figure 1-6. Note that if you have images with a lot of white in them, such as snow, you should cover the scanner with a piece of dark paper to better delineate the boundaries of each image. Conversely, for scanners with a black background and scanning photos with a lot of black, cover the scanner with a piece of light paper.

Figure 1-6: The Divide Scanned Photos command extracts and straightens your images into separate files.

Applying One-Step Auto Fixes

Elements has five automatic lighting-, contrast-, and color-correction tools that can quickly improve the look of your images with a single menu command. These commands are available in either Edit Full or Edit Quick mode, and they're all on the Enhance menu.

What's great about these auto fixes is that they're very easy to use. You don't need to know a heck of a lot about color or contrast to use them. The not-so-good news is that sometimes the result of these auto fixes isn't as good as you could get via a manual color-correction method. And sometimes these fixes may even make your image look worse than before by giving you strange shifts in color. But because these correctors are quick and easy — and easily undone — they're worth a try. Usually you don't want to apply more than one of the auto fixes. If one doesn't work on your image, just remember you can undo the fix and try another. If you still don't like the

result, move on to one of the manual methods that we describe in Book VIII, Chapter 2.

Auto Smart Fix

This all-in-one command attempts to adjust it all. It's designed to improve lighting, improve the details in shadow and highlight areas, and correct the color balance, as shown in Figure 1-7. The overexposed image on the left was improved with the Auto Smart Fix command.

Figure 1-7: Apply the Auto Smart Fix command to quickly improve an image overall.

For Windows users, the Auto Smart Fix command, as well as the Auto Color, Auto Levels, Auto Contrast, Auto Sharpen, and Auto Red Eye Fix, are available in the Organizer (under the Fix pane), where you can apply the commands to several selected images simultaneously.

If the Auto Smart Fix didn't quite cut it, you can ramp it up and try Adjust Smart Fix. This command is similar to Auto Smart Fix, but gives you a slider that allows you to control the amount of correction applied to the image.

Auto Levels

The Auto Levels command adjusts the overall contrast of an image. This command works best on images that have pretty good contrast (detail in the shadow, highlight, and midtone areas) to begin with and just need a little adjustment, but it can also work wonders for seemingly unsalvageable images, as shown in Figure 1-8. Auto Levels works by *mapping,* or converting, the lightest and darkest pixels in your image to black and white, which makes highlights appear lighter and shadows appear darker.

Figure 1-8: Auto Levels adjusts the overall contrast of an image.

Although Auto Levels can improve your contrast, it may also produce an unwanted *colorcast* (a slight trace of color). If this happens, undo the command and try the Auto Contrast command instead. If that still doesn't improve the contrast, try the Levels command that we describe in Book VIII, Chapter 2.

Auto Contrast

The Auto Contrast command is designed to adjust the overall contrast in an image without adjusting its color. This command may not do as good a job of improving contrast as the Auto Levels command, but it does a better job of retaining the color balance of an image. Auto Contrast usually doesn't cause the strange colorcasts that can occur when you're using Auto Levels. This command works really well on images with a haze, as shown in Figure 1-9.

Figure 1-9: The Auto Contrast command clears up hazy images.

Auto Color Correction

The Auto Color Correction command adjusts both the color and contrast of an image, based on the shadows, midtones, and highlights it finds in the image and a default set of values. These values adjust the number of black and white pixels that Elements removes from the darkest and lightest areas of the image. You usually use this command to remove a colorcast or to balance the color in your image, as shown in Figure 1-10. Sometimes this command can be useful in correcting oversaturated or undersaturated colors.

Figure 1-10: Use Auto Color Correction to remove a colorcast.

Auto Sharpen

Sometimes photos taken with a digital camera or scanned on a flatbed scanner can appear *soft,* meaning slightly out of focus. Sharpening gives the illusion of increased focus by increasing the contrast between pixels. Auto Sharpen attempts to improve the focus, as shown in Figure 1-11, without going too far. What happens when you oversharpen? Your images go from soft to grainy and noisy. Always make sharpening the last fix after you make all other fixes and enhancements. You don't want to sharpen nasty flaws and make them even more noticeable than they already are. For more accurate sharpening methods, see the Unsharp Mask and Adjust Sharpness features discussed in Book VIII, Chapter 2.

**Book VIII
Chapter 1**

Quick Image
Makeovers

Figure 1-11: Use Auto Sharpen to improve focus.

Auto Red Eye Fix

The Auto Red Eye Fix command automatically detects and eliminates red eye in an image. Red eye occurs when a person or animal (where a red eye can also be a yellow, green, or even blue eye) looks directly into the flash. Many cameras have a red-eye prevention mode, which is a pre-flash that causes the subjects' irises to contract, making their pupils smaller when the real flash goes off. Other cameras mount the flash high or to side of the lens, which also minimizes the chance of red eye. However, these preventive measures are of little solace when you have a great picture that features bright red pupils as its dominant feature.

Using the Red Eye Removal tool

If for some reason the Auto Red Eye Fix doesn't correct the problem, you can always try the Red Eye Removal tool on the Tools panel. Here's how to remove red eye manually:

1. **Select the Red Eye Removal tool from the Tools panel in the Editor in Edit Full mode.**

 Note that this tool is also available in Edit Quick mode.

2. **Using the default settings, click the red portion of the eye in your image.**

 This one-click tool darkens the pupil while retaining the tonality and texture of the rest of the eye, as shown in Figure 1-12.

Figure 1-12: The Auto Red Eye Fix and the Red Eye Removal tool detect and destroy dreaded red eye.

3. **If you're unhappy with the fix, adjust one or both of these options:**

 • *Pupil Size:* Use the slider to increase or decrease the size of the pupil.

 • *Darken Pupil:* Use the slider to darken or lighten the color of the pupil.

 If all goes well, your image is now cured of the dreaded red eye. (Refer to the image on the right in Figure 1-12.)

Note that you also use the Brush tool with a Color blend mode and paint away the red. Or you can use the Color Replacement tool with a black foreground to color away the crimson. If you're trying to fix green eye in animals, your best bet is to use the Color Replacement tool.

Editing with Edit Quick Mode

It turns out that if you master the auto fixes we cover in the previous sections while working in Edit Quick mode, you probably already have all the tools you need to repair and enhance your images. This means you rarely have to visit Edit Full mode. Given the power and flexibility of Edit Quick mode, then, we're going to devote an entire section to it.

As you've probably already figured out by now, Edit Quick mode is a pared-down version of Edit Full mode that provides basic image-correcting tools and throws in a few unique features — such as a before-and-after preview of your image — for good measure. To get a general idea how Edit Quick mode works, take a look at the following step-by-step workflow, which shows you how you'd put Edit Quick mode to use to fix your photos:

1. **Do one of the following:**

 • In the Organizer (for Windows users), select one or more photos. Click Fix in the upper-right of the Application window and then click the Edit Quick button in the panel below.

- Windows or Mac users, in Edit Full mode, select your desired image(s) from the Photo Bin. Click the Quick button in the upper-right area of the Application window.

- Windows or Mac users, in Edit Full mode, open your desired images by choosing File⇨Open. Click the Quick button in the upper-right area of the Application window.

2. **Specify your preview preference from the View pop-up menu at the bottom of the Application window.**

 You can choose to view just your original image (Before Only), your fixed image (After Only), or both images side by side (Before & After) in either portrait (Vertical) or landscape (Horizontal) orientation, as shown in Figure 1-13.

Figure 1-13: Edit Quick mode enables you to view before-and-after previews of your image.

3. **Use the Zoom and Hand tools to magnify and navigate around your image.**

 You can also specify the Zoom percentage by using the Zoom slider at the bottom of the Application window.

4. **Crop your image by using the Crop tool on the Tools panel.**

 You can also use any of the methods we describe in the "Cropping an Image" section, earlier in this chapter.

5. **To rotate the image in 90-degree increments, click the Rotate Left or Rotate Right button at the bottom of the Application window.**

6. **Use the Auto Red Eye Fix to remove the red from your subjects' eyes.**

 Automatically fix red eye by clicking the Auto button under Red Eye Fix in the General Fixes pane on the Edit tab in the Panel Bin on the right side of the Application window. If that doesn't work, try the Red Eye Removal tool located in the Tools panel.

7. **Apply any necessary auto fixes, such as Auto Smart Fix, Auto Levels, Auto Contrast, and Auto Color Correction.**

 All these commands are under the Enhance menu or in the General Fixes, Lighting, and Color panes on the Edit tab in the Panel Bin on the right side of the Application window.

 Each of these fixes is described in the section "Applying One-Step Auto Fixes," earlier in this chapter. Remember that usually one of the fixes is enough. Don't stack them on top of each other. If one doesn't work, click the Reset button in the top-right of the image preview and try another. If you're not happy, go to Step 8. If you are happy, skip to Step 9.

8. **If the auto fixes don't quite cut it, gain more control by using the sliders available for Smart Fix, Levels, Contrast, and Color, located in the various panes on the Edit tab in the Panel Bin on the right of the Application window.**

 Here's a brief description of each available adjustment:

 - *Lighten Shadows:* When you drag the slider to the right, the darker areas of your image lighten without adjusting the highlights.

 - *Darken Highlights:* When you drag the slider to the right, the lighter areas of your image darken without adjusting the shadows.

 - *Midtone Contrast:* Adjusts the contrast of the middle (gray) values and leaves the highlights and shadows as they are.

 - *Saturation:* Adjusts the intensity of the colors.

 - *Hue:* Changes all colors in an image. Make a selection first to change the color of just one or more elements. Otherwise use restraint with this adjustment.

 - *Temperature:* Adjusts the colors to make them warmer (red) or cooler (blue). This adjustment can be used to correct skin tones or to correct overly cool images (such as snowy winter photos) or overly warm images (such as photos shot at sunset or sunrise).

 - *Tint:* Adjusts the tint after you adjust temperature to make the color more green or magenta.

 If you still don't get the results you need, move on to one of the more manual adjustments that we describe in Book VIII, Chapter 2.

 You can always apply fixes to just selected portions of your image. Edit Quick mode offers the Quick Selection tool for your selection tasks. For details on using this tool, see Book IV, Chapter 1.

9. Add final fixes by using the remaining tools in the Tools panel.

Note that all tools that were previously located in the Touch Up pane have been relocated to the Tools panel. The Touch Up pane is history.

Here's a quick description of each tool:

- *Red Eye Removal tool:* If the Auto Red Eye Fix didn't work, try using this tool, described in the section "Auto Red Eye Fix," earlier in this chapter.

- *Whiten Teeth:* This new digital fix whitens teeth at a fraction of the cost of the real analog procedure. Choose an appropriate brush size from the Brushes drop-down panel before whitening (for more on brush options, see Book V, Chapter 1). Using a brush diameter that's larger than the area of the teeth also whitens/brightens whatever else it touches — lips, chin, and so on. Click the teeth. Note that this tool makes a selection and whitens simultaneously. After your initial click, your selection option converts from New Selection to Add to Selection in the Options bar. If you pick up too much in your dental selection, click the Subtract from Selection option and click the area you want to eliminate. When you're happy with the results of your whitening session, choose Select⇨Deselect or press Ctrl+D (⌘+D on the Mac).

- *Make Dull Skies Blue:* Click or drag over areas of your sky that need brightening. Choosing a brush size and selection option is similar to using the Whiten Teeth fix, described in the preceding bullet. When you click your sky, it's selected and brightened at the same time. When you're done, choose Select⇨Deselect or press Ctrl+D (⌘+D on the Mac).

- *Black and White–High Contrast:* This tool converts your image into a high-contrast grayscale image. The method and options are similar to those for the Whiten Teeth and Make Dull Skies Blue options, described in the preceding bullets.

You can find these same fixes (and many more) in Edit Full mode, under the Smart Brush and Detail Smart Brush tools. Check out Book VIII, Chapter 2 for the lowdown on these tools.

10. Sharpen your image either automatically (by clicking the Auto button) or manually (by dragging the slider on the Sharpen panel).

This fix should always be the last adjustment you make on your image. Sharpening increases contrast, so you want to fix the flaws first so you don't exacerbate them by making them more noticeable.

Cloning with the Clone Stamp Tool

Say that you want to duplicate an element in your image. That's easy enough, right? Make a selection and copy and paste it into the new location. That works fine most of the time. But what if the element has a shadow behind it, next to it, above it, or below it? You face the dilemma of having a hard edge on the copied element because the shadow (called a *cast shadow*) is cut off by the selection outline. You could feather the selection, but then you have to make sure that the copied element blends realistically with the background. What a pain. The better method is to clone the element by using the Clone Stamp tool. It's quick, easy, and no one will know that only one element was there originally.

Believe it or not, you can also reach for this tool when retouching imperfections such as scratches, scars, bruises, date/time stamp imprints from cameras, and other minor flaws. In fact, that used to be one of its major functions. In some retouching instances, it does a decent job, although the arrival of the Healing Brush and Spot Healing tools has relegated the Clone Stamp tool more to the pure cloning functions and less to the hard-core retouching jobs.

The Clone Stamp tool works by taking sampled pixels from one area and *cloning* (or copying) them onto another area. Follow these steps to clone an element without any genetic engineering:

1. **Open an image and choose the Clone Stamp tool from the Tools panel in Edit Full mode.**

2. **On the Options bar, choose a brush from the Brush Preset drop-down list, and then use the brush as is or adjust its size with the Size slider.**

3. **Select the blend mode of your choice in the Options bar.**

 Selecting a mode such as Difference, Multiply, or Color can produce some interesting special effects. For info on blend modes, see Book VI, Chapter 3.

4. **To make the clone more or less opaque, use the Opacity slider or text box on the Options bar.**

 To make your cloned image appear ghosted, use an opacity setting of less than 100 percent.

5. **Specify how fast the Clone Stamp tool applies the clone by adjusting the Flow Rate percentage.**

 Again, we left our option at 100%.

6. **Select or deselect the Aligned option, depending on your preference.**

 With Aligned selected, the clone source moves when you move your cursor to a different location. If you want to clone multiple times from the same location, deselect the Aligned option.

7. **Select or deselect the All Layers option.**

 This option enables you to sample pixels from all visible layers for the clone. If this option is deselected, the Clone Stamp tool clones from only the active layer. Check out Book VI for details about working with layers.

8. **Alt-click (Option-click on the Mac) the area of your image that you want to clone to define the source of the clone.**

9. **Click or drag along the area where you want the clone to appear, as shown in Figure 1-14.**

 While you drag, Elements displays a crosshair cursor along with your Clone Stamp cursor. The crosshair represents the source you're cloning from, and the Clone Stamp cursor shows where the clone is being applied. While you move the mouse, the crosshair moves as well. This provides a continuous reference to the area of your image that you're cloning. Keep an eye on the crosshair, or you may clone something you don't want.

 When you successfully complete the cloning process, you have two identical objects. Figure 1-15 shows our identical apples.

Figure 1-14: When using the Clone Stamp tool, drag along the area where you want your clone to appear.

Figure 1-15: Our twin apples are the products of cloning.

If you're cloning an element, try to clone it without lifting your mouse. Also, when you're retouching a flaw, try not to overdo it. Clicking once or twice on each flaw is usually plenty. If you're heavy-handed with the Clone Stamp, you get a blotchy effect that's a telltale sign something has been retouched.

10. Save the image and close it.

Here are a few additional tidbits regarding the Clone Stamp tool:

- ✐ **Use the Clone Stamp tool to fix simple flaws.** To clean up a flaw that's pretty straight, such as a stray hair or scratch, Alt-click (Option-click on the Mac) with the tool to define the source. Then click at one end of the straight flaw and Shift-click at the other end. The cloned source pixels cover up the flaw.

- ✐ **Pay attention to the origin point for sampling.** Depending on what you're cloning (for example, when covering up a flaw), if you keep sampling from the same point without ever varying it, the area you're cloning starts to look like ugly shag carpeting. Or, at best, it starts to appear blotchy and over-retouched.

- ✐ **Zoom out once in a while to check how your image looks overall.** Doing so helps you avoid those funky telltale clone-stamp repetitive patterns and blotches.

Cosmetic Surgery with the Healing Brush Tool

The Healing Brush tool is similar to the Clone Stamp tool. Both tools let you clone pixels from one area and apply them to another area. But that's where the similarities end, and the Healing Brush leaves the Clone Stamp tool in the dust.

The problem with the Clone Stamp tool is that it doesn't take the tonality of the flawed area — the shadows, midtones, and highlights — into consideration. So, if the pixels you're sampling from aren't shaded and lit exactly like the ones you're covering, you have a mismatch in color, which makes seamless and indecipherable repairs hard to achieve.

That's where the Healing Brush tool comes in. This very intelligent tool clones by using the *texture* from the sampled area (the source) and then using the *colors* around the brush stroke when you paint over the flawed area (the destination). The highlights, midtones, and shadows remain intact, and the result of the repair is more realistic and natural — not blotchy, miscolored, and screaming "retouched." Follow these steps to heal your favorite, but imperfect, photo:

1. **Open an image in need of a makeover and select the Healing Brush tool from the Tools panel in the Editor in Edit Full mode.**

 Our guy, as shown in Figure 1-16, looks like he could stand to get some "work done," as they say in Hollywood. Note that you can also heal between two images. Just make sure that they have the same color mode — for example, both RGB (red, green, blue).

2. **On the Options bar, click the Brush Preset Picker.**

 In the drop-down panel, select your desired diameter and hardness, as well as spacing, angle, and roundness if you want, for your brush tip. You'll most likely specify your brush settings several times while retouching your image. Using the appropriate brush size for the flaw you're repairing is important.

www.istockphoto.com

Figure 1-16: Getting ready for a digital makeover.

3. **Specify a diameter and hardness for your brush tip from the Brush Picker drop-down panel on the Options bar.**

 You can also adjust the spacing, angle, and roundness. For details on these options, see Book V, Chapter 1. Be sure to adjust the size of your brush, as needed. Using the appropriate brush size for the flaw you're retouching is crucial for creating realism.

4. **Choose your desired Blend mode.**

 You can change your Blend mode, if necessary. The Replace mode preserves textures, such as noise or film grain, around the edges of your strokes when you're using a soft brush. For most simple retouching jobs, such as this one, you can leave it at Normal.

5. **Choose one of these Source options:**

 You have a choice between Sampled and Pattern:

 - *Sampled:* Uses the pixels from the image. You'll probably use this option 99.9 percent of the time.

 - *Pattern:* Uses pixels from a pattern you select from the Pattern Picker drop-down panel.

 For our example, we're sticking with Sampled because we don't think our guy would look that good with a Tie-Dye pattern across his face.

6. **Select or deselect the Aligned option on the Options bar.**

 For most retouching tasks, you probably should leave Aligned selected. Here are the details on each option:

 - *With Aligned selected:* When you click or drag with the Healing Brush, Elements displays a crosshair along with the Healing Brush cursor. The crosshair represents the sampling point, also known as the *source.* When you move the Healing Brush tool, the crosshair also moves, providing a constant reference to the area you're sampling. (We left the Aligned option selected in our example.)

 - *With Aligned deselected:* Elements applies the source pixels from your initial sampling point, no matter how many times you stop and start dragging.

7. **Select the All Layers option to heal an image by using all visible layers.**

 If this option is deselected, you heal from only the active layer.

 To ensure maximum editing flexibility later, select the Sample All Layers option and add a new, blank layer above the image you want to heal. When you heal the image, the pixels appear on the new layer and not on the image itself. You can then adjust opacity, Blend modes, and make other tweaks to the "healed" pixels.

8. **Establish the sampling point by Alt-clicking (Option-clicking on the Mac).**

Make sure to click the area of your image you want to clone *from*.

In our example, we clicked the smooth area on the chin and portions of the forehead.

9. **Release the Alt (Option on the Mac) key and click or drag over a flawed area of your image.**

Pay attention to where the cross-hair is located because that's the area you're healing from. We brushed over the wrinkles under and around the eyes and on the forehead. This guy never looked so good, as shown in Figure 1-17, and he experienced absolutely no recovery time.

www.istockphoto.com

Figure 1-17: In just five or ten minutes, this gentleman lost about ten years.

Zeroing In with the Spot Healing Brush

Whereas the Healing Brush is designed to fix larger flawed areas, the Spot Healing Brush is designed for smaller blemishes and little imperfections. The biggest difference between the Healing Brush and the Spot Healing Brush is that the Spot Healing Brush doesn't require you to specify a sampling source. It automatically takes a sample from around the area to be retouched. The good news is it's quick and easy. The downside is that it doesn't give you as much control over the sampling source. Consequently, reserve this tool for small and simple flaws.

Follow these steps to quickly fix little, nitpicky imperfections with the Spot Healing Brush tool:

1. **In the Editor, in Edit Full mode, open your image and grab the Spot Healing Brush tool from the Tools panel.**

The moles around this guy's mouth, as shown in Figure 1-18 on the left, are no match for the power of the Spot Healing Brush.

2. **On the Options bar, click the Brush Preset Picker and select your desired diameter, hardness, and other options for your brush tip from the drop-down panel.**

Try to select a brush that's a little larger than the flawed area you want to fix.

PhotoSpin

Figure 1-18: Watch these moles (left) disappear (right).

3. **Select a blend mode from the Options bar.**

 Just as with the Healing Brush, you can select the Replace mode. Most likely, the Normal mode works the best.

4. **Select a type from the Options bar:**
 - *Proximity Match:* Samples the pixels around the edge of the selection to use to fix the flawed area
 - *Create Texture:* Uses all the pixels in the selection to create a texture to fix the flaw

 Try Proximity Match first and, if it doesn't work, undo and try Create Texture.

5. **Choose Sample All Layers to heal an image by using all visible layers.**

 If you leave this option unselected, you heal from only the active layer.

6. **Click, or click and drag, the area you want to fix.**

 In Figure 1-18, we used the Spot Healing Brush for the moles and spots on the face.

Colorizing with the Color Replacement Tool

The Color Replacement tool allows you to replace the original color of an image with the foreground color. You can use this tool in a variety of ways.

Create the look of a hand-painted photo by colorizing a grayscale image. Or maybe you just want to change the color of an object or two, such as a couple of flowers in a bouquet. And even though Elements has a bona fide Red Eye tool, you can also use the Color Replacement tool to eliminate red (or yellow or green) eye in people and animals.

The great thing about the Color Replacement tool is that, like the other healing tools, it completely preserves the tonality of the image. The color that you apply doesn't obliterate the midtones, shadows, and highlights as it would if you were applying color with the regular Brush tool. The Color Replacement tool works by first sampling the original colors in the image and then replacing those colors with the foreground color. By specifying different sampling methods, limits, and tolerance settings, you can control the range of colors that Elements replaces.

Follow these steps to replace existing color with your foreground color:

1. **In the Editor, in Edit Full mode, open your image and select the Color Replacement tool from the Tools panel.**

 This tool shares a flyout menu with the Brush and Pencil tools.

 You can press the B key to select it (or Shift+B to cycle through the tools).

2. **On the Options bar, specify your desired brush-tip diameter and hardness from the Brush Preset Picker drop-down panel.**

3. **In the Options bar, select your desired Blend mode:**

 • *Color:* This default mode works well for most colorizing jobs. Use this mode if you're trying to get rid of red eye.

 • *Hue:* This mode is similar to color, but less intense, providing a subtler effect.

 • *Saturation:* This mode is the one to use to convert the color in your image to grayscale. Set your foreground color to Black on the Tools panel.

 • *Luminosity:* This mode is the opposite of the Color mode. Although this Blend mode can create a beautiful effect between two image layers, it doesn't tend to provide that great an effect in other circumstances.

4. **Select your sampling method (represented by the icons) from the icons in the Options bar:**

 • *Continuous:* Samples and replaces color continuously while you drag your mouse.

 • *Once:* Replaces colors in only the areas that contain the color you first sampled when you initially clicked.

 • *Background Swatch:* Replaces colors in only the areas containing your current background color.

5. **Select your sampling limits mode.**

 - *Contiguous:* The default setting replaces the color of pixels containing the sampled color that are adjacent to each other directly under the brush.

 - *Discontiguous:* Replaces the color of the pixels containing the sampled color wherever it occurs under your brush.

6. **Specify your tolerance percentage.**

 Tolerance refers to a range of color. A high tolerance lets you replace a broad range of color. A low tolerance limits the replacement of color to only the areas that are very similar to the sampled color.

7. **Choose whether you want anti-aliasing.**

 Remember, anti-aliasing slightly softens and smooths the edge of the sampled areas.

8. **After you establish your settings, click or drag in your image.**

 Notice how the foreground color, which in our example is pink (who doesn't yearn for pink cowboy boots?), replaces the original colors of the sampled areas (see Figure 1-19). Of course, the exact effect you get depends on your settings.

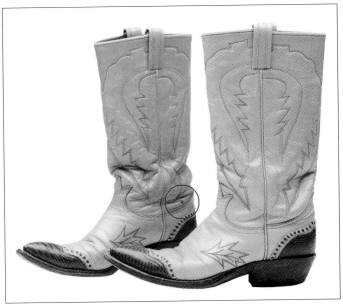

PhotoDisc

Figure 1-19: Use the Color Replacement tool to replace the original color in your image with your current foreground color.

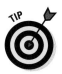

If you want to be more accurate, make a selection before you replace your color so you can avoid coloring elements you don't want to color.

Lightening and Darkening with Dodge and Burn Tools

Dodging and burning originated in the darkroom, where photographers would salvage negatives containing areas that were too dark or too light by adding or subtracting exposure as an enlarger made the prints.

An enlarger makes a print by projecting an image of a negative onto a piece of photosensitive paper. During the exposure, the darkroom technician can reduce the amount of light falling onto the paper by placing some object (often a disk shape of cardboard or metal impaled on a piece of wire) in the light path to *dodge* part of the image. The worker can *burn* other parts of an image by exposing only a small portion through an opening, such as the fingers in a cupped pair of hands or a piece of cardboard with a hole. The Dodge and Burn tools in Elements adopt their icons from those analog tools used in the darkroom.

However, the digital counterparts are a great deal more flexible and precise. For example, the worker in a darkroom varies the size of the dodging or burning tool by moving it up or down in the light path. Unfortunately, the closer the real-world tool gets to the paper, the sharper it appears, forcing the darkroom worker to move the tool more rapidly and frequently to blur the edges of the effects. With the Elements Dodge and Burn tools, you can specify the size of the tool and its softness by selecting one of the many brush tips available.

You can also limit the correction to a specific tonal range in your image — shadows, midtones, or highlights. You can adjust the degree of lightening and darkening applied by specifying an exposure percentage, too.

The Dodge (used to lighten) and Burn (used to darken) tools can be very effective, but you can't add detail that isn't there. Keep the following in mind:

 When you lighten very dark shadows that contain little detail, you end up with grayish shadows.

 Darkening very light areas that are completely washed out doesn't make your image look very good, either. You'll end up with white patches.

In either case, you want to use the Dodge and Burn tools in moderation and work only with small areas. To dodge or burn a portion of an image, just follow these steps:

1. **In the Editor, in Edit Full mode, open an image with under- or over-exposed areas and select the Dodge or Burn tool from the Tools panel.**

 Press the O key to choose the tool or press Shift+O to cycle through the available tools until the one you want is active.

2. **In the Options bar, select a brush from the Brush Preset Picker drop-down panel and also adjust the brush size, if necessary.**

 Larger, softer brushes spread the dodging-and-burning effect over a larger area, making blending with the surrounding area easier, creating a more realistic, unretouched appearance.

3. **In the Options bar, under the Range drop-down list, select Shadows, Midtones, or Highlights.**

 Select Shadows to lighten or darken detail in the darker areas of your image. Choose Midtones to adjust the tones of average darkness. And select Highlights to make the brightest areas even lighter or darker.

 In Figure 1-20, the original image had mostly dark areas, so we dodged the shadows. Note the increased detail in the eyes, teeth, and hair. We also gave a couple swipes to the highlight areas with the Burn tool.

Figure 1-20: The Dodge and Burn tools are effective when touching up smaller dark and light areas.

Book VIII
Chapter 1

Quick Image Makeovers

4. **In the Options bar, select the amount of correction you want to apply with each stroke by using the Exposure slider or text box.**

Exposure is similar to the Opacity setting that you use with the regular Brush tool. Start with a lower percentage to better control the amount of darkening or lightening. High exposure values can overcorrect and produce unnatural-looking, obviously dodged or burned areas in your images. (We used a setting of 10 percent.)

5. **Drag or "paint" over the areas you want to lighten or darken, gradually building up the desired effect.**

Note that you can make a selection prior to your dragging to make certain that the adjustment is applied only to that specific area.

6. **If you go too far, press Ctrl+Z (⌘+Z on the Mac) to reverse your most recent stroke.**

7. **When you finish, choose File⇨Save to store the image.**

Turning Color Up or Down with the Sponge Tool

The Sponge tool soaks up or squeezes out color. It can reduce the richness or intensity (or saturation) of a color in applied areas. It can also perform the reverse, giving a specific area richer, more vibrant colors.

Surprisingly, the Sponge tool also works in grayscale mode by darkening or lightening the pixels. Unlike the Hue/Saturation command (under Enhance⇨Adjust Color), which works only on layers or selections, you can use the Sponge tool on any area that you can paint with a brush.

You can use the Sponge tool on an image in subtle ways to reduce the saturation in selected areas for an interesting effect. For example, you may have an object that's the center of attention in your picture simply because the colors are very bright. The Sponge tool lets you reduce the color saturation of that area (and only that area) to allow the other sections of your image to become the focal point. You can also use the Sponge tool to make an artistic statement: You could reduce or increase the saturation of a single person in a group shot to give that person more attention (perhaps as being more colorful than the rest).

To use the Sponge tool, just follow these steps:

1. **In the Editor, in Edit Full mode, open an image and select the Sponge tool from the Tools panel.**

Press the O key to choose the Sponge if it's active, or press Shift+O to cycle through the tools until the Sponge tool is active.

2. **In the Options bar, select a brush from the Brushes Presets drop-down panel.**

 Use large, soft brushes to saturate/desaturate a larger area.

 Smaller brushes are useful mostly to change the saturation of a specific small object in an image.

3. **In the Options bar, select either Desaturate (reduce saturation) or Saturate (increase saturation) from the Mode drop-down list.**

4. **In the Options bar, select a *flow rate* (that is, the speed with which the saturation/desaturation effect builds while you brush) with the Flow slider or text box.**

5. **Paint carefully over the areas you want to saturate or desaturate with color.**

 In Figure 1-21, we saturated the shower cap lady to make her more of a focal point and desaturated the other performers and the background.

Purestock

Figure 1-21: The Sponge tool saturates (increases color intensity) and desaturates (decreases color intensity).

Smoothing with the Smudge Tool

The Smudge tool performs a kind of warping effect by pushing your pixels around as if they consisted of wet paint, using the color that's under the cursor when you start to stroke. However, don't view the Smudge tool as a simple distortion tool that produces only comical effects. We use it on tiny

areas of an image to soften the edges of objects in a way that often looks more natural than when we use the Blur tool. The Smudge tool can also be used to create a soft, almost-painted look, as shown in Figure 1-22. Just don't get too carried away, or you may obliterate detail that you want to preserve.

Figure 1-22: The Smudge tool can give your objects a soft, painted look.

Smudged areas may be obvious because of their smooth appearance. Adding a little texture by using the Noise filter after you smudge is often a good idea if you want to blend a smudged section in with its surroundings. You can find tips on applying the Noise filter in Book VII, Chapter 1.

To apply the Smudge tool, just follow these steps:

1. **In the Editor, in Edit Full mode, open the image and select the Smudge tool from the Tools panel.**

 Press Shift+R to cycle through the Smudge, Blur, and Sharpen tools.

2. **In the Options bar, select a brush from the Brushes Presets drop-down panel.**

 Use a small brush for smudging tiny areas, such as edges. Larger brushes produce drastic effects, so use them with care.

3. **In the Options bar, select a blending mode from the Mode pop-up menu.**

4. **In the Options bar, select the strength of the smudging effect with the Strength slider or text box.**

 Low values produce a lighter effect; high values really push your pixels around.

5. **If your image has multiple layers, select the Sample All Layers option to make Elements use pixels from all visible layers when it produces the effect.**

 The smudge still appears only on the active layer, but the look is a bit different depending on the contents of the underlying layers.

6. **Use the Finger Painting option to begin the smudge by using the foreground color.**

 You can get some interesting effects with this option. Rather than use the color under your cursor, this option smears your foreground color at the start of each stroke.

 You can switch the Smudge tool into Finger Painting mode temporarily by holding down the Alt key (the Option key on the Mac) while you drag. Release Alt (Option) to go back to Normal mode.

7. **Paint over the areas you want to smudge.**

 Pay attention to your strokes because this tool can radically change your image. If you don't like the results, press Ctrl+Z (⌘+Z on the Mac) to undo the changes and then lower the Strength percentage (discussed in Step 4) even more.

 This tool can be a little destructive. If you're looking to preserve reality, use it with restraint. If you want to get wild, go crazy.

8. **When you finish, choose File⇨Save to store your image.**

Softening with the Blur Tool

The Blur tool can be used for both repair and more creative tasks. Adding a little blur here and there can save an image with a few defects. Blurring can also be used for artistic effect — say, to add a little motion to a soccer ball frozen in time by a too-fast shutter speed. You can also blur portions of your image to emphasize and focus on a particular element, as shown in Figure 1-23, where we blurred the water and the girl's body a bit to draw attention to her face. The Blur tool makes it easy to paint your blur effects exactly where you want them. This tool works by decreasing the contrast among adjacent pixels in the painted area.

The mechanics of using the Blur tool and several of its options are similar to those of the Smudge tool. Just follow these steps:

1. **In the Editor, in Edit Full mode, open an image and select the Blur tool from the Tools panel.**

Corbis Digital Stock

Figure 1-23: Use the Blur tool to soften a rough edge or emphasize a focal point.

2. **In the Options bar, select a brush from the Brushes Presets drop-down panel.**

 Use a small brush for applying small areas of blur.

 Use larger brushes with caution. For example, if your goal is to blur the entire background to make a foreground object appear sharper in comparison, it's better to make a selection and apply the Blur filter, as described in Book VII, Chapter 1.

3. **In the Options bar, select a blending mode from the Mode pop-up menu.**

4. **In the Options bar, select the strength of the blurring effect with the Strength slider or text box.**

5. **If your image has multiple layers, select the Sample All Layers option to make Elements use pixels from all visible layers when it produces the effect.**

 Selecting this option can produce a smoother blur when you merge the layers later. See Book VI for more info on layers.

6. **Paint over the areas you want to blur.**

7. **When you finish, choose File⇨Save to store your image.**

Focusing with the Sharpen Tool

In theory, the Sharpen tool is nothing more than the Blur tool in reverse — instead of decreasing contrast among pixels, the Sharpen tool increases the

contrast. In practice, however, use this tool with a bit more care than the Blur tool. Whereas blurred areas tend to fade from a viewer's notice (at least, in terms of how his or her eyes perceive them), sharpened areas of an image jump out at people. Even a small area that's been oversharpened can quickly lead to overly grainy and noisy images.

You can often successfully sharpen small areas with the Sharpen tool. Sometimes, the eyes in a portrait can benefit from a little sharpening, as shown in Figure 1-24. Or you might want to sharpen an area to make it stand out more distinctly against a slightly blurred background.

Follow these simple steps to use the Sharpen tool:

 1. In the Editor, in Edit Full mode, open an image and select the Sharpen tool from the Tools panel.

2. In the Options bar, select a brush from the Brushes Presets drop-down panel.

Use a small brush for applying small areas of sharpening.

Figure 1-24: Use the Sharpen tool sparingly and in small areas, such as in the eyes of this portrait.

3. In the Options bar, select a blending mode from the Mode pop-up menu.

4. In the Options bar, select the strength of the sharpening effect with the Strength slider or text box.

 Using a fairly low value (say, 25 percent or less) is a good idea because you can build up sharpness slowly, being careful not to overdo it.

You know you've gone too far with the sharpness when the pixels start to look noisy and grainy.

5. If your image has multiple layers, select the Sample All Layers option to make Elements use pixels from all visible layers when it produces the effect.

6. Paint over the areas you want to sharpen.

7. When you finish, choose File⇨Save to store your image.

 Sharpening increases contrast, so be careful when using the Sharpen tool if you plan to also adjust the Levels or Curves controls. Any change that increases contrast in the whole image also boosts the contrast of an area you've sharpened.

The Unsharp Mask and Smart Sharpen filters offer more options and better overall control, so unless you really need to use the sharpening effect, you're usually better off using a filter. (Book VII, Chapter 1, has more on filters in general.)

Putting It Together

Fixing a Photo

Unless you're a highly skilled photographer, you probably have a few photos that require a number of digital fixes. Certainly, we both do. Although it may seem like fixing them is too much trouble or will take too long, you'll find how easy it is after you practice the techniques a few times. After a while, you may even get into the habit of running through your personal quick-editing workflow before you organize and archive your images in the Organizer (or Adobe Bridge on the Mac). If you have more time to burn, you can also add a few artistic touches to further enhance those shots. That way when you get the urge to share those photos, they're just an e-mail or print away.

Note that most of the details for executing these steps are described in this chapter. When they aren't, we give you the book and chapter where you can find further explanations. If these steps are too tedious for you, you can always follow the Edit Quick mode route we described earlier in the section, "Editing with Edit Quick Mode."

1. **In the Editor, in Edit Full mode, open any image in need of repair.**

The image of our woman is in bad shape — horrible contrast, color, soft focus, scratches, and in need of some healing, as shown in the figure.

2. **Crop your image using the Crop tool on the Tools panel.**

PhotoSpin

3. **If you need to rotate the image, choose Image⇨Rotate and select your desired rotation amount.**

4. **To allow for maximum flexibility in editing, convert your background to a layer by double-clicking** *Background* **in the Layers panel. Click OK in the New Layer dialog box.**

 For details on working with layers, see Book VI.

5. **Adjust the contrast of your image, if needed. Try Enhance⇨Auto Contrast. If that doesn't work well, undo it with Ctrl+Z (⌘+Z on the Mac) and choose Enhance⇨ Adjust Lighting⇨Shadows and Highlights or Levels.**

 Make sure you have good tones in the shadows (dark areas), midtones (middle-toned areas), and highlights (light areas). Also ensure that you can see details in all the tonal ranges, as shown in the figure. For details on using the Shadows and Highlights and Levels commands, see Book VIII, Chapter 2. For our woman, we broke out the big guns — Levels.

 PhotoSpin

6. **Adjust the color of your image, if needed. If you didn't use an auto fix in Step 6, you could try the Auto Color command under the Enhance submenu. Or choose Enhance⇨Adjust Color and select one of the color-adjustment commands described in Book VIII, Chapter 2.**

 If you need to adjust the skin tones of your people, you can try the Adjust Skin Tones command. We recommend using the Adjust Color Curves command for overall color adjustment, as we did for our woman in the figure. Usually working with this curve will do the trick, no matter what your color issues are.

 Note that you can fix just selected portions of your image. Make a selection first and then apply the adjustment. For details on making selections, see Book IV, Chapter 1.

Book VIII
Chapter 1

Quick Image Makeovers

continued

continued

PhotoSpin

7. **If you have any people or animals with nasty red eye, use the Red Eye Removal or Color Replacement tool.**

 Remember to use the Zoom and Hand tools to magnify and navigate around your image, as needed.

8. **If you need to whiten the teeth of any of your people, choose Edit Quick from the Edit tab in the top right and use the Whiten Teeth tool in the Tools panel.**

 We whitened the teeth of our woman.

 Choose Edit Full from the Edit tab to return to Edit Full mode.

PhotoSpin

9. **Perform any additional repair or healing tasks by using the Healing Brush, Spot Healing Brush, and Clone Stamp tools.**

We fixed all the scratches in the background using the Clone Stamp tool. Then we gave our woman a "refresher" by smoothing out the wrinkles using the Healing Brush tool, as shown in the figure.

10. **Sharpen your image. You can return to Edit Quick mode and either click the Auto button or drag the Sharpen slider under the Sharpen panel. Or, for more precise control, in Edit Full mode, choose Enhance⇨Adjust Sharpness, as described in Book VIII, Chapter 2.**

This fix should always be the last adjustment you make on your image. You want to make sure that all your contrast, color, and flaws are fixed before sharpening. The reason is that the sharpening process increases contrast, so you don't want to exacerbate any problems that may exist. Our "fixed" woman is shown in the final figure.

PhotoSpin

Chapter 2: Correcting Lighting, Color, and Clarity

In This Chapter

↙ **Understanding the Histogram panel**

↙ **Adjusting lighting, color, and clarity**

↙ **Working with the Smart Brush tools**

*I*f you've tried the quick automatic fixes on your photos but they didn't correct them to your satisfaction, this chapter should be of some help. Fortunately, Elements offers multiple ways and multiple levels of correcting and enhancing your images. If an auto fix doesn't work, elevate to a manual fix. Chances are that if you can't find the tools to correct and repair your images in Elements, those images are probably beyond salvaging.

Using this chapter and the information provided in Chapter 1 of this mini-book as your jumping-off points, try to employ some kind of logical work-flow when you tackle the correction and repair of your images. Personally, we're partial to the following series of steps:

1. **Crop, straighten, and resize your images, if necessary.**

2. **After you have the images in their proper physical state, correct the lighting and establish good tonal range for your shadows, highlights, and midtones in order to display the greatest detail possible.**

 Often, just correcting the lighting solves minor color problems. If not, move on to adjusting the color balance.

3. **Eliminate any colorcasts and adjust the saturation, if necessary.**

4. **Grab the retouching tools, such as the healing tools and filters, to retouch any flaws.**

5. **Sharpen your image if you feel that it could use a boost in clarity and sharpness.**

6. **Apply any enhancements or special effects, if desired.**

 By following these steps, in this order, you should be able to get all your images in shape to print, post, and share with family and friends.

Understanding the Histogram Panel

One of the first things you want to do before you make any color or tonal adjustments to your image is to take a good look at the quality and distribution of the tones throughout your image. We don't mean just eyeballing the composite image on your screen. We're talking about getting inside your image and looking at its guts with the Histogram panel — and keeping it onscreen so you can see its constant feedback on your image adjustments.

Figure 2-1: The Histogram panel displays how pixels are distributed at each of the 256 brightness levels.

A *histogram* displays the tonal range of an image, as shown in Figure 2-1. It shows how the pixels are distributed by graphing the number of pixels at each of the 256 brightness levels in an image. On this graph, pixels with the same brightness level are stacked in bars along a vertical axis. The higher the line from this axis, the greater the number of pixels at that brightness level. You can view the distribution for the entire image, a selected layer, or an adjustment composite (described in the following section).

From this graph, you can determine whether the image contains enough detail in the shadow, midtone, and highlight areas. This information helps you determine what image adjustments you may need to make. The following steps walk you through the basics of using the panel and understanding the information you find there:

1. **Choose Window⇨Histogram to bring up the panel.**

2. **Choose your desired source of the histogram's display from the Source drop-down list:**

 • *Entire Image:* Displays a histogram of the entire image.

 • *Selected Layer:* Displays a histogram of just the selected layers in the Layers panel.

 • *Adjustment Composite:* Displays a histogram of a selected adjustment layer and all the layers below it.

3. **Choose to view isolated portions of your image by choosing an option from the Channel drop-down list:**

 • *RGB:* Displays a composite image of all color channels — red, green, and blue.

- *Red, Green and Blue:* Displays the histogram of each individual color channel.

- *Luminosity:* Displays the luminance, or intensity, of the RGB composite image.

- *Colors:* Displays the composite RGB histogram by color. Red, green, and blue represent the pixels in each of those channels. Gray represents the area where all three channels overlap.

4. **Examine the tonal range in the histogram.**

 An image with good tonal range displays pixels in all areas. An image with poor tonal range has gaps in the histogram, as shown in Figure 2-2.

 The rest of this chapter explains ways you can correct contrast and color problems that you find.

Overexposed Correct Exposure Underexposed

Figure 2-2: Images with poor tonal range have noticeable gaps in the histogram.

5. **(Optional) If you're into numbers, check the statistics to evaluate your image, as well:**

 Drag your cursor within the histogram to see the statistics about a range of values. Or position the cursor within a specific area of the histogram you're interested in.

 Some of these statistics, such as Standard Deviation, may be for those who live in the mathematical land of Statistics. But you may be able to get some useful information from the other statistics that can help you in your image-adjusting tasks. Here's a brief explanation of each statistic:

 - *Mean:* Average intensity value

 - *Standard Deviation:* How much the intensity values vary

 - *Median:* Middle value of the intensity value range

 - *Pixels:* Total number of pixels used to represent the histogram

 - *Level:* Intensity level

 - *Count:* The total number of pixels corresponding to that intensity level

 - *Percentile:* The number of cumulative pixels (in percentages) at or below that level, from 0% (left) to 100% (right)

 - *Cache Level:* The current level of image cache used to calculate the histogram. For more info on cache, see Book I, Chapter 4.

Adjusting Lighting

Elements has several simple, manual tools you can use to fix lighting if the Auto tools (that we describe in Book VIII, Chapter 1) don't cut the mustard. The manual tools offer more control for adjusting overall contrast, as well as bringing out details in shadow, midtones, and highlight areas of your images. Note that all lighting adjustments can be found in both Edit Full and Edit Quick modes.

Fixing lighting with Shadows/Highlights

The Shadows/Highlights command offers a quick-and-easy method of correcting over- and underexposed areas. This feature works especially well with images shot in bright, overhead light or in light coming from the back (backlit). These images usually suffer from having the subject partially or completely surrounded in shadows, such as the original image (left) in Figure 2-3.

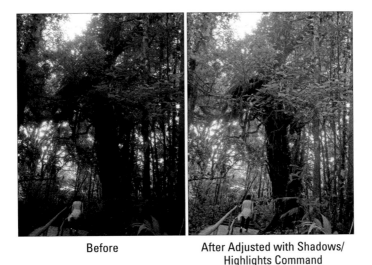

Before | After Adjusted with Shadows/
Highlights Command

Figure 2-3: Correct the lighting in your images with the Shadows/
Highlights command.

To use the Shadows/Highlights command, follow these steps:

1. **In Edit Full or Edit Quick mode, choose Enhance⇨Adjust Lighting⇨ Shadows/Highlights and make sure the Preview check box is selected.**

 When the Shadows/Highlights dialog box appears, the default correction is applied automatically in your preview.

2. **If the default adjustment doesn't fix the problem, move the sliders (or enter a value) to adjust the amount of correction for your shadows (dark areas), highlights (light areas), and midtones (middle-toned areas).**

 Try to reveal more detail in the dark and light areas of your image. If, after you do so, your image still looks as if it needs more correction, add or delete contrast in your midtone areas.

3. **Click OK to apply the adjustment and close the dialog box.**

 If you want to start over, press the Alt (Option on the Mac) key and click the Reset button (previously the Cancel button).

Using Brightness/Contrast

Despite its very descriptive name, the Brightness/Contrast command doesn't do a great job of either brightening (making an image darker or lighter) or adjusting contrast. Initially, users tend to be drawn to this command because

of its logical name and ease of use. But after users realize its limitations, they move on to better tools with more controls, such as Shadows/Highlights and Levels.

The problem with the Brightness/Contrast command is that it applies the adjustment equally to all areas of the image. For example, you may have a photo that has some highlights that need darkening, but all the midtones and shadows are okay. The Brightness slider isn't adept enough to recognize that, so when you start to darken the highlights in your image, the midtones and shadows also become darker. To compensate for the unwanted darkening, you try to adjust the Contrast, which doesn't fix the problem.

The moral is, if you want to use the Brightness/Contrast command, select only the areas that need the correction, as shown in Figure 2-4. (For more on selections, see Book IV, Chapters 1 and 2.) After you make your selection, choose Enhance⇨Adjust Lighting⇨Brightness/Contrast.

You can also find the Brightness/Contrast command in Guided mode.

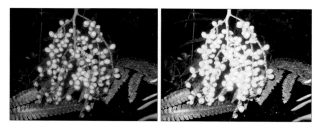

Figure 2-4: The Brightness/Contrast command is best reserved for correcting selected areas (left) rather than the entire image (right).

Nailing proper contrast with Levels

If you want the real deal when it comes to correcting the brightness and contrast (and even the color) in your image, look no further than the Levels command. Granted, the dialog box is a tad more complex than those for the other lighting and color-adjustment commands, but when you understand how it works, the payoff is well worth it.

You can get a taste of what Levels can do by using Auto Levels, explained in Book VIII, Chapter 1. However, the Levels command offers much more control. And, unlike the rudimentary Brightness/Contrast command, Levels enables you to darken or lighten 256 different tones. Keep in mind that Levels can be used on your entire image, a single layer, or a selected area. You can also

apply the Levels command by using an adjustment layer, a recommended method, as we describe in Book VI, Chapter 1.

If you're serious about image editing, the Levels command is one tool you want to master. Here's how it works:

1. **In Edit Full or Edit Quick mode, choose Enhance⇨Adjust Lighting⇨ Levels.**

 We recommend using Edit Full mode for this command because you have access to the Info panel needed in Step 2.

 The Levels dialog box appears, displaying its own histogram. This graph displays how the pixels of the image are distributed at each of the 256 available brightness levels. Shadows are shown on the left side of the histogram, midtones are in the middle, and highlights are on the right. For details on histograms, see the first section of this chapter.

 Although you generally make changes to the entire document by using the RGB channel, you can apply changes to any one of an image's component color channels by selecting the specific channel in the Channel pop-up menu. You can also make adjustments to just selected areas, which can be helpful when one area of your image needs adjusting and others don't.

2. **In Edit Full mode, choose Window⇨Info to open the Info panel.**

3. **Set the black and white points manually by using the eyedroppers in the dialog box; first select the White Eyedropper tool and then move the cursor over the image.**

4. **Look at the Info panel, try to find the lightest white in the image, and then select that point by clicking it.**

 The lightest white has the highest RGB values.

5. **Repeat Steps 3 and 4, using the Black Eyedropper tool and trying to find the darkest black in the image.**

 The darkest black has the lowest RGB values.

 When you set the pure black and pure white points, the remaining pixels are redistributed between those two points.

 You can also reset the white and black points by moving the position of the white and black triangles on the input sliders (just below the histogram). Or, you can enter values in the Input Levels boxes. The three boxes represent the black, gray, and white triangles, respectively. Use the numbers 0 to 255 in the white and black boxes.

6. **Use the Gray Eyedropper tool to remove any colorcasts by selecting a neutral gray portion of your image, one in which the Info panel shows equal values of red, green, and blue.**

 Note that if your image is grayscale, you can't use the Gray Eyedropper tool.

 If you're not sure where there's a neutral gray, you can also remove a colorcast by choosing a color channel from the Channel pop-up menu and doing one of the following:

 • Choose the Red channel and drag the midtone slider to the right to add cyan or to the left to add red.

 • Choose the Green channel and drag the midtone slider to the right to add magenta or to the left to add green.

 • Choose the Blue channel and drag the midtone slider to the right to add yellow or to the left to add blue.

7. **If your image has too much contrast, adjust the output sliders at the bottom of the Levels dialog box.**

 Moving the black triangle to the right reduces the contrast in the shadows and lightens the image. Moving the white triangle to the left reduces the contrast in the highlights and darkens the image.

8. **Adjust the midtones (or *gamma values*) with the gray triangle input slider.**

 The default value for gamma is 1.0. Drag the triangle to the left to lighten midtones and drag to the right to darken them. You can also enter a value.

9. **Click OK to apply your settings and close the dialog box.**

 The contrast in your images should be improved, as shown in Figure 2-5.

When you click the Auto button, Elements applies the same adjustments as the Auto Levels command, as we explain in Book VIII, Chapter 1. Note the changes and subsequent pixel redistribution shown in the histogram after you click this button.

Figure 2-5: Improve the contrast of an image with the Levels command.

Adjusting Color

Getting the color you want sometimes seems about as attainable as finding a pot of gold at the end of a rainbow. Sometimes, an unexpected *colorcast* (a shift in color) can be avoided when photographing, for example, by using (or not using, in some cases) a flash or lens filter. After the fact, you can usually do a decent job of correcting the color with one of the many Elements adjustments. Occasionally, you may want to change the color of your image to create a certain special effect. Conversely, you also may want to strip out most of the color from your image to create a vintage feel. Remember that all these color adjustments can be applied to your entire image, a single layer, or just a selection. Whatever your color needs, they'll no doubt be met in Elements.

All color adjustments can be found in either Edit Full or Edit Quick mode except for Defringe Layers, which is available only in Edit Full mode.

If you shoot your photos in the Camera Raw file format, you can open and fix your files in the Camera Raw dialog box. Remember that Camera Raw files haven't been processed by your camera. You're in total control of the color and the exposure. For more on Camera Raw, see Book III, Chapter 3.

Removing colorcasts automatically

If you ever took a photo in an office or classroom and got a nasty green tint in your image, it was most likely caused by the overhead fluorescent lighting. To eliminate this green tint, or *colorcast,* you can apply the Remove Color Cast command. This feature is designed to adjust the image's overall color and remove the cast.

Follow these short steps to correct your image:

1. **Choose Enhance⇨Adjust Color⇨Remove Color Cast in either Edit Full or Edit Quick mode.**

 The Remove Color Cast dialog box appears. Move the dialog box to better view your image. Note that this command is also available in Guided mode.

2. **Click an area in your photo that should be white, black, or neutral gray, as shown in Figure 2-6.**

 The colors in the image are adjusted according to the color you choose. Which color should you choose? The answer depends on the subject matter of your image. Feel free to experiment. Your adjustment is merely a preview at this point and isn't applied until you click OK. If you goof up, click the Reset button, and your image reverts to its unadjusted state.

3. **If you're satisfied with the adjustment, click OK to accept it and close the dialog box.**

Corbis Digital Stock

Figure 2-6: Get rid of nasty color shifts with the Remove Color Cast command.

If the Remove Color Cast command doesn't fix the problem, try using the Color Variations command or applying a photo filter (as we describe in the section "Adjusting color temperature with photo filters," later in this chapter). For example, if your photo has too much green, try applying a magenta filter.

Adjusting with Hue/Saturation

The Hue/Saturation command enables you to adjust the colors in your image based on their hue, saturation, and lightness. *Hue* is the color in your image. *Saturation* is the intensity, or richness, of that color. And *lightness* controls the brightness value.

Follow these steps to adjust color by using the Hue/Saturation command:

1. **In either Edit Full or Edit Quick mode, choose Enhance⇨Adjust Color⇨ Adjust Hue/Saturation.**

 The Hue/Saturation dialog box appears. Be sure to select the Preview check box so that you can view your adjustments. Note that this command is also available in Guided mode.

2. **Select all the colors (Master) from the dialog box's Edit drop-down list or choose one color to adjust.**

3. **Drag the slider for one or more of the following attributes to adjust the colors as described:**

 - *Hue:* Shifts all the colors clockwise (drag right) or counterclockwise (drag left) around the color wheel.

 - *Saturation:* Increases (drag right) or decreases (drag left) the richness of the colors. Note that dragging all the way to the left gives you the appearance of a grayscale image.

- *Lightness:* Increases the brightness values by adding white (drag right) or decreases the brightness values by adding black (drag left).

The top color ramp at the bottom of the dialog box represents the colors in their order on the color wheel before you make any changes. The lower color bar displays the colors after you make your adjustments.

When you select an individual color to adjust, sliders appear between the color bars so that you can define the range of color to be adjusted. You can select, add, or subtract colors from the range by choosing one of the Eyedropper tools and clicking in the image.

The Hue/Saturation dialog box also lets you colorize images, a useful option for creating sepia-colored images.

4. **(Optional) Check the Colorize option to change the colors in your image to a new, single color. Drag the Hue slider to change the color to the desired hue.**

The pure white and black pixels remain unchanged, and the intermediate gray pixels are colorized.

Use the Hue/Saturation command with the Colorize option to create tinted photos, such as the one shown in Figure 2-7. You can also make selections in a grayscale image and apply a different tint to each selection. This can be especially fun with portraits. Tinted images can create a vintage or moody feel and can greatly improve mediocre photos.

Purestock

Figure 2-7: Adjust the color, intensity, or brightness of your image with the Hue/Saturation command.

Eliminating color with Remove Color

Despite all the talk in this chapter about color, we realize that there may be times when you don't want *any* color. With the Remove Color command, you can eliminate all the color from an image, layer, or selection. In Figure 2-8, we selected the background and applied the Remove Color command. To use this one-step command, simply choose Enhance⬦Adjust Color⬦Remove Color.

Purestock

Figure 2-8: Eliminate color with the Remove Color command.

Sometimes, stripping away color with this command can leave your image *flat,* or low in contrast. If this is the case, adjust the contrast by using one of many lighting fixes in Elements, such as Auto Levels, Auto Contrast, or Levels.

The Convert to Black and White command (under the Enhance menu) enables you to convert a selection, a layer, or an entire image to grayscale. But, rather than just arbitrarily stripping color (as the Remove Color command does), the Convert to Black and White command enables you to select a conversion method by first choosing an image style. To further refine the results, you can add or subtract colors (red, green, or blue) or contrast by moving the Intensity sliders until your grayscale image looks the way you want. Note that you aren't really adding color; you're simply altering the amount of data in the color channels.

Switching colors with Replace Color

The Replace Color command enables you to replace designated colors in an image with other colors. You first select the colors you want to replace by

creating a *mask,* which is a selection made by designating white (selected), black (unselected), and gray (partially selected) areas. (See Book VI, Chapter 4 for more details on working with masks.) You can then adjust the hue and/or saturation of those selected colors.

Follow these steps to replace colors with others:

1. **In Edit Quick or Edit Full mode, choose Enhance⇨Adjust Color⇨ Replace Color.**

 The Replace Color dialog box appears. Make sure to select the Preview check box.

2. **Choose either Selection or Image:**
 - *Selection:* Shows the mask in the Preview area. The deselected areas are black, partially selected areas are gray, and selected areas are white.
 - *Image:* Shows the actual image in the Preview area.

3. **Click the colors you want to select in either the image or the Preview area.**

4. **Shift-click or use the plus sign (+) Eyedropper tool to add more colors.**

5. **Press the Alt (Option on the Mac) key or use the minus sign (–) Eyedropper tool to delete colors.**

6. **To add colors similar to the ones you select, use the Fuzziness slider to fine-tune your selection, adding or deleting from the selection based on the Fuzziness value.**

 To further fine-tune your selection, try using the new Localized Color Clusters option. This option lets you select multiple color clusters and can assist in getting a cleaner, more precise selection, especially when you're trying to select more than one color.

7. **Move the Hue and/or Saturation sliders to change the color or color richness, respectively. Move the Lightness slider to lighten or darken the image.**

 Go easy with the Lightness slider. You can reduce the tonal range too much and end up with a mess.

8. **View the result in the Image window.**

9. **Click OK to apply the settings and close the dialog box.**

 Figure 2-9 shows how we substituted the color of our tulips to change them from red to purple.

Figure 2-9: The Replace Color command enables you to replace one color with another.

Correcting with Color Curves

The most sophisticated of the color correctors is the Color Curves command. This adjustment attempts to improve the tonal range in color images by making adjustments to highlights, shadows, and midtones in each color channel. Try using this command on images in which the foreground elements appear overly dark due to backlighting. Conversely, the adjustment is also designed to correct images that appear overexposed and washed out.

Here's how to use this adjustment on a selection, a layer, or an entire image:

1. **In Edit Quick or Edit Full mode, choose Enhance⇨Adjust Color⇨ Adjust Color Curves.**

 The Adjust Color Curves dialog box appears. Make sure to select the Preview check box. Move the dialog box to the side so that you can view the Image window while making adjustments.

 Various curve adjustments appear in the Select a Style area of the dialog box.

2. **Select a style to make your desired adjustments while viewing your image in the After window.**

3. **If you need more precision, use the Adjust Highlights, Midtone Brightness, Midtone Contrast, and Adjust Shadows sliders, as shown in Figure 2-10.**

The graph on the right represents the distribution of tones in your image. When you first access the Adjust Color Curves dialog box, the tonal range of your image is represented by a straight line. While you drag the sliders, the straight line is altered, and the tonal range is adjusted accordingly.

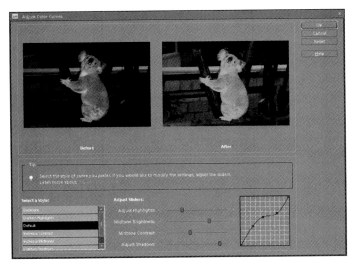

Figure 2-10: The Color Curves command provides basic and advanced controls.

4. **Click OK when you've adjusted the image satisfactorily.**

5. **To start over, click the Reset button.**

See Figure 2-11 for before-and-after images.

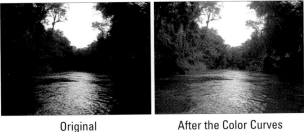

Original

After the Color Curves adjustment

Figure 2-11: Color Curves improves tonal range in color images.

Adjusting skin tones

Sometimes, the family and friends in your photos appear nauseated (green), sunburned (red), frigid (blue), or have taken on some other non-flesh-colored tone. To fix that problem, Elements provides a command that's designed to adjust the overall color in the image and get skin tones back to more natural and attractive shades.

Here's how to fix those skin tones:

1. **Open your image in Edit Quick or Edit Full mode, select the Preview check box, and do one or both of the following:**

 • *Select the layer that needs to be adjusted.* If you don't have any layers, your entire image is adjusted.

 • *Select the desired areas of skin that need to be adjusted.* Only the selected areas are adjusted. This is recommended if you're satisfied with the color of your other elements and just want to fix the skin tones. For more on selection techniques, see Book IV, Chapter 1.

2. **Choose Enhance⇨Adjust Color⇨Adjust Color for Skin Tone.**

 The Adjust Color for Skin Tone dialog box appears. This command can also be found in Guided mode.

3. **In the Image window, click the portion of skin that needs to be corrected.**

 The command adjusts the color of the skin tone, as well as the color in the overall image, layer, or selection, depending on what you selected in Step 1.

4. **If you're unhappy with the results, click another area or adjust the Skin and Ambient Light sliders:**

 • *Tan:* Increases or decreases the amount of brown in the skin.

 • *Blush:* Increases or decreases the amount of red in the skin.

 • *Temperature:* Adjusts the overall color of the skin, making it warmer (right toward red) or cooler (left toward blue).

5. **When you're satisfied with the correction, click OK to apply the adjustment and close the dialog box.**

 Your improved skin appears, as shown in Figure 2-12.

 To start from square one, click the Reset button. And, of course, to bail out completely, click Cancel.

Purestock

Figure 2-12: Give your friends and family a complexion makeover with the Adjust Color for Skin Tone command.

Defringing layers

A surefire sign of a sloppily composited image is a selection with a fringe. Don't get us wrong, if the fringe is the kind that is hanging off of your '70s-era buckskin leather jacket, that's fine. You just don't want the fringe that consists of those background pixels surrounding the edges of your selections, as shown in Figure 2-13. Sometimes, when you make a selection, some of the background pixels are picked up in the process. These pixels are referred to as a *fringe* or *halo.* Luckily, the Defringe command replaces the color of the fringe pixels with the colors of neighboring pixels that don't contain the background color. In our example, we plucked the globe out of a white background and placed it on a black background. Some of the background pixels were included in our selection and appear as white fringe. When we apply the Defringe command, those white fringe pixels are changed to colors of nearby pixels, as shown in Figure 2-13.

Follow these steps to defringe your selection:

1. **In Edit Full mode only, copy and paste a selection onto a new or existing layer, or drag and drop a selection onto a new document.**

2. **Choose Enhance⇨Adjust Color⇨Defringe Layer.**

 The Defringe dialog box appears.

3. **Enter a value for the number of pixels that needs to be converted.**

 Try entering 1 or 2 first to see whether that fixes the fringe problem. If not, you may need to enter a slightly higher value.

4. **Click OK to accept the value and close the dialog box.**

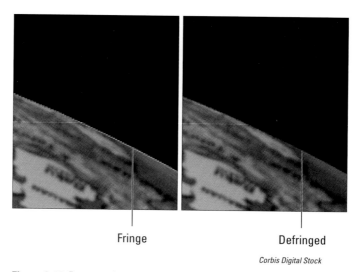

Fringe Defringed

Corbis Digital Stock

Figure 2-13: Remove the colored halo around your selections with the Defringe command.

Correcting with Color Variations

Although we give you several ways in this chapter to eliminate colorcasts in an image, here's one more. The Variations command has been around for years and is largely unchanged. That's probably because it's one of those rare features that's easy to use, easy to understand, and is actually effective. The command enables you to make corrections by visually comparing thumbnails of color variations of your image. You might use this command when you're not quite sure what's wrong with the color or what kind of colorcast your image has.

Here's how to use the Color Variations command:

1. **Choose Enhance➪Adjust Color➪Color Variations in Edit Quick or Edit Full mode.**

 The Color Variations dialog box appears, displaying a preview of your original image (before) and the corrected image (after), as shown in Figure 2-14.

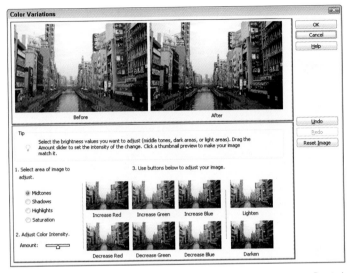

Figure 2-14: Color Variations enables you to color-correct your images by comparing thumbnails.

2. **Select your desired tonal range or color richness (if you're unsure which range to select, start with the Midtones):**

 - *Shadows, Midtones, or Highlights:* Adjusts the dark, middle, or light areas in the image, respectively.

 - *Saturation:* Adjusts the color intensity or richness, making colors more intense *(saturated)* or less intense *(desaturated).* If your image is faded from time, be sure to increase the saturation after you correct any colorcast issues.

 Usually, just correcting the midtones is enough to improve your image's color. But if that doesn't do the trick, try adjusting the shadows and highlights as well.

3. **Specify how much adjustment you want with the Adjust Color Intensity slider.**

 Drag left to decrease the amount of adjustment and drag right to increase the amount.

4. **If you selected Midtones, Shadows, or Highlights in Step 2, adjust the color by clicking the various Increase or Decrease *Color* buttons.**

 Click more than once if your initial application wasn't sufficient to correct the problem.

Be sure to keep an eye on the After thumbnail, which reflects your corrections while you make them.

5. **Click the Darken or Lighten buttons to make the colors a little darker or lighter, respectively.**

6. **If you selected Saturation in Step 2, click the Less Saturation or More Saturation buttons.**

7. **If you make a mistake, click the Undo button.**

The Color Variations dialog box supports multiple levels of undo. If you totally mess up things, click the Reset Image button to start again. Keep in mind that you can't undo the Reset Image command after you click it. Click Cancel to abandon ship.

8. **To apply your color adjustments and close the dialog box, click OK.**

Try using the Color Variations command to correct those old, faded, green-tinted photos from back in the day. This feature enables you to easily correct the color and saturation of those memory-filled shots. Remember to either decrease the offending color or add the color that's the opposite of the colorcast in the image. If it's too green, add magenta and vice versa.

Adjusting color temperature with photo filters

Light has its own color temperature. A photo shot in a higher color temperature of light makes an image blue. An image shot in a lower color temperature makes a photo yellow. Photographers sometimes use colored glass filters in front of their camera lenses to adjust the color temperature of the light. They do this to warm up or cool down their photos, or just to add a hint of color for subtle special effects. You can, however, mimic this effect in Elements with the digital versions of these filters.

To apply the Photo Filter adjustment, follow these steps:

1. **In Edit Full mode, choose Filter⇨Adjustments⇨Photo Filter.**

The Photo Filter dialog box appears.

Note that you can also apply the photo filter to an individual layer by creating a photo-filter adjustment layer. For details on adjustment layers, see Book VI, Chapter 1.

2. **In the dialog box, select Filter to choose a preset filter from the drop-down list, or select Color to select your own filter color from the Color Picker.**

Here's a brief description of each of the preset filters:

• *Warming Filter (85), (81), and (LBA):* Adjust the white balance in an image to make the colors warmer or more yellow. Filter (81) is like (85) and (LBA), but it's best used for minor adjustments.

- *Cooling Filter (80), (82), and (LBB):* Also adjust the white balance that's shown, but instead of making the colors warmer, they make the colors cooler or bluer. Filter (82) is like (80) and (LBB), but it's designed for slight adjustments.

 - *Red, Orange, Yellow, and so on:* The various color filters adjust the hue, or color, of a photo. Choose a color filter to try to eliminate a colorcast or to apply a special effect.

3. **Adjust the Density option to specify the amount of color applied to your image.**

4. **Check Preserve Luminosity to prevent the photo filter from darkening your image.**

5. **Click OK to apply your filter and close the dialog box.**

 Figure 2-15 shows the image before and after the application of a photo filter.

A good way to minimize the need for color adjustments is to be sure to set your camera's white balance for your existing lighting conditions before shooting your photo.

Purestock

Figure 2-15: Photo filters adjust the color temperature of your image.

Mapping your colors

Elements provides some commands referred to as *color mappers,* which change the colors in your image by mapping them to other values. The color mappers are found in the Filter⇨Adjustments submenu. Figure 2-16 shows results of using these commands, which are also briefly described in the following sections.

Equalize

This mapper first locates the lightest and darkest pixels in the image and assigns them values of white and black. It then redistributes all the remaining pixels among the grayscale values. The exact effect depends on your individual image.

Equalize Gradient Map Invert

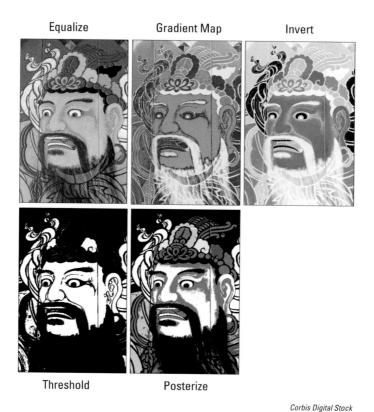

Threshold Posterize

Figure 2-16: Change the colors in your image by remapping them to other values.

Gradient Map

This command maps the tonal range of an image to the colors of your chosen gradient. For example, colors (such as orange, green, and purple) are mapped to the shadows, highlight, and midtone areas.

Invert

This command reverses all the colors in your image, creating a kind of negative. Black reverses to white, and colors convert to their complementary hues (blue goes to yellow, red goes to cyan, and so on).

Posterize

This command reduces the number of colors in your image. Choose a value between 2 and 255 colors. Lower values create an illustrative, poster-like look, and higher values produce a more photo-realistic image.

Threshold

Threshold makes your image black and white, with all pixels that are brighter than a value you specify represented as white, and all pixels that are darker than that value as black. You can change the threshold level to achieve different high-contrast effects.

The Threshold command can come in handy when you need to clean up scans of line art, such as hand-drawn sketches, people's signatures, pages from a book, or even sheet music. Often, when you scan things on paper, the slight color from the paper appears as a dull gray background in the scan. By applying the Threshold command, you can adjust the tones in your image to black and white and drop out the gray. Simply move the slider to get your desired balance of white and black areas.

Adjusting Clarity

After you've corrected the contrast and color and fixed your major flaws, like scratches, wrinkles and blemishes (as we describe in Chapter 1 of this minibook), you're ready to finally work on the overall clarity of that image. If your image suffers from an overall problem like dust, scratches, or *artifacts* (blocky pixels or halos), you may need to employ the help of a filter. Then finally, after you totally clean up your image, your last task is to give it a good sharpening. Why wait until the very end to do so? Sometimes improving the contrast and color and getting rid of flaws can reduce the clarity and sharpness of an image. So you want to be sure that your image is as soft as it's going to get before you dive into sharpening. On the other hand, keep in mind that sharpening increases contrast, so (depending on how much of your image you're sharpening) you may need to go back and fine-tune it by using the lighting adjustments described in the section "Adjusting Lighting," earlier in this chapter.

Lastly, we know we've been harping on the value of sharpening but, believe it or not, you may also need to occasionally blur your image. Blurring can eliminate unpleasant patterns that occur during scanning, soften distracting backgrounds to give a better focal point, or even create the illusion of motion.

Removing noise, artifacts, dust, and scratches

We know it sounds ironic, but the tools you use to eliminate unwanted garbage from your images are found on the Filter⇨Noise submenu in Edit Full mode. With the exception of the Add Noise filter, the others actually help to hide noise, dust, scratches, and artifacts. Here's the list of *cleaners:*

- **Despeckle:** Decreases the contrast, without affecting the edges, to make the dust in your image less pronounced. You may notice a slight blurring of your image (that's what's hiding the garbage), but the edges should still be sharp.

✔ **Dust & Scratches:** Hides, well, dust and scratches by blurring those areas of your image that contain the gunk (it looks for harsh transitions in tone). Specify your desired Radius value, which is the size of the area to be blurred. Also, specify the Threshold value, which determines how much contrast between pixels must be present before they're blurred.

Use restraint with this filter. It can wipe out detail and make your image look like mush.

✔ **Median:** Reduces contrast around dust spots. The process the filter goes through is rather technical, but basically light spots darken, dark spots lighten, and the rest of the image isn't changed. Specify your desired radius, which is the size of the area to be adjusted.

✔ **Reduce Noise:** Designed to remove luminance noise and artifacts from your images. We used this filter to correct the original image (on the left) in Figure 2-17, which had the nasty blockiness caused by JPEG compression. *Luminance noise* is grayscale noise that makes images look overly grainy. Specify these options to reduce the noise in your image:

 • *Strength:* Specify the amount of noise reduction.

 • *Preserve Details:* A higher percentage preserves edges and details but reduces the amount of noise that's removed.

 • *Reduce Color Noise:* Remove random colored pixels.

 • *Remove JPEG Artifact:* Remove the blocks and halos that can occur from low-quality JPEG compression.

Figure 2-17: Use the Reduce Noise filter to remove noise and artifacts.

Blurring when you need to

It may sound strange that anyone would intentionally want to blur an image. But, if your photo is overly grainy or suffers from an ugly *moiré* pattern

(described in the following list), you may need to blur the image to correct the problem. Also, often, you may even want to blur the background of an image to deemphasize distractions, or to make the foreground elements appear sharper and provide a better focal point.

All the blurring tools are accessed by choosing Filter⇨Blur in Edit Full or Edit Quick mode. The exception is the Blur tool, which we explain in Chapter 1 of this minibook:

- **Average:** This one-step filter calculates the average value of the image or selection and fills the area with that average value. You can use it for smoothing overly noisy areas in your image.

- **Blur:** Another one-step filter, this one applies a fixed amount of blurring to the whole image.

- **Blur More:** This one-step blur filter gives the same effect as Blur, but more intensely.

- **Motion Blur:** This filter mimics the blur given off by moving objects. Specify the angle of motion and the distance of the blur. Make sure to select the Preview check box to see the effect while you enter the values.

- **Radial Blur:** This filter produces a circular blur effect. Specify the amount of blur you want. Choose the Spin method to blur along concentric circular lines, as shown in the thumbnail. Or choose Zoom to blur along radial lines and mimic the effect of zooming in to your image. Specify the desired Quality level. Because the Radial Blur filter is notoriously slow, Elements gives you the option of Draft (fast but grainy), Good, or Best (slow but smooth). The difference between Good and Best is evident only on large, high-resolution images. Finally, indicate where you want the center of your blur by moving the blur diagram thumbnail.

- **Smart Blur:** This filter provides several options to enable you to specify how the blur is applied. Specify a value for the radius and threshold, both defined in the following section. Start with a lower value for both and adjust from there. Choose a quality setting from the pop-up menu. Choose a mode setting. Normal blurs the entire image or selection. Edge Only blurs only the edges of your elements and uses black and white in the blurred pixels. Overlay Edge also blurs just the edges, but it applies only white to the blurred pixels.

- **Surface Blur:** This filter blurs the surface, or interior, of the image, rather than the edges. If you want to preserve your edge details but blur everything else, this is the filter for you.

- **Gaussian Blur:** The last Blur filter we discuss is probably the one you'll use most often. It offers a Radius setting to let you adjust the amount of blurring you desire.

TIP

Use the Gaussian Blur filter to camouflage moiré patterns on scanned images. A *moiré pattern* is caused when you scan halftone images. A *halftone* is created when a continuous-tone image, such as a photo, is digitized and converted into a screen pattern of repeating lines (usually between 85 and 150 lines per inch) and then printed. When you then scan that halftone, a second pattern results and is overlaid on the original pattern. These two different patterns clash and create an ugly moiré pattern. The Gaussian Blur filter doesn't eliminate the moiré — it just merges the dots and reduces the appearance of the pattern, as shown in Figure 2-18.

Figure 2-18: Blur your image to emphasize a focal point.

Sharpening for better focus

Of course, if your images don't need any contrast-, color-, and flaw-fixing, feel free to move right into sharpening. Sometimes, images captured by a scanner or a digital camera are a little soft, and it's not due to any tonal adjustments. Occasionally, you may even want to sharpen a selected area in your image just so that it becomes a better focal point.

Keep in mind that you can't really improve the focus of an image after it's captured. But you can do a decent job of faking it. All sharpening tools work by increasing the contrast between adjacent pixels. This increased contrast causes the edges to appear more distinct, thereby giving the illusion that the focus is improved, as shown in Figure 2-19. Remember that you can also use the Sharpen tool for very small areas, as described in Chapter 1 of this minibook. Here's the lowdown on sharpening commands:

- **Unsharp Mask:** Unsharp Mask, in the Enhance menu in Edit Full or Edit Quick mode, gives you several options that enable you to control the amount of sharpening and the width of the areas to be sharpened. Use them to nail your desired sharpening:

 - *Amount:* Specify an amount (from 1 to 500%) of edge sharpening. The higher the value, the more contrast between pixels around the edges.

Start with a value of 100 percent (or less), which usually gives good contrast without appearing overly grainy.

- *Radius:* Specify the width (from .1 to 250 pixels) of the edges that the filter will sharpen. The higher the value, the wider the edge. The value you use is largely based on the resolution of your image. Low-resolution images require a smaller radius value. High-resolution images require a higher value.

 Be warned that specifying a value that's too high overemphasizes the edges of your image and makes them appear thick and goopy.

 A good rule of thumb in selecting a starting radius value is to divide your image's resolution by 150. For example, if you have a 300-ppi (pixels per inch) image, set the radius at **2** and then use your eye to adjust from there.

- *Threshold:* Specify the difference in brightness (from 0 to 255) that must be present between adjacent pixels before the edge is sharpened. A lower value sharpens edges with very little contrast difference. Higher values sharpen only when adjacent pixels are very different in contrast. We recommend leaving Threshold set at 0 unless your image is very grainy. Increasing the value too much can cause unnatural transitions between sharpened and unsharpened areas.

Figure 2-19: Sharpening mimics an increase in focus by increasing contrast between adjacent pixels.

Occasionally, the values you enter for Amount and Radius may sharpen the image effectively but they can create excess *grain,* or noise, in your image. You can sometimes reduce this noise by increasing the Threshold value.

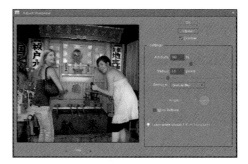

Figure 2-20: The Adjust Sharpness command.

✔ **Adjust Sharpness:** Another sharpening option is the Adjust Sharpness command, as shown in Figure 2-20. This feature enables you to control the amount of sharpening applied to shadow and highlight areas. It also allows you to select from various sharpening algorithms.

Specify the following options:

- *Amount and Radius:* See the two descriptions in the preceding Unsharp Mask bullet.

- *Remove:* Choose your sharpening algorithm. Gaussian Blur is the algorithm used for the Unsharp Mask command. Lens Blur detects detail in the image and attempts to respect the details while reducing the nasty halos that can occur with sharpening. Motion Blur tries to sharpen the blurring that occurs when your camera, or your subject, moves.

- *Angle:* Specify the direction of motion for the Motion Blur algorithm, described in the preceding Remove bullet.

- *More Refined:* Runs the algorithm more slowly than the default speed for better accuracy.

Working Intelligently with the Smart Brush Tools

The Smart Brush tools — Smart Brush and Detail Smart Brush — are two fun tools that enable you to selectively apply an image adjustment or special effects that then appear on all or part of your image. What's great is that these adjustments and effects are applied via an adjustment layer, meaning that they "hover" over your layers and don't permanently alter the pixels in your image. The adjustments can also be flexibly edited and deleted, if you so desire.

Using the Smart Brush

The Smart Brush tool allows you to paint a variety of image adjustments on all or just a portion of your image. The action of the tool is similar to that of

the Selection Brush — as you brush, you make a selection and adjust simultaneously. Follow these steps to use the Smart Brush tool:

1. **Select the Smart Brush tool from the Tools panel in Edit Full mode.**

 The tool icon looks like a house paintbrush with an adjacent gear.

2. **Choose your desired brush attributes, such as diameter and hardness, from the Brush Picker drop-down panel.**

 For more on working with brushes, see Book V, Chapter 1.

3. **Select your desired adjustment category and then a particular preset adjustment from the Smart Paint panel, as shown in Figure 2-21.**

 Note that you can "tear off" this panel by grabbing the grip area in the upper-left corner of the panel and dragging it anywhere in your Application window (Windows) or on your screen (Mac). In the Smart Paint menu, choose adjustments ranging from photographic effects, such as a vintage Yellowed Photo, to nature effects, such as Sunset (which gives a warm, orange glow to your image).

Purestock

Figure 2-21: The Smart Brush enables you to paint on adjustments.

**Book VIII
Chapter 2**

Correcting Lighting,
Color, and Clarity

4. **Paint an adjustment on a layer in your image.**

 Note that while you paint, the Smart Brush tool attempts to detect edges in your image and snaps to those edges. In addition, while you brush, a selection border appears.

 A new adjustment layer is automatically created with your first paint stroke. The accompanying layer mask also appears on that adjustment layer. For more on adjustment layers, see Book VI, Chapter 1.

5. **Using the Add and Subtract Smart Brush modes, fine-tune your adjusted area by adding and subtracting from it.**

 When you add and subtract from your adjusted area, you're essentially modifying your layer mask. Adding to the adjusted area adds white to the layer mask, and subtracting from an adjusted area adds black to the layer mask. For more on layer masks, see Book VI, Chapter 4.

6. **Select a different preset adjustment for your selected area, if you want.**

 In fact, try them all out before you make your final choice.

7. **If you feel you need to refine your selected area, choose the Refine Edges option on the Options bar.**

 For more on Refine Edges, see Book IV, Chapter 2.

 If you'd rather apply the adjustment to your unselected area, select the Inverse option on the Options bar.

 If you want to modify your adjustment, double-click the Adjustment Layer pin on your image. The pin is annotated by a small, square black and red gear icon. After you double-click the pin, the dialog box corresponding to your particular adjustment appears. For example, if you double-click the Shoebox photo adjustment (under Photographic), you access the Hue/Saturation dialog box.

8. **Make your necessary adjustments in the dialog box and click OK.**

 You can also right-click (Control-click on the Mac) and select Change Adjustment Settings from the contextual menu that appears. Or, you can select Delete Adjustment and Hide Selection from the same menu.

9. **After you finish, simply deselect your selection by choosing Select⇨ Deselect.**

You can add multiple Smart Brush adjustments. After you apply one effect, reset the Smart Brush tool and apply additional adjustments.

Getting accurate with the Detail Smart Brush

The Detail Smart Brush tool also enables you to paint various image adjustments on all or part of your image. The action of the tool is similar to the regular Brush tool, enabling finer control than that of the Smart Brush. Follow these steps to use the Detail Smart Brush tool:

1. **Select the Detail Smart Brush tool from the Tools panel in Edit Full mode.**

 This tool shares the flyout menu with the Smart Brush tool. The tool icon looks like an art paintbrush with an adjacent gear. You can also press the F key, or Shift+F, if the Smart Brush tool is visible.

2. **Choose a brush tip preset and brush size as well as attributes from the Brushes drop-down panel.**

 Feel free to change your brush tip and size as needed to achieve the desired effect. For more on working with brushes, see Book V, Chapter 1. For better accessibility, you can "tear off" this panel (and the Smart Paint panel in Step 3) by grabbing the grip area in the upper-left corner of the panel and dragging it anywhere in your Application window.

3. **Select your desired adjustment category and then your particular preset adjustment from the Smart Paint panel.**

 Several of the Special Effects adjustments are shown in Figure 2-22.

Corbis Digital Stock

Figure 2-22: The Detail Smart Brush lets you paint on a variety of special effects.

Book VIII
Chapter 2

Correcting Lighting,
Color, and Clarity

4. **Paint an adjustment on the desired layer in your image.**

 A new adjustment layer is automatically created with your first paint stroke, along with an accompanying layer mask.

5. **Follow Steps 5–8 in the preceding list for the Smart Brush tool.**

Chapter 3: Compositing with Photomerge

In This Chapter

✔ **Stitching a scene with Panorama**

✔ **Getting the hero shot with Group Shot**

✔ **Manipulating an image's DNA with Faces**

✔ **Eliminating with Scene Cleaner**

✔ **Working with Exposure**

Sometimes, working with just a single shot isn't quite enough. Imagine this scenario: As much as you try, you just can't quite squeeze that vacation scenic vista into one photo; in fact, it takes a total of three shots. Or one of your relations is always blinking or looking the wrong way in your family reunion snapshots, so no single shot ends up being the perfect group photo. Or maybe bystanders or cars keep crossing the path of your camera when you're trying to capture that historic landmark. Not to worry, that's what the Elements Photomerge commands are for. One command seamlessly stitches multiple shots of your panorama into a single image, while another eliminates distracting elements from your shots, and a third command enables you to combine multiple group shots to get the best composite. Finally, one command even lets you take two faces and combine them into a kind of hybrid human. (How cool is that?)

Stitching a Scene with Photomerge Panorama

The Photomerge Panorama command enables you to combine multiple images into a single panoramic image. You can take several overlapping photos, from skylines to mountain ranges, and stitch them together into one shot.

If you know your ultimate goal is to create a Photomerge composition, you can make things easier for yourself by making sure that when you shoot your photos, you overlap your individual images by 15 to 40 percent, but no more than 50 percent. Adobe also recommends that you avoid using

distortion lenses (such as a fish-eye) and that you also avoid using your camera's zoom setting. Additionally, try to keep the same exposure settings for even lighting. Finally, try to stay in the same position and keep your camera at the same level for each shot. Using a tripod and rotating the head can help you achieve this consistency. Note, however, that rotating the head may introduce a perspective distortion. This can be corrected during the "stitching" described in the steps below.

Follow these steps to assemble your own Photomerge Panorama composition:

1. **In the Editor, in Edit Full mode, choose File⟿New⟿Photomerge Panorama.**

2. **In the first Photomerge dialog box, as shown in Figure 3-1, select your source files.**

 You can select from Files (which uses individual files you select) or from Folder (which uses all images in a folder) from the Use drop-down list. Click the Add Open Files button to use all currently open files. Or click the Browse button to navigate to certain files or folders.

Figure 3-1: Select the source files for your composition.

3. **Under Layout, select a projection mode, as shown in Figure 3-1.**

 The thumbnail illustration visually demonstrates each mode, but we give you a little more description of each here:

 - *Auto:* Using the Auto mode, Elements analyzes your images on its own.

- *Perspective:* Select this mode if your images have been shot with perspective or at acute angles. This is also a good mode to use if you've shot images using the tripod method described earlier in this section.

- *Cylindrical:* Select this option if you shot images with a wide-angle lens. This mode is also good for those 360-degree, full panoramic shots.

- *Reposition Only:* When you select this mode, Elements doesn't take into account any distortion, but merely scans the images and positions them in what it considers the best position.

 If you choose any of the preceding modes, Elements opens and automatically assembles the source files to create the composite panorama in the work area of the dialog box. If it looks good, skip to Step 7.

 Elements alerts you if it can't automatically composite your source files. You then have to assemble the images manually by using the Interactive Layout mode.

- *Interactive Layout:* This option opens the work area pane. Elements tries to align and stitch the images the best it can, but you may have to manually complete or adjust the panorama, as shown in Figure 3-2. If you choose the Interactive Layout option, proceed to Step 4.

Note that, with any of the modes, Elements leaves your merged image in layers. Also notice that a layer mask has been added to each layer to better blend the panoramic image. For more on layer masks, see Book VI.

4. **If Elements hasn't already done so, drag the image thumbnails from the lightbox area (the small white area at the top) onto the work area with the Select Image tool (the arrow).**

 Alternatively, double-click the lightbox thumbnail to add it to the composition.

5. **Arrange and position your images using one or more of the following tools:**

 - *Select Image tool:* Positions the images

 - *Rotate Image tool:* Makes rotations

 - *Zoom and Move View tools:* Help view and navigate around your panorama, respectively

 - *Navigator View box:* Zooms into and out of your composition when you drag the slider

 - *Snap to Image option:* Enables overlapping images to automatically snap into place

Select Image

Rotate Image

Navigator View box

Settings Area

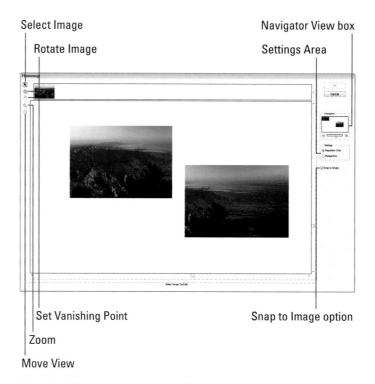

Set Vanishing Point

Zoom

Move View

Snap to Image option

Figure 3-2: You may have to manually assemble your panorama.

6. **To adjust the Vanishing Point, first select the Perspective option in the Settings area and click the image with the Set Vanishing Point tool.**

 A *vanishing point* is the point on the horizon where perspective planes recede and eventually converge. By default, Elements selects the center image as the vanishing point. If necessary, you can move the other images.

 Note that when you select the Perspective setting, Elements links non–Vanishing Point images to the Vanishing Point image. To break the link, click the Normal Setting button or separate the images in the work area.

7. **Click OK to create the panorama.**

 The file opens as a new file in Elements, as shown in Figure 3-3.

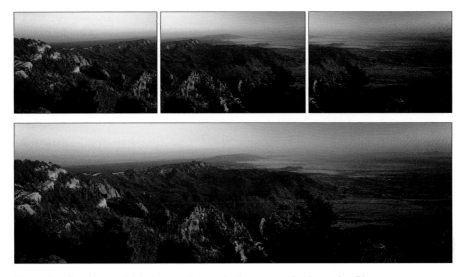

Figure 3-3: Combine multiple images into a single panoramic shot using Photomerge Panorama.

Getting the Best Shot with Photomerge Group Shot

Getting a group of people to smile, not blink or fidget, and look in the same direction is about as easy as herding cats. With Elements, you no longer have to worry about snapping the perfect group shot anymore. Just take a bunch of shots and later create the ultimate perfect shot by compositing those shots using Photomerge Group Shot.

Here are the steps to create a Photomerge Group Shot image:

1. **In any of the Edit modes, select two or more photos from your Project Bin at the bottom of your Application window.**

2. **Choose File➪New➪Photomerge Group Shot.**

 The Photomerge Group Shot dialog box appears.

3. **Take your best overall group shot and drag it from the Project Bin onto the Final pane.**

4. **Select another photo in the Project Bin to use as your Source image and then drag it to the Source pane.**

5. **With the Pencil tool, draw a line around the portions of the Source photo you want to merge into your Final photo, as shown in Figure 3-4.**

 In the Options area on the right side of the dialog box, you can choose to show the yellow pencil strokes (Show Strokes) or show regions (Show Regions), which are then highlighted with a blue overlay. Use the Eraser tool to remove any portions you don't want merged onto the final image.

6. **Repeat Steps 4 and 5 with any remaining photos.**

 If your photos aren't aligned, you can use the Alignment tool under Advanced Options.

7. **Using the Alignment tool, click the Source image and position the three target markers on three key locations.**

 Do the same on the final image and choose similar locations.

 You can click the Pixel Blending option to better blend pixels.

8. **Click the Align Photos button.**

 Again, as with Photomerge Panorama, the more similar in framing, size, lighting, and so on, that your source and final images are, the better the merged result.

9. **If you make a mess of things, click the Reset button.**

Figure 3-4: Use Photomerge Group Shot to composite the perfect group shot from several images.

10. **When you're satisfied with the result, click Done.**

 The file opens as a new file in Elements, as shown in Figure 3-5.

Figure 3-5: The perfect group shot.

Manipulating Image DNA with Photomerge Faces

Photomerge Faces — admittedly more of a fun tool than a useful one — lets you blend features from multiple faces to get a kind of hybrid face.

To create a hybrid human by using the Photomerge Faces feature, follow these steps:

1. **Select two or more photos from your Project Bin.**

2. **Choose File⇨New⇨Photomerge Faces in any of the Edit modes.**

 The Photomerge Faces dialog box appears.

3. **Choose the face you want to have as your *canvas* (or starting image) and drag it from the Project Bin onto the Final pane.**

4. **Select one of your other photos in the Project Bin to use as the Source image and then drag it to the Source pane.**

5. **With the Alignment tool, click the Source image and position the three target markers on the eyes and mouth of the face, and then do the same on the Final image.**

6. **Click the Align Photos button.**

 This command sizes the images to better match and align the features. It's always best to start with similarly sized, framed, and oriented images. Shooting the images in similar lighting helps as well.

7. **With the Pencil tool, draw a line around the features of the Source photo that you want to merge into your Final photo, as shown in Figure 3-6.**

 In the Options area on the right side of the dialog box, you can choose to show your blue pencil strokes (Show Strokes) or show your regions (Show Regions), which are then highlighted with a blue overlay. Use the Eraser tool to remove any portions of the face you don't want merged onto your final image.

Figure 3-6: Create a single human from multiple images with Photomerge Faces.

8. **If you make a mess of things, click the Reset button.**

9. **When you're satisfied with the result, click Done.**

 The hybrid face opens as a new file in Elements, as shown in Figure 3-7.

Figure 3-7: A hybrid person created from two people.

Eliminating with Photomerge Scene Cleaner

Photomerge Scene Cleaner sounds like a covert job with the CIA where you spend your days mopping up evidence at crime scenes, but it isn't quite that intriguing. This Photomerge command toolset enables you to create the optimum image by allowing you to eliminate annoying distractions, such as cars, passersby, and so on.

To get the best Source images for a "clean scene," be sure to take multiple shots of your scene from the same angle and distance. It also works best when the elements you want to eliminate are moving.

Follow these steps to create a Photomerge Scene Cleaner composite:

1. **Select two or more photos from your Project Bin.**
2. **Choose File⇨New⇨Photomerge Scene Cleaner in any of the Edit modes.**

 The Photomerge Scene Cleaner dialog box appears.

 Elements attempts to auto-align your images the best it can.

3. **Take your best overall shot of the scene and drag it from the Project Bin onto the Final pane.**

4. **Select one of your other photos in the Project Bin to use as your Source image and then drag it to the Source pane.**

5. **With the Pencil tool, draw a line around the elements in the Final photo that you want to be replaced by content from the Source photo, as shown in Figure 3-8.**

6. **Repeat Steps 4 and 5 with the remaining shots of the scene.**

 If your photos aren't aligned, you can use the Alignment tool under the Advanced Options.

7. **Using the Alignment tool, click the Source image and position the three target markers on three key locations.**

 Do the same on the Final image, choosing similar locations.

8. **Click the Align Photos button.**

 Again, as with the other Photomerge commands, the more similar the starting source images (similar framing, similar angle, similar lighting), the better the merged result will be.

9. **If you make a mess of things, click the Reset button.**

10. **When you're satisfied with the result, click Done.**

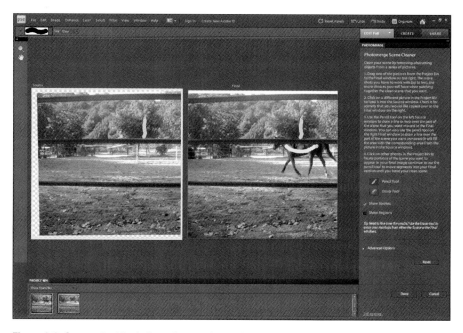

Figure 3-8: Create the ideal photo from multiple shots with Photomerge Scene Cleaner.

The cleaned-up image opens as a new file in Elements. You have to admit, for a command that's so easy to use, the results are pretty impressive, as shown in Figure 3-9.

Be sure to check the perimeter edges of your composite image carefully. You may have some strange artifacts or blurring caused by the aligning of the multiple images. Execute a quick crop with the Cropping tool and you're good to go.

Figure 3-9: A clean scene, free of any annoying distractions.

Photomerge Exposure

Occasionally, you need to capture a shot that presents an exposure challenge — your foreground and background require different exposure settings. This often occurs in shots that are backlit. For example, you have a person in front of an indoor window in the day or someone in front of a lit nighttime cityscape or sunset. With Photomerge Exposure, you can take photos with two different exposure settings and let the command blend them together for the perfect shot.

You can capture your shots using *exposure bracketing* (shooting at consecutive exposure camera settings) or with a flash and then without. Elements can detect all these camera settings. We recommend that you use a tripod to keep your shots as aligned as possible. This will help the blending algorithm do a better job.

Here's how to use this new command:

1. **Select two or more photos from your Project Bin.**

2. **Choose File⇨New⇨Photomerge Exposure in any of the Edit modes.**

 You can also perform this task in the Organizer, or in Adobe Bridge on the Mac. Just select any two images and choose the same command.

3. **If you've used a tripod or have just done a good job keeping your shots aligned, leave the mode on Automatic.**

 Select the Simple Blending option, and Elements automatically blends the two images. Select the Smart Blending option to access sliders to adjust the Highlights, Shadows, and Saturation settings for finer tuning of the resulting images. If you mess up things, click the Reset button.

4. **If you feel the need for even more control, click the Manual mode tab.**

5. **In Manual mode, choose your first shot from the Project Bin and drag it to the Final window.**

 If your other image isn't already the Source image, drag it from the Project Bin to the Source window.

6. **With the Pencil tool, draw over the well-exposed areas you wish to retain in the Source image.**

 As you draw, your Final image shows the incorporation of those drawn areas, as shown in Figure 3-10.

7. **If you mistakenly draw over something you didn't want to, grab the Eraser tool and erase the Pencil tool marks.**

 Choose to have your preview show strokes and/or regions.

8. **Further control the blending by dragging the Transparency slider.**

 Dragging to the right will blend less of the Source areas into the Final image. Check the Edge blending option to get an even better blend of the two images.

9. **If your photos aren't aligning correctly, grab the Alignment tool under Advanced Options:**

 a. *With the Alignment tool, click your Source image and position the three target markers on three key locations.*

 b. *Do the same on the Final image, choosing similar locations.*

10. **Click the Align Photos button.**

 Again, as with the other Photomerge commands, the more alike your starting source images are (similar framing, similar angle, and so on), the better the merged result.

11. **Again, if you muck up things too badly, click the Reset button.**

12. **When you're satisfied with the result, click Done.**

 The file opens as a new, layered file in Elements. The blended image appears on Layer 1. The background is your starting Final image. You can either flatten the layered file, which will retain the appearance of Layer 1. Or you can double-click your background to convert it to a layer and then delete it by dragging it to the trash icon in the Layers panel.

Figure 3-10: Get your desired shot by blending two images with two different exposures.

Chapter 4: Getting Help in Guided Mode

In This Chapter

✓ **Understanding the Guided Edit panel**

✓ **Making basic photo edits**

✓ **Controlling lighting and exposure**

✓ **Correcting color**

✓ **Using Guided Activities**

✓ **Merging photos**

✓ **Automating actions**

✓ **Using photographic effects**

Wouldn't it be nice if you could have a mentor sitting behind you who could walk you through the necessary steps each time you encountered a new feature in a program?

Photoshop Elements doesn't provide you with a robot mentor to instruct you on the best way to perform an edit, but it does offer you the next best thing in the form of the Guided Edit panel.

The Guided Edit panel provides you easy control over some important editing tasks that you perform routinely when working on images. In this chapter, we show you how to use the Guided Edit panel and all it has to offer you.

Understanding Guided Mode

You see all the guided actions and activities in the Guided Edit panel in Edit Guided mode. Choose Edit Guided from the Edit Tab drop-down list in the top right of the Application window. The Guided Edit panel opens to display the items shown in Figure 4-1.

As you can see in Figure 4-1, the Guided Edit panel has seven categories. Below each category title, you find some items that relate to the respective category. The categories include

Figure 4-1: The Guided Edit panel.

✓ **Basic Photo Edits:** Here you find the kinds of edits frequently used on photos. Cropping images, straightening photos, and sharpening photos are part of this group.

✓ **Lighting and Exposure:** Almost all photos you either take with cameras or scan from printed pictures require some lighting adjustments. You find lighten, darken, as well as brightness and contrast controls here. In addition, it offers help to use Levels for more brightness and contrast adjustments.

✓ **Color Correction:** Another frequently used edit involves adjusting color. You can enhance colors, remove color casts, and correct skin tones using these items.

✓ **Guided Activities:** This item helps you make adjustments for enhancing images with instructions for removing scratches, blemishes, tear marks, and correcting distortions. Guide for Editing a Photo walks you through several edits for cropping, brightness adjustments, enhancing, and touchups.

✓ **Photomerge:** Photomerge is used for merging photos. The subcategories include help with merging group shots or pictures with faces. It shows you how to remove obstructing objects from a group of merged photos using the Scene Cleaner.

✔ **Automated Actions:** A host of different sequences are assembled together as actions. You can, for example, choose one or a group of photos and apply a sepia tone with just one mouse click. The action then applies several editing steps automatically to create a good result.

✔ **Photographic Effects:** Using this guide, you can easily apply a variety of different filters that produce many different effects, such as line drawings, transformation of your image into an old-fashioned photo, or saturated film effects.

Basic Photo Edits

The commands in this category help you perform the kinds of basic edits frequently used in most of your Elements editing sessions. When you choose Crop Photo, for example, the Guided Edit panel opens with the Crop tool selected and a crop frame drawn on the photo. Instructions that make it easy for you to crop an image appear in the Guided Edit panel.

Similar steps are also provided for straightening a photo. You might use this feature frequently when scanning photos. The new Recompose command allows you to intelligently resize an image without losing any vital content.

The last item listed under Basic Photo Edits is Sharpen Photo. This is another edit you make frequently when working on your photos in Elements. To get a feel for using the Sharpen Photo item in Edit Guided mode, do the following:

1. **Open a photo in Edit Guided mode.**

2. **In the Guided Edit panel, in the Basic Photo Edits category, click Sharpen Photo.**

 The panel changes to display the options you have for sharpening a photo.

3. **Change the view in the Image window.**

 By default, you see your photo appear in the Image window in a maximized view. You can view your photo with a before/after effect where the original photo appears unedited on the left side of the window and the edits you apply appear on the right side of the window. To create a before/after effect, click the up-pointing arrow where you see After Only at the bottom of the panel. When you click the up-pointing arrow, the icon changes to two icons adjacent to each other and the name changes to Before & After – Horizontal, as shown in Figure 4-2.

Figure 4-2: Click After Only, and you can see a before/after display of the original and the edited version beside each other.

If you want to view the before/after images vertically, click the Before & After – Horizontal icon, and the view changes to the Before & After – Vertical icon, with the Before image appearing vertically on top of the After image.

4. **Adjust the sharpening slider.**

You have the option of clicking the Auto button, and Elements makes a best-guess adjustment to sharpen the image. To manually sharpen the image, move the slider left and right.

5. **Click Done to apply the edits.**

The advantage you have in using the Guided Edit panel is that some helpful information is offered to guide you through the edits. Note that in the panel shown in Figure 4-2, you see a tip informing you that it's best to view your photo in a 100% view when you apply sharpening to a photo.

Lighting and Exposure

One of the most important and most-frequent edits you make on photos is adjusting lighting and exposure. When you click Lighting and Exposure and view the options, the first two items you see deal with handling Lighten/

Darken and Brightness/Contrast issues. Clicking one of these items changes the panel view to one where you can move sliders similar to those you have for sharpening adjustments. The tweaks you can do here are pretty straightforward and, with the help offered in the panel, it's intuitive and easy to make these kinds of adjustments.

Things get a bit more complicated when you start using the Levels adjustment. We go into quite a bit of detail about Levels in Book VIII, Chapter 2. Be sure to read that chapter when you want to figure out more about using this important dialog box.

When you use Levels, it's commonly used on adjustment layers. You find more information on creating and using adjustment layers in Book VI, Chapter 1.

Creating an adjustment layer and applying settings from the Levels dialog box can be a little confusing when you first start correcting lighting and exposure. The Guided Edit panel, fortunately, breaks down the complicated steps into easy-to-follow instructions to assist you in making the edits.

When you click Adjust Levels in the Guided Edit panel, the panel view changes to what you see in Figure 4-3. Here you find helpful information explaining how the Levels dialog box is used and what the histograms mean. When you start with this edit, it's a good idea to read all the help information before making the adjustments.

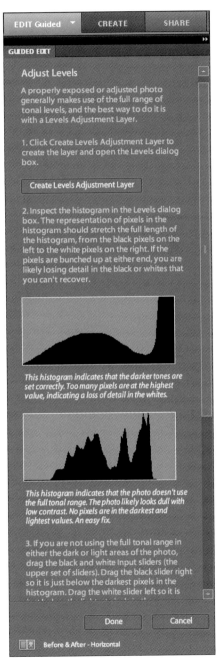

Figure 4-3: The Adjust Levels panel.

After reading the information contained in the panel, click the Create Levels Adjustment Layer button and then the New Layer dialog box opens, as shown in Figure 4-4.

Figure 4-4: The New Layer dialog box.

Type a name for the new adjustment layer and then click OK; the Levels dialog box opens, as shown in Figure 4-5.

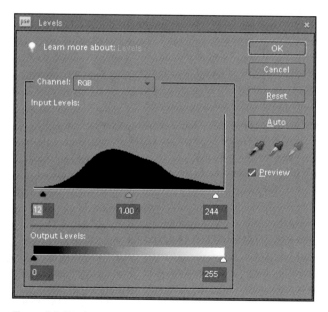

Figure 4-5: The Levels dialog box.

From the information you obtained in the Guided Edit panel, move the sliders in the Levels dialog box to make your corrections.

Color Correction

The three items you find in the Color Correction panel help you improve the color in your photos. When you click the Enhance Colors item, the panel changes to provide you with sliders to adjust hue, saturation, and brightness. Click the Remove a Color Cast link and you find an Eyedropper tool where you can sample a medium gray tone, and Elements corrects color in the image. For more information on removing colorcasts, see Book VIII, Chapter 2.

One of the most important color adjustments you can make is adjusting skin tones. The Adjust Skin Tones panel, as shown in Figure 4-6, provides you with an Eyedropper tool. Click an area in the image representing a neutral skin tone, and the color is adjusted to match that neutral tone for the entire image.

 When adjusting skin tones, it's a good idea to select only the areas you want to correct for color adjustments. Look over Book IV, Chapter 1 to determine how to make selections.

You can tweak the color for skin tones by moving the sliders in the panel.

Figure 4-6: Click the Eyedropper tool and then click a skin tone in the photo.

**Book VIII
Chapter 4**

Getting Help in
Guided Mode

Guided Activities

Guided Activities in the Guided Edit panel provides you with several different options. When you click Touch Up Scratches, Blemishes, or Tear Marks, the Touch Up Photo panel opens, as shown in Figure 4-7.

Move the sliders respective to the edits you want to make. As with other panels, you find some help information to guide you through the steps. We cover much more on touching up images in Book VIII, Chapters 1 and 2.

If you move down the Guided Activities list and click Guide for Editing a Photo, the Guided Edit panel changes to first display the Crop panel. Make a choice for cropping an image and click the Next button. Move on to Recompose, which enables you to resize an image without losing vital content. Click Next to move on to Lighten or Darken a Photo. Click Next and move on to the Touch Up Photo panel, and so on. This panel is one that takes you through the entire editing process, and what you find in each step is a duplicate of many of the other panels discussed in this chapter.

The Fix Keystone Distortion panel helps you correct problems with architectural photography with parallax distortion. To understand the distortion problem,

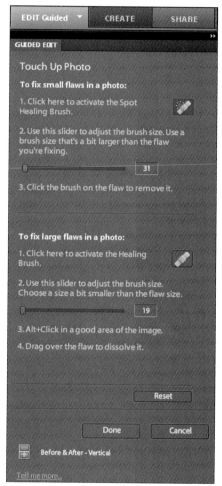

Figure 4-7: The Touch Up Photo panel.

look over Figure 4-8. The image previews show you a sample photo (at the top of the panel) and the result of applying the correction (in the bottom photo in the panel).

Photomerge

We devote a complete chapter to Photomerge in Book VIII, Chapter 3 so we won't go into the steps to produce a photo merged from other photos in this chapter. The Photomerge panel helps you walk through all the steps we explain there.

You select several photos you want to merge and then use the Photomerge panel to align and merge the photos. The content of your images can be scenes or faces. The Scene Cleaner is used to remove items that distract from the merged scene. The new Exposure command enables you to get the perfect shot by blending multiple shots taken with different exposure settings.

Automated Actions

The Action Player is like having a tape recorder play a recorded series of steps to produce a result. You might have one effect that requires creating a layer, adjusting brightness on the new layer, changing layer opacity, adjusting hue/saturation and brightness, adding some noise, applying a filter, and

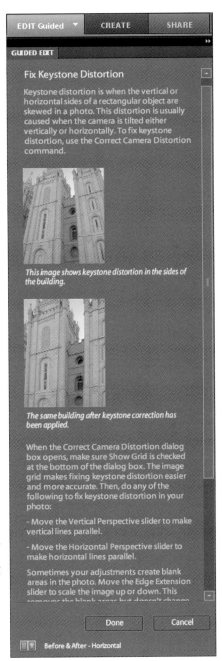

Figure 4-8: Correcting keystone distortion.

flattening the layers. Rather than perform each step manually, you can use the Action Player that applies multiple edits with one mouse click.

To see how the Action Player is used, follow these steps:

1. **Open a photo in Edit Guided mode.**

2. **In the Guided Edit panel, in the Automated Actions category, click Action Player to open the Action Player panel.**

3. **Choose an action from the first drop-down list.**

 In our example, we chose Special Effects.

4. **Select the action to run from the second drop-down list.**

5. **Click Play Action.**

 Elements performs all the steps necessary to create the result. In our example, when we choose to run Sepia Toning, the action creates the image shown in Figure 4-9.

6. **Click Done.**

Figure 4-9: The result of running the action.

Photographic Effects

Photographic effects are like applying filters that we cover extensively in Book VII, Chapters 1 and 2. Whereas the Filters panel provides you with many different options to apply a filter, the Guided Edit panel offers you filter effects and then takes you through steps for adjusting brightness values, changing hue/saturation, and making other adjustments to perfect the result.

You can choose from three different options for applying Photographic Effects. Line Drawing converts your photos to a pen-and-ink drawing. Old Fashioned Photo gives your images a vintage appearance, and Saturated Slide Film Effect provides you a way to simulate colors of the saturated film used in film cameras (as opposed to digital cameras).

To experiment a little, take a look at the Old Fashioned Photo option and follow these steps to produce an image with a vintage appearance:

1. **Open an image in Edit Guided mode.**

2. **In the Guided Edit panel, in the Photographic Effects category, click Old Fashioned Photo to open the Create an Old Fashioned Photo panel, as shown in Figure 4-10.**

Figure 4-10: Click Old Fashioned Photo in the Guided Edit panel.

This panel offers you several buttons to click to convert the photo. Scroll the panel and read the help information; then click the buttons to make the choices you want.

3. Select the option for conversion to black and white.

Scroll the panel and look over the options you have for converting the photo to black and white. Click one of the three buttons — Newspaper, Urban/Snapshots, or Vivid Landscapes, as shown in Figure 4-11.

4. Add tonality and texture.

Scroll the panel until you see the Adjust Tonality and Add Texture buttons, as shown in Figure 4-12. Click both buttons.

5. Adjust hue/saturation.

Scroll the list and click the Adjust Hue/Saturation button. The Hue/Saturation dialog box opens, as shown in Figure 4-13. To change the color, move the Hue slider. Move the Saturation and Lightness sliders to apply more or less saturation and change the brightness values.

Even though you converted your photo to black and white in step 3, the color mode remained in an RGB mode. Notice that the Colorize check box is checked in Figure 4-13. Be sure to keep this check box checked to add a color tint to the photo.

6. Click Done.

The result of applying all the edits is shown in Figure 4-14.

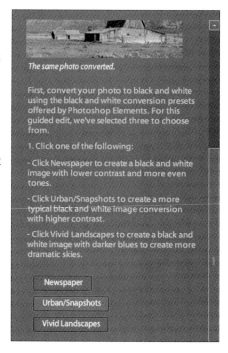

Figure 4-11: Click one of the buttons to convert to black and white.

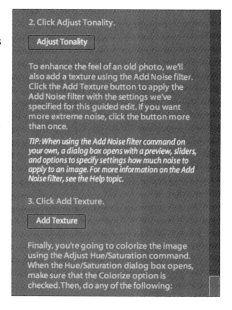

Figure 4-12: Click Adjust Tonality and Add Texture.

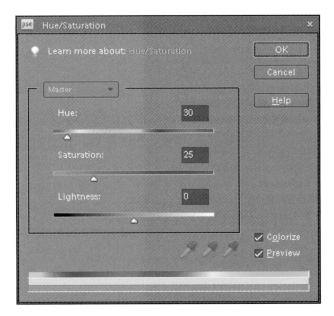

Figure 4-13: The Hue/Saturation dialog box.

Figure 4-14: Click Done to complete your edits.

Book IX
Creating and Sharing with Elements

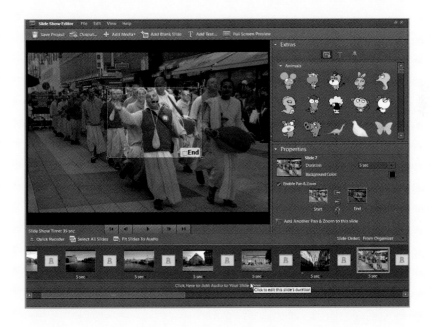

Greetings from Tagum

*P*hotos are meant to be shared with others or printed using both desktop and professional printing devices. In this book, we take you through the journey of sharing photos online and using an Adobe partner sharing service that can help you create professional-looking presentations.

We cover all you need to know about printing your pictures, managing the color, and using color profiles. We also give you the lowdown on Web-hosting images.

Chapter 1: Creating Elements Projects

In This Chapter

✓ Understanding creations

✓ Creating photo books and a calendar

✓ Producing photo collages and greeting cards

✓ Making photo stamps and CD/DVD labels

✓ Constructing VCDs with menus

✓ Making flipbooks

Adobe Photoshop Elements offers you a number of creations that can be shared onscreen or in print. From both the Create and Share panels in the Panel Bin in the Organizer and from within both editing modes, you have a number of menu choices for producing creations designed for sharing.

In Book IX, Chapter 3, we look at creating files for screen and Web viewing. In this chapter, we talk about creations designed for print and sharing.

Getting a Handle on Creations

In Book IX, Chapter 4, we talk about online albums, attaching files to e-mail, using photo mail, and using online sharing services. All these creations offer different output options, such as e-mailing, burning files to a disc, and creating HTML documents — as well as printing and PDF creation — and you create them all using the Share panel.

You work with the remaining creations — photo books, photo collages, photo calendars, greeting cards, print labels, and photo stamps — by choosing options from the Create panel, as shown in Figure 1-1. All these creations are designed for output to your printer or for sending files to an online printing service or to friends and family.

When you make a creation that will ultimately be sent to an online service or shared with other users, keep in mind that you first must select the photos you want in your creation. For example, creating a photo book by clicking the Photo Book button in the Create panel first requires you to let Elements know what photos are to be used in your photo book. If you happen to click a button and nothing happens, more than likely you haven't selected any photos.

Many creation options follow a similar set of steps to produce a file that will be shared with other users or sent to an online printing service. In the Project Bin, you find all you need to make a new project. It gives you choices for layouts and producing a creation. Some of the choices from both the Create and Share panels are

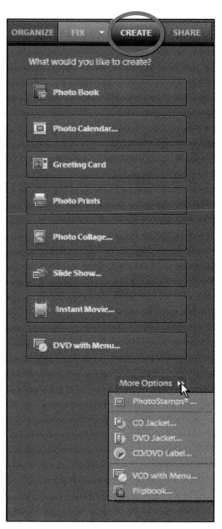

Figure 1-1: The Create panel.

- ✔ **Layout options:** Select some photos in the Organizer and click an item, such as Photo Book, to make the Create panel change to the Project view. This view displays some information about making a new creation.

- ✔ **Auto-Fill with Project Bin Photos:** This check box is selected by default, and the files you see in the Project Bin are added to your project.

- ✔ **Include Captions:** Select this check box if you want the photo captions to appear on each page below their respective photos.

- ✔ **Number of Pages:** Elements automatically creates the number of pages to accommodate the number of photos you selected in the Organizer. Note that some creations require a minimum number of photos to produce a project. Photo Book, for example, requires a minimum of 18 pages.

After assembling your creation, click the Create button. Elements then incorporates the selected photos into the layout and theme you specified in the panel. Be patient and wait for Elements to complete the task.

After a creation has been made, the document appears like any other image you open in Elements. You can crop, modify, print, and more. Using an Elements file, choose File⇨Save to open the Save As dialog box. Type a name and click Save.

Creating a Photo Book

Elements provides some fancy ways to create pages for a photo album. The Photo Book Creation panel offers many different options for choosing page templates, adding artwork and type, printing your album pages, or sending the files to an online service for professional printing.

Follow these steps to create a photo book:

1. **Select files in the Organizer and click the Create tab (Windows) or open several photos in Edit Full mode (Windows/Mac) and click Create.**

 The procedure for all creations is the same. You first select files in the Organizer (Windows) or an editing mode (Windows or Mac) and then click the Create tab in the Panel Bin. Ideally, it's best to create an album, as we explain in Book II, Chapter 2, and click the album to display the album photos in the Organizer window. But remember, after you display an album in the Organizer, you still need to select all the photos.

 To select all photos shown in an Organizer window, press Ctrl+A.

2. **Click Photo Book in the Create panel.**

 Regardless of whether you're working in the Organizer or an editing mode, the Photo Book option is available in the same Create panel. When you click Photo Book, the order system for Shutterfly opens. *Shutterfly* is an online order supplier where you can order prints of photos and have them shipped back to you and any other individuals you may wish to share your photos with.

 Regardless of whether you're working in the Organizer or an editing mode, the Photo Book option is available in the same Create panel. The Create panel changes to the first of several panes that walk you through the steps to create a photo book. If you start in the Organizer, clicking Photo Book in the Create panel opens your selected photos in Edit Full mode.

3. **Choose a photo book option from the Order Shutterfly Wizard.**

 The Shutterfly Wizard displays server options for ordering a photo book, as shown in Figure 1-2. Click one of the Create Now buttons for the type of book you want to order.

 The next screen offers you several options for a cover style.

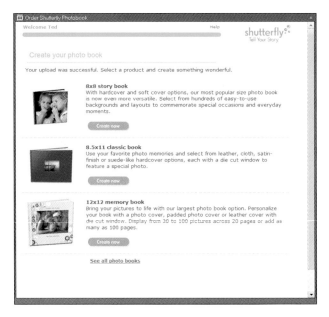

Figure 1-2: Click a Create Now button for the type of book you want to order.

4. Make a selection and click Next.

Your default Web browser opens the Shutterfly URL, where you're guided through steps to order your book, as shown in Figure 1-3. Proceed through the steps for ordering and identifying recipients.

Figure 1-3: Proceed through the online steps to order your photo book.

Making a Photo Calendar (Windows)

Are you ready to design a personal calendar using your favorite photos? Elements helps you design an attractive calendar of the kids, the girls' soccer team, the bullhead moose fraternity, or any other type of activity or event you want to work with. Elements makes it easy to create professional-looking calendars.

Here's how you create a calendar that can be professionally printed and ordered via an online service:

1. **Select photos in the Organizer.**

 For calendars, you might want to select 13 photos — 1 photo for the calendar cover and 12 for each month. You can also choose 12 photos and use one of the calendar months for the cover photo.

2. **Open the Create panel and click Photo Calendar.**

 The Kodak EasyShare Gallery Services opens. If you don't have an account, sign up on the opening page in the Kodak EasyShare Wizard. If you have an account, supply your logon and password.

3. **Click through the wizard to upload photos and click the final Next button to log on to the services Web page.**

 At this point, you leave Elements and work within a Web browser.

 When you first log on to the Kodak Gallery Web page, you're prompted to auto-fill or manually fill the calendar.

4. **Click Autofill and then click Next.**

5. **On the next page, as shown in Figure 1-4, choose the background design and theme. Then click Next.**

6. **On the next page, click one of the layout options for the number of photos you want to appear on each month. Then click Next.**

 If you chose 12 or 13 photos, use the 1-Up option, as shown in Figure 1-5.

7. **On the preview page, as shown in Figure 1-6, add a title and author/date name.**

 This page provides text boxes where you can add a title for the calendar and supply your name as the author.

8. **To preview the calendar, click the (preview) link shown in Figure 1-6.**

 Alternatively, click the First Month drop-down list and view the layout for each month.

9. **When the calendar appears as you like, click the Order button.**

 You proceed to the order page where you can select the number of copies and recipients for your calendar.

Figure 1-4: Click a theme in the scrollable window.

Figure 1-5: Click a layout option.

Figure 1-6: Preview the calendar.

Assembling a Photo Collage

To put together a photo collage, you first need to select a few photos in the Organizer and then click Photo Collage in the Create panel.

On the Macintosh, click several photos in Adobe Bridge and open a context menu. Choose Open With⇨Adobe Photoshop Elements 8.0, and the selected photos open in Edit Full mode. Click the Create panel to display the panel options and then click Photo Collage.

The panel changes, as shown in Figure 1-7.

The rest of the photo collage process is pretty straightforward. Just choose a page size from the Page Size drop-down list and a theme from the scrolla-ble options. If you like, you can choose a background from the Content panel and click the Apply button to apply a background style to the photos.

Figure 1-7: Select photos in the Organizer (or Adobe Bridge on a Mac) and click Photo Collage in the Create panel to open the Photo Collage panel.

After creating your photo book, you can submit it for an online order or print the book on your printer. When you choose File⇨Print, the Print dialog box opens, as shown in Figure 1-8. Notice along the left side of the Print dialog box are the photos added to your photo book. Click the arrows at the bottom center of the dialog box to preview the images before printing.

Figure 1-8: Choose File⇨Print to open the Print dialog box.

For more information on printing photos and photo projects, see Book IX, Chapter 2.

After you assemble a creation, you can save the project and return to make additional edits, such as changing a theme or background. Choose File⇨ Save As and choose Photo Project Format for the file type in the Save As dialog box.

Creating a Slide Show

To create a slide show using the Create panel, first select the images you want in the Organizer, click the Create tab in the Panel Bin, and then click PDF Slide Show. On the Macintosh, click photos in Adobe Bridge and open the photos in Elements, click the Create tab, and click PDF Slide Show. When you click PDF Slide Show, on the Mac you return to the Bridge window, where you choose all options for the final output.

The first thing you see is the Slide Show Preferences dialog box, as shown in Figure 1-9. You make choices in this dialog box for setting up your slide show — stuff like setting transition type, transition duration, and background color.

When you click OK in the Slide Show Preferences dialog box, the Slide Show Editor opens, as shown in Figure 1-10, where you define the attributes such as editing transitions, artwork from the Extras panel, and specifying zooms and time codes.

Rather than submit the slide show for online viewing, you can choose other output options. Click the Output button (refer to Figure 1-10), and the Slide Show Output dialog box opens, as shown in Figure 1-11.

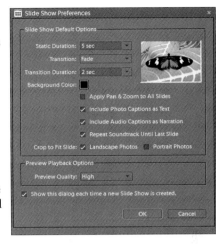

Figure 1-9: The Slide Show Preferences dialog box (Windows).

Figure 1-10: The Slide Show Editor.

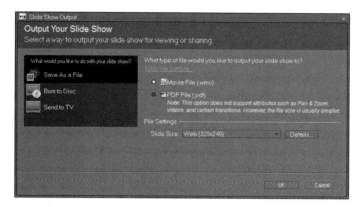

Figure 1-11: The Slide Show Output dialog box.

In the dialog box, you have several options from which to choose. These include

✓ **Save as a File:** Click Save as a File, and in the right pane, you can choose from

- *Movie File:* Choose Movie File to export the file as a video in WMV format.

- *PDF File:* Choose PDF File to export the file as an Adobe PDF document.

✓ **Burn to Disc:** Choose Burn to Disc to write a self-running VCD (Video CD).

✓ **Send to TV:** Choose Send to TV to burn a DVD using one of the following formats:

- *Standard Definition (NTSC):* Standard TV format using NTSC that is supported by USA and Japanese video players.

- *Standard Definition (PAL):* Standard TV format using PAL that's supported by video players outside the USA and Japan.

- *Widescreen Definition (NTSC):* Widescreen TV format using NTSC that's supported by USA and Japanese video players.

- *Widescreen Definition (PAL):* Widescreen TV format using PAL that's supported by video players outside the USA and Japan.

- *Enhanced Definition:* For use with TV sets supporting enhanced definition.

- *Widescreen Enhanced Definition:* For use with TV sets supporting widescreen enhanced definition.

- *Widescreen High Definition:* For use with TV sets supporting widescreen high definition.

Click OK in the dialog box after making the output choice, and your slide show is output using the settings you applied in the Slide Show Output dialog box.

Ordering Prints Online (Windows)

To order prints online using the Create panel, you must have a Kodak EasyShare account. When you select photos in the Organizer and click Order Prints in the Create panel, the Kodak Order Prints logon window opens, similar to the screen shown in Figure 1-12.

Figure 1-12: The Kodak Order Calendar order page.

After you log on to Kodak Order Calendar (click the Sign In button if you have an account or fill in the text boxes to create a new account), the files you selected earlier are uploaded and you see an order page similar to the one in Figure 1-12. Choose from the different print-size options and specify the quantity for each print. As you navigate through the order process, you can identify other recipients for your order and have copies of the calendars mailed back to you and sent to others.

Getting in Touch with Greeting Cards

You can create greeting cards in a snap in Photoshop Elements by using the Greeting Card panel. Here's how to do it:

1. **Open the Organizer (Windows) and select a photo or open a photo in Edit Full mode (Windows/Macintosh).**

2. **Click Create in the Panel Bin.**

3. **Click Greeting Card to open the Greeting Card panel.**

 The options available for creating greeting cards are shown in the panel (Windows), as you can see in Figure 1-13. On the Mac, the panel changes to display the settings shown in Figure 1-14.

4. **In the Greeting Card panel, scroll the Choose a Theme window and click a theme you want to use.**

5. **In the Content panel, choose a Content option.**

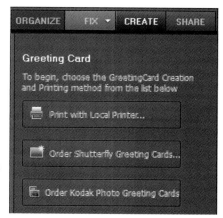

Figure 1-13: Choose a printing method for a greeting card (Windows).

Figure 1-14: Add some text to your greeting card by choosing a Type option in the Content panel and then clicking the photo (Mac).

The Content panel offers a number of choices from drop-down lists. In our example, we added text by choosing Text from the drop-down list, as shown in Figure 1-14.

To add text, click a style in the scrollable list and click the Apply button. Default text appears on your layout. Highlight the default text and type the text you want to add to your greeting card.

6. **Choose File⇨Save to save the file.**

Making Photo Stamps (Windows)

Another online creation feature in Elements is the option to create your own personal postage stamps. Yes, they're real stamps that you can use for mailing though the post office.

Here's the simple, easy way to use Elements to place an order for your very own personal postage stamps:

1. **Select an image in the Organizer.**

 Your file needs to be less than 5MB. (See Book III, Chapter 1 for more on resizing images.)

2. **Click Create in the Panel Bin and then choose PhotoStamps from the More Options drop-down list.**

 The PhotoStamps dialog box opens.

3. **Click the Upload My Photos button in the dialog box (see Figure 1-15).**

 Your photo is uploaded to the PhotoStamps.com Web site.

Figure 1-15: Choose PostageStamps from the Create panel's More Options drop-down list to open this dialog box.

4. **Place your order.**

 The PhotoStamps.com Web site provides an easy-to-use interface for ordering stamps. After you fill out the order and provide billing information, your stamps are mailed to you.

Getting Organized with CD/DVD Labels

Another creation option in Elements is a simple, easy way to create CD and DVD labels. From the Create panel, choose a menu item for CD Jacket, DVD Jacket, or CD/DVD Label from the More Options drop-down list. From templates provided in the panel, Elements offers you an easy method for printing your own, personalized labels and jackets for CDs and DVDs.

This feature for printing CD/DVD labels is a bit weak in Elements. You may need to fiddle around quite a bit to get the images to fit a label. Using some templates provided by label developers is often a much better method for printing labels.

Creating a VCD with Menu (Windows)

Select a slide show project and open the Create panel. From the More Options drop-down list, choose VCD with Menu. The Create a VCD with Menu dialog box opens, as shown in Figure 1-16. Select a project, make a choice for NTSC or PAL format, and click Burn. The file created is a Video CD with a menu you can control with your DVD player's remote control device.

Figure 1-16: The Create a VCD with Menu dialog box.

Making a Flipbook (Windows)

At the bottom of the More Options drop-down list in the Create panel, you can find a command for Flipbook. If you want to create a quick little video that shows off your photos by flashing stills on your screen or your TV set, you can quickly create a flipbook. Here's how you do it:

1. **Open the Organizer and select the files you want to use.**

 Note that you must select at least two files in order to create the flipbook.

2. **Click the Create tab in the Panel Bin and choose Flipbook from the More Options drop-down list.**

 The Elements Organizer Flipbook dialog box opens, as shown in Figure 1-17.

3. **Set the playback speed by typing a value in the Speed text box or moving the slider to the desired speed.**

 Note that flipping through photos looks best at low speeds, such as one or two frames per second (fps). Also, you can select the size for your video file from options on the Movie Size drop-down list. As file sizes are reduced, the download speeds when sharing files on the Internet increase. To get familiar with the file size that works best for you, experiment a little by saving files at different sizes.

4. **Click Output.**

 The Save Video Flipbook dialog box opens.

5. **Type a filename and click Save.**

Figure 1-17: The Elements Organizer Flipbook dialog box permits you to select a speed and movie file size.

Your file is written as a .wmv file. You can use Microsoft Movie Maker to write the file to a CD or DVD.

The WMV format is not recognized by many DVD players. You may need to convert the file format to a format recognized by your DVD player. Do an Internet search and explore some Web sites that offer freeware or shareware conversion utilities to find out more about video file formats acceptable to DVD players.

Chapter 2: Getting It Printed

In This Chapter

✓ **Preparing images for printing**

✓ **Setting up your print options**

✓ **Printing multiple images**

✓ **Using color profiles**

✓ **Printing color from different printers**

✓ **Using online printing services**

✓ **Exploring other print options**

*P*erhaps the greatest challenge for individuals using programs like Photoshop Elements (and even for the professionals who use its grand-daddy, Adobe Photoshop) is turning what you see on your monitor into a reasonable facsimile on a printed page. You can find all sorts of books on color printing — how to get color right, how to calibrate your equipment, and how to create and use color profiles — all for the purpose of getting a good match between your computer monitor and your printer. It's down-right discouraging to spend a lot of time tweaking an image so that all the brilliant blue colors jump out on your com-puter monitor, only to find that all those blues turn to murky purples when the photo is printed.

If you've already read Book III, Chapters 1 and 2, you're ahead of the game because you know a little bit about color management, color pro-files, and printer resolutions. After you check out those chapters, your next step is to get to know your printer or your print service center and understand how to correctly print your pictures.

In this chapter, we talk about options — many options — for setting print attributes for printing to your own color printer. We also toss in some tips on how to get better results when you're using print service cen-ters. If you need to, reread this chapter a few times just to be certain that you understand the process for printing good-quality images. A little time spent here will, we hope, save you some headaches down the road.

Getting Images Ready for Printing

The first step toward getting your photos to your desktop printer or to a printing service is to prepare each image for optimum output. You have several considerations when you're preparing files, including the ones in this list:

- ✔ **Set resolution and size.** Before you print a file, use the Image Size dialog box (Image➪Resize➪Image Size) to set your image size and the optimum resolution for your printer. Files that have too much resolution can print images that are inferior to files optimized for a printer. See your printer's documentation for recommendations for resolution. As a general rule, 300 ppi (pixels per inch) works best for most printers printing on high-quality paper. If you print on plain paper, you often find that lower resolutions work just as well or even better.

- ✔ **Make all brightness and color corrections before printing.** It stands to reason that you want to make sure that your pictures appear their best before sending them off to your printer. If you have your monitor properly calibrated, as we discuss in Book III, Chapter 4, you should see a fair representation of what your pictures will look like after they are printed.

- ✔ **Decide how color will be managed before you print.** You can color-manage output to your printer in three ways, as we discuss in the next section. Know your printer's profiles and how to use them before you start to print your files.

- ✔ **Get your printer ready.** Finally, when printing to desktop color printers, always be certain your ink cartridges have ink and the nozzles are clean. Make sure you use the proper settings for paper and ink when you send a file to your printer. Be sure to review the manual that came with your printer to become aware of how to perform all the steps required to make a quality print.

Setting Print Options

As you might expect, you print files from Elements by choosing File➪Print. Depending on what workspace you have open, you can set print options in the Print dialog box from the Organizer or from within Edit Full mode. The different modes provide you with some different options, so we want to look at printing from both the Organizer and Edit Full mode.

You have a number of different settings to adjust when printing color photos, as we explain a little later in the section "Printing with Color Profiles." For now, take a look at the different options you have in the print dialog boxes you open from the Organizer and from Edit Full mode.

Printing from the Organizer (Windows)

You can print photos from either the Organizer (Windows) or in Edit Full mode (Windows and Macintosh). On the Mac, you have a few printing options from within Adobe Bridge, but they're limited to printing contact sheets and picture packages. For printing individual photos on the Macintosh, you need to open the photos in Elements.

You can select one or more images in the Organizer and then choose File➪Print. The images selected when you choose the Print command appear in a scrollable list, as shown in Figure 2-1.

Figure 2-1: Thumbnails of selected images appear in the Prints dialog box.

Options you have in the Prints dialog box include

- ✔ **Image thumbnails:** When you select multiple images in the Organizer, all the selected images appear in a scrollable window on the left side of the dialog box.

- ✔ **Scroll bar:** When so many photos are selected that they all can't be viewed in the thumbnail list on the left side of the dialog box, you can use the scroll bar to see all images.

✔ **Add/Remove:** If the Prints dialog box is open and you want to add more photos to print, click the Add (+) icon and the Add Media dialog box opens, as shown in Figure 2-2. A list of thumbnails appears, showing all photos in the current open catalog. Check the check boxes adjacent to the thumbnails to indicate the photos you want to add to your print queue. You can also choose an entire catalog, albums, photos marked with keyword tags, and photos with a rating. For more information on albums, keyword tags, and ratings, see Book II, Chapter 2.

Figure 2-2: Thumbnails of selected images appear in the Add Media dialog box.

If you want to remove photos from the list to be printed, click the photo in the scrollable list in the Prints dialog box and click the Remove (–) icon.

✔ **Help:** Click the Help button to open help information pertaining to printing photos.

✔ **Page Setup:** Click this button to open the Page Setup dialog box, as shown a little later, in Figure 2-3.

✔ **More Options:** Click More Options to open another dialog box where additional options are chosen (see the section "Using More Options" later in this chapter).

✔ **Scroll Print Preview:** Click the arrows to toggle a print preview for all images in the list.

✓ **Print Preview:** This image displays a preview of the image in the preview that's to be printed.

✓ **Print:** Click Print after making all adjustments in the Prints dialog box.

✓ **Cancel:** Clicking Cancel dismisses the dialog box without sending a photo to the printer.

✓ **Select Printer:** Choose a target printer from the drop-down list.

✓ **Printer Settings:** Click this button to open properties unique to the selected printer.

✓ **Select Paper Size:** Choose from print sizes that are supported by your printer. This list may change when you choose a different printer from the Select Printer drop-down list.

✓ **Select Type of Print:** You have three options available: Individual Prints, Contact Sheets, or Picture Packages. For more information on contact sheets and picture packages, see "Printing Multiple Images" later in this chapter.

✓ **Select Print Size:** Select from the number of options for print sizes supported by your printer.

✓ **Crop to Fit:** Check this box to crop an image to fit the selected paper size.

✓ **Print ___ Copies of Each Image:** By default, One Photo Per Page is selected. Remove the check mark and you can choose to print a number of prints on the same page by making selections from the drop-down list.

Using Page Setup

When you click the Page Setup button in the Prints dialog box, the Page Setup dialog box opens, as shown in Figure 2-3. In this dialog box, you can make a few selections for print attributes that may be unique to your printer. However, for most desktop printers, the options you find in the Page Setup dialog box can be controlled in the Prints dialog box.

Using More Options

When printing photos from the Organizer, click the More Options button in the Prints dialog box. The More Options dialog box opens, as shown in Figure 2-4.

If you've used Photoshop Elements prior to version 8, you'll notice that the More Options dialog box has changed. As shown in Figure 2-4, you have three categories listed in the left pane. The first item — Printing Choices — is similar to what was available in earlier versions of Elements. The next two items — Custom Print Size and Color Management — have been moved from the Prints dialog box to the More Options dialog box.

Figure 2-3: The Page Setup dialog box.

Figure 2-4: The More Options dialog box.

When you want to manage color in Elements 8 as we explain later in the section "Printing with Color Profiles," you need to open the More Options dialog box.

The default selection in this dialog box is Printing Choices. The choices available for printing your photos include

🖝 **Photo Details:** Check the check boxes for the detail items you want printed as labels on your output.

🖝 **Border:** Check Thickness, and you can specify the size of the border in the text box and choose a unit of measure in the drop-down list. Click the Color swatch to choose a color for the border.

🖝 **Layout:** If you want one photo printed per page, check this box.

🖝 **Iron-On Transfer (Flip Image):** This option is used for heat transfer material: Mylar, Lexjet, and other substrates that require *e-down* printing — *emulsion-down* printing, where the negative and the image are flipped.

🖝 **Trim Guidelines:** Check Print Crop marks to add marks to the print to show where the paper needs to be trimmed.

Printing from Edit Full mode

If you want to print a photo while in Edit Full mode, choose File➪Print and the Print dialog box opens. The Print dialog box in Edit Full mode in Elements 8 is identical to the Print dialog box you use when printing from the Organizer. On the Macintosh, you find the same settings (see Figure 2-5) as Windows with the exception of the Select Type of Print drop-down list and Print Settings. You make the menu choices for contact sheets and picture packages from within Adobe Bridge.

Figure 2-5: The Print dialog box on the Macintosh.

Printing Multiple Images

You have choices in the Organizer or Edit Full mode for choosing a command for printing multiple images as either a contact sheet or picture package. On Windows, when you choose to print a contact sheet or picture package from within Edit Full mode, Elements switches you to the Organizer view. You continue as an action from the Organizer and leave Edit Full mode. On the Macintosh, you make the same choices from within Adobe Bridge that changes your view to Edit Full mode.

Printing contact sheets

Contact sheets in traditional photography were used to get a print from a roll of film. Rather than viewing negatives, a photographer could see a thumbnail print of each frame on a roll in a few contact sheets. These revealed how the frames would appear when printed.

You can get the same results in Elements by printing contact sheets from a collection of photos. When you can look over the thumbnails and choose which photos to print at larger sizes, you're saving money on your printer consumables.

To print a contact sheet, do the following:

1. **Open the Organizer (Windows) or Adobe Bridge (Macintosh).**

2. **In the Organizer/Bridge, select the photos you want to print on a contact sheet.**

 Press Ctrl-click (⌘-click on the Macintosh) to choose multiple photos in a noncontiguous selection. You can also sort photos by keyword tags, albums, dates, and so on. You then select all the sorted photos by pressing Ctrl+A. For more information on sorting files, see Book II, Chapter 2.

3. **In Windows, choose File⇨Print or press Ctrl+P. On the Macintosh, choose Tools⇨Photoshop Elements⇨Contact Sheet II in Adobe Bridge.**

 In Windows, the Print Photos dialog box opens. In the dialog box, select the printer you want to use for your output from the Select Printer drop-down list.

 On the Macintosh, you switch to Elements in Edit Full mode and see the Contact Sheet dialog box, where you make your choices and then click OK. After that, the contact sheet is assembled. Choose File⇨Print or press ⌘+P to print the contact sheet.

4. **Choose Contact Sheet from the Select Type of Print drop-down list.**

 The Prints dialog box refreshes to show your contact sheet options, as shown in Figure 2-6 (Windows).

On the Mac, you click Print in the Elements Print dialog box and then you see the Mac Print dialog box (collapsed by default), where you either click Print or expand the dialog box to make different choices for paper, color management, and so on.

Figure 2-6: Choose Contact Sheet and select a layout for the number of columns.

5. **Select a layout.**

 Choose the number of columns you want for the contact sheet. If you specify fewer columns, the images appear larger; as more columns are selected, the images appear smaller. Choose a size according to the number of columns that you want to print.

6. **(Optional) Check the boxes for the items you want included in the captions.**

 If you want print options to be shown on your prints, check the Show Print Options check box, and the list of options is displayed below the check box. Caption items can include the date, a text line for the caption, filename, and page numbers.

7. **Click More Options in the bottom of the dialog box.**

 Choose a color profile from the Print Space drop-down list. For more on printing with color profiles see the section "Printing with Color Profiles" in this chapter.

8. **Click OK in the More Options dialog box.**

9. **Click Print (back in the Prints dialog box) to print your contact sheet.**

Printing picture packages

Another option you have for printing multiple photos is picture packages. This feature prints multiple copies of the same photo or multiple copies of many photos.

A picture package is typically a single sheet of paper with the same photo printed at different sizes — something like your graduation photos or prom photos. You can choose to print a single picture package from one photo selected in the Organizer, or you can select multiple photos and print them all as multiple picture packages.

To create a picture package, do the following:

1. **Open the Organizer (Windows) or Adobe Bridge (Macintosh).**

2. **Select a single photo or multiple photos in the Organizer that you want to print as a picture package(s).**

3. **In Windows, choose File⇨Print or press Ctrl+P. On the Macintosh in Adobe Bridge, choose Tools⇨Photoshop Elements⇨Picture Package.**

 In Windows, the Prints dialog box opens. From the Select Printer drop-down list, choose the printer you want to use for your output.

 On the Macintosh, you see the Elements Picture Package dialog box, where you make the choices corresponding to the following steps, after which the picture package is assembled for you. After Elements finishes the assembly, choose File⇨Print or press ⌘+P.

4. **Choose Picture Package from the Select Type of Print drop-down list.**

 The Print Photos dialog box refreshes to show your picture package options.

5. **Choose a layout.**

 Choose a layout from the Select a Layout drop-down list. As you make layout selections, you see a dynamic preview of the picture package, as shown in Figure 2-7. Select different layouts to examine the results and choose the layout you want for your picture package.

6. **Select a frame.**

 The photos can be printed with a frame. Choose an option from the Select a Frame drop-down list or leave the default None selected to print no frame on the photos.

7. **Click More Options.**

 Choose a color profile from the same dialog box that appears when you print a contact sheet.

8. **Click OK.**

9. **In the Print Photos dialog box, click Print.**

Figure 2-7: Choose Picture Package and select a layout for the package.

Printing with Color Profiles

All the options we've talked about so far in this chapter give you a picture on paper, but even if you follow all the steps up to this point to a T, you may still not get the color right. You need to do more than adjust the settings in the Print Photos and Print dialog boxes to print the most accurate color you can on your printer. To do so requires using printer profiles that are created for every printer, paper, and ink set you use.

Printer profiles are created by printer developers for use with their inks and papers. If you decide to modify your printer and use large ink bottles or use lower-cost inks from third-party suppliers, the profiles shipped by your printer developer aren't optimized for the change in ink pigments. Likewise, third-party papers aren't optimized for the printer profiles shipped by your printer developer. In order to get accurate color when you use inks and papers different from those recommended by your printer developer, you may need to develop custom profiles for each ink set and each paper. You can find several sources of services that create custom profiles for you by searching the Internet.

Working with color printer profiles

In Book III, Chapter 4, we talk about creating color profiles for your monitor and selecting a color workspace. The final step in a color-managed workflow is to convert color from the profile of your color workspace to the color

profile of your printer. Basically, this conversion means that the colors you see on your monitor in your current workspace are accurately converted to the color that can be reproduced by your printer.

Understanding how Elements uses color profiles

When using the Print dialog box (or the More Options section of the Print dialog box), you can manage color in Photoshop Elements in one of three ways when it comes time to print your files:

- ✔ **Printer Manages Colors:** This method permits your printer to decide which profile is used when your photo is printed to your desktop color printer. Your printer makes this decision according to the paper you select as the source paper used to print your photos. If you choose Epson Premium Glossy Photo Paper, for example, your printer chooses the profile that goes along with that particular paper. If you choose another paper, your printer chooses a different color profile. This method is all automatic, and color profile selection is made when you print your file.

- ✔ **Photoshop Elements Manages Color:** When you make this choice, color management is taken away from your printer and is controlled by Elements. You must choose a color profile after making this choice in the Print dialog box. Desktop printers that fall in the medium-to-more-expensive range often have many color profiles they can install.

- ✔ **No Color Management:** You use this choice if you have a color profile embedded in one of your pictures. You'll probably rarely use this option. Unless you know how to embed profiles or receive files with embedded profiles from other users, don't make this choice in the Print dialog box.

Each of these three options requires you to make some kind of choice about how color is managed. You make choices (as we discuss later in this chapter, when we walk you through the steps for printing) about whether to color-manage your output. These selections are all unique to the Print dialog box for your individual printer.

Printing to Inkjet Printers

Printers are installed on your computer with printer drivers that are designed to offer you settings and controls for options unique to your printer. We can't hope to cover all printers and the variations you find with each device.

What we can do is give you some general idea for printing by showing how it's done with Epson printers — one of the more-popular desktop printer makes out there. This gives you a basis for understanding some of the settings you need to adjust when printing color to desktop printers and submitting photos to some service providers.

If you own a different brand of printer or use a service that uses other printers, what's important to remember in reviewing this section is the process involved in printing your files. Regardless of what type of printer you own, be aware of when a color profile is used and how color is either managed or not managed. You may have different check box selections and menu commands, but the process is the same for any printer printing your photos.

Over the past few years, at least half of the many service-provider troubleshooting tech calls coming from clients involved problems with accurate color output from Epson and some other ink jet printers. We're not talking about subtle changes between monitor and printer, but huge, monstrous color changes on output prints. As it turns out, almost all the strange output results originated from just one minor error that occurred when the file was set up to print — it involved when and how to manage color in the Print dialog box.

Color profiles are also dependent upon the ink being used. *Refilling* cartridges with generic ink can (in some cases) result in colors being shifted. Similarly, if the nozzles aren't clean and delivering ink consistently, you can get some very strange results.

We've come up with settings that will work well for you to get accurate results without stress or frustration. Just remember to use the settings exactly as described, and you can achieve superior results with either desktop or professional printers.

When you install your printer driver, the installation utility also installs a number of color profiles. You can choose the profiles in the Photoshop Elements Print dialog box and control all the printing by using the profile provided by your printer manufacturer.

You can also print from the Organizer by selecting one or more image thumbnails in the Organizer window and then choosing File➪Print. We use printing from Edit Full mode for the examples shown here because you may often want to perform some final corrections before printing.

You have a choice for how these profiles are used. You can

✏ **Choose to let your printer manage color:** The profiling selection is automatic, and you don't have to worry about making other choices in the Print dialog boxes.

✓ **Choose to let Photoshop Elements manage color:** In this case, you need to make some choices about the color profile to be used and make choices for the color-management process.

We're talking about two very different issues here. One issue is *color management,* which ultimately comes down to whether Elements manages your color, your printer manages color, or whether you use no color management at all. The other issue is choosing a color profile. Therefore, you have a series of combined options to choose from. You can choose a profile and either turn color management on or off, or you can elect not to make a profile choice and decide whether color management is on or off. The choices you make are critical to getting color right on your output.

All the methods are described in the following sections.

Automatic profile selection for Epson printers

The automatic profile selection method exists, and depending on what model of printer you have, you may be required to make this choice.

Your options all depend on whether the printer you buy installs color profiles on your computer. If you buy some low-end color printers that cost less than $100, the installer software typically doesn't install color profiles. When no profiles are installed, the printer manages the color through built-in profiles contained in the printer's memory.

High-end models (above the $100 price range) often install individual color profiles. You might see the profiles for various papers in the Printer Profile pop-up menu in the Elements More Options dialog box. If you have one of these high-end printers, you might want to choose the profile that matches the paper you're using and let Elements manage the color.

As we discuss in Book III, Chapter 4, you have two choices for your color workspace. Those choices are sRGB or Adobe RGB (1998). The workspace is used to see color on your monitor. We also talk (in Book III, Chapter 4) about calibrating your monitor so the colors you see appear as close to real-world color as you can get.

When you print a picture, the color from your workspace (either sRGB or Adobe RGB [1998]) is converted to your printer color. So, you want to fit all the color you see in an sRGB workspace, for example, into the printer's profile so that the print looks as close as possible to what you see on your monitor. Elements takes care of this color conversion. The only thing you need to worry about is making the right choice for how that conversion takes place.

Follow these steps to print from the native color space:

1. **Choose File⊅Print.**

 The Print dialog box that opens contains all the settings you need to print a file.

2. **Select the orientation of your print.**

 Your choices are either Portrait or Landscape. Click the proper orientation in the Page Setup dialog box (refer to Figure 2-3).

3. **Choose your printer.**

 Select your printer from the Select Printer drop-down list.

4. **Set the print attributes.**

 Select the number of copies, position, scaling, and output items you want.

 Click More Options and choose Color Management in the More Options dialog box. In the Color Management area of the Print dialog box, as shown in Figure 2-8, make your choices for how to manage color when you print files.

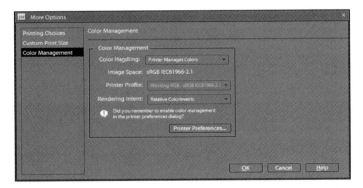

Figure 2-8: Look over the Color Management area in the More Options dialog box for options on how to manage color.

5. **From the Color Handling drop-down list, select Printer Manages Color. Click OK in the More Options dialog box.**

 This choice uses your current workspace color and later converts the color from your workspace to the printer output file when you open the printer driver dialog box.

6. **Click Print in the Print dialog box.**

The file doesn't print yet. First, the Windows system Print dialog box opens. Click Preferences, and the Printing Preferences dialog box opens, as shown in Figure 2-9.

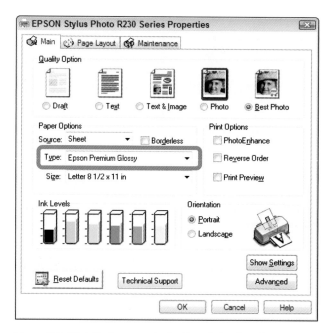

Figure 2-9: Click Preferences in the first dialog box that opens, and the selected printer preferences opens.

On the Macintosh, the OS X System Print dialog box opens. You need to make two choices here:

- Open the pop-up menu below the Pages item and choose Print Settings, as shown in Figure 2-10. From the Media Type pop-up menu, choose the paper for your output.

- The second choice Macintosh users need to make is the selection for Color Management. Open the Print Settings pop-up menu and choose Color Management, as shown in Figure 2-11. Leave the default setting at Color Controls (this setting is used when the printer manages color).

On the Macintosh, click Print, and the file is printed.

7. **Set print attributes.**

In our Epson example, select Epson Premium Glossy (or another paper from the Type drop-down list that you may be using) and then click the Best Photo radio button. (Refer to Figure 2-9.)

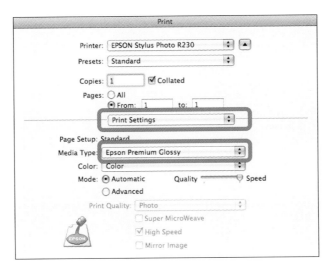

Figure 2-10: Choose Print Settings on the Macintosh and make a choice for the paper you use for the output.

Figure 2-11: Choose Color Management and make sure Color Controls is selected.

Now, it's time to color-manage your file. This step is critical in your print-production workflow.

8. **Click the Advanced button and then, in the Warning dialog box that appears, simply click Continue.**

 The Advanced Settings options in the Printing Preferences dialog box opens, as shown in Figure 2-12.

Figure 2-12: Click Advanced and then click Continue to access the advanced settings in the Epson printer driver.

9. **Make your choices in the Advanced Settings options of the Printing Preferences dialog box.**

Here are the most important choices:

- *Select a paper type.* You selected paper already? The second drop-down list in the Paper & Quality Options section of the dialog box determines the application of inks. Choose the same paper here as you did in Step 8.

- *Turn on color management.* Because you're letting the printer driver determine the color, you need to be certain that the Color Controls radio button is active. This setting tells the printer driver to automatically select a printer profile for the paper type you selected.

- *Set the color mode.* Don't use Epson Vivid. This choice produces inferior results on photos. Choose Best Photo, the Epson Standard, or Adobe RGB, depending on your printer.

If you frequently print files using the same settings, you can save your settings by clicking the Save Setting button.

10. **To print the photo, click OK, and then OK again in the Print dialog box.**

 Your file is sent to your printer. The color is converted automatically from your source workspace of sRGB or Adobe RGB (1998) to the profile the printer driver automatically selects for you.

Selecting a printer profile

Another method for managing color when you're printing files is to select a printer profile from the available list of color profiles installed with your printer. Whereas in the preceding section, you used your printer to manage color, this time you let Photoshop Elements manage the color.

The steps in this section are the same as the ones described in the preceding section for printing files for automatic profile selection when you're setting up the page and selecting a printer. When you choose File⇨Print, you open the Elements Print dialog box. To let Elements handle the color conversion, follow these steps in the Print dialog box:

1. **From the Printer Profile drop-down list in the Color Management section of the Print dialog box, select the color profile designed for use with the paper you've chosen.**

 In this example, we use a heavy-weight-matte-paper color profile, as shown in Figure 2-13. (Note that custom color profiles you acquire from a profiling service come with recommended color-rendering intents. For this paper, Relative Colorimetric is recommended and is chosen on the Rendering Intent drop-down list, as shown in Figure 2-13.)

 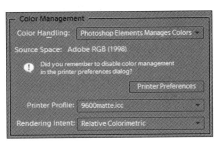

 Figure 2-13: Choose a printer profile that matches the paper you use.

2. **Click Print.**

 The second Print dialog box opens.

3. **Click the Properties button.**

 You arrive at the same dialog box shown in Figure 2-9. On the Macintosh, you arrive at the same dialog box shown in Figure 2-10.

4. **In Windows, click the Best Photo radio button and from the Type drop-down list, select the recommended paper choice. On the Macintosh, make your paper choice, as shown in Figure 2-10.**

Custom color profiles are also shipped with guidelines for selecting proper paper.

5. **In Windows, click Advanced and then click Continue to arrive at the dialog box shown in Figure 2-14. On the Macintosh, choose Color Management from the pop-up menu to arrive at the same dialog box shown in Figure 2-11.**

 The paper choice selection is automatically carried over from the previous Properties dialog box (see Step 2 in the preceding section). The one setting you change is in the Color Management section.

6. **In Windows, click the ICM (Image Color Management) radio button and select the Off (No Color Adjustment) check box, as shown in Figure 2-14. On the Macintosh, click the Off (No Color Adjustment) radio button.**

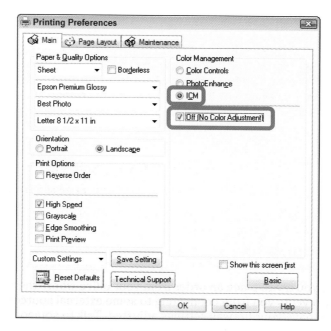

Figure 2-14: Click ICM and check Off (No Color Adjustment).

Because you selected the color profile in Step 1 and you're letting Elements manage the color, be sure the Color Management feature is turned off. If you don't turn off Color Management, you end up double-profiling your print.

The choice to manage color or not to manage it is simplified in Photoshop Elements. In the Color Management area of the dialog box, a message is reported each time you make a selection from the Color Handling drop-down list. Right below Source Space, you see a message asking if you remembered to turn Color Management on or off. Each time you make a selection for the Color Handling, pause a moment and read the message. This is your reminder that you need to follow the recommendation to properly handle color.

Using Online Printing Services (Windows)

Photoshop Elements supports the Adobe Photoshop Services program, which is a joint effort between Adobe Systems and Kodak EasyShare (formerly Ofoto), a division of Kodak. The Services program offers online ordering of prints and sharing of photos and projects, and it has a huge array of different print products for consumers and professionals.

As of this writing, you get ten free prints, so it's worth taking a little time to check out the service — especially if you want to order prints and have them mailed directly to your home or office. No lines, no hassles, no dealing with high gasoline costs — this service offers great prints and an abundance of convenience.

To use the service, follow these steps:

1. **Select files in the Organizer much as you'd select files for printing.**

2. **In either editing mode or the Organizer, choose File⇨Order Prints.**

 Alternatively, you can click the Share tab in the Panel Bin and then click the Order Prints button.

 The Kodak EasyShare Wizard opens, as shown in Figure 2-15. The first screen shown in the wizard is a form for you to create an account.

 If you try to place an order from your office where the IT department prevents you from connecting to some external sources, you may need to have your firewall settings adjusted. Talk to someone in your IT department to help you make a connection.

3. **If you haven't set up an account already, fill in the information and step through the wizard by clicking the Next button on each page. If you have set up an account, supply your logon information.**

 The selected files in the Organizer are automatically loaded in Step 1 of the wizard's order page.

Figure 2-15: Choose File⇨Order Prints to open the Kodak EasyShare Wizard.

4. **Modify your order by deleting files from the order and specifying different print sizes and quantities.**

 One nice feature in the service is the option to send duplicate prints to another party. You can keep an address book on the provider's Web site and specify whom you want to receive an order. This feature is helpful if you're away spending your children's inheritance on a Caribbean cruise and want to send photos of the great time you're having to all your kids. Just pop open your laptop on the pool deck, load the digital camera images, and connect via a wireless connection. Before you return to Buffalo in midwinter with a suntan, your kids will frown as they fan through the prints they received a week earlier.

5. **Continue stepping through the wizard to upload your files and confirm your order, and then click the Finish button on the last pane.**

 Your order is complete.

Exploring Other Print Options

Photoshop Elements provides you with other options for printing things, such as video images and contact sheets; adding borders and trim lines; and inverting images for heat transfers, such as the ones you may use for iron-on T-shirt designs. You can find these options in the Print dialog box. Most of these print options are intuitive and easy to use. Just poke around, experiment, and have fun. When it comes time to print, follow the recommendations we offer here for getting your color right.

Chapter 3: Getting It on the Web

In This Chapter

✓ Understanding Web optimization

✓ Understanding Web Safe colors

✓ Optimizing type for screen viewing

✓ Optimizing images for Web hosting

When we talk about optimizing images for Web viewing, we're also talking about viewing files on computer monitors, TVs, iPods, and other screen devices. After all, viewing Web pages at this time in technology history requires viewing Web pages on a screen of some kind. This chapter presents concepts related to preparing and viewing files on the Web, as well as sharing files for viewing onscreen devices.

There are a few variances between Web-viewing photos and screen-viewing photos. It is important to use a color palette that can display the same colors on Web-page images whatever the viewer's computer operating system.

In this chapter, we talk about preparing images for Web hosting and screen viewing, working with color palettes optimized for Web-hosted images, preparing type for Web and screen viewing, and creating Web galleries to upload your files to a Web service.

Understanding Basic Web Optimization

If you've read through chapters in any of the previous minibooks, you're aware of some of the differences between files you prepare for print and those that are used for Web pages.

To optimize images for Web viewing, you want to reduce the file size for every image uploaded to a URL. If you download files from your camera or card reader (as we explain in Book II, Chapter 1) or prepare files for print (as we explain in Book IX, Chapter 2), you must often reduce the file sizes for Web-hosted images in order to ensure faster downloads.

Anyone viewing a Web page is likely to get impatient if file sizes are large and the download times are extraordinary. Getting files to the smallest file size without compromising image quality is the goal of every Web designer.

Choosing a resolution

Your first effort at optimizing files for Web hosting involves obtaining the best resolutions for Web-hosted files.

On the Macintosh, Web-hosted files are optimum at 72 ppi (pixels per inch); on Windows, resolutions of 72 and 96 ppi are optimum for Web hosting.

Before moving on to other optimizing tasks, it's best to downsample images to either 72 or 96 ppi. As a standard, you can set the resolution to 72 ppi, confident that all Web browsers will display the images at the same size.

To downsample an image, do the following:

1. **Open an image in Edit Full mode.**

2. **Choose Image⇨Resize⇨Image Size, or press Alt+Ctrl+I (Windows) or Option+⌘+I (Mac).**

 The Image Size dialog box opens, as shown in Figure 3-1.

3. **Set the dimensions.**

 Type the new dimensions in either the Width or Height text box for the document size. By default, the proportions are constrained so when you type a value in either text box, the other size is supplied automatically by Elements.

4. **Check the Resample Image check box and choose a resampling method from the drop-down list.**

Figure 3-1: The Image Size dialog box.

By default, the resampling method used is Bicubic, which provides the best results for continuous-tone images such as photos. You have other options in the drop-down list that work better with illustrated art, line art, and other types of images. For more information on the downsampling methods, see Book III, Chapter 1.

5. **Enter the desired resolution in the Resolution field.**

6. **Click OK.**

 The file is downsampled according to the settings made in the Image Size dialog box.

Upsampling images

As a general rule, avoid *upsampling* images — sizing up an image with the Resample Image check box enabled in the Image Size dialog box. We cover some of the pitfalls for upsampling images in Book III, Chapter 1. We also point you to a third-party plug-in that can be useful if you absolutely have to upsize images.

Rasterizing files

Rasterizing files is the process of converting vector artwork to raster artwork. Artwork created in programs like Adobe Illustrator and CorelDraw are typically vector art files. Vector objects in Elements can be type as well as some shapes that are created on vector layers.

When you flatten layers in Elements you rasterize the vector layers. When you open vector art, such as Adobe Illustrator files, CorelDraw files, or PDF files, you rasterize the artwork. To read more about raster versus vector art, see Book III, Chapter 1. To read more about type on layers, see Book V, Chapter 3.

Rasterizing vector artwork on layers in Elements converts the artwork to pixels at the resolution of the open file where the vector artwork is added. When you open a file containing vector art, you can choose to rasterize the artwork at a user-defined resolution.

Choosing File⇨Open

When you open artwork containing vector art, you see a dialog box where you control the options for rasterizing the file. In Figure 3-2, we opened a PDF document. The Import PDF dialog provides some controls for determining the size and resolution.

Unlike raster art, upsizing a vector art file doesn't degrade the image. Because the artwork is not yet pixels, you can rasterize a vector file to any size you like. When preparing these images, you want both the physical dimensions and the resolution to be the best for your Web pages.

Figure 3-2: The Import PDF dialog box.

Selecting a color mode

In Book III, Chapter 2, we cover all the color modes supported by Elements. When you create images for Web pages, all the color modes available in Elements are acceptable for Web graphics. Your choices for color modes include

- **Bitmap:** The bitmap color mode is generally used for line art. Images, such as black-and-white logos, might be scanned as line art and, therefore, be rendered as bitmap images. After you have a bitmap image in Elements, you can save the files as GIF or PNG, but you don't have an option for using the Save for Web command. It's generally best to convert bitmap images to grayscale first and then save the files for the Web.

- **Grayscale:** Grayscale images can be saved for Web hosting.

- **Indexed Color:** Indexed color images provide some options for reducing the number of colors in a file to get smaller file sizes. Continuous-tone images, such as photographs, generally won't look as good onscreen unless they're saved as RGB color images. However, artwork, such as color logos, can be reduced in file size by limiting the number of colors to fewer than 256 without degrading image quality.

- **RGB color:** RGB is best used with continuous-tone images.

Understanding file formats

Elements has a number of different file formats for saving files. However, only a few of the long list of supported file formats work with Web graphics. We cover all the formats in Book III, Chapter 2. For a little review, here are the formats you can use when preparing files for Web hosting.

GIF

GIF is one of the popular file formats you find on many Web sites. GIF files are saved as indexed color where the total number of colors in an image can be reduced to fewer than 256 in order to get smaller file sizes. You can also use the GIF format when saving images that display animated effects.

When you choose File⇨Save As in Edit Full mode and choose CompuServe GIF (*.GIF), the Indexed Color palette box opens, as shown in Figure 3-3. In this dialog box, you make choices for

Figure 3-3: The Indexed Color palette box opens when you save files as CompuServe GIF.

 ✓ **Palette:** Open the Palette drop-down list and you can choose from a number of different color-palette options. Among your choices is the Web palette. Making this choice reduces the total colors from the default 256 to 217. The 217 colors are known as *Web Safe* colors, meaning that these colors look the same on both the Macintosh and Windows operating systems.

 ✓ **Colors:** You can reduce colors lower than the default 256 by typing a number in the Colors text box. The more colors you eliminate, the lower the file size. However, if you reduce colors in continuous-tone images, you notice severe contrast between tones. This contrast is likely to produce degraded images. Furthermore, reducing colors in artwork too far may produce other unwanted results. You need to experiment a little when reducing colors by checking the Preview check box and viewing the image before actually saving. What you see on your screen is what you get. If the preview looks good, go ahead and click OK.

 ✓ **Forced:** This option is available with bitmap images. You can save as Black and White, and when the Transparency check box is enabled, the whites appear as transparent.

 ✓ **Matte:** When you have transparency in an image, you can use a matte color for the transparent areas. Your choices include a list of preset colors as well as a Custom option for you to set the color to a custom color within the palette you choose.

✔ **Dither:** When indexed files are saved and the colors contain up to a maximum of 256 colors, you need a way to simulate color transitions. This is handled through a dithering process whereby the color transitions simulate a view that appears to have more than 256 colors. Your dither choices include Diffusion, Pattern, and Noise. For continuous tone images, the Diffusion dither produces the least-obvious color transitions.

✔ **Preserve Exact Colors:** Check this box to preserve colors that have exact matches to the color palette you choose.

JPEG

JPEG is also one of the most popular file formats you find on Web pages. JPEG images can be saved as progressive JPEGs to permit the image file to be downloaded *progressively* (in stages, in other words), This format supports some great file compression. When you save as JPEG, the JPEG Options dialog box opens, as shown in Figure 3-4. Your options in this dialog box include

✔ **Matte:** This option is the same as when saving as GIF.

✔ **Quality:** Type a value between 1 and 12 for the amount of compression you want to apply to the

Figure 3-4: The JPEG Options dialog box.

saved file. JPEG is a *lossy* file format, meaning that data are thrown away during compression. The lower the number, the more data are thrown away. If you reduce the value too low, you see obvious image degradation. Keep the Preview check box checked, and you can dynamically see the results your tweaking has on the image before clicking OK.

The drop-down list adjacent to the Quality value offers you five settings. When making a menu choice, the Quality value changes respective to the menu choice. Additionally, you can move the slider to change the value in the Quality text box.

When previewing different compression options, be sure to zoom in on your photos. If the photo is fit in the Image window, you may not see the results of the compression selections you make when the Preview check box is checked. If you start with the image fit within the Image window, you can keep the JPEG Options dialog box open and press Ctrl++ (⌘++ on a Mac) to zoom in. You can place the cursor in the Image window, and you see the Hand tool. Click and drag the photo around to view areas respective to the Quality setting you choose in the JPEG Options dialog box.

✔ **Format Options:** You have three choices. The first two use line-by-line passing and an optimized encoding system to display images. The Progressive option displays images using several passes. You specify the number of passes in the Scans drop-down list, where you can choose from 3 and 5.

PNG

PNG supports two different formats — PNG-8 and PNG-24. You can save files as PNG-8 using the Save As dialog box. However, using the Save As command doesn't provide you all the options that can be set for PNG files. (In fact, all you get from the Save As dialog box are the rather paltry options shown in Figure 3-5.) If you want to use the PNG-24 format or take advantage of more option choices for PNG-8, you must use the Save for Web dialog box. See "Optimizing Images with Save for Web" later in this chapter.

Figure 3-5: The PNG Options dialog box when using Save As and choosing the PNG format.

Using a Web-Safe Palette and Hexadecimal Colors

When working with indexed color files, you have a maximum of 256 colors available in the Indexed Color palette. Compare that value with the 16.7 million colors that you have available with RGB color.

When you convert an RGB image to indexed color, the colors outside the Indexed Color spectrum are dithered to simulate colors that more closely resemble an image in RGB mode.

Out of the 256 colors that you find in the Indexed Color palette, 39 colors do not look the same in different operating systems. The color display is determined by the operating system (OS) for the Macintosh and Windows computers, and it turns out that these operating systems produce 39 different color values that can't be viewed identically across platforms. Therefore, you have 217 out of 256 colors that are viewed identically by both operating systems.

Specifying a foreground Web Safe color

The 217 colors are referred to as being within a *Web Safe* color palette, and Elements makes it easy for you to work with the palette when converting color images, creating type, and creating graphic elements, such as buttons and icons.

To specify a color within the Web Safe color palette, do the following:

1. **Open Edit Full mode.**

2. **Click the Foreground color swatch in the Tools panel.**

 The Color Picker (Foreground Color) dialog box opens.

3. **Click Only Web Colors.**

 Only the colors within a Web Safe color palette are displayed in the dialog box.

4. **Click in the large color swatch to make a color selection.**

 You can scroll the hues by moving the slider to the right of the large color swatch. When you enter the hue range of a color you want, click in the swatch, as shown in Figure 3-6.

Figure 3-6: Check Only Web Colors to display the Web Safe color palette.

The color choice you make in the Foreground Color dialog box reports the hexadecimal value of the color. In Figure 3-6, the value is ff0033. You can use this value in HTML code when creating Web pages to specify background color and color for other Web page elements.

5. **Click OK.**

 The Web Safe color you selected is loaded in the Foreground color swatch in the Tools panel. When you fill selections and use the painting and marking tools, the color you apply is a Web Safe color. For more information on filling selections and painting, see Book IV, Chapter 1.

Using a Web Safe palette

If you create various elements and objects that you want to include in a Web page design, you want to open a palette and work with Web Safe colors. To do so, follow these steps:

1. **Open Edit Full mode.**

2. **Open the Color Swatches palette.**

 Choose Window➪Color Swatches.

3. **Load a Web Safe palette.**

 Open the drop-down list in the Color Swatches palette and choose from Web Hues, Web Safe Colors, or Web Spectrum, as shown in Figure 3-7. The colors you work with from any of these color swatch libraries are within the Web Safe color spectrum.

Figure 3-7: Choose a Web Safe color palette from the drop-down list.

Making Type Look Good Onscreen

Adding type to images or creating type on a blank, new file (for example, one that creates a banner on a Web page) is something that you do frequently in Elements if you're a Web page designer.

You need to take few precautions when creating type for the Web. These include

✔ **Setting the file size and resolution before creating the type.**

 Don't rely on resampling images when you have type as either a stand-alone element or an addition to photos and layouts.

✔ **Using Web Safe colors.**

 Set the foreground color from the Web Safe color palette, or choose a color from the Color Swatches library of Web Safe colors.

✔ **Being certain to use anti-aliased type.**

 When you create type, be certain the Anti-alias icon is enabled in the Options bar, as shown in Figure 3-8.

Figure 3-8: When creating type, click the Anti-alias icon in the Options bar.

When you anti-alias type, Elements creates some pixels of different color values at the edges of your type to simulate a smoother type appearance. If you don't anti-alias the type, the edges appear jagged. In Figure 3-9, you see type created on the left without anti-aliasing. On the right, you see the same type created with anti-aliasing.

Figure 3-9: Type created without anti-aliasing (left) and with anti-aliasing (right).

We cover a lot more related to working with type in Book V, Chapter 3. Look over that chapter to understand much more about specifying type.

Optimizing Images with Save for Web

The save options you have available in the Save As dialog box enable you to save files in formats that are compatible with Web-hosted images. However, the options you have in the Save As dialog box are much more limited than the ones available to you in the Save for Web dialog box.

In the Save for Web dialog box, you can optimize images and create previews to simulate download times. Even if you don't tweak the sampling and/or resolution of your files, you can rely on the Save for Web dialog box to offer you many other optimization features.

Choose File⇔Save for Web to open the Save for Web dialog box, as shown in Figure 3-10. In this dialog box, you can choose any of the compatible file formats that support Web-hosting images. Additionally, you can adjust settings and optimize your files to create the smallest file sizes.

Figure 3-10: The Save for Web dialog box.

The option choices you have in the Save for Web dialog box are covered in Book III, Chapter 2. Look over that chapter to explore all the possible options.

Chapter 4: Sharing Projects with Others

In This Chapter

- ✓ Using the Share panel
- ✓ Creating online albums
- ✓ Attaching files to e-mail
- ✓ Using Photo Mail
- ✓ Using online sharing services

You shoot photos primarily for two reasons (if you're not selling them for income). One reason is for personal satisfaction so you can revel in your own work. The other reason involves sharing your creations with others.

Perhaps the most enjoyable aspect of photography is experiencing the appreciation of family and friends who laugh, cry, ooh, and aah when looking at your images.

Photoshop Elements provides you with a number of different sharing options to get those laughs, cries, oohs, and aahs from others. When it comes down to it, the sharing of photos just might be one of the best reasons you have for using Photoshop Elements.

In this chapter, we look at the number of different opportunities Elements provides to enable you to share photos in your living room or across the world.

Getting a Grip on the Share Panel

When you open Edit Full mode (Windows) and click the Share button, the options for sharing photos appear listed in the Share panel, as shown in Figure 4-1. On the Macintosh, the

common items you find in Edit Full mode include E-Mail Attachments, CD/DVD, and PDF Slide Show. The Macintosh also includes Web Photo Gallery.

On Windows, the Share panel in the Organizer has the same options found in Edit Full mode with the addition of Burn Video DVD/BluRay, Burn Data CD/DVD, Online Video Sharing, and Mobile Phones and Players. These four choices require installation of Adobe Premiere Elements.

To share photos, you either select the images you want to share in the Organizer (Windows) or load up photos in the Project Bin in Edit Full mode (Windows or Macintosh). Then click one of the buttons in the panel or open the More Options menu and choose one of the menu items.

Figure 4-1: The Share panel in Edit Full mode on Windows.

Creating an Online Album (Windows)

The first of the sharing options we cover in this chapter involves creating an online album for Windows users. Elements offers a few options for sharing photo albums online. The name of this option is a bit misleading because you don't necessarily have to host your album online in order to share it. In fact, you have several separate options for sharing photo albums, including

- **Photoshop Showcase:** An album is prepared for uploading to Photoshop Services where people you invite can see your albums online.

- **Export to CD/DVD:** This option gives you the opportunity to save your creation to a CD or DVD.

- **Export to FTP:** You can host an album on Photoshop.com as a Web page. All the HTML code is included in your upload, so you don't need to worry about how images are viewed or how to create URL links. Note that this sharing option no longer lets you host pages on a Web server space from your local Internet service provider (ISP). To upload files to your own Web site, you need to use an ftp client and upload files much like you upload your own Web pages.

✓ **Export to Hard Disk:** This option permits you to create a photo album and save it to your hard disk. You can later upload the album to an online service.

Elements makes it easy for you to create an online album. To verify our claim, follow these steps:

1. **Open the Organizer and select the photos you want to use in a new album.**

2. **Click Share in the Panel Bin and choose Online Album from the panel options (refer to Figure 4-1).**

3. **Select the item to Share To and then choose one of the options listed earlier in this section.**

4. **Create a new album to share online.**

 Click the Create New Album radio button in the Share panel and leave the default Photoshop Showcase radio button active. Click Next to proceed to the next panel.

 The next pane shows two tabs — one for the content and the other for sharing options. The default tab in view is the Content panel, as shown in Figure 4-2.

5. **At the top of the panel, choose a category from the Album Category drop-down list and type a name for your album.**

 You can't proceed to share your album until you type a name for the album.

6. **(Optional) Add or remove photos from the album.**

 If you find that you don't want some of the photos shown in the Content panel, click the unwanted photos and then click the minus (–) icon. If you want to add additional photos, drag them from the Organizer to the Content panel or click a photo in the Organizer and then click the Add (+) icon.

Figure 4-2: Order your photos in the Content panel.

7. **Change the order of the photos in the album.**

 The order shown in the panel is the same order the photos will appear in your album. If you want to rearrange the photos, click and drag them around the Content panel. The panel behaves much like a slide sorter.

8. **Click the Sharing tab in the Share panel.**

 Elements builds a preview of your album.

9. **Choose a template.**

 At the top of the preview shown in Figure 4-3, you find several options for choosing a template. Click one of the preview thumbnails to change the template for the album. You have a number of category choices from the Select a Template drop-down list. Go ahead and click different template options and Elements updates the preview.

Figure 4-3: Click the Sharing tab and choose a template for your album.

10. **After choosing the template you want, click Done.**

 Your album is uploaded to Photoshop Showcase.

Creating an E-Mail Attachment

Elements makes it easy for you to attach photos to an e-mail message. You can stay in the Organizer (Windows) or Adobe Bridge (Macintosh). You don't have to open your e-mail client and search your hard drive to locate the photos you want to attach to an e-mail message.

To attach photos to a message, do the following:

1. **Open the Organizer (Windows) or Adobe Bridge (Macintosh).**

2. **Select photos you want to e-mail.**

3. **In Windows, open the Share panel in the Panel Bin and click E-Mail Attachments. On the Macintosh, choose File⇨Attach to Email at which point Bridge switches you to Edit Full mode and the editor launches your e-mail client.**

 The photos you select in the Organizer appear in the E-Mail Attachments panel, as shown in Figure 4-4.

4. **Choose a photo size from the Maximum Photo Size drop-down list and adjust the quality slider.**

 Notice the readout below the slider informs you of the size of the image and the amount of time necessary to send the file at 56Kbps.

5. **Click Next.**

 Scroll to the bottom of the panel to locate the Next button.

 The next pane in the E-Mail Attachments panel opens where you can type a message.

6. **Add a message to the Message text box.**

7. **Add contacts.**

 If you don't find a list of recipients, you don't have any in your Elements address book. To add recipients:

 a. *Click the Edit Recipients in Address Book icon in the top-right corner of the Select Recipients area of the E-Mail Attachments panel.*

 You add new contacts to the Contact Book dialog box that opens.

 b. *Add contacts and click OK.*

 c. *When you return to the E-Mail Attachments panel, check the boxes adjacent to the names of the contacts you want to receive your e-mail.*

Figure 4-4: Choose a size for the file attachment.

8. **Click Next.**

 Your default e-mail client opens with the files you selected appearing as attachments and a default message.

9. **(Optional) Feel free to edit the message if you like.**

10. **Click Send.**

 Your e-mail, with photo attachments, is sent on its way.

Sending Photo Mail (Windows)

Although similar to sending e-mail attachments, using Photo Mail lets you package your photo attachments in a neat layout you create in Elements. You select photos in the Organizer, assemble them in a design, and then send them off via e-mail.

To use Photo Mail, do the following:

1. **Open the Organizer.**

2. **Select photos you want to use with Photo Mail.**

3. **Open the Share panel in the Panel Bin and click Photo Mail (refer to Figure 4-1).**

 Photos you select in the Organizer appear in the Photo Mail panel, which is similar to the same panel used with E-Mail Attachments (refer to Figure 4-4).

4. **Click Next.**

 The next pane opens in the Photo Mail panel, again similar to the E-Mail Attachments panel.

5. **Type a message and add recipients.**

 The options for adding recipients and the message in Photo Mail are the same as you have when sending e-mail attachments (see the preceding section for details).

6. **Click Next.**

 The Stationery & Layouts Wizard opens, as shown in Figure 4-5.

7. **Choose a layout design.**

 In the left pane, you find a list of categories representing different layouts. Click a category to expand it, and click one of the items nested below the category name.

8. **Click Next Step to open the Layout panel.**

Figure 4-5: The Stationery and Layouts Wizard.

9. **Adjust the layout to your liking.**

 The Layout panel provides options for sizing images, choosing from a list of layout designs, assigning text attributes, and adjusting borders and border colors, as shown in Figure 4-6. Make choices for the design effect you want to use for your Photo Mail.

10. **Click Next.**

 Elements creates the design and adds it as a file attachment in a new e-mail message in your default e-mail client.

11. **Click Send to e-mail the layout to the recipients you identified in Step 5.**

Sharing Photos Online

Several methods of sharing your creations are available in Elements via third-party services. Additional options are available in the Share panel when you click the More Options button (refer to Figure 4-1). Here you find several supported services for displaying and sharing photos.

Figure 4-6: Adjust the layout according to the appearances you want.

Using Kodak EasyShare

We talk about using Kodak EasyShare in Book IX, Chapter 1. To find out how to share your photos using this service, refer to that chapter.

Sharing Video with Adobe Photoshop Showcase (Windows)

Elements supports a great companion product — Adobe Premiere Elements. Premiere Elements is a tool for editing videos. In order to use the Sharing Video with Adobe Photoshop Showcase feature, you need Premiere Elements.

Premiere Elements can be downloaded free from Adobe's Web site for a 30-day trial period. You can use Premiere Elements and all its features during the trial. If Premiere Elements is of interest to you, you can purchase the product online after the 30-day trial. To download your trial copy, simply click the Sharing Video with Adobe Photoshop Showcase button and follow the instructions to proceed to the download area.

Sending photos to SmugMug Gallery (Windows)

Select Photos in the Organizer and choose the Send Photos to SmugMug Gallery menu item. The service offers attractive album creation options for your photos that can be printed or shared online.

Sending photos to CIVEA Digital Photo Frame

CIVEA Digital Photo Frame is also a paid service where you can order a wide variety of frames to display your pictures. Log on to the service, set up an account, and browse the catalog of various photo frames to order.

Sharing Flickr (Windows)

Flickr is a popular photo-sharing service offered free from Yahoo!. You follow the same steps as other sharing services. Select photos in the Organizer and open the Share panel. Click the More Options button and choose Share to Flickr. You're prompted to log on to your account, and the photos are uploaded to Flickr.

Index